Salvation and Spiritual Growth, Level 1

Salvation and Spiritual Growth, Level 1

For New Converts

Apostle, Dr. June H. Lawrence, Phil 4:7

authorHOUSE®

AuthorHouse™
1663 Liberty Drive
Bloomington, IN 47403
www.authorhouse.com
Phone: 1-800-839-8640

Revised for Church Distribution
Day Break Ministries Incorporated

First published by AuthorHouse 6/16/2011

ISBN: 978-1-4634-1869-4 (sc)
ISBN: 978-1-4634-1868-7 (hc)
ISBN: 978-1-4634-1867-0-(e)

Library of Congress Control Number: 2011910564

Printed in the United States of America

Dedicated
To
My Beloved Son

On the way to the grocery store, with my son, as we walked, I expounded upon him the way of salvation. He was 5 years old. By the time we arrived I had led him to Christ, our Redeemer, on a fall evening.My son was my first convert.

Statement of Faith
OrMission's Statement

Yahweh
(In Hebrew, the Divine Source)

We believe in the fullness of God, explained in and through **God the Father**, as **Elohim**, the **Almighty God**, (Psalms 8:2). We believe that He is the Ruler of all as **El Shaddai**, (St. Luke 1:49). We believe that He is the Creator of all things, as the **Alpha and the Omega**, the first and the last, the beginning and the ending, (Revelation 22:13).

Yashua
(In Hebrew, the Messiah as the King of Kings)

We believe in the deity of the **Son of God,** Who existed from the beginning, as **I AM**, and is and was and is to come, (St. John 1:1, 14). We believe that the **Lord Jesus Christ** was born of a virgin, (St. Matthew 1:21); Suffered and died on the cross for the sins of all mankind, (St. John 3: 16 & 17). We believe that Christ was resurrected from the died, (I Corinthians 15: 1-5). He ascended on high, (Acts 1: 9-11). We believe that the **Lord Jesus Christ** now sits at the right hand of God the Father, (Hebrews 10:12), making intercession for all believers, as the **Mediator** between God and man of the New Testament (I Timothy 2:4-5).

God the Holy Spirit
(The Source of the Anointing of God)

We believe in God the Holy Spirit, as **the Comforter**, and **Keeper** (St. John 15:26-27). We believe that God the Holy Spirit is the **Giver of life and Truth**, (St. John16:13). We believe that He makes all things complete, (St. John 16:12). We believe that God the Holy Spirit, was promised by God the Son, to come and abode within the life of all born again believers, as our **Personal Savior**, and **a witness** of God's spiritual existence, (St.

John 16:7). We believe that the main function of God the Holy Spirit is to **reprove** and or **convict** the world of sin, through guilt (St. John 16:8-13). We also believe that God the Holy Spirit is our **Teacher** and **Guide**, who brings all things to our **remembrance** (St. John 14:26).

The Word of God
(God Speaking To Us)

We believe that the **Word of God** was written by **inspired men** of God, through the workings or the unction of God the Holy Spirit, (II Timothy 3:16 & 17). We believe that it is **infallible**, and **true**, (II Peter 1:21), it is our **roadmap** and **guide to salvation and spiritual growth**, (Psalms 119:11). We believe that the Word of God holds the keys to eternal life, (St. John 5:39).

Salvation by Grace
(Restoration of Fellowship with God)

We believe that **salvation** is a **gift of heavenly eternal life** from God, extended to all mankind, (Ephesians 2:8-9), as a walk by faith and not be sight, (Hebrews 11:1, 6). We believe that we have **all sinned** and come short of the **glory and the grace** of God, (Romans 3:23). We believe that as a result of one man, **Adam**, disobeying the Word from God, that all, through his seed, became defiled, and lost, through **the past** curse for disobedience, (Hebrews 9:15-28). We believe that through God's **second Adam**, the Lord Jesus Christ, the plan of salvation, was carried out, through Christ, the **Messiah**, or the **Savior** of the world, (St. John 3: 16, 17), for all mankind who will receive Him, (Romans 10:9,10). We believe, therefore, that through the **finished redemptive work of Christ**, as the **Sin Blood Atoning Sacrifice** for our sins, we now have direct access and **renewed fellowship** with God, through our **Mediator**, His Son, as our **High Priest**, Savior and Advocate, (Hebrew 9: 11-14). We believe that now we can lay claim to **restored fellowship** with God, as Adam and Eve once had in the Garden, (Hebrews 9:22-28). We believe that we **walk by faith** and not by sight, (St. John 3:1-12), as we are saved from our sins, through **repentance** and acknowledge that we are sinners, **saved by Grace**, (Ephesians 3:17-21).

Salvation Present
(Faithful, Daily Walk With God)

We believe that as we walk daily, we are **presently** being saved from our sins, as we remember to ask for forgiveness, to God and to man, (1 John 1:9).

Salvation Eternity Future
(Second Coming of Christ as the Blessed Hope)

We lastly acknowledge that we as **believers**, who make up the **body of Christ**, as His **Church** and **His Bride**, wait for the **Second Coming** of the Lord Jesus Christ, known as the **Blessed Hope**, (Titus 2:13).
We believe that we as believers will then be saved or delivered **from** the **presence of sin** through our mortal body of corruptness and transformed to **incorruption** and **immortality** in a moment, in a twinkling of an eye, we shall be changed, (I Corinthians 15: 51-58).
We believer that all believers **who died** in Christ, will **also ascend** to be with the Lord, throughout all eternity, as the **first fruits** of resurrection, even as **their souls** are now resting, waiting for that **Blessed Hope,** the Second Coming of the **Messiah.,** (I Thessalonians 4:13-17).

Angels and Heaven

We believe that **Angels** are heavenly **ministering spirits**, sent to earth on assignment by God, (Luke 1:19, 28-35).We believe in **Heaven**, a prepared place for a **prepared people,** (St. John 14:1-4; Revelations Ch 21, 22:11-13).

The Devil, Demons and Hell

We believe in the **Devil**, as the **prince of darkness**, (II Corinthians 4:4; St. John 12:31, 16:11) is sent forth to **kill, steal and to destroy** the works of goodness and righteousness upon the earth, and in the lives of the believers, (St. John 10:10). We believe that there are dark angels or demons, known as **spirits of darkness**, walk amongst and in the midst of the lives of the believers; (Job 1:6-12; II Peter 2: 4; Psalms 78:49.

We believe that **Hell** is a prepared place for the Devil and his angels, (Revelation 20:10).

We believe that although Hell was intended for such, that **all of those** who do not accept the Lord Jesus Christ as their Personal Savior, once passed from this life, will **forever be dammed,** (Revelations 21:8).

Prelog

From the author and the instructor

Day Break Ministries Incorporated introduces to you, **Salvation and Spiritual Growth**, a Beginners level class, designed for an entire year. Once you as the student have completed **Salvation and Spiritual Growth**, you will:

- Have a working knowledge of salvation assurance, as a believer in Jehovah Tsidkenu (God our Righteousness) and the Redeemer (our Lord Jesus Christ).
- Have a personal experience with El Shaddai (Almighty God).
- You will know what is needed to stay on the pathway of the teachings and instruction, designed by Jehovah M' Kaddesh (God our Sanctifier).
- You will find that the final is a review of the unit reviews, and the unit reviews are a review of each chapter review. Repetition promotes memorization and a good study technique.
- Have a working knowledge of what is needed to lead someone to the Redeemer, the Lamb of God, as the Lord Jesus Christ.
- Learn the value of Bible memorization, as you learn to use it as a weapon in your daily encounters with anything contrary to the will of Jehovah Rohi (God, our Shepherd).

In addition, take note of these study techniques:
Bible Study Techniques

- It is recommended that you have a study partner, and or a study group, particularly if you are not taking this course within a church or a Bible School setting.
- Study on your own, or with a partner or a study group, in a quiet place.
- Have a notebook to take notes.

- Get into a habit of going back to read the entire chapter, during the course of the week, as you wait for the next topic lesson.
- As spare time awards itself, take advantage of it, and memorize scriptures in the Bible, needed to use as a weapon against anything contrary to the will of Jehovah Tsidkenu, Our God of Righteousness.
- Begin to develop, as time and finances allow, a Bible Study & Reference collection

 1. Bible Dictionary
 2. Bible Concordance
 3. Study Reverence Bible, examples:

 - The New King James Study Reference Bible
 - The Scofield Reference Bible
 - The King James Study Reference Bible
 - The American Standard Study Bible (an easier translation)

- You have invested your time wisely in taking Level I. ***Salvation and Spiritual Growth.***
- I recommend this reading for all levels of spiritual growth.

Have a Blessed Year.
May the Prince of Peace, Yashua, the Lord Jesus Christ; and Yahweh, our God as also Elohim, be with you, always.

Apostle, Dr. June H. Lawrence, Phil. 4:7

Contents

UNIT ONE: PRAYER

Contents

Unit Introduction

In this unit on Prayer, we shall focus on Prayer, by definition. In addition, we can illustrate types of prayers supported by Bible illustration. Lastly, we shall provide you with the basic outline on the Disciples Prayer, which became the universal prayer for all mankind, not by intention, but because of it's defined components. Now, we present unto you, ***what is Prayer?***

Prayer Chapter 1

Prayer Defined with Examples
Text
St. Luke 10:27
St John 10:11
St. John 14:16
St. Mark 14:33-36
Romans 10:9-10
St. Luke 18:10-14
I John 1:9
I Timothy 2:5
I John 1:9
Romans 8:26 & 27
St. Matthew 26:41
Psalms 95: 6-7
I Timothy 2:8
Romans 8: 26-27
I Samuel 2: 1-2
I Samuel 9:13
I John 5: 14-15
I Kings 3:5-12

Introduction

In order to obtain what you want from God, you must first know how to pray, and what is prayer? In this segment, we shall explain, **what Is Prayer?** We shall also provide you with some examples.

The Lesson

What is prayer?

Prayer is communicating with God in a variety of ways. It can be communicating through, adoration and praise with thanksgiving. Pray can be in the form of repentance, or it can be intercession, for another. Or it can merely be meditating on the things of God. Pray can even be a request, a vow. Whatever the purpose is, the end result is that the individual praying, whether he/she is a saint or a sinner, is in a direct line of communication to God, through our Lord and Savior, Jesus Christ. However, the only guaranteed prayer that is heard and answered from the mouth of a sinner is initially, *God have mercy upon me, a sinner and save me from my sins, for Christ sake*, or something to that effect. **St. Luke 18:13. Prayer can be defined as:**

Meditation

Text
St. Luke 10:27

Luke 10

[1] After these things the LORD appointed other seventy also, and sent them two and two before his face into every city and place, whither he himself would come. [2] Therefore said he unto them, The harvest truly is great, but the labourers are few: pray ye therefore the Lord of the harvest, that he would send forth labourers into his harvest. [3] Go your ways: behold, I send you forth as lambs among wolves. [4] Carry neither purse, nor scrip, nor shoes: and salute no man by the way. [5] And into whatsoever house ye enter, first say, Peace be to this house. [6] And if the son of peace be there, your peace shall rest upon it: if not, it shall turn to you again. [7] And in the same house remain, eating and drinking such things as they give: for the labourer is worthy of his hire. Go not from house to house. [8] And into whatsoever city ye enter, and they receive you, eat such things as are set before you: [9] And heal the sick that are therein, and say unto them, The kingdom of God is come nigh unto you. [10] But into whatsoever city ye enter, and they receive you not, go your ways out into the streets of the same, and say, [11] Even the very dust of your city, which cleaveth on us, we do

wipe off against you: notwithstanding be ye sure of this, that the kingdom of God is come nigh unto you. ¹² But I say unto you, that it shall be more tolerable in that day for Sodom, than for that city. ¹³ Woe unto thee, Chorazin! woe unto thee, Bethsaida! for if the mighty works had been done in Tyre and Sidon, which have been done in you, they had a great while ago repented, sitting in sackcloth and ashes. ¹⁴ But it shall be more tolerable for Tyre and Sidon at the judgment, than for you. ¹⁵ And thou, Capernaum, which art exalted to heaven, shalt be thrust down to hell. ¹⁶ He that heareth you heareth me; and he that despiseth you despiseth me; and he that despiseth me despiseth him that sent me. ¹⁷ And the seventy returned again with joy, saying, Lord, even the devils are subject unto us through thy name. ¹⁸ And he said unto them, I beheld Satan as lightning fall from heaven. ¹⁹ Behold, I give unto you power to tread on serpents and scorpions, and over all the power of the enemy: and nothing shall by any means hurt you. ²⁰ Notwithstanding in this rejoice not, that the spirits are subject unto you; but rather rejoice, because your names are written in heaven. ²¹ In that hour Jesus rejoiced in spirit, and said, I thank thee, O Father, Lord of heaven and earth, that thou hast hid these things from the wise and prudent, and hast revealed them unto babes: even so, Father; for so it seemed good in thy sight. ²² All things are delivered to me of my Father: and no man knoweth who the Son is, but the Father; and who the Father is, but the Son, and he to whom the Son will reveal him. ²³ And he turned him unto his disciples, and said privately, Blessed are the eyes which see the things that ye see: ²⁴ For I tell you, that many prophets and kings have desired to see those things which ye see, and have not seen them; and to hear those things which ye hear, and have not heard them. ²⁵ And, behold, a certain lawyer stood up, and tempted him, saying, Master, what shall I do to inherit eternal life? ²⁶ He said unto him, What is written in the law? how readest thou? ²⁷ **And he answering said, Thou shalt love the Lord thy God with all thy heart, and with all thy soul, and with all thy strength, and with all thy mind; and thy neighbour as thyself.** *²⁸ And he said unto him, Thou hast answered right: this do, and thou shalt live. ²⁹ But he, willing to justify himself, said unto Jesus, And who is my neighbour? ³⁰ And Jesus answering said, A certain man went down from Jerusalem to Jericho, and fell among thieves, which stripped him of his raiment, and wounded him, and departed, leaving him half dead. ³¹ And by chance there came down a certain priest that way: and when he saw him, he passed by on the other side. ³² And likewise a Levite, when he was at the place, came and looked on him, and passed by on the other side. ³³ But a certain Samaritan, as he journeyed, came where he was: and*

when he saw him, he had compassion on him, ³⁴ And went to him, and bound up his wounds, pouring in oil and wine, and set him on his own beast, and brought him to an inn, and took care of him. ³⁵ And on the morrow when he departed, he took out two pence, and gave them to the host, and said unto him, Take care of him; and whatsoever thou spendest more, when I come again, I will repay thee. ³⁶ Which now of these three, thinkest thou, was neighbour unto him that fell among the thieves? ³⁷ And he said, He that shewed mercy on him. Then said Jesus unto him, Go, and do thou likewise. ³⁸ Now it came to pass, as they went, that he entered into a certain village: and a certain woman named Martha received him into her house. ³⁹ And she had a sister called Mary, which also sat at Jesus' feet, and heard his word. ⁴⁰ But Martha was cumbered about much serving, and came to him, and said, Lord, dost thou not care that my sister hath left me to serve alone? bid her therefore that she help me. ⁴¹ And Jesus answered and said unto her, Martha, Martha, thou art careful and troubled about many things: ⁴² But one thing is needful: and Mary hath chosen that good part, which shall not be taken away from her.

Explanation

Prayer is being in tune with God. Therefore, within our daily spiritual walk with God, we are conscience, that He is Omni Present. Therefore, meditation is a daily way of life.
St. Luke 10:27
Text
St John 10:11

John 10

¹ Verily, verily, I say unto you, He that entereth not by the door into the sheepfold, but climbeth up some other way, the same is a thief and a robber. ² But he that entereth in by the door is the shepherd of the sheep. ³ To him the porter openeth; and the sheep hear his voice: and he calleth his own sheep by name, and leadeth them out. ⁴ And when he putteth forth his own sheep, he goeth before them, and the sheep follow him: for they know his voice. ⁵ And a stranger will they not follow, but will flee from him: for they know not the voice of strangers. ⁶ This parable spake Jesus unto them: but they understood not what things they were which he spake unto them. ⁷ Then said Jesus unto them again, Verily, verily, I say unto you, I am the door of the sheep. ⁸ All that

ever came before me are thieves and robbers: but the sheep did not hear them. ⁹ I am the door: by me if any man enter in, he shall be saved, and shall go in and out, and find pasture. ¹⁰ The thief cometh not, but for to steal, and to kill, and to destroy: I am come that they might have life, and that they might have it more abundantly. ¹¹ **I am the good shepherd: the good shepherd giveth his life for the sheep.** ¹² But he that is an hireling, and not the shepherd, whose own the sheep are not, seeth the wolf coming, and leaveth the sheep, and fleeth: and the wolf catcheth them, and scattereth the sheep. ¹³ The hireling fleeth, because he is an hireling, and careth not for the sheep. ¹⁴ I am the good shepherd, and know my sheep, and am known of mine. ¹⁵ As the Father knoweth me, even so know I the Father: and I lay down my life for the sheep. ¹⁶ And other sheep I have, which are not of this fold: them also I must bring, and they shall hear my voice; and there shall be one fold, and one shepherd. ¹⁷ Therefore doth my Father love me, because I lay down my life, that I might take it again. ¹⁸ No man taketh it from me, but I lay it down of myself. I have power to lay it down, and I have power to take it again. This commandment have I received of my Father. ¹⁹ There was a division therefore again among the Jews for these sayings. ²⁰ And many of them said, He hath a devil, and is mad; why hear ye him? ²¹ Others said, These are not the words of him that hath a devil. Can a devil open the eyes of the blind? ²² And it was at Jerusalem the feast of the dedication, and it was winter. ²³ And Jesus walked in the temple in Solomon's porch. ²⁴ Then came the Jews round about him, and said unto him, How long dost thou make us to doubt? If thou be the Christ, tell us plainly. ²⁵ Jesus answered them, I told you, and ye believed not: the works that I do in my Father's name, they bear witness of me. ²⁶ But ye believe not, because ye are not of my sheep, as I said unto you. ²⁷ My sheep hear my voice, and I know them, and they follow me: ²⁸ And I give unto them eternal life; and they shall never perish, neither shall any man pluck them out of my hand. ²⁹ My Father, which gave them me, is greater than all; and no man is able to pluck them out of my Father's hand. ³⁰ I and my Father are one. ³¹ Then the Jews took up stones again to stone him. ³² Jesus answered them, Many good works have I shewed you from my Father; for which of those works do ye stone me? ³³ The Jews answered him, saying, For a good work we stone thee not; but for blasphemy; and because that thou, being a man, makest thyself God. ³⁴ Jesus answered them, Is it not written in your law, I said, Ye are gods? ³⁵ If he called them gods, unto whom the word of God came, and the scripture cannot be broken; ³⁶ Say ye of him, whom the Father hath sanctified, and sent into the world, Thou blasphemest; because I said, I am the Son of God? ³⁷ If I do not

the works of my Father, believe me not. [38] But if I do, though ye believe not me, believe the works: that ye may know, and believe, that the Father is in me, and I in him. [39] Therefore they sought again to take him: but he escaped out of their hand, [40] And went away again beyond Jordan into the place where John at first baptized; and there he abode. [41] And many resorted unto him, and said, John did no miracle: but all things that John spake of this man were true. [42] And many believed on him there.

Explanation

We are the sheep, who listen and meditate, upon his ever presence, in the person of God the Holy Spirit or the Comforter. With that in mind, it is also, having quiet time alone to listen to the **voice of God,** through His Son, the Lord Jesus Christ, who is the Good Shepherd. **St John 10:11**
Text
St. John 14:16

John 14

[1] Let not your heart be troubled: ye believe in God, believe also in me. [2] In my Father's house are many mansions: if it were not so, I would have told you. I go to prepare a place for you. [3] And if I go and prepare a place for you, I will come again, and receive you unto myself; that where I am, there ye may be also. [4] And whither I go ye know, and the way ye know. [5] Thomas saith unto him, Lord, we know not whither thou goest; and how can we know the way? [6] Jesus saith unto him, I am the way, the truth, and the life: no man cometh unto the Father, but by me. [7] If ye had known me, ye should have known my Father also: and from henceforth ye know him, and have seen him. [8] Philip saith unto him, Lord, shew us the Father, and it sufficeth us. [9] Jesus saith unto him, Have I been so long time with you, and yet hast thou not known me, Philip? he that hath seen me hath seen the Father; and how sayest thou then, Shew us the Father? [10] Believest thou not that I am in the Father, and the Father in me? the words that I speak unto you I speak not of myself: but the Father that dwelleth in me, he doeth the works. [11] Believe me that I am in the Father, and the Father in me: or else believe me for the very works' sake. [12] Verily, verily, I say unto you, He that believeth on me, the works that I do shall he do also; and greater works than these shall he do; because I go unto my Father. [13] And whatsoever ye shall ask in my name, that will I do, that the Father may be

glorified in the Son. *¹⁴ If ye shall ask any thing in my name, I will do it. ¹⁵ If ye love me, keep my commandments.* **¹⁶ And I will pray the Father, and he shall give you another Comforter, that he may abide with you for ever;** *¹⁷ Even the Spirit of truth; whom the world cannot receive, because it seeth him not, neither knoweth him: but ye know him; for he dwelleth with you, and shall be in you. ¹⁸ I will not leave you comfortless: I will come to you. ¹⁹ Yet a little while, and the world seeth me no more; but ye see me: because I live, ye shall live also. ²⁰ At that day ye shall know that I am in my Father, and ye in me, and I in you. ²¹ He that hath my commandments, and keepeth them, he it is that loveth me: and he that loveth me shall be loved of my Father, and I will love him, and will manifest myself to him. ²² Judas saith unto him, not Iscariot, Lord, how is it that thou wilt manifest thyself unto us, and not unto the world? ²³ Jesus answered and said unto him, If a man love me, he will keep my words: and my Father will love him, and we will come unto him, and make our abode with him. ²⁴ He that loveth me not keepeth not my sayings: and the word which ye hear is not mine, but the Father's which sent me. ²⁵ These things have I spoken unto you, being yet present with you. ²⁶ But the Comforter, which is the Holy Ghost, whom the Father will send in my name, he shall teach you all things, and bring all things to your remembrance, whatsoever I have said unto you. ²⁷ Peace I leave with you, my peace I give unto you: not as the world giveth, give I unto you. Let not your heart be troubled, neither let it be afraid. ²⁸ Ye have heard how I said unto you, I go away, and come again unto you. If ye loved me, ye would rejoice, because I said, I go unto the Father: for my Father is greater than I. ²⁹ And now I have told you before it come to pass, that, when it is come to pass, ye might believe. ³⁰ Hereafter I will not talk much with you: for the prince of this world cometh, and hath nothing in me. ³¹ But that the world may know that I love the Father; and as the Father gave me commandment, even so I do. Arise, let us go hence.*

Explanation

The Comforter is the Holy Ghost, whose job is to enable the believer to live a holy life before God and man. **St. John 14:16**
Text
St. Mark 14:33-36

Mark 14

¹ After two days was the feast of the Passover, and of unleavened bread: and the chief priests and the scribes sought how they might take him by craft, and put him to death. ² But they said, Not on the feast day, lest there be an uproar of the people. ³ And being in Bethany in the house of Simon the leper, as he sat at meat, there came a woman having an alabaster box of ointment of spikenard very precious; and she brake the box, and poured it on his head. ⁴ And there were some that had indignation within themselves, and said, Why was this waste of the ointment made? ⁵ For it might have been sold for more than three hundred pence, and have been given to the poor. And they murmured against her. ⁶ And Jesus said, Let her alone; why trouble ye her? she hath wrought a good work on me. ⁷ For ye have the poor with you always, and whensoever ye will ye may do them good: but me ye have not always. ⁸ She hath done what she could: she is come aforehand to anoint my body to the burying. ⁹ Verily I say unto you, Wheresoever this gospel shall be preached throughout the whole world, this also that she hath done shall be spoken of for a memorial of her. ¹⁰ And Judas Iscariot, one of the twelve, went unto the chief priests, to betray him unto them. ¹¹ And when they heard it, they were glad, and promised to give him money. And he sought how he might conveniently betray him. ¹² And the first day of unleavened bread, when they killed the passover, his disciples said unto him, Where wilt thou that we go and prepare that thou mayest eat the passover? ¹³ And he sendeth forth two of his disciples, and saith unto them, Go ye into the city, and there shall meet you a man bearing a pitcher of water: follow him. ¹⁴ And wheresoever he shall go in, say ye to the goodman of the house, The Master saith, Where is the guestchamber, where I shall eat the passover with my disciples? ¹⁵ And he will shew you a large upper room furnished and prepared: there make ready for us. ¹⁶ And his disciples went forth, and came into the city, and found as he had said unto them: and they made ready the passover. ¹⁷ And in the evening he cometh with the twelve. ¹⁸ And as they sat and did eat, Jesus said, Verily I say unto you, One of you which eateth with me shall betray me. ¹⁹ And they began to be sorrowful, and to say unto him one by one, Is it I? and another said, Is it I? ²⁰ And he answered and said unto them, It is one of the twelve, that dippeth with me in the dish. ²¹ The Son of man indeed goeth, as it is written of him: but woe to that man by whom the Son of man is betrayed! good were it for that man if he had never been born. ²² And as they did eat, Jesus took bread, and blessed, and brake it, and gave to them, and said, Take, eat: this is my body. ²³ And he took the cup,

and when he had given thanks, he gave it to them: and they all drank of it. *²⁴ And he said unto them, This is my blood of the new testament, which is shed for many.* ²⁵ *Verily I say unto you, I will drink no more of the fruit of the vine, until that day that I drink it new in the kingdom of God.* ²⁶ *And when they had sung an hymn, they went out into the mount of Olives.* ²⁷ *And Jesus saith unto them, All ye shall be offended because of me this night: for it is written, I will smite the shepherd, and the sheep shall be scattered.* ²⁸ *But after that I am risen, I will go before you into Galilee.* ²⁹ *But Peter said unto him, Although all shall be offended, yet will not I.* ³⁰ *And Jesus saith unto him, Verily I say unto thee, That this day, even in this night, before the cock crow twice, thou shalt deny me thrice.* ³¹ *But he spake the more vehemently, If I should die with thee, I will not deny thee in any wise. Likewise also said they all.* ³² *And they came to a place which was named Gethsemane: and he saith to his disciples, Sit ye here, while I shall pray.* **³³ And he taketh with him Peter and James and John, and began to be sore amazed, and to be very heavy; ³⁴ And saith unto them, My soul is exceeding sorrowful unto death: tarry ye here, and watch. ³⁵ And he went forward a little, and fell on the ground, and prayed that, if it were possible, the hour might pass from him. ³⁶ And he said, Abba, Father, all things are possible unto thee; take away this cup from me: nevertheless not what I will, but what thou wilt.** ³⁷ *And he cometh, and findeth them sleeping, and saith unto Peter, Simon, sleepest thou? couldest not thou watch one hour?* ³⁸ *Watch ye and pray, lest ye enter into temptation. The spirit truly is ready, but the flesh is weak.* ³⁹ *And again he went away, and prayed, and spake the same words.* ⁴⁰ *And when he returned, he found them asleep again, (for their eyes were heavy,) neither wist they what to answer him.* ⁴¹ *And he cometh the third time, and saith unto them, Sleep on now, and take your rest: it is enough, the hour is come; behold, the Son of man is betrayed into the hands of sinners.* ⁴² *Rise up, let us go; lo, he that betrayeth me is at hand.* ⁴³ *And immediately, while he yet spake, cometh Judas, one of the twelve, and with him a great multitude with swords and staves, from the chief priests and the scribes and the elders.* ⁴⁴ *And he that betrayed him had given them a token, saying, Whomsoever I shall kiss, that same is he; take him, and lead him away safely.* ⁴⁵ *And as soon as he was come, he goeth straightway to him, and saith, Master, master; and kissed him.* ⁴⁶ *And they laid their hands on him, and took him.* ⁴⁷ *And one of them that stood by drew a sword, and smote a servant of the high priest, and cut off his ear.* ⁴⁸ *And Jesus answered and said unto them, Are ye come out, as against a thief, with swords and with staves to take me?* ⁴⁹ *I was daily with you in the temple*

teaching, and ye took me not: but the scriptures must be fulfilled. [50] And they all forsook him, and fled. [51] And there followed him a certain young man, having a linen cloth cast about his naked body; and the young men laid hold on him: [52] And he left the linen cloth, and fled from them naked. [53] And they led Jesus away to the high priest: and with him were assembled all the chief priests and the elders and the scribes. [54] And Peter followed him afar off, even into the palace of the high priest: and he sat with the servants, and warmed himself at the fire. [55] And the chief priests and all the council sought for witness against Jesus to put him to death; and found none. [56] For many bare false witness against him, but their witness agreed not together. [57] And there arose certain, and bare false witness against him, saying, [58] We heard him say, I will destroy this temple that is made with hands, and within three days I will build another made without hands. [59] But neither so did their witness agree together. [60] And the high priest stood up in the midst, and asked Jesus, saying, Answerest thou nothing? What is it which these witness against thee? [61] But he held his peace, and answered nothing. Again the high priest asked him, and said unto him, Art thou the Christ, the Son of the Blessed? [62] And Jesus said I am: and ye shall see the Son of man sitting on the right hand of power, and coming in the clouds of heaven. [63] Then the high priest rent his clothes, and saith, what need we any further witnesses? [64] Ye have heard the blasphemy: what think ye? And they all condemned him to be guilty of death. [65] And some began to spit on him, and to cover his face, and to buffet him, and to say unto him, Prophesy: and the servants did strike him with the palms of their hands. [66] And as Peter was beneath in the palace, there cometh one of the maids of the high priest: [67] And when she saw Peter warming himself, she looked upon him, and said, And thou also wast with Jesus of Nazareth, [68] but he denied, saying, I know not, neither understand I what thou sayest. And he went out into the porch; and the cock crew. [69] And a maid saw him again, and began to say to them that stood by, this is one of them. [70] And he denied it again. And a little after, they that stood by said again to Peter, Surely thou art one of them: for thou art a Galilaean, and thy speech agreeth thereto. [71] but he began to curse and to swear, saying, I know not this man of whom ye speak. [72] And the second time the cock crew. And Peter called to mind the word that Jesus said unto him, before the cock crow twice, thou shalt deny me thrice. And when he thought thereon, he wept.

Evaluation

34 God's plan and design was for His Son the Lord Jesus Christ to be the Savior of the world. 35 The term fell on the ground refers to the Lord, laying on the ground to totally surrender to God the Father, in prayer. The cup refers to His suffering and death on the cross, for the sins of the world, as our Redeemer.36 As we pray to God, we are to make clear to our Heavenly Father, what we desire of Him. He knows, however, Yahweh's (Almighty God) total fulfillment is to share in fellowship with mankind, spiritually, because our God, El Shaddai, Almighty God is a Spirit. **St. Mark 14:33-36**

Sinner's Request for Repentance

Text
Romans 10:9-10

Romans 10

[1] Brethren, my heart's desire and prayer to God for Israel is, that they might be saved. [2] For I bear them record that they have a zeal of God, but not according to knowledge. [3] For they, being ignorant of God's righteousness, and going about to establish their own righteousness, have not submitted themselves unto the righteousness of God. [4] For Christ is the end of the law for righteousness to every one that believeth. [5] For Moses describeth the righteousness which is of the law, that the man which doeth those things shall live by them. [6] But the righteousness which is of faith speaketh on this wise, Say not in thine heart, who shall ascend into heaven? (That is, to bring Christ down from above :) [7] Or, Who shall descend into the deep? (That is, to bring up Christ again from the dead.) [8] But what saith it? The word is nigh thee, even in thy mouth, and in thy heart: that is, the word of faith, which we preach; ***[9] that if thou shalt confess with thy mouth the Lord Jesus, and shalt believe in thine heart that God hath raised him from the dead, thou shalt be saved. [10] For with the heart man believeth unto righteousness; and with the mouth confession is made unto salvation.*** *[11] for the scripture saith, whosoever believeth on him shall not be ashamed. [12] For there is no difference between the Jew and the Greek: for the same Lord over all is rich unto all that call upon him. [13] For whosoever shall call upon the name of the Lord shall be saved. [14]*

How then shall they call on him in whom they have not believed? and how shall they believe in him of whom they have not heard? and how shall they hear without a preacher? ¹⁵ *And how shall they preach, except they be sent? as it is written, How beautiful are the feet of them that preach the gospel of peace, and bring glad tidings of good things!* ¹⁶ *But they have not all obeyed the gospel. For, Esaias saith, Lord, who hath believed our report?* ¹⁷ *So then faith cometh by hearing, and hearing by the word of God.* ¹⁸ *but I say, have they not heard? Yes verily, their sound went into all the earth, and their words unto the ends of the world,* ¹⁹ *but I say, did not Israel know? First Moses saith, I will provoke you to jealousy by them that are no people, and by a foolish nation I will anger you.* ²⁰ *But Esaias is very bold, and saith, I was found of them that sought me not; I was made manifest unto them that asked not after me.* ²¹ *But to Israel he saith, All day long I have stretched forth my hands unto a disobedient and gainsaying people.*

Explanation

9. If we take time out to confess with our mouths, as believers, then we believe what we are confessing, pertaining to the finished works of Christ, necessary for our confession.10. We also believe with our heart, if we confess with our mouths, pertaining to acceptance of salvation, made possible, through our Lord and Savior, Jesus Christ. **Romans 10:9-10**

The Sinner's Prayer for Repentance

Text
St. Luke 18:10-14

Luke 18

¹ *And he spake a parable unto them to this end, that men ought always to pray, and not to faint;* ² *Saying, There was in a city a judge, which feared not God, neither regarded man:* ³ *And there was a widow in that city; and she came unto him, saying, Avenge me of mine adversary.* ⁴ *And he would not for a while: but afterward he said within himself, Though I fear not God, nor regard man;* ⁵ *Yet because this widow troubleth me, I will avenge her, lest by her continual coming she weary me.* ⁶ *And the Lord said, Hear what the unjust judge saith.* ⁷ *And shall not God avenge his own elect, which cry day*

and night unto him, though he bear long with them? *8 I tell you that he will avenge them speedily. Nevertheless when the Son of man cometh, shall he find faith on the earth? 9 And he spake this parable unto certain which trusted in themselves that they were righteous, and despised others:* **10 Two men went up into the temple to pray; the one a Pharisee, and the other a publican. 11 The Pharisee stood and prayed thus with himself, God, I thank thee, that I am not as other men are, extortioners, unjust, adulterers, or even as this publican. 12 I fast twice in the week, I give tithes of all that I possess. 13 And the publican, standing afar off, would not lift up so much as his eyes unto heaven, but smote upon his breast, saying, God be merciful to me a sinner. 14 I tell you, this man went down to his house justified rather than the other: for every one that exalteth himself shall be abased; and he that humbleth himself shall be exalted.** *15 And they brought unto him also infants, that he would touch them: but when his disciples saw it, they rebuked them. 16 But Jesus called them unto him, and said, Suffer little children to come unto me, and forbid them not: for of such is the kingdom of God. 17 Verily I say unto you, Whosoever shall not receive the kingdom of God as a little child shall in no wise enter therein. 18 And a certain ruler asked him, saying, Good Master, what shall I do to inherit eternal life? 19 And Jesus said unto him, Why callest thou me good? none is good, save one, that is, God. 20 Thou knowest the commandments, Do not commit adultery, Do not kill, Do not steal, Do not bear false witness, Honour thy father and thy mother. 21 And he said, All these have I kept from my youth up. 22 Now when Jesus heard these things, he said unto him, Yet lackest thou one thing: sell all that thou hast, and distribute unto the poor, and thou shalt have treasure in heaven: and come, follow me. 23 And when he heard this, he was very sorrowful: for he was very rich. 24 And when Jesus saw that he was very sorrowful, he said, How hardly shall they that have riches enter into the kingdom of God! 25 For it is easier for a camel to go through a needle's eye, than for a rich man to enter into the kingdom of God. 26 And they that heard it said, Who then can be saved? 27 And he said, The things which are impossible with men are possible with God. 28 Then Peter said, Lo, we have left all, and followed thee. 29 And he said unto them, Verily I say unto you, There is no man that hath left house, or parents, or brethren, or wife, or children, for the kingdom of God's sake, 30 Who shall not receive manifold more in this present time, and in the world to come life everlasting. 31 Then he took unto him the twelve, and said unto them, Behold, we go up to Jerusalem, and all things that are written by the prophets concerning the Son of man shall be accomplished. 32*

For he shall be delivered unto the Gentiles, and shall be mocked, and spitefully entreated, and spitted on: [33] And they shall scourge him, and put him to death: and the third day he shall rise again. [34] And they understood none of these things: and this saying was hid from them, neither knew they the things which were spoken. [35] And it came to pass, that as he was come nigh unto Jericho, a certain blind man sat by the way side begging: [36] And hearing the multitude pass by, he asked what it meant. [37] And they told him, that Jesus of Nazareth passeth by. [38] And he cried, saying, Jesus, thou son of David, have mercy on me. [39] And they which went before rebuked him, that he should hold his peace: but he cried so much the more, Thou son of David, have mercy on me. [40] And Jesus stood, and commanded him to be brought unto him: and when he was come near, he asked him, [41] Saying, What wilt thou that I shall do unto thee? And he said, Lord, that I may receive my sight. [42] And Jesus said unto him, Receive thy sight: thy faith hath saved thee. [43] And immediately he received his sight, and followed him, glorifying God: and all the people, when they saw it, gave praise unto God.

Evaluation

12 The Word of God states in the Book of James that one of the things that the Lord hates is a proud look. It also states that the meek shall inherit the earth, not the proud. 13 This verse, God be merciful to me a sinner, is the traditional sinner's prayer. 14 God does not even begin to listen to the voice of the proud. **St. Luke 18:10-14**

Prayer of Daily Repentance

Text
I John 1:9

1 John 1

[1] That which was from the beginning, which we have heard, which we have seen with our eyes, which we have looked upon, and our hands have handled, of the Word of life; [2] (For the life was manifested, and we have seen it, and bear witness, and shew unto you that eternal life, which was with the Father, and was manifested unto us;) [3] That which we have seen and heard declare we unto you, that ye also may have fellowship with us: and truly our fellowship is

with the Father, and with his Son Jesus Christ. *4 And these things write we unto you, that your joy may be full.* *5 This then is the message which we have heard of him, and declare unto you, that God is light, and in him is no darkness at all.* *6 If we say that we have fellowship with him, and walk in darkness, we lie, and do not the truth:* *7 But if we walk in the light, as he is in the light, we have fellowship one with another, and the blood of Jesus Christ his Son cleanseth us from all sin.* *8 If we say that we have no sin, we deceive ourselves, and the truth is not in us.* **9 If we confess our sins, he is faithful and just to forgive us our sins, and to cleanse us from all unrighteousness.** *10 If we say that we have not sinned, we make him a liar, and his word is not in us.*

Evaluation

This scripture refers to our daily **sins** we commit. It is our responsibility to **repent** daily **to God** and to mankind, whenever, we wrongfully **do something** to another. This also refers to having a **negative** attitude towards another. **I John 1:9**

Text

I Timothy 2:5, 8

1Timothy 2

1 I exhort therefore, that, first of all, supplications, prayers, intercessions, and giving of thanks, be made for all men; *2 For kings, and for all that are in authority; that we may lead a quiet and peaceable life in all godliness and honesty.* *3 For this is good and acceptable in the sight of God our Saviour;* *4 Who will have all men to be saved, and to come unto the knowledge of the truth.* *5 **For there is one God, and one mediator between God and men, the man Christ Jesus;*** *6 Who gave himself a ransom for all, to be testified in due time.* *7 Whereunto I am ordained a preacher, and an apostle, (I speak the truth in Christ, and lie not;) a teacher of the Gentiles in faith and verity.* *8 **I will therefore that men pray every where, lifting up holy hands, without wrath and doubting**. *9 In like manner also, that women adorn themselves in modest apparel, with shamefacedness and sobriety; not with broided hair, or gold, or pearls, or costly array;* *10 But (which becometh women professing godliness) with good works.* *11 Let the woman learn in silence with all subjection.* *12 But I suffer not a woman to teach, nor to usurp authority over the man, but to be in silence.* *13 For Adam was first formed, then Eve.*

[14] And Adam was not deceived, but the woman being deceived was in the transgression. [15] Notwithstanding she shall be saved in childbearing, if they continue in faith and charity and holiness with sobriety.

(Refer above to the (2) proceeding scriptures for full text)
Evaluation
Intercessory Prayer

Immanuel, God being with us, refers to intercessory prayer, through the Advocate and the Mediator between God and men, Christ Jesus. **I Timothy 2:5**

Also

Text
I Timothy 2:8
[8] I will therefore that men pray every where, lifting up holy hands, without wrath and doubting.

Explanation
This is Adoration.

It is communing with God, through the lifting up of holy hands. **I Timothy 2:8**
Text
Romans 8: 26-27

Romans 8

[1] There is therefore now no condemnation to them which are in Christ Jesus, who walk not after the flesh, but after the Spirit. [2] For the law of the Spirit of life in Christ Jesus hath made me free from the law of sin and death. [3] For what the law could not do, in that it was weak through the flesh, God sending his own Son in the likeness of sinful flesh, and for sin, condemned sin in the flesh: [4] That the righteousness of the law might be fulfilled in us, who walk not after the flesh, but after the Spirit. [5] For they that are after the flesh do mind the things of the flesh; but they that are after the Spirit the things of the Spirit. [6] For to be carnally minded is death; but to be spiritually minded is

life and peace. ⁷ *Because the carnal mind is enmity against God: for it is not subject to the law of God, neither indeed can be.* ⁸ *So then they that are in the flesh cannot please God.* ⁹ *But ye are not in the flesh, but in the Spirit, if so be that the Spirit of God dwell in you. Now if any man have not the Spirit of Christ, he is none of his.* ¹⁰ *And if Christ be in you, the body is dead because of sin; but the Spirit is life because of righteousness.* ¹¹ *But if the Spirit of him that raised up Jesus from the dead dwell in you, he that raised up Christ from the dead shall also quicken your mortal bodies by his Spirit that dwelleth in you.* ¹² *Therefore, brethren, we are debtors, not to the flesh, to live after the flesh.* ¹³ *For if ye live after the flesh, ye shall die: but if ye through the Spirit do mortify the deeds of the body, ye shall live.* ¹⁴ *For as many as are led by the Spirit of God, they are the sons of God.* ¹⁵ *For ye have not received the spirit of bondage again to fear; but ye have received the Spirit of adoption, whereby we cry, Abba, Father.* ¹⁶ *The Spirit itself beareth witness with our spirit, that we are the children of God:* ¹⁷ *And if children, then heirs; heirs of God, and joint-heirs with Christ; if so be that we suffer with him, that we may be also glorified together.* ¹⁸ *For I reckon that the sufferings of this present time are not worthy to be compared with the glory which shall be revealed in us.* ¹⁹ *For the earnest expectation of the creature waiteth for the manifestation of the sons of God.* ²⁰ *For the creature was made subject to vanity, not willingly, but by reason of him who hath subjected the same in hope,* ²¹ *Because the creature itself also shall be delivered from the bondage of corruption into the glorious liberty of the children of God.* ²² *For we know that the whole creation groaneth and travaileth in pain together until now.* ²³ *And not only they, but ourselves also, which have the firstfruits of the Spirit, even we ourselves groan within ourselves, waiting for the adoption, to wit, the redemption of our body.* ²⁴ *For we are saved by hope: but hope that is seen is not hope: for what a man seeth, why doth he yet hope for?* ²⁵ *But if we hope for that we see not, then do we with patience wait for it.* **²⁶ Likewise the Spirit also helpeth our infirmities: for we know not what we should pray for as we ought: but the Spirit itself maketh intercession for us with groanings which cannot be uttered.** **²⁷ And he that searcheth the hearts knoweth what is the mind of the Spirit, because he maketh intercession for the saints according to the will of God.** ²⁸ *And we know that all things work together for good to them that love God, to them who are the called according to his purpose.* ²⁹ *For whom he did foreknow, he also did predestinate to be conformed to the image of his Son, that he might be the firstborn among many brethren.* ³⁰ *Moreover whom he did predestinate, them he also called: and whom he called, them he*

also justified: and whom he justified, them he also glorified. *31* What shall we then say to these things? If God be for us, who can be against us? *32* He that spared not his own Son, but delivered him up for us all, how shall he not with him also freely give us all things? *33* Who shall lay any thing to the charge of God's elect? It is God that justifieth. *34* Who is he that condemneth? It is Christ that died, yea rather, that is risen again, who is even at the right hand of God, who also maketh intercession for us. *35* Who shall separate us from the love of Christ? shall tribulation, or distress, or persecution, or famine, or nakedness, or peril, or sword? *36* As it is written, For thy sake we are killed all the day long; we are accounted as sheep for the slaughter. *37* Nay, in all these things we are more than conquerors through him that loved us. *38* For I am persuaded, that neither death, nor life, nor angels, nor principalities, nor powers, nor things present, nor things to come, *39* Nor height, nor depth, nor any other creature, shall be able to separate us from the love of God, which is in Christ Jesus our Lord.

Explanation

This is when we are so disturbed that we cannot put the prayer into words. The Holy Spirit, who is our **Comforter,** prays for us. **Romans 8: 26-27**

Prayer in method and attitude

Text:
St. Matthew 26:41

Matthew 26

1 And it came to pass, when Jesus had finished all these sayings, he said unto his disciples, *2* Ye know that after two days is the feast of the passover, and the Son of man is betrayed to be crucified. *3* Then assembled together the chief priests, and the scribes, and the elders of the people, unto the palace of the high priest, who was called Caiaphas, *4* And consulted that they might take Jesus by subtilty, and kill him. *5* But they said, Not on the feast day, lest there be an uproar among the people. *6* Now when Jesus was in Bethany, in the house of Simon the leper, *7* There came unto him a woman having an alabaster box of very precious ointment, and poured it on his head, as he sat at meat. *8* But when his disciples saw it, they had indignation, saying, To what purpose is this

waste? ⁹ For this ointment might have been sold for much, and given to the poor. ¹⁰ When Jesus understood it, he said unto them, Why trouble ye the woman? for she hath wrought a good work upon me. ¹¹ For ye have the poor always with you; but me ye have not always. ¹² For in that she hath poured this ointment on my body, she did it for my burial. ¹³ Verily I say unto you, wheresoever this gospel shall be preached in the whole world, there shall also this, that this woman hath done, be told for a memorial of her. ¹⁴ Then one of the twelve, called Judas Iscariot, went unto the chief priests, ¹⁵ And said unto them, What will ye give me, and I will deliver him unto you? And they covenanted with him for thirty pieces of silver. ¹⁶ And from that time he sought opportunity to betray him. ¹⁷ Now the first day of the feast of unleavened bread the disciples came to Jesus, saying unto him, Where wilt thou that we prepare for thee to eat the Passover? ¹⁸ And he said, Go into the city to such a man, and say unto him, The Master saith, My time is at hand; I will keep the passover at thy house with my disciples. ¹⁹ And the disciples did as Jesus had appointed them; and they made ready the Passover. ²⁰ Now when the even was come, he sat down with the twelve. ²¹ And as they did eat, he said, Verily I say unto you, that one of you shall betray me. ²² And they were exceeding sorrowful, and began every one of them to say unto him, Lord, is it I? ²³ And he answered and said, He that dippeth his hand with me in the dish, the same shall betray me. ²⁴ The Son of man goeth as it is written of him: but woe unto that man by whom the Son of man is betrayed! it had been good for that man if he had not been born. ²⁵ Then Judas, which betrayed him, answered and said, Master, is it I? He said unto him, Thou hast said. ²⁶ And as they were eating, Jesus took bread, and blessed it, and brake it, and gave it to the disciples, and said, Take, eat; this is my body. ²⁷ And he took the cup, and gave thanks, and gave it to them, saying, Drink ye all of it; ²⁸ For this is my blood of the new testament, which is shed for many for the remission of sins. ²⁹ But I say unto you, I will not drink henceforth of this fruit of the vine, until that day when I drink it new with you in my Father's kingdom. ³⁰ And when they had sung an hymn, they went out into the mount of Olives. ³¹ Then saith Jesus unto them, All ye shall be offended because of me this night: for it is written, I will smite the shepherd, and the sheep of the flock shall be scattered abroad. ³² But after I am risen again, I will go before you into Galilee. ³³ Peter answered and said unto him, Though all men shall be offended because of thee, yet will I never be offended. ³⁴ Jesus said unto him, Verily I say unto thee, That this night, before the cock crow, thou shalt deny me thrice. ³⁵ Peter said unto him, Though I should die with thee, yet will I not deny thee. Likewise also said all the disciples.

*³⁶ Then cometh Jesus with them unto a place called Gethsemane, and saith unto the disciples, Sit ye here, while I go and pray yonder. ³⁷ And he took with him Peter and the two sons of Zebedee, and began to be sorrowful and very heavy. ³⁸ Then saith he unto them, My soul is exceeding sorrowful, even unto death: tarry ye here, and watch with me. ³⁹ And he went a little farther, and fell on his face, and prayed, saying, O my Father, if it be possible, let this cup pass from me: nevertheless not as I will, but as thou wilt. ⁴⁰ And he cometh unto the disciples, and findeth them asleep, and saith unto Peter, What, could ye not watch with me one hour? ⁴¹ **Watch and pray, that ye enter not into temptation: the spirit indeed is willing, but the flesh is weak.** ⁴² He went away again the second time, and prayed, saying, O my Father, if this cup may not pass away from me, except I drink it, thy will be done. ⁴³ And he came and found them asleep again: for their eyes were heavy. ⁴⁴ And he left them, and went away again, and prayed the third time, saying the same words. ⁴⁵ Then cometh he to his disciples, and saith unto them, Sleep on now, and take your rest: behold, the hour is at hand, and the Son of man is betrayed into the hands of sinners. ⁴⁶ Rise, let us be going: behold, he is at hand that doth betray me. ⁴⁷ And while he yet spake, lo, Judas, one of the twelve, came, and with him a great multitude with swords and staves, from the chief priests and elders of the people. ⁴⁸ Now he that betrayed him gave them a sign, saying, Whomsoever I shall kiss, that same is he: hold him fast. ⁴⁹ And forthwith he came to Jesus, and said, Hail, master; and kissed him. ⁵⁰ And Jesus said unto him, Friend, wherefore art thou come? Then came they, and laid hands on Jesus and took him. ⁵¹ And, behold, one of them which were with Jesus stretched out his hand, and drew his sword, and struck a servant of the high priest's, and smote off his ear. ⁵² Then said Jesus unto him, Put up again thy sword into his place: for all they that take the sword shall perish with the sword. ⁵³ Thinkest thou that I cannot now pray to my Father, and he shall presently give me more than twelve legions of angels? ⁵⁴ But how then shall the scriptures be fulfilled, that thus it must be? ⁵⁵ In that same hour said Jesus to the multitudes, Are ye come out as against a thief with swords and staves for to take me? I sat daily with you teaching in the temple, and ye laid no hold on me. ⁵⁶ But all this was done, that the scriptures of the prophets might be fulfilled. Then all the disciples forsook him, and fled. ⁵⁷ And they that had laid hold on Jesus led him away to Caiaphas the high priest, where the scribes and the elders were assembled. ⁵⁸ But Peter followed him afar off unto the high priest's palace, and went in, and sat with the servants, to see the end. ⁵⁹ Now the chief priests, and elders, and all the council, sought false witness against Jesus, to put him to death; ⁶⁰ But*

found none: yea, though many false witnesses came, yet found they none. At the last came two false witnesses, ⁶¹ And said, This fellow said, I am able to destroy the temple of God, and to build it in three days. ⁶² And the high priest arose, and said unto him, Answerest thou nothing? what is it which these witness against thee? ⁶³ But Jesus held his peace, And the high priest answered and said unto him, I adjure thee by the living God, that thou tell us whether thou be the Christ, the Son of God. ⁶⁴ Jesus saith unto him, Thou hast said: nevertheless I say unto you, Hereafter shall ye see the Son of man sitting on the right hand of power, and coming in the clouds of heaven. ⁶⁵ Then the high priest rent his clothes, saying, He hath spoken blasphemy; what further need have we of witnesses? behold, now ye have heard his blasphemy. ⁶⁶ What think ye? They answered and said, He is guilty of death. ⁶⁷ Then did they spit in his face, and buffeted him; and others smote him with the palms of their hands, ⁶⁸ Saying, Prophesy unto us, thou Christ, Who is he that smote thee? ⁶⁹ Now Peter sat without in the palace: and a damsel came unto him, saying, Thou also wast with Jesus of Galilee. ⁷⁰ But he denied before them all, saying, I know not what thou sayest. ⁷¹ And when he was gone out into the porch, another maid saw him, and said unto them that were there, This fellow was also with Jesus of Nazareth. ⁷² And again he denied with an oath, I do not know the man. ⁷³ And after a while came unto him they that stood by, and said to Peter, Surely thou also art one of them; for thy speech bewrayeth thee. ⁷⁴ Then began he to curse and to swear, saying, I know not the man. And immediately the cock crew. ⁷⁵ And Peter remembered the word of Jesus, which said unto him, Before the cock crow, thou shalt deny me thrice. And he went out, and wept bitterly.

Explanation

When praying, we, as believers are to know who we are in Christ. Therefore, in doing so, we realize and remember that we are weak, and need to rely upon our Creator, and God, Elohim. **St. Matthew 26:41**

Adoration

Text
Psalms 95: 6-7

Psalms 95

¹ O come, let us sing unto the LORD: let us make a joyful noise to the rock of our salvation. ² Let us come before his presence with thanksgiving, and make a joyful noise unto him with psalms. ³ For the LORD is a great God, and a great King above all gods. ⁴ In his hand are the deep places of the earth: the strength of the hills is his also. ⁵ The sea is his, and he made it: and his hands formed the dry land. **⁶ O come, let us worship and bow down: let us kneel before the LORD our maker. ⁷ For he is our God; and we are the people of his pasture, and the sheep of his hand. To day if ye will hear his voice,** *⁸ Harden not your heart, as in the provocation, and as in the day of temptation in the wilderness: ⁹ When your fathers tempted me, proved me, and saw my work. ¹⁰ Forty years long was I grieved with this generation, and said, It is a people that do err in their heart, and they have not known my ways: ¹¹ Unto whom I sware in my wrath that they should not enter into my rest.*

Explanation

⁶We can kneel before God, when we pray, reverencing Him as **Adoni**, our Lord. ⁷This refers to believers who are in fellowship with Christ. Therefore, we know His voice. The pasture, refer to the church, made up of believers. **Psalms 95: 6-7**

Prayer in the form of a Vow
Prayer in the form of a Request
Prayer in the form of Intercessory by the Holy Spirit
Hannah

Text
I Samuel 1:8-15

1 Samuel 1

¹ Now there was a certain man of Ramathaimzophim, of mount Ephraim, and his name was Elkanah, the son of Jeroham, the son of Elihu, the son of Tohu, the son of Zuph, an Ephrathite: ² And he had two wives; the name of the one was Hannah, and the name of the other Peninnah: and Peninnah had children, but Hannah had no children. ³ And this man went up out of

his city yearly to worship and to sacrifice unto the LORD of hosts in Shiloh. And the two sons of Eli, Hophni and Phinehas, the priests of the LORD, were there. ⁴ And when the time was that Elkanah offered, he gave to Peninnah his wife, and to all her sons and her daughters, portions: ⁵ But unto Hannah he gave a worthy portion; for he loved Hannah: but the LORD had shut up her womb. ⁶ And her adversary also provoked her sore, for to make her fret, because the LORD had shut up her womb. ⁷ And as he did so year by year, when she went up to the house of the LORD, so she provoked her; therefore she wept, and did not eat. **⁸ Then said Elkanah her husband to her, Hannah, why weepest thou? and why eatest thou not? and why is thy heart grieved? am not I better to thee than ten sons? ⁹ So Hannah rose up after they had eaten in Shiloh, and after they had drunk. Now Eli the priest sat upon a seat by a post of the temple of the LORD. ¹⁰ And she was in bitterness of soul, and prayed unto the LORD, and wept sore. ¹¹ And she vowed a vow, and said, O LORD of hosts, if thou wilt indeed look on the affliction of thine handmaid, and remember me, and not forget thine handmaid, but wilt give unto thine handmaid a man child, then I will give him unto the LORD all the days of his life, and there shall no razor come upon his head. ¹² And it came to pass, as she continued praying before the LORD, that Eli marked her mouth. ¹³ Now Hannah, she spake in her heart; only her lips moved, but her voice was not heard: therefore Eli thought she had been drunken. ¹⁴ And Eli said unto her, How long wilt thou be drunken? put away thy wine from thee. ¹⁵ And Hannah answered and said, No, my lord, I am a woman of a sorrowful spirit: I have drunk neither wine nor strong drink, but have poured out my soul before the LORD.** *¹⁶ Count not thine handmaid for a daughter of Belial: for out of the abundance of my complaint and grief have I spoken hitherto. ¹⁷ Then Eli answered and said, Go in peace: and the God of Israel grant thee thy petition that thou hast asked of him. ¹⁸ And she said, Let thine handmaid find grace in thy sight. So the woman went her way, and did eat, and her countenance was no more sad. ¹⁹ And they rose up in the morning early, and worshipped before the LORD, and returned, and came to their house to Ramah: and Elkanah knew Hannah his wife; and the LORD remembered her. ²⁰ Wherefore it came to pass, when the time was come about after Hannah had conceived, that she bare a son, and called his name Samuel, saying, Because I have asked him of the LORD. ²¹ And the man Elkanah, and all his house, went up to offer unto the LORD the yearly sacrifice, and his vow. ²² But Hannah went not up; for she said unto her husband, I will not go*

up until the child be weaned, and then I will bring him, that he may appear before the LORD, and there abide for ever. ²³ *And Elkanah her husband said unto her, Do what seemeth thee good; tarry until thou have weaned him; only the LORD establish his word. So the woman abode, and gave her son suck until she weaned him.* ²⁴ *And when she had weaned him, she took him up with her, with three bullocks, and one ephah of flour, and a bottle of wine, and brought him unto the house of the LORD in Shiloh: and the child was young.* ²⁵ *And they slew a bullock, and brought the child to Eli.* ²⁶ *And she said, Oh my lord, as thy soul liveth, my lord, I am the woman that stood by thee here, praying unto the LORD.* ²⁷ *For this child I prayed; and the LORD hath given me my petition which I asked of him:* ²⁸ *Therefore also I have lent him to the LORD; as long as he liveth he shall be lent to the LORD. And he worshipped the LORD there.*

Explanation

Hannah was barren, and was very grieved, resulting in her inability, in experiencing bringing life into the world. So she went to the Temple to pray. She was so grieved that she could not speak out. Only her mouth moved, but there was no sound. However, God heard her, in her despair. She made a vow unto the Lord, that if she had a son, she would dedicate him to the service of the Lord. God gave her a boy, and she called him Sampson. **I Samuel 1:8-15**
Text
I Samuel 2: 1-2

1 Samuel 2

¹ *And Hannah prayed, and said, My heart rejoiceth in the LORD, mine horn is exalted in the LORD: my mouth is enlarged over mine enemies; because I rejoice in thy salvation.* ² *There is none holy as the LORD: for there is none beside thee: neither is there any rock like our God.* ³ *Talk no more so exceeding proudly; let not arrogancy come out of your mouth: for the LORD is a God of knowledge, and by him actions are weighed.* ⁴ *The bows of the mighty men are broken, and they that stumbled are girded with strength.* ⁵ *They that were full have hired out themselves for bread; and they that were hungry ceased: so that the barren hath born seven; and she that hath many children is waxed feeble.* ⁶ *The LORD killeth, and maketh*

alive: he bringeth down to the grave, and bringeth up. *⁷ The LORD maketh poor, and maketh rich: he bringeth low, and lifteth up. ⁸ He raiseth up the poor out of the dust, and lifteth up the beggar from the dunghill, to set them among princes, and to make them inherit the throne of glory: for the pillars of the earth are the LORD's, and he hath set the world upon them. ⁹ He will keep the feet of his saints, and the wicked shall be silent in darkness; for by strength shall no man prevail. ¹⁰ The adversaries of the LORD shall be broken to pieces; out of heaven shall he thunder upon them: the LORD shall judge the ends of the earth; and he shall give strength unto his king, and exalt the horn of his anointed. ¹¹ And Elkanah went to Ramah to his house. And the child did minister unto the LORD before Eli the priest. ¹² Now the sons of Eli were sons of Belial; they knew not the LORD. ¹³ And the priest's custom with the people was, that, when any man offered sacrifice, the priest's servant came, while the flesh was in seething, with a fleshhook of three teeth in his hand; ¹⁴ And he struck it into the pan, or kettle, or caldron, or pot; all that the fleshhook brought up the priest took for himself. So they did in Shiloh unto all the Israelites that came thither. ¹⁵ Also before they burnt the fat, the priest's servant came, and said to the man that sacrificed, Give flesh to roast for the priest; for he will not have sodden flesh of thee, but raw. ¹⁶ And if any man said unto him, Let them not fail to burn the fat presently, and then take as much as thy soul desireth; then he would answer him, Nay; but thou shalt give it me now: and if not, I will take it by force. ¹⁷ Wherefore the sin of the young men was very great before the LORD: for men abhorred the offering of the LORD. ¹⁸ But Samuel ministered before the LORD, being a child, girded with a linen ephod. ¹⁹ Moreover his mother made him a little coat, and brought it to him from year to year, when she came up with her husband to offer the yearly sacrifice. ²⁰ And Eli blessed Elkanah and his wife, and said, The LORD give thee seed of this woman for the loan which is lent to the LORD. And they went unto their own home. ²¹ And the LORD visited Hannah, so that she conceived, and bare three sons and two daughters. And the child Samuel grew before the LORD. ²² Now Eli was very old, and heard all that his sons did unto all Israel; and how they lay with the women that assembled at the door of the tabernacle of the congregation. ²³ And he said unto them, Why do ye such things? for I hear of your evil dealings by all this people. ²⁴ Nay, my sons; for it is no good report that I hear: ye make the LORD's people to transgress. ²⁵ If one man sin against another, the judge shall judge him: but if a man sin against the LORD, who shall intreat for him? Notwithstanding they hearkened not unto the voice of their father, because the LORD would slay them. ²⁶ And the*

child Samuel grew on, and was in favour both with the LORD, and also with men. ²⁷ And there came a man of God unto Eli, and said unto him, Thus saith the LORD, Did I plainly appear unto the house of thy father, when they were in Egypt in Pharaoh's house? ²⁸ And did I choose him out of all the tribes of Israel to be my priest, to offer upon mine altar, to burn incense, to wear an ephod before me? and did I give unto the house of thy father all the offerings made by fire of the children of Israel? ²⁹ Wherefore kick ye at my sacrifice and at mine offering, which I have commanded in my habitation; and honourest thy sons above me, to make yourselves fat with the chiefest of all the offerings of Israel my people? ³⁰ Wherefore the LORD God of Israel saith, I said indeed that thy house, and the house of thy father, should walk before me for ever: but now the LORD saith, Be it far from me; for them that honour me I will honour, and they that despise me shall be lightly esteemed. ³¹ Behold, the days come, that I will cut off thine arm, and the arm of thy father's house, that there shall not be an old man in thine house. ³² And thou shalt see an enemy in my habitation, in all the wealth which God shall give Israel: and there shall not be an old man in thine house for ever. ³³ And the man of thine, whom I shall not cut off from mine altar, shall be to consume thine eyes, and to grieve thine heart: and all the increase of thine house shall die in the flower of their age. ³⁴ And this shall be a sign unto thee, that shall come upon thy two sons, on Hophni and Phinehas; in one day they shall die both of them. ³⁵ And I will raise me up a faithful priest, that shall do according to that which is in mine heart and in my mind: and I will build him a sure house; and he shall walk before mine anointed for ever. ³⁶ And it shall come to pass, that every one that is left in thine house shall come and crouch to him for a piece of silver and a morsel of bread, and shall say, Put me, I pray thee, into one of the priests' offices, that I may eat a piece of bread.

Explanation

Hannah, gives thanksgiving in the joy of bringing life, as a mother, and dedicates her son Sampson to God. I Samuel 2:1-2

Prayer as a Blessing

Text
I Samuel 9:13

1 Samuel 9

¹ *Now there was a man of Benjamin, whose name was Kish, the son of Abiel, the son of Zeror, the son of Bechorath, the son of Aphiah, a Benjamite, a mighty man of power. ² And he had a son, whose name was Saul, a choice young man, and a goodly: and there was not among the children of Israel a goodlier person than he: from his shoulders and upward he was higher than any of the people. ³ And the asses of Kish Saul's father were lost. And Kish said to Saul his son, Take now one of the servants with thee, and arise, go seek the asses. ⁴ And he passed through mount Ephraim, and passed through the land of Shalisha, but they found them not: then they passed through the land of Shalim, and there they were not: and he passed through the land of the Benjamites, but they found them not. ⁵ And when they were come to the land of Zuph, Saul said to his servant that was with him, Come, and let us return; lest my father leave caring for the asses, and take thought for us. ⁶ And he said unto him, Behold now, there is in this city a man of God, and he is an honourable man; all that he saith cometh surely to pass: now let us go thither; peradventure he can shew us our way that we should go. ⁷ Then said Saul to his servant, But, behold, if we go, what shall we bring the man? for the bread is spent in our vessels, and there is not a present to bring to the man of God: what have we? ⁸ And the servant answered Saul again, and said, Behold, I have here at hand the fourth part of a shekel of silver: that will I give to the man of God, to tell us our way. ⁹ (Beforetime in Israel, when a man went to enquire of God, thus he spake, Come, and let us go to the seer: for he that is now called a Prophet was beforetime called a Seer.) ¹⁰ Then said Saul to his servant, Well said; come, let us go. So they went unto the city where the man of God was. ¹¹ And as they went up the hill to the city, they found young maidens going out to draw water, and said unto them, Is the seer here? ¹² And they answered them, and said, He is; behold, he is before you: make haste now, for he came to day to the city; for there is a sacrifice of the people to day in the high place:* **¹³ As soon as ye be come into the city, ye shall straightway find him, before he go up to the high place to eat: for the people will not eat until he come, because he doth bless the sacrifice; and afterwards they eat that be bidden. Now therefore get you up; for about this time ye shall find him.** ¹⁴ *And they went up into the city: and when they were come into the city, behold, Samuel came out against them, for to go up to the high place. ¹⁵ Now the LORD had told Samuel in his ear a day before Saul came, saying, ¹⁶ To morrow about this time I will send thee a man out of the land of Benjamin,*

and thou shalt anoint him to be captain over my people Israel, that he may save my people out of the hand of the Philistines: for I have looked upon my people, because their cry is come unto me. ¹⁷ And when Samuel saw Saul, the LORD said unto him, Behold the man whom I spake to thee of! this same shall reign over my people. ¹⁸ Then Saul drew near to Samuel in the gate, and said, Tell me, I pray thee, where the seer's house is. ¹⁹ And Samuel answered Saul, and said, I am the seer: go up before me unto the high place; for ye shall eat with me to day, and to morrow I will let thee go, and will tell thee all that is in thine heart. ²⁰ And as for thine asses that were lost three days ago, set not thy mind on them; for they are found. And on whom is all the desire of Israel? Is it not on thee, and on all thy father's house? ²¹ And Saul answered and said, Am not I a Benjamite, of the smallest of the tribes of Israel? and my family the least of all the families of the tribe of Benjamin? wherefore then speakest thou so to me? ²² And Samuel took Saul and his servant, and brought them into the parlour, and made them sit in the chiefest place among them that were bidden, which were about thirty persons. ²³ And Samuel said unto the cook, Bring the portion which I gave thee, of which I said unto thee, Set it by thee. ²⁴ And the cook took up the shoulder, and that which was upon it, and set it before Saul. And Samuel said, Behold that which is left! set it before thee, and eat: for unto this time hath it been kept for thee since I said, I have invited the people. So Saul did eat with Samuel that day. ²⁵ And when they were come down from the high place into the city, Samuel communed with Saul upon the top of the house. ²⁶ And they arose early: and it came to pass about the spring of the day, that Samuel called Saul to the top of the house, saying, Up, that I may send thee away. And Saul arose, and they went out both of them, he and Samuel, abroad. ²⁷ And as they were going down to the end of the city, Samuel said to Saul, Bid the servant pass on before us, (and he passed on), but stand thou still a while, that I may shew thee the word of God.

Explanation

Blessing is a prayer of blessing over a meal. **I Samuel 9:13**

Prayer of Confidence through faithfulness

Text
I John 5:14-15

1 John 5

*¹ Whosoever believeth that Jesus is the Christ is born of God: and every one that loveth him that begat loveth him also that is begotten of him. ² By this we know that we love the children of God, when we love God, and keep his commandments. ³ For this is the love of God, that we keep his commandments: and his commandments are not grievous. ⁴ For whatsoever is born of God overcometh the world: and this is the victory that overcometh the world, even our faith. ⁵ Who is he that overcometh the world, but he that believeth that Jesus is the Son of God? ⁶ This is he that came by water and blood, even Jesus Christ; not by water only, but by water and blood. And it is the Spirit that beareth witness, because the Spirit is truth. ⁷ For there are three that bear record in heaven, the Father, the Word, and the Holy Ghost: and these three are one. ⁸ And there are three that bear witness in earth, the Spirit, and the water, and the blood: and these three agree in one. ⁹ If we receive the witness of men, the witness of God is greater: for this is the witness of God which he hath testified of his Son. ¹⁰ He that believeth on the Son of God hath the witness in himself: he that believeth not God hath made him a liar; because he believeth not the record that God gave of his Son. ¹¹ And this is the record, that God hath given to us eternal life, and this life is in his Son. ¹² He that hath the Son hath life; and he that hath not the Son of God hath not life. ¹³ These things have I written unto you that believe on the name of the Son of God; that ye may know that ye have eternal life, and that ye may believe on the name of the Son of God. ¹⁴ **And this is the confidence that we have in him, that, if we ask any thing according to his will, he heareth us: ¹⁵ And if we know that he hear us, whatsoever we ask, we know that we have the petitions that we desired of him.** ¹⁶ If any man see his brother sin a sin which is not unto death, he shall ask, and he shall give him life for them that sin not unto death. There is a sin unto death: I do not say that he shall pray for it. ¹⁷ All unrighteousness is sin: and there is a sin not unto death. ¹⁸ We know that whosoever is born of God sinneth not; but he that is begotten of God keepeth himself, and that wicked one toucheth him not. ¹⁹ And we know that we are of God, and the whole world lieth in wickedness. ²⁰ And we know that the Son of God is come, and hath given us an understanding, that we may know him that is true, and we are in him that is true, even in his Son Jesus Christ. This is the true God, and eternal life. ²¹ Little children, keep yourselves from idols. Amen.*

Explanation

This is praying in confidence that as believers, we are walking in accordance to the teachings of the Word of God, and therefore, whatever, we ask, God hears and responds through our prayers. **I John 5:14-15**

A prayer for and of humanity
A prayer request
A prayer for wisdom for instruction
Solomon

Text
I Kings 3:5-13

1 Kings 3

¹ And Solomon made affinity with Pharaoh king of Egypt, and took Pharaoh's daughter, and brought her into the city of David, until he had made an end of building his own house, and the house of the LORD, and the wall of Jerusalem round about. ² Only the people sacrificed in high places, because there was no house built unto the name of the LORD, until those days. ³ And Solomon loved the LORD, walking in the statutes of David his father: only he sacrificed and burnt incense in high places. ⁴ And the king went to Gibeon to sacrifice there; for that was the great high place: a thousand burnt offerings did Solomon offer upon that altar. ⁵ **In Gibeon the LORD appeared to Solomon in a dream by night: and God said, Ask what I shall give thee. ⁶ And Solomon said, Thou hast shewed unto thy servant David my father great mercy, according as he walked before thee in truth, and in righteousness, and in uprightness of heart with thee; and thou hast kept for him this great kindness, that thou hast given him a son to sit on his throne, as it is this day. ⁷ And now, O LORD my God, thou hast made thy servant king instead of David my father: and I am but a little child: I know not how to go out or come in. ⁸ And thy servant is in the midst of thy people which thou hast chosen, a great people, that cannot be numbered nor counted for multitude. ⁹ Give therefore thy servant an understanding heart to judge thy people, that I may discern between good and bad: for who is able to judge this thy so great a people? ¹⁰ And the speech pleased the LORD, that Solomon had asked this thing. ¹¹ And God said**

unto him, Because thou hast asked this thing, and hast not asked for thyself long life; neither hast asked riches for thyself, nor hast asked the life of thine enemies; but hast asked for thyself understanding to discern judgment; *12* Behold, I have done according to thy words: lo, I have given thee a wise and an understanding heart; so that there was none like thee before thee, neither after thee shall any arise like unto thee. *13* And I have also given thee that which thou hast not asked, both riches, and honour: so that there shall not be any among the kings like unto thee all thy days. *14* And if thou wilt walk in my ways, to keep my statutes and my commandments, as thy father David did walk, then I will lengthen thy days. *15* And Solomon awoke; and, behold, it was a dream. And he came to Jerusalem, and stood before the ark of the covenant of the LORD, and offered up burnt offerings, and offered peace offerings, and made a feast to all his servants. *16* Then came there two women, that were harlots, unto the king, and stood before him. *17* And the one woman said, O my lord, I and this woman dwell in one house; and I was delivered of a child with her in the house. *18* And it came to pass the third day after that I was delivered, that this woman was delivered also: and we were together; there was no stranger with us in the house, save we two in the house. *19* And this woman's child died in the night; because she overlaid it. *20* And she arose at midnight, and took my son from beside me, while thine handmaid slept, and laid it in her bosom, and laid her dead child in my bosom. *21* And when I rose in the morning to give my child suck, behold, it was dead: but when I had considered it in the morning, behold, it was not my son, which I did bear. *22* And the other woman said, Nay; but the living is my son, and the dead is thy son. And this said, No; but the dead is thy son, and the living is my son. Thus they spake before the king. *23* Then said the king, The one saith, This is my son that liveth, and thy son is the dead: and the other saith, Nay; but thy son is the dead, and my son is the living. *24* And the king said, Bring me a sword. And they brought a sword before the king. *25* And the king said, Divide the living child in two, and give half to the one, and half to the other. *26* Then spake the woman whose the living child was unto the king, for her bowels yearned upon her son, and she said, O my lord, give her the living child, and in no wise slay it. But the other said, Let it be neither mine nor thine, but divide it. *27* Then the king answered and said, Give her the living child, and in no wise slay it: she is the mother thereof. *28* And all Israel heard of the judgment which the king had judged; and they feared the king: for they saw that the wisdom of God was in him, to do judgment.

Explanation

As a result of King Solomon, not wanting riches, and wealth, and prayed for wisdom in dealing with the people he had ruled over, not only did God grant him wisdom; he became the wisest man that ever lived, in his day. It is stated that the Queen of Sheba came from across the world, to see the wisdom and the riches of Solomon. **I Kings 3:5-13**

Conclusion

Prayer is communicating with God, through our Intercessor, the Lord Jesus Christ.
Prayer is meditation, wherein we are in a constant state of being in tune with God
Prayer is a means of making our request known to God.
Prayer is glorifying and thanking God for His goodness, in the form of adoration.

Questions

What is prayer?

Name seven types of prayer. Provide scripture.
Types of Prayer Scripture

What is one of the ways, taught in this lesson that we can get what we need from God? Provide scripture.

Do we have to speak out loud to God when we pray? Provide scripture.

Where is the sinner's prayer of repentance found? Provide scripture.

What does it say?_____ be _____to _____ a

Why did God not hear the Pharisee's prayer?

_____He put himself above all other men.

_____He was self righteous, boosting on all the natural deeds he performed which are good

_____ He was just praying because of the time of day, being that he was a religious man.

_____He was full of pride

_____ He did not first acknowledge God's goodness, in remembering that all that performs, God gives him the ability to do so

 All of the above

Can doing good deeds get us into heaven? Or do we come through the Door, which is the blood of the Lord Jesus Christ, the Redeemer of our sins through repentance?

Thought Question

What do you think would be the most effective prayer in the Bible, or the most important?

The sinner's repentant prayer: *God be merciful to me a sinner and save me from my sins.*

The Lord's Prayer
Chapter 2

Text
St. Matthew 6:9-13

Introduction

The basic guideline for prayer is called The Lord's Prayer or the **Disciples Prayer**. It is used as a **guide**, as a **basic standard** in which to draw upon. Also, it can be used as a, daily prayer.

The Lesson

Text
St. Matthew 6:9-15

Matthew 6

¹ Take heed that ye do not your alms before men, to be seen of them: otherwise ye have no reward of your Father which is in heaven. ² Therefore when thou doest thine alms, do not sound a trumpet before thee, as the hypocrites do in the synagogues and in the streets, that they may have glory of men. Verily I say unto you, They have their reward. ³ But when thou doest alms, let not thy left hand know what thy right hand doeth: ⁴ That thine alms may be in secret: and thy Father which seeth in secret himself shall reward thee openly. ⁵ And when thou prayest, thou shalt not be as the hypocrites are: for they love to pray standing in the synagogues and in the corners of the streets, that they may be seen of men. Verily I say unto you, They have their reward. ⁶ But thou, when thou prayest, enter into thy closet, and when thou hast shut thy door, pray to thy Father which is in secret; and thy Father which seeth in secret shall reward thee openly. ⁷ But when ye pray, use not vain repetitions, as the heathen do: for they think that they shall be heard for their much speaking. ⁸ Be not ye therefore

like unto them: for your Father knoweth what things ye have need of, before ye ask him. *⁹ After this manner therefore pray ye: Our Father which art in heaven, Hallowed be thy name.* *¹⁰ Thy kingdom come, Thy will be done in earth, as it is in heaven.* *¹¹ Give us this day our daily bread.* *¹² And forgive us our debts, as we forgive our debtors.* *¹³ And lead us not into temptation, but deliver us from evil: For thine is the kingdom, and the power, and the glory, for ever. Amen.* *¹⁴ For if ye forgive men their trespasses, your heavenly Father will also forgive you:* *¹⁵ But if ye forgive not men their trespasses, neither will your Father forgive your trespasses.* *¹⁶ Moreover when ye fast, be not, as the hypocrites, of a sad countenance: for they disfigure their faces, that they may appear unto men to fast. Verily I say unto you, They have their reward.* *¹⁷ But thou, when thou fastest, anoint thine head, and wash thy face;* *¹⁸ That thou appear not unto men to fast, but unto thy Father which is in secret: and thy Father, which seeth in secret, shall reward thee openly.* *¹⁹ Lay not up for yourselves treasures upon earth, where moth and rust doth corrupt, and where thieves break through and steal:* *²⁰ But lay up for yourselves treasures in heaven, where neither moth nor rust doth corrupt, and where thieves do not break through nor steal:* *²¹ For where your treasure is, there will your heart be also.* *²² The light of the body is the eye: if therefore thine eye be single, thy whole body shall be full of light.* *²³ But if thine eye be evil, thy whole body shall be full of darkness. If therefore the light that is in thee be darkness, how great is that darkness!* *²⁴ No man can serve two masters: for either he will hate the one, and love the other; or else he will hold to the one, and despise the other. Ye cannot serve God and mammon.* *²⁵ Therefore I say unto you, Take no thought for your life, what ye shall eat, or what ye shall drink; nor yet for your body, what ye shall put on. Is not the life more than meat, and the body than raiment?* *²⁶ Behold the fowls of the air: for they sow not, neither do they reap, nor gather into barns; yet your heavenly Father feedeth them. Are ye not much better than they?* *²⁷ Which of you by taking thought can add one cubit unto his stature?* *²⁸ And why take ye thought for raiment? Consider the lilies of the field, how they grow; they toil not, neither do they spin:* *²⁹ And yet I say unto you, That even Solomon in all his glory was not arrayed like one of these.* *³⁰ Wherefore, if God so clothe the grass of the field, which to day is, and to morrow is cast into the oven, shall he not much more clothe you, O ye of little faith?* *³¹ Therefore take no thought, saying, What shall we eat? or, What shall we drink? or, Wherewithal shall we be clothed?* *³² (For after all these things do the Gentiles seek:) for your heavenly Father knoweth that ye have need of all these things.* *³³ But seek ye first the*

kingdom of God, and his righteousness; and all these things shall be added unto you. *34 Take therefore no thought for the morrow: for the morrow shall take thought for the things of itself. Sufficient unto the day is the evil thereof.* **St. Matthew 6:9-15**

(See explanation below)

Also

Text
St. Luke 11:2-4

Luke 11

1 And it came to pass, that, as he was praying in a certain place, when he ceased, one of his disciples said unto him, Lord, teach us to pray, as John also taught his disciples. 2 And he said unto them, When ye pray, say, Our Father which art in heaven, Hallowed be thy name. Thy kingdom come. Thy will be done, as in heaven, so in earth. 3 Give us day by day our daily bread. 4 And forgive us our sins; for we also forgive every one that is indebted to us. And lead us not into temptation; but deliver us from evil. 5 And he said unto them, Which of you shall have a friend, and shall go unto him at midnight, and say unto him, Friend, lend me three loaves; 6 For a friend of mine in his journey is come to me, and I have nothing to set before him? 7 And he from within shall answer and say, Trouble me not: the door is now shut, and my children are with me in bed; I cannot rise and give thee. 8 I say unto you, Though he will not rise and give him, because he is his friend, yet because of his importunity he will rise and give him as many as he needeth. 9 And I say unto you, Ask, and it shall be given you; seek, and ye shall find; knock, and it shall be opened unto you. 10 For every one that asketh receiveth; and he that seeketh findeth; and to him that knocketh it shall be opened. 11 If a son shall ask bread of any of you that is a father, will he give him a stone? or if he ask a fish, will he for a fish give him a serpent? 12 Or if he shall ask an egg, will he offer him a scorpion? 13 If ye then, being evil, know how to give good gifts unto your children: how much more shall your heavenly Father give the Holy Spirit to them that ask him? 14 And he was casting out a devil, and it was dumb. And it came to pass, when the devil was gone out, the dumb spake; and the people wondered. 15 But some of them said, He casteth

out devils through Beelzebub the chief of the devils. ¹⁶ And others, tempting him, sought of him a sign from heaven. ¹⁷ But he, knowing their thoughts, said unto them, Every kingdom divided against itself is brought to desolation; and a house divided against a house falleth. ¹⁸ If Satan also be divided against himself, how shall his kingdom stand? because ye say that I cast out devils through Beelzebub. ¹⁹ And if I by Beelzebub cast out devils, by whom do your sons cast them out? therefore shall they be your judges. ²⁰ But if I with the finger of God cast out devils, no doubt the kingdom of God is come upon you. ²¹ When a strong man armed keepeth his palace, his goods are in peace: ²² But when a stronger than he shall come upon him, and overcome him, he taketh from him all his armour wherein he trusted, and divideth his spoils. ²³ He that is not with me is against me: and he that gathereth not with me scattereth. ²⁴ When the unclean spirit is gone out of a man, he walketh through dry places, seeking rest; and finding none, he saith, I will return unto my house whence I came out. ²⁵ And when he cometh, he findeth it swept and garnished. ²⁶ Then goeth he, and taketh to him seven other spirits more wicked than himself; and they enter in, and dwell there: and the last state of that man is worse than the first. ²⁷ And it came to pass, as he spake these things, a certain woman of the company lifted up her voice, and said unto him, Blessed is the womb that bare thee, and the paps which thou hast sucked. ²⁸ But he said, Yea rather, blessed are they that hear the word of God, and keep it. ²⁹ And when the people were gathered thick together, he began to say, This is an evil generation: they seek a sign; and there shall no sign be given it, but the sign of Jonas the prophet. ³⁰ For as Jonas was a sign unto the Ninevites, so shall also the Son of man be to this generation. ³¹ The queen of the south shall rise up in the judgment with the men of this generation, and condemn them: for she came from the utmost parts of the earth to hear the wisdom of Solomon; and, behold, a greater than Solomon is here. ³² The men of Nineve shall rise up in the judgment with this generation, and shall condemn it: for they repented at the preaching of Jonas; and, behold, a greater than Jonas is here. ³³ No man, when he hath lighted a candle, putteth it in a secret place, neither under a bushel, but on a candlestick, that they which come in may see the light. ³⁴ The light of the body is the eye: therefore when thine eye is single, thy whole body also is full of light; but when thine eye is evil, thy body also is full of darkness. ³⁵ Take heed therefore that the light which is in thee be not darkness. ³⁶ If thy whole body therefore be full of light, having no part dark, the whole shall be full of light, as when the bright shining of a candle doth give thee light. ³⁷ And as he spake, a certain Pharisee besought him to dine with him: and he went in, and sat down to meat. ³⁸ And

when the Pharisee saw it, he marvelled that he had not first washed before dinner. [39] And the Lord said unto him, Now do ye Pharisees make clean the outside of the cup and the platter; but your inward part is full of ravening and wickedness. [40] Ye fools, did not he that made that which is without make that which is within also? [41] But rather give alms of such things as ye have; and, behold, all things are clean unto you. [42] But woe unto you, Pharisees! for ye tithe mint and rue and all manner of herbs, and pass over judgment and the love of God: these ought ye to have done, and not to leave the other undone. [43] Woe unto you, Pharisees! for ye love the uppermost seats in the synagogues, and greetings in the markets. [44] Woe unto you, scribes and Pharisees, hypocrites! for ye are as graves which appear not, and the men that walk over them are not aware of them. [45] Then answered one of the lawyers, and said unto him, Master, thus saying thou reproachest us also. [46] And he said, Woe unto you also, ye lawyers! for ye lade men with burdens grievous to be borne, and ye yourselves touch not the burdens with one of your fingers. [47] Woe unto you! for ye build the sepulchres of the prophets, and your fathers killed them. [48] Truly ye bear witness that ye allow the deeds of your fathers: for they indeed killed them, and ye build their sepulchres. [49] Therefore also said the wisdom of God, I will send them prophets and apostles, and some of them they shall slay and persecute: [50] That the blood of all the prophets, which was shed from the foundation of the world, may be required of this generation; [51] From the blood of Abel unto the blood of Zacharias which perished between the altar and the temple: verily I say unto you, It shall be required of this generation. [52] Woe unto you, lawyers! for ye have taken away the key of knowledge: ye entered not in yourselves, and them that were entering in ye hindered. [53] And as he said these things unto them, the scribes and the Pharisees began to urge him vehemently, and to provoke him to speak of many things: [54] Laying wait for him, and seeking to catch something out of his mouth, that they might accuse him.

Explanation
General Explanation
Comparison of St. Matthews and St. Luke

St. Matthews is the larger version of the Lord's Prayer. St. Luke has a shorter version.

The line by line explanation is now the following

9 We address God, as He sits on the Throne of God, in heaven, by reverencing His Name, Yahweh. 10 As we pray, we address the futuristic events of the New Heaven and the New Earth, descending down from heaven, after the Second Coming of the Messiah, as The Day Star. Until then, we as believers in Christ want God to look out for our needs, according to His riches in heaven, by Christ Jesus, the Mediator between God and man. 11 Our daily bread, refers to what we need spiritually, which can only be supplied by God, defined as spiritual knowledge and guidance, through reading the Word of God as God the Holy Spirit leads us in our daily walk of life, through Truth. 12 We ask God to forgive us. However if we do not forgive others, God will not forgive us. Also, He is saying that with the measurement of how we forgive others, partially or completely, God will forgive us in the same manner. 13 God does not tempt us. We tempt ourselves and allow ourselves to fall into sin. Therefore, we are asking God to deliver us from evil by having mercy upon us, even though we don't always deserve it. God holds the kingdom in His Hands, as we remind ourselves, who He is. He holds all power and glory in His Kingdom as Elohim, our Creator and Lord. Amen, states, this is the conclusion of the whole matter. 14
We are commanded to forgive others who:

- Trespass against us
- Sin against us
- Do anything in word or actions that are not pleasing in the eyesight of God

In order for God to forgive us in whatever capacity that is needed on a daily basis, we must forgive others.

- We must forgive others in order for God to forgive us
- We must not hold any malice or hatred in our hearts for anyone, for no reason or without a reason
- Therefore, we should not be envious or jealous of another. The Bible states that it is a sin. Such is defined as ill feelings without a cause. The Word of God states that jealousy is as cruel as the grave. (Song of Solomon 8:6). Therefore such a person can be devoured by envy

and jealousy to the point that it causes illness and eventually, if not checked and remedied, can cause death. **St. Luke 11:2-4**

Conclusion

In order to be able to get what we want from God, we must know the meaning of prayer.

Also, we must know how to pray, as the apostles and disciples were taught by the Chief Cornerstone, and the Chief Shepherd, the Lord Jesus Christ.

Prayer is our spiritual link to God, as Jehovah Tsidkenu, God our Righteousness. The scriptures are our roadmap, and guide.

Questions

Do you know the Lord's Prayer by heart? If so write it.

Who was the prayer originally for? What is it used for?

What does it mean to lead us not into temptation?

Thought Question

Have you prayed the sinner's prayer, which is the most important prayer in the Bible? (Refer to the previous lesson).

Chapter 3

Week One: Review
Week Two: Open Book Test
Week Three: Review and Open Discussion of the Unit

Unit 1: Prayer
Practice for Review
And later
Unit Test

What is Prayer?

What is prayer?

Name three types of prayer. Provide scripture.

What is one of the ways, taught in this lesson that we can get what we need from God? Provide scripture.

Do we have to speak out loud to God when we pray? Provide scripture.

Where is the sinner's prayer of repentance found? Provide scripture.

What does it say:_____ be_____ to_____ a

Why did God not hear the Pharisee's prayer?
_____He put himself above all other men.
_____He was self righteous, boosting on all the natural deeds he performed which are good

_____He was just praying because of the time of day, being that he was a religious man.

_____He was full of pride.

_____He did not first acknowledge God's goodness, in remembering that all that he performs, God gives him the ability to do so.

_____All of the above

Can doing good deeds get us into heaven? Or do we come through the door, which is the blood of the Lord Jesus Christ, the Redeemer of our sins through repentance?

The Lord's Prayer

Do you know the Lord's Prayer by heart? If so write it.

Who was the prayer originally for? What is it used for?

What does it mean to lead us not into temptation?

UNIT TWO: THE GOSPEL

Contents

Unit Introduction

In the previous unit we talked about Prayer. In this unit we shall discuss briefly the Gospel. In order to operate in the Gospel, one must know the meaning of prayer, and then the Gospel is a means in which to operate in. It is through the Gospel that we can travel with Christ. It is through the Gospel that we can commune with Christ through prayer and through reading the Gospel.It is with those thoughts that we present to you, ***The Gospel*** . . .

The Gospel
Chapter 1

Text
St Matthew, St. Mark, St. Luke, and St John

Introduction

The Gospel is the Good News of the Lord Jesus Christ, and His ministry and purpose on earth defined in St. John 3:16 & 17 (See lesson on salvation). Through the four gospels, Christ is defined as Prophet, Priest, and King.

The Lesson

Text
St. Matthew:

- The King
- King of the Church
- Eternal, Immortal, and Invisible
 Psalms 10:16
 I Timothy 1:17

St. Matthew: focus upon events.
St. Mark:

- Servant and a Branch
- Worker (found in like fashion as a man)
- Servant (the lowly servant)
- Branch
 Philippians 2: 5-8
 II Timothy 5:2
 Philemon 24

- St. Mark: focus upon supernatural works of Christ's during His ministry.
- **St. Luke:**
- The Prophet
- God's representative with the people.
- Used to establish truth.
- Used to rebuke and correct, bringing them back to truth.
- A foreteller
- God's mouthpiece.
 Hebrews 1: 1-2

Galatians 3:6:14 (Christ first coming)
St. Luke: focus upon individuals.
St. John:

- The Priest/Prophet
- The people's representative with God.
- Advocate or Mediator between God and mankind
 Ephesians 2:8-9
 Hebrews 5:1-2; 8: 1-3

St. John: focus upon the life of Christ, in ministry as the Messiah/Savior.

The Church is the body of Believers

Text
St. Matthew 16:18

Matthew 16

[1] *The Pharisees also with the Sadducees came, and tempting desired him that he would shew them a sign from heaven.* [2] *He answered and said unto them, When it is evening, ye say, It will be fair weather: for the sky is red.* [3] *And in the morning, It will be foul weather to day: for the sky is red and lowering. O ye hypocrites, ye can discern the face of the sky; but can ye not discern the signs of the times?* [4] *A wicked and adulterous generation seeketh after a sign; and there shall no sign be given unto it, but the sign of the prophet Jonas. And he left them, and departed.* [5] *And when his disciples were come to the other side,*

they had forgotten to take bread. ⁶ Then Jesus said unto them, Take heed and beware of the leaven of the Pharisees and of the Sadducees. ⁷ And they reasoned among themselves, saying, It is because we have taken no bread. ⁸ Which when Jesus perceived, he said unto them, O ye of little faith, why reason ye among yourselves, because ye have brought no bread? ⁹ Do ye not yet understand, neither remember the five loaves of the five thousand, and how many baskets ye took up? ¹⁰ Neither the seven loaves of the four thousand, and how many baskets ye took up? ¹¹ How is it that ye do not understand that I spake it not to you concerning bread, that ye should beware of the leaven of the Pharisees and of the Sadducees? ¹² Then understood they how that he bade them not beware of the leaven of bread, but of the doctrine of the Pharisees and of the Sadducees. ¹³ When Jesus came into the coasts of Caesarea Philippi, he asked his disciples, saying, Whom do men say that I the Son of man am? ¹⁴ And they said, Some say that thou art John the Baptist: some, Elias; and others, Jeremias, or one of the prophets. ¹⁵ He saith unto them, But whom say ye that I am? ¹⁶ And Simon Peter answered and said, Thou art the Christ, the Son of the living God. ¹⁷ And Jesus answered and said unto him, Blessed art thou, Simon Barjona: for flesh and blood hath not revealed it unto thee, but my Father which is in heaven.
¹⁸ And I say also unto thee, That thou art Peter, and upon this rock I will build my church; and the gates of hell shall not prevail against it.
¹⁹ And I will give unto thee the keys of the kingdom of heaven: and whatsoever thou shalt bind on earth shall be bound in heaven: and whatsoever thou shalt loose on earth shall be loosed in heaven. ²⁰ Then charged he his disciples that they should tell no man that he was Jesus the Christ. ²¹ From that time forth began Jesus to shew unto his disciples, how that he must go unto Jerusalem, and suffer many things of the elders and chief priests and scribes, and be killed, and be raised again the third day. ²² Then Peter took him, and began to rebuke him, saying, Be it far from thee, Lord: this shall not be unto thee. ²³ But he turned, and said unto Peter, Get thee behind me, Satan: thou art an offence unto me: for thou savourest not the things that be of God, but those that be of men. ²⁴ Then said Jesus unto his disciples, If any man will come after me, let him deny himself, and take up his cross, and follow me. ²⁵ For whosoever will save his life shall lose it: and whosoever will lose his life for my sake shall find it. ²⁶ For what is a man profited, if he shall gain the whole world, and lose his own soul? or what shall a man give in exchange for his soul? ²⁷ For the Son of man shall come in the glory of his Father with his angels; and then he shall reward every man according to his works. ²⁸ Verily I say unto you, There be

some standing here, which shall not taste of death, till they see the Son of man coming in his kingdom.

Explanation

Peter is the messenger to the Gentiles. Christ is the head of the Church. Peter was appointed to begin the ministry of the Gentiles, the body of non-believers, who are now engrafted into the plan of salvation. Nothing will be able to stop God's continuous plan of evangelizing the world with the Good News of the Lord Jesus Christ. The scripture states that this gospel will be preached to the entire world, and then only, will the end come.

St. Matthew 16:18

Text
Ephesians 5:23

Ephesians 5

¹ Be ye therefore followers of God, as dear children; ² And walk in love, as Christ also hath loved us, and hath given himself for us an offering and a sacrifice to God for a sweetsmelling savour. ³ But fornication, and all uncleanness, or covetousness, let it not be once named among you, as becometh saints; ⁴ Neither filthiness, nor foolish talking, nor jesting, which are not convenient: but rather giving of thanks. ⁵ For this ye know, that no whoremonger, nor unclean person, nor covetous man, who is an idolater, hath any inheritance in the kingdom of Christ and of God. ⁶ Let no man deceive you with vain words: for because of these things cometh the wrath of God upon the children of disobedience. ⁷ Be not ye therefore partakers with them. ⁸ For ye were sometimes darkness, but now are ye light in the Lord: walk as children of light: ⁹ (For the fruit of the Spirit is in all goodness and righteousness and truth;) ¹⁰ Proving what is acceptable unto the Lord. ¹¹ And have no fellowship with the unfruitful works of darkness, but rather reprove them. ¹² For it is a shame even to speak of those things which are done of them in secret. ¹³ But all things that are reproved are made manifest by the light: for whatsoever doth make manifest is light. ¹⁴ Wherefore he saith, Awake thou that sleepest, and arise from the dead, and Christ shall give thee light. ¹⁵ See then that ye walk circumspectly, not as fools,

but as wise, ¹⁶ *Redeeming the time, because the days are evil. ¹⁷ Wherefore be ye not unwise, but understanding what the will of the Lord is. ¹⁸ And be not drunk with wine, wherein is excess; but be filled with the Spirit; ¹⁹ Speaking to yourselves in psalms and hymns and spiritual songs, singing and making melody in your heart to the Lord; ²⁰ Giving thanks always for all things unto God and the Father in the name of our Lord Jesus Christ; ²¹ Submitting yourselves one to another in the fear of God. ²² Wives, submit yourselves unto your own husbands, as unto the Lord. ²³* **For the husband is the head of the wife, even as Christ is the head of the church: and he is the saviour of the body.** *²⁴ Therefore as the church is subject unto Christ, so let the wives be to their own husbands in every thing. ²⁵ Husbands, love your wives, even as Christ also loved the church, and gave himself for it; ²⁶ That he might sanctify and cleanse it with the washing of water by the word, ²⁷ That he might present it to himself a glorious church, not having spot, or wrinkle, or any such thing; but that it should be holy and without blemish. ²⁸ So ought men to love their wives as their own bodies. He that loveth his wife loveth himself. ²⁹ For no man ever yet hated his own flesh; but nourisheth and cherisheth it, even as the Lord the church: ³⁰ For we are members of his body, of his flesh, and of his bones. ³¹ For this cause shall a man leave his father and mother, and shall be joined unto his wife, and they two shall be one flesh. ³² This is a great mystery: but I speak concerning Christ and the church. ³³ Nevertheless let every one of you in particular so love his wife even as himself; and the wife see that she reverence her husband.*

Explanation

Christ is the Savior for all mankind. **Ephesians 5:23**

The Gospel in a Nutshell

Text
I Corinthians 15: 3, 4, 5 & 7

1 Corinthians 15

¹ **Moreover, brethren, I declare unto you the gospel which I preached unto you, which also ye have received, and wherein ye stand; ² By which also ye are saved, if ye keep in memory what I preached unto**

you, unless ye have believed in vain. *³ For I delivered unto you first of all that which I also received, how that Christ died for our sins according to the scriptures; ⁴ And that he was buried, and that he rose again the third day according to the scriptures: ⁵ And that he was seen of Cephas, then of the twelve: ⁶ After that, he was seen of above five hundred brethren at once; of whom the greater part remain unto this present, but some are fallen asleep. ⁷ After that, he was seen of James; then of all the apostles.* ⁸ And last of all he was seen of me also, as of one born out of due time. ⁹ For I am the least of the apostles, that am not meet to be called an apostle, because I persecuted the church of God. ¹⁰ But by the grace of God I am what I am: and his grace which was bestowed upon me was not in vain; but I laboured more abundantly than they all: yet not I, but the grace of God which was with me. ¹¹ Therefore whether it were I or they, so we preach, and so ye believed. ¹² Now if Christ be preached that he rose from the dead, how say some among you that there is no resurrection of the dead? ¹³ But if there be no resurrection of the dead, then is Christ not risen: ¹⁴ And if Christ be not risen, then is our preaching vain, and your faith is also vain. ¹⁵ Yea, and we are found false witnesses of God; because we have testified of God that he raised up Christ: whom he raised not up, if so be that the dead rise not. ¹⁶ For if the dead rise not, then is not Christ raised: ¹⁷ And if Christ be not raised, your faith is vain; ye are yet in your sins. ¹⁸ Then they also which are fallen asleep in Christ are perished. ¹⁹ If in this life only we have hope in Christ, we are of all men most miserable. ²⁰ But now is Christ risen from the dead, and become the firstfruits of them that slept. ²¹ For since by man came death, by man came also the resurrection of the dead. ²² For as in Adam all die, even so in Christ shall all be made alive. ²³ But every man in his own order: Christ the firstfruits; afterward they that are Christ's at his coming. ²⁴ Then cometh the end, when he shall have delivered up the kingdom to God, even the Father; when he shall have put down all rule and all authority and power. ²⁵ For he must reign, till he hath put all enemies under his feet. ²⁶ The last enemy that shall be destroyed is death. ²⁷ For he hath put all things under his feet. But when he saith all things are put under him, it is manifest that he is excepted, which did put all things under him. ²⁸ And when all things shall be subdued unto him, then shall the Son also himself be subject unto him that put all things under him, that God may be all in all. ²⁹ Else what shall they do which are baptized for the dead, if the dead rise not at all? why are they then baptized for the dead? ³⁰ And why stand we in jeopardy every hour? ³¹ I protest by your rejoicing which I have in Christ Jesus our Lord, I die daily. ³² If after the manner of

men I have fought with beasts at Ephesus, what advantageth it me, if the dead rise not? let us eat and drink; for to morrow we die. *33* Be not deceived: evil communications corrupt good manners. *34* Awake to righteousness, and sin not; for some have not the knowledge of God: I speak this to your shame. *35* But some man will say, How are the dead raised up? and with what body do they come? *36* Thou fool, that which thou sowest is not quickened, except it die: *37* And that which thou sowest, thou sowest not that body that shall be, but bare grain, it may chance of wheat, or of some other grain: *38* But God giveth it a body as it hath pleased him, and to every seed his own body. *39* All flesh is not the same flesh: but there is one kind of flesh of men, another flesh of beasts, another of fishes, and another of birds. *40* There are also celestial bodies, and bodies terrestrial: but the glory of the celestial is one, and the glory of the terrestrial is another. *41* There is one glory of the sun, and another glory of the moon, and another glory of the stars: for one star differeth from another star in glory. *42* So also is the resurrection of the dead. It is sown in corruption; it is raised in incorruption: *43* It is sown in dishonour; it is raised in glory: it is sown in weakness; it is raised in power: *44* It is sown a natural body; it is raised a spiritual body. There is a natural body, and there is a spiritual body. *45* And so it is written, The first man Adam was made a living soul; the last Adam was made a quickening spirit. *46* Howbeit that was not first which is spiritual, but that which is natural; and afterward that which is spiritual. *47* The first man is of the earth, earthy; the second man is the Lord from heaven. *48* As is the earthy, such are they also that are earthy: and as is the heavenly, such are they also that are heavenly. *49* And as we have borne the image of the earthy, we shall also bear the image of the heavenly. *50* Now this I say, brethren, that flesh and blood cannot inherit the kingdom of God; neither doth corruption inherit incorruption. *51* Behold, I shew you a mystery; We shall not all sleep, but we shall all be changed, *52* In a moment, in the twinkling of an eye, at the last trump: for the trumpet shall sound, and the dead shall be raised incorruptible, and we shall be changed. *53* For this corruptible must put on incorruption, and this mortal must put on immortality. *54* So when this corruptible shall have put on incorruption, and this mortal shall have put on immortality, then shall be brought to pass the saying that is written, Death is swallowed up in victory. *55* O death, where is thy sting? O grave, where is thy victory? *56* The sting of death is sin; and the strength of sin is the law. *57* But thanks be to God, which giveth us the victory through our Lord Jesus Christ. *58* Therefore, my beloved brethren, be ye stedfast, unmoveable, always abounding in the work of the Lord, forasmuch as ye know that your labour is not in vain in the Lord.

Explanation

The Gospel in a net shell, according to I Corinthians 15 is: Christ DIED, ROSE and was SEEN. **I Corinthians 15: 3, 4, 5 & 7**

Conclusion

- Ephesian 5:23 and Matthew, Mark and Luke and John tell the Good News (Defined as the Gospel).
- The Gospel in a nutshell is described in I Corinthians 15: 3, 4, 5 & 7.
- The Lord Jesus Christ is described as a Prophet, Priest and a King, Servant and the Branch.

Questions

What is the Gospel in a Net shell?

State which gospels identify Christ as a prophet, priest, king, servant and the branch?

Books Christ identified as

Matthew _____

Mark _____

Luke _____

John_____

What is Grace?

_____ Unmerited favor with God

_____ Underserved favor with God

_____ Being in the right standing with God, thereby counted righteous before God

_____ All of the above

Name the four gospels and associate (2) other focus points for each.

The Gospels (2) Other focused points

Thought Question

The Gospel is expressed in the New Testament. Do you have an entire Bible or at least the New Testament?

The Blessed Hope
Chapter 2

Text
Titus 2: 13
I Thessalonians 1: 10
Revelations 20: 5-6
Revelations 20: 15
St. Luke 23: 43
Other Text not discussed:
St. Matthew 25: 41-46
St. Mark 9: 43-48
St. Luke 16:19-26
II Thessalonians 1: 7-9
II Corinthians 5:8
Philippians 1: 23,
Philippians 3:21
Revelations 3: 10,
Revelations 19: 11-16
Revelations 20:1-6
St. Matthews 25: 46
St. John 5: 28-29

Introduction

The Blessed Hope is the glorious appearing of our Lord Jesus Christ, when He appears the second time for the body of believers, called his Church. It is also defined as the Gospel or the Good News of salvation and the gift of eternal life, as they look for him, in whom they believe. In this lesson, we shall explain the doctrine of the Second Coming of Christ, in accordance to the Holy Scriptures, as stated in the Statement of Faith.

The Lesson
Things to Come: The Blessed Hope

Text
Titus 2:13

Titus 2

*¹ But speak thou the things which become sound doctrine: ² That the aged men be sober, grave, temperate, sound in faith, in charity, in patience. ³ The aged women likewise, that they be in behaviour as becometh holiness, not false accusers, not given to much wine, teachers of good things; ⁴ That they may teach the young women to be sober, to love their husbands, to love their children, ⁵ To be discreet, chaste, keepers at home, good, obedient to their own husbands, that the word of God be not blasphemed. ⁶ Young men likewise exhort to be sober minded. ⁷ In all things shewing thyself a pattern of good works: in doctrine shewing uncorruptness, gravity, sincerity, ⁸ Sound speech, that cannot be condemned; that he that is of the contrary part may be ashamed, having no evil thing to say of you. ⁹ Exhort servants to be obedient unto their own masters, and to please them well in all things; not answering again; ¹⁰ Not purloining, but shewing all good fidelity; that they may adorn the doctrine of God our Saviour in all things. ¹¹ For the grace of God that bringeth salvation hath appeared to all men, ¹² Teaching us that, denying ungodliness and worldly lusts, we should live soberly, righteously, and godly, in this present world; ¹³ **Looking for that blessed hope, and the glorious appearing of the great God and our Saviour Jesus Christ;** ¹⁴ Who gave himself for us, that he might redeem us from all iniquity, and purify unto himself a peculiar people, zealous of good works. ¹⁵ These things speak, and exhort, and rebuke with all authority. Let no man despise thee.*

Explanation

This is the Second Coming of the Lord Jesus Christ, as the Messiah, to receive the Body of Believers. Upon His arrival, the receiving of His Church, the Messiah will first establish his earthly millennial kingdom. This is called the New Heaven and the New Earth. After the Millennial kingdom, very little is recorded, with the exception of Judgment Day for all unbelievers, along with the Devil and his demons, will suffer eternal

consequences, in the eternal lake of fire. This is recorded also as the second death for all who are not written in the Lambs Book of Life. **Titus 2:13**
Text:
I Thessalonians 1:10

1 Thessalonians 1

¹ Paul, and Silvanus, and Timotheus, unto the church of the Thessalonians which is in God the Father and in the Lord Jesus Christ: Grace be unto you, and peace, from God our Father, and the Lord Jesus Christ. ² We give thanks to God always for you all, making mention of you in our prayers; ³ Remembering without ceasing your work of faith, and labour of love, and patience of hope in our Lord Jesus Christ, in the sight of God and our Father; ⁴ Knowing, brethren beloved, your election of God. ⁵ For our gospel came not unto you in word only, but also in power, and in the Holy Ghost, and in much assurance; as ye know what manner of men we were among you for your sake. ⁶ And ye became followers of us, and of the Lord, having received the word in much affliction, with joy of the Holy Ghost. ⁷ So that ye were ensamples to all that believe in Macedonia and Achaia. ⁸ For from you sounded out the word of the Lord not only in Macedonia and Achaia, but also in every place your faith to God-ward is spread abroad; so that we need not to speak any thing. ⁹ For they themselves shew of us what manner of entering in we had unto you, and how ye turned to God from idols to serve the living and true God; **¹⁰ And to wait for his Son from heaven, whom he raised from the dead, even Jesus, which delivered us from the wrath to come.**

Explanation
We believe in the physical **resurrection** of all men. The believers are also known as the saints, to everlasting joy and peace, with God on the New Earth. St. Matthews 27:52), **I Thessalonians 1:10**
Also
Text
Revelations 20: 5-6, 15
Revelation 20
¹ And I saw an angel come down from heaven, having the key of the bottomless pit and a great chain in his hand. ² And he laid hold on the dragon, that old serpent, which is the Devil, and Satan, and bound him a thousand years, ³ And cast him into the bottomless pit, and shut him up, and set a seal upon him, that he should deceive the nations no more, till the thousand years should

be fulfilled: and after that he must be loosed a little season. *⁴ And I saw thrones, and they sat upon them, and judgment was given unto them: and I saw the souls of them that were beheaded for the witness of Jesus, and for the word of God, and which had not worshipped the beast, neither his image, neither had received his mark upon their foreheads, or in their hands; and they lived and reigned with Christ a thousand years. ⁵* **But the rest of the dead lived not again until the thousand years were finished. This is the first resurrection. ⁶ Blessed and holy is he that hath part in the first resurrection: on such the second death hath no power, but they shall be priests of God and of Christ, and shall reign with him a thousand years.** *⁷ And when the thousand years are expired, Satan shall be loosed out of his prison, ⁸ And shall go out to deceive the nations which are in the four quarters of the earth, Gog, and Magog, to gather them together to battle: the number of whom is as the sand of the sea. ⁹ And they went up on the breadth of the earth, and compassed the camp of the saints about, and the beloved city: and fire came down from God out of heaven, and devoured them. ¹⁰ And the devil that deceived them was cast into the lake of fire and brimstone, where the beast and the false prophet are, and shall be tormented day and night for ever and ever. ¹¹ And I saw a great white throne, and him that sat on it, from whose face the earth and the heaven fled away; and there was found no place for them. ¹² And I saw the dead, small and great, stand before God; and the books were opened: and another book was opened, which is the book of life: and the dead were judged out of those things which were written in the books, according to their works. ¹³ And the sea gave up the dead which were in it; and death and hell delivered up the dead which were in them: and they were judged every man according to their works. ¹⁴ And death and hell were cast into the lake of fire. This is the second death. ¹⁵* **And whosoever was not found written in the book of life was cast into the lake of fire.**

Explanation

The first resurrection is the Second Coming of the Lord Jesus Christ, Who comes to take the body of believers of all nationality and dominations, who have accepted the Lord Jesus Christ as their Personal Savior, and the Redeemer of their souls. The second resurrection, involves those who were left behind, who were not believers, and now, since they now believe, must get saved without the power of the Holy Spirit to assist them, which has now been lifted up off of the earth, with the believers, who are called the

first fruits of salvation. Therefore, they become martyrs for Christ, and will receive a martyr's crown, on the Day of Rejoicing. **Revelations 20: 5-6**

Also

Text
Revelation 20:15 (Refer to above full text)
And whosoever was not found written in the Book of Life was cast into the Lake of Fire.

Explanation

As previously stated, all unbelievers, along with the Devil and his demons, will suffer eternal consequences, in the eternal lake of fire. This is recorded also as the second death for all who are not written in the Lambs Book of Life. **Revelation 20:15**
Text
St. Luke 23:43

Luke 23

¹ And the whole multitude of them arose, and led him unto Pilate. ² And they began to accuse him, saying, We found this fellow perverting the nation, and forbidding to give tribute to Caesar, saying that he himself is Christ a King. ³ And Pilate asked him, saying, Art thou the King of the Jews? And he answered him and said, Thou sayest it. ⁴ Then said Pilate to the chief priests and to the people, I find no fault in this man. ⁵ And they were the more fierce, saying, He stirreth up the people, teaching throughout all Jewry, beginning from Galilee to this place. ⁶ When Pilate heard of Galilee, he asked whether the man were a Galilaean. ⁷ And as soon as he knew that he belonged unto Herod's jurisdiction, he sent him to Herod, who himself also was at Jerusalem at that time. ⁸ And when Herod saw Jesus, he was exceeding glad: for he was desirous to see him of a long season, because he had heard many things of him; and he hoped to have seen some miracle done by him. ⁹ Then he questioned with him in many words; but he answered him nothing. ¹⁰ And the chief priests and scribes stood and vehemently accused him. ¹¹ And Herod with his men of war set him at nought, and mocked him, and arrayed him in a gorgeous robe, and sent him

again to Pilate. *¹²* *And the same day Pilate and Herod were made friends together: for before they were at enmity between themselves.* *¹³* *And Pilate, when he had called together the chief priests and the rulers and the people,* *¹⁴* *Said unto them, Ye have brought this man unto me, as one that perverteth the people: and, behold, I, having examined him before you, have found no fault in this man touching those things whereof ye accuse him:* *¹⁵* *No, nor yet Herod: for I sent you to him; and, lo, nothing worthy of death is done unto him.* *¹⁶* *I will therefore chastise him, and release him.* *¹⁷* *(For of necessity he must release one unto them at the feast.)* *¹⁸* *And they cried out all at once, saying, Away with this man, and release unto us Barabbas:* *¹⁹* *(Who for a certain sedition made in the city, and for murder, was cast into prison.)* *²⁰* *Pilate therefore, willing to release Jesus, spake again to them.* *²¹* *But they cried, saying, Crucify him, crucify him.* *²²* *And he said unto them the third time, Why, what evil hath he done? I have found no cause of death in him: I will therefore chastise him, and let him go.* *²³* *And they were instant with loud voices, requiring that he might be crucified. And the voices of them and of the chief priests prevailed.* *²⁴* *And Pilate gave sentence that it should be as they required.* *²⁵* *And he released unto them him that for sedition and murder was cast into prison, whom they had desired; but he delivered Jesus to their will.* *²⁶* *And as they led him away, they laid hold upon one Simon, a Cyrenian, coming out of the country, and on him they laid the cross, that he might bear it after Jesus.* *²⁷* *And there followed him a great company of people, and of women, which also bewailed and lamented him.* *²⁸* *But Jesus turning unto them said, Daughters of Jerusalem, weep not for me, but weep for yourselves, and for your children.* *²⁹* *For, behold, the days are coming, in the which they shall say, Blessed are the barren, and the wombs that never bare, and the paps which never gave suck.* *³⁰* *Then shall they begin to say to the mountains, Fall on us; and to the hills, Cover us.* *³¹* *For if they do these things in a green tree, what shall be done in the dry?* *³²* *And there were also two other, malefactors, led with him to be put to death.* *³³* *And when they were come to the place, which is called Calvary, there they crucified him, and the malefactors, one on the right hand, and the other on the left.* *³⁴* *Then said Jesus, Father, forgive them; for they know not what they do. And they parted his raiment, and cast lots.* *³⁵* *And the people stood beholding. And the rulers also with them derided him, saying, He saved others; let him save himself, if he be Christ, the chosen of God.* *³⁶* *And the soldiers also mocked him, coming to him, and offering him vinegar,* *³⁷* *And saying, If thou be the king of the Jews, save thyself.* *³⁸* *And a superscription also was written over him in letters of Greek, and Latin, and Hebrew, THIS IS THE KING OF THE JEWS.* *³⁹*

And one of the malefactors which were hanged railed on him, saying, If thou be Christ, save thyself and us. ⁴⁰ But the other answering rebuked him, saying, Dost not thou fear God, seeing thou art in the same condemnation? ⁴¹ And we indeed justly; for we receive the due reward of our deeds: but this man hath done nothing amiss. **⁴² And he said unto Jesus, Lord, remember me when thou comest into thy kingdom. ⁴³ And Jesus said unto him, Verily I say unto thee, To day shalt thou be with me in paradise.** *⁴⁴ And it was about the sixth hour, and there was a darkness over all the earth until the ninth hour. ⁴⁵ And the sun was darkened, and the veil of the temple was rent in the midst. ⁴⁶ And when Jesus had cried with a loud voice, he said, Father, into thy hands I commend my spirit: and having said thus, he gave up the ghost. ⁴⁷ Now when the centurion saw what was done, he glorified God, saying, Certainly this was a righteous man. ⁴⁸ And all the people that came together to that sight, beholding the things which were done, smote their breasts, and returned. ⁴⁹ And all his acquaintance, and the women that followed him from Galilee, stood afar off, beholding these things. ⁵⁰ And, behold, there was a man named Joseph, a counsellor; and he was a good man, and a just: ⁵¹ (The same had not consented to the counsel and deed of them;) he was of Arimathaea, a city of the Jews: who also himself waited for the kingdom of God. ⁵² This man went unto Pilate, and begged the body of Jesus. ⁵³ And he took it down, and wrapped it in linen, and laid it in a sepulchre that was hewn in stone, wherein never man before was laid. ⁵⁴ And that day was the preparation, and the sabbath drew on. ⁵⁵ And the women also, which came with him from Galilee, followed after, and beheld the sepulchre, and how his body was laid. ⁵⁶ And they returned, and prepared spices and ointments; and rested the sabbath day according to the commandment.*

Explanation

We believe that the souls of believers are, at death, absent from the body and present with the Lord, where they await their resurrection when spirit, soul, and body are reunited to be glorified forever with the Lord as a celestial being, waiting in Paradise.**St. Luke 23:43**

Text

Revelation 20: 12-13 (Review full text prior to St. Luke)

¹² And I saw the dead, small and great, stand before God; and the books were opened: and another book was opened, which is the book of life: and the dead were judged out of those things which were written in the books, according to

their works. ¹³ And the sea gave up the dead which were in it; and death and hell delivered up the dead which were in them: and they were judged every man according to their works. ¹⁴ And death and hell were cast into the lake of fire. This is the second death. ¹⁵ And whosoever was not found written in the book of life was cast into the lake of fire.

Explanation

We believe that the souls of unbelievers remain, after death, in conscious misery until their resurrection when, with soul and body reunited. The unbelievers will then appear and be sentenced before, the Great White Throne judgment, wherein they shall be cast into the Lake of Fire to suffer everlasting punishment. **Revelation 20: 12-13**

Conclusion

All believers who are alive look for the Blessed Hope, which is the glorious appearing of the second coming of the Lord, God, Jesus Christ, for the lifting up of the body of believers.
Those who are ready will be caught up to be with Christ throughout all eternity
The Bible states that no one knows the day, or the hour, when the Son of man cometh, not even the Son of Man. (see Matthews 24:36).
The Blessed Hope is known as the second coming of the Lord.

Questions

What is the Blessed Hope?
_____The Second Coming of the Messiah
_____The glorious appearing of our Lord Jesus Christ, when He appears the second time for the body of believers
_____This is when the Word of God speaks that every eye shall see Him, as Christ, the King of all Kings and the Lord of all Lords
_____This will usher in the Great White Throne judgment for all unbelievers
_____This will also proceed with the 1000 Year Reign of Christ on the Earth, with the New Heaven and the New Earth, wherein the Devil and his demons are locked up for 1000 years

_____All of the above

What is the Book of Life?

_____It has the names of all believers, in Christ Jesus, our Redeemer written in it.

_____It represents the Word of God, for those who walk according to the Word of God

_____It is also called the Lamb**s** book of Life, symbolizing our Personal Savior

_____All of the above

And what happens to the souls of those who are found written in the Book of Life?

_____They possess the final stages of the gift of eternal life with God in the heavenlies

_____They live and reign with Christ during the millennium period of 1000 years on Earth

_____They live and reign with The Lamb of God forever.

_____All of the above

Does the Son of God, and or the Devil know when the Lord will return in the Second Coming, which is also called the first resurrection?

What happens to the souls of the unbelievers, who are not found written in the Book of Life?

_____They are pronounced judgment with the Devil and his messengers/assistants and demons

_____They are cast into the Lake of Fire for eternal torment

_____They are judged in the Great White Throne Judgment, according to their works of unrighteousness, prior to being sentence with the Devil and the demons that ruled for a short season

_____All of the above

Thought Question

How do you think we arrived from the made up compound term Blessed Hope. First determine what each term means separately, to obtain your answer. Both terms are stated in the Bible but not together.

Chapter 3

Week One: Review
Week Two: Open Book Test
Week Three: Review and Open Discussion of the Unit

Unit 2: The Gospel in a Nutshell
Practice for Review
And later
Unit Test
The Gospel

What is the Gospel in a Net shell?

The Four Gospels tell the Good News?

What is Grace?

_____Unmerited favor with God

_____Underserved favor with God

_____Being in the right standing with God, thereby counted righteous before God

_____All of the above

Name the four gospels and (4) things that each of them focus upon.

Four Gospels (4) things that each focus upon

The Blessed Hope

What is the Blessed Hope?

_____The Second Coming of the Messiah

_____The glorious appearing of our Lord Jesus Christ, when He appears the second time for the body of believers

_____This is when the Word of God speaks that every eye shall see Him

_____This will usher in the Great White Throne judgment for all believers

_____ This will also proceed with the 1000 Year Reign of Christ on the Earth, with the New Heaven and the New Earth, wherein the Devil and his demons are locked up for 1000 years

_____All of the above

What is the Book of Life?

_____The names of all believers, in Christ Jesus, our Redeemer

_____It represents the Word of God, for those who walk according to what it states

_____It is also called the Lambs book of Life, symbolizing our Personal Savior

_____All of the above

And what happens to the souls of those who are found written in the Book of Life?

_____They possess the final stages of the gift of eternal life with God in the heavenlies

_____They live and reign with Christ during the Millennium period of 1000 years on Earth

_____They live and reign with The Lamb of God forever

_____All of the above

Does the Son of God or the Devil know when the Lord will return in the Second Coming?

What happens to the souls of the unbelievers, who are not found written in the Book of Life?

_____They are pronounced judgment with the Devil and his messengers/ assistants and or demons

_____They are cast into the Lake of Fire for eternal torment

_____They are judged in the Great White Throne Judgment, according to their works of unrighteousness, prior to be sentence with the Devil and the demons that ruled for a short season

_____All of the above

UNIT THREE:
THE NEED FOR
SALVATION

Contents

Unit Introduction

Once we have been introduced to the Gospel, and we know the reason and the method for and of prayer, then we need to be aware of our need for salvation. This unit expounds upon why, as a result of one man, there is now a need for all mankind to be saved. God has no respect for person. All must be saved. It is with those thoughts that we present to you, *The Need for Salvation* . . .

The Need for Salvation: Salvation from the Creation to the Gentile Chapter 1

Text
Genesis 1: 26-27
Romans 3: 23
Ephesians 2:8-9
Romans 5:8-9
I Peter 2: 24

Introduction

In this lesson, we shall learn that as a result of the first Adams' disobedience to God, there was a need for a more excellent way. However, the way of redemption now for mankind, was through a once and for all sacrificial Lamb of God, necessary for the atonement for our sins, through the second Adam, the Lord Jesus Christ.

The Lesson
Humanity: God's creation of mankind

Text
Genesis 1: 26-27

Genesis 1

¹ In the beginning God created the heaven and the earth. ² And the earth was without form, and void; and darkness was upon the face of the deep. And the Spirit of God moved upon the face of the waters. ³ And God said, Let there be light: and there was light. ⁴ And God saw the light, that it was good: and God divided the light from the darkness. ⁵ And God called the light Day, and the darkness he called Night. And the evening and the morning were the first

day. *⁶ And God said, Let there be a firmament in the midst of the waters, and let it divide the waters from the waters. ⁷ And God made the firmament, and divided the waters which were under the firmament from the waters which were above the firmament: and it was so. ⁸ And God called the firmament Heaven. And the evening and the morning were the second day. ⁹ And God said, Let the waters under the heaven be gathered together unto one place, and let the dry land appear: and it was so. ¹⁰ And God called the dry land Earth; and the gathering together of the waters called he Seas: and God saw that it was good. ¹¹ And God said, Let the earth bring forth grass, the herb yielding seed, and the fruit tree yielding fruit after his kind, whose seed is in itself, upon the earth: and it was so. ¹² And the earth brought forth grass, and herb yielding seed after his kind, and the tree yielding fruit, whose seed was in itself, after his kind: and God saw that it was good. ¹³ And the evening and the morning were the third day. ¹⁴ And God said, Let there be lights in the firmament of the heaven to divide the day from the night; and let them be for signs, and for seasons, and for days, and years: ¹⁵ And let them be for lights in the firmament of the heaven to give light upon the earth: and it was so. ¹⁶ And God made two great lights; the greater light to rule the day, and the lesser light to rule the night: he made the stars also. ¹⁷ And God set them in the firmament of the heaven to give light upon the earth, ¹⁸ And to rule over the day and over the night, and to divide the light from the darkness: and God saw that it was good. ¹⁹ And the evening and the morning were the fourth day. ²⁰ And God said, Let the waters bring forth abundantly the moving creature that hath life, and fowl that may fly above the earth in the open firmament of heaven. ²¹ And God created great whales, and every living creature that moveth, which the waters brought forth abundantly, after their kind, and every winged fowl after his kind: and God saw that it was good. ²² And God blessed them, saying, Be fruitful, and multiply, and fill the waters in the seas, and let fowl multiply in the earth. ²³ And the evening and the morning were the fifth day. ²⁴ And God said, Let the earth bring forth the living creature after his kind, cattle, and creeping thing, and beast of the earth after his kind: and it was so. ²⁵ And God made the beast of the earth after his kind, and cattle after their kind, and every thing that creepeth upon the earth after his kind: and God saw that it was good.* **²⁶ And God said, Let us make man in our image, after our likeness: and let them have dominion over the fish of the sea, and over the fowl of the air, and over the cattle, and over all the earth, and over every creeping thing that creepeth upon the earth. ²⁷ So God created man in his own image, in the image of God created**

he him; male and female created he them. *²⁸* *And God blessed them, and God said unto them, Be fruitful, and multiply, and replenish the earth, and subdue it: and have dominion over the fish of the sea, and over the fowl of the air, and over every living thing that moveth upon the earth. ²⁹ And God said, Behold, I have given you every herb bearing seed, which is upon the face of all the earth, and every tree, in the which is the fruit of a tree yielding seed; to you it shall be for meat. ³⁰ And to every beast of the earth, and to every fowl of the air, and to every thing that creepeth upon the earth, wherein there is life, I have given every green herb for meat: and it was so. ³¹ And God saw every thing that he had made, and, behold, it was very good. And the evening and the morning were the sixth day.*

Explanation

We believe that humanity came into existence by creation through God's handy work, and that humanity is uniquely made in the image and likeness of God. Therefore, we have a God conscience, and a freedom of choice, knowing right and wrong, good and evil, even if it were not being put into use, as in the beginning of creation, Adam and Eve still possess the freedom of choice, and the knowledge of good and evil. **Genesis 1: 26-27**

Text

Romans 3: 23

Romans 3

¹ What advantage then hath the Jew? or what profit is there of circumcision? ² Much every way: chiefly, because that unto them were committed the oracles of God. ³ For what if some did not believe? shall their unbelief make the faith of God without effect? ⁴ God forbid: yea, let God be true, but every man a liar; as it is written, That thou mightest be justified in thy sayings, and mightest overcome when thou art judged. ⁵ But if our unrighteousness commend the righteousness of God, what shall we say? Is God unrighteous who taketh vengeance? (I speak as a man) ⁶ God forbid: for then how shall God judge the world? ⁷ For if the truth of God hath more abounded through my lie unto his glory; why yet am I also judged as a sinner? ⁸ And not rather, (as we be slanderously reported, and as some affirm that we say,) Let us do evil, that good may come? whose damnation is just. ⁹ What then? are we better than

*they? No, in no wise: for we have before proved both Jews and Gentiles, that they are all under sin; 10 As it is written, There is none righteous, no, not one: 11 There is none that understandeth, there is none that seeketh after God. 12 They are all gone out of the way, they are together become unprofitable; there is none that doeth good, no, not one. 13 Their throat is an open sepulchre; with their tongues they have used deceit; the poison of asps is under their lips: 14 Whose mouth is full of cursing and bitterness: 15 Their feet are swift to shed blood: 16 Destruction and misery are in their ways: 17 And the way of peace have they not known: 18 There is no fear of God before their eyes. 19 Now we know that what things soever the law saith, it saith to them who are under the law: that every mouth may be stopped, and all the world may become guilty before God. 20 Therefore by the deeds of the law there shall no flesh be justified in his sight: for by the law is the knowledge of sin. 21 But now the righteousness of God without the law is manifested, being witnessed by the law and the prophets; 22 Even the righteousness of God which is by faith of Jesus Christ unto all and upon all them that believe: for there is no difference: 23 **For all have sinned, and come short of the glory of God; 24 Being justified freely by his grace through the redemption that is in Christ Jesus:** 25 Whom God hath set forth to be a propitiation through faith in his blood, to declare his righteousness for the remission of sins that are past, through the forbearance of God; 26 To declare, I say, at this time his righteousness: that he might be just, and the justifier of him which believeth in Jesus. 27 Where is boasting then? It is excluded. By what law? of works? Nay: but by the law of faith. 28 Therefore we conclude that a man is justified by faith without the deeds of the law. 29 Is he the God of the Jews only? is he not also of the Gentiles? Yes, of the Gentiles also: 30 Seeing it is one God, which shall justify the circumcision by faith, and uncircumcision through faith. 31 Do we then make void the law through faith? God forbid: yea, we establish the law.*

Explanation

We believe that all humanity, because of Adam's fall, has inherited a sinful nature, that all human beings choose to sin. **Romans 3: 23**
Text
Romans 6: 23

Romans 6

¹ What shall we say then? Shall we continue in sin, that grace may abound? ² God forbid. How shall we, that are dead to sin, live any longer therein? ³ Know ye not, that so many of us as were baptized into Jesus Christ were baptized into his death? ⁴ Therefore we are buried with him by baptism into death: that like as Christ was raised up from the dead by the glory of the Father, even so we also should walk in newness of life. ⁵ For if we have been planted together in the likeness of his death, we shall be also in the likeness of his resurrection: ⁶ Knowing this, that our old man is crucified with him, that the body of sin might be destroyed, that henceforth we should not serve sin. ⁷ For he that is dead is freed from sin. ⁸ Now if we be dead with Christ, we believe that we shall also live with him: ⁹ Knowing that Christ being raised from the dead dieth no more; death hath no more dominion over him. ¹⁰ For in that he died, he died unto sin once: but in that he liveth, he liveth unto God. ¹¹ Likewise reckon ye also yourselves to be dead indeed unto sin, but alive unto God through Jesus Christ our Lord. ¹² Let not sin therefore reign in your mortal body, that ye should obey it in the lusts thereof. ¹³ Neither yield ye your members as instruments of unrighteousness unto sin: but yield yourselves unto God, as those that are alive from the dead, and your members as instruments of righteousness unto God. ¹⁴ For sin shall not have dominion over you: for ye are not under the law, but under grace. ¹⁵ What then? shall we sin, because we are not under the law, but under grace? God forbid. ¹⁶ Know ye not, that to whom ye yield yourselves servants to obey, his servants ye are to whom ye obey; whether of sin unto death, or of obedience unto righteousness? ¹⁷ But God be thanked, that ye were the servants of sin, but ye have obeyed from the heart that form of doctrine which was delivered you. ¹⁸ Being then made free from sin, ye became the servants of righteousness. ¹⁹ I speak after the manner of men because of the infirmity of your flesh: for as ye have yielded your members servants to uncleanness and to iniquity unto iniquity; even so now yield your members servants to righteousness unto holiness. ²⁰ For when ye were the servants of sin, ye were free from righteousness. ²¹ What fruit had ye then in those things whereof ye are now ashamed? for the end of those things is death. ²² But now being made free from sin, and become servants to God, ye have your fruit unto holiness, and the end everlasting life. **²³ For the wages of sin is death; but the gift of God is eternal life through Jesus Christ our Lord.**

Explanation

All sin separates mankind from being in communion with God. Humanity is therefore unable to remedy this fallen state of broken fellowship with God. **Romans 6: 23**
Salvation: To all mankind, to the Jew and also to the Gentile
Text
Ephesians 2:8-9

Ephesians 2

[1] And you hath he quickened, who were dead in trespasses and sins; [2] Wherein in time past ye walked according to the course of this world, according to the prince of the power of the air, the spirit that now worketh in the children of disobedience: [3] Among whom also we all had our conversation in times past in the lusts of our flesh, fulfilling the desires of the flesh and of the mind; and were by nature the children of wrath, even as others. [4] But God, who is rich in mercy, for his great love wherewith he loved us, [5] Even when we were dead in sins, hath quickened us together with Christ, (by grace ye are saved;) [6] And hath raised us up together, and made us sit together in heavenly places in Christ Jesus: [7] That in the ages to come he might shew the exceeding riches of his grace in his kindness toward us through Christ Jesus. **[8] For by grace are ye saved through faith; and that not of yourselves: it is the gift of God: [9] Not of works, lest any man should boast.** *[10] For we are his workmanship, created in Christ Jesus unto good works, which God hath before ordained that we should walk in them. [11] Wherefore remember, that ye being in time past Gentiles in the flesh, who are called Uncircumcision by that which is called the Circumcision in the flesh made by hands; [12] That at that time ye were without Christ, being aliens from the commonwealth of Israel, and strangers from the covenants of promise, having no hope, and without God in the world: [13] But now in Christ Jesus ye who sometimes were far off are made nigh by the blood of Christ. [14] For he is our peace, who hath made both one, and hath broken down the middle wall of partition between us; [15] Having abolished in his flesh the enmity, even the law of commandments contained in ordinances; for to make in himself of twain one new man, so making peace; [16] And that he might reconcile both unto God in one body by the cross, having slain the enmity thereby: [17] And came and preached peace to you which were afar off, and to them that were nigh. [18] For through him we both have access by one Spirit*

unto the Father. [19] *Now therefore ye are no more strangers and foreigners, but fellowcitizens with the saints, and of the household of God;* [20] *And are built upon the foundation of the apostles and prophets, Jesus Christ himself being the chief corner stone;* [21] *In whom all the building fitly framed together groweth unto an holy temple in the Lord:* [22] *In whom ye also are builded together for an habitation of God through the Spirit.*

Explanation

We believe that salvation is a gift of God's grace through faith in the finished work of Jesus Christ on the cross. **Ephesians 2:8-9**
Text
Romans 5:8-9

Romans 5

[1] *Therefore being justified by faith, we have peace with God through our Lord Jesus Christ:* [2] *By whom also we have access by faith into this grace wherein we stand, and rejoice in hope of the glory of God.* [3] *And not only so, but we glory in tribulations also: knowing that tribulation worketh patience;* [4] *And patience, experience; and experience, hope:* [5] *And hope maketh not ashamed; because the love of God is shed abroad in our hearts by the Holy Ghost which is given unto us.* [6] *For when we were yet without strength, in due time Christ died for the ungodly.* [7] *For scarcely for a righteous man will one die: yet peradventure for a good man some would even dare to die.* [8] ***But God commendeth his love toward us, in that, while we were yet sinners, Christ died for us.*** [9] ***Much more then, being now justified by his blood, we shall be saved from wrath through him.*** [10] *For if, when we were enemies, we were reconciled to God by the death of his Son, much more, being reconciled, we shall be saved by his life.* [11] *And not only so, but we also joy in God through our Lord Jesus Christ, by whom we have now received the atonement.* [12] *Wherefore, as by one man sin entered into the world, and death by sin; and so death passed upon all men, for that all have sinned:* [13] *(For until the law sin was in the world: but sin is not imputed when there is no law.* [14] *Nevertheless death reigned from Adam to Moses, even over them that had not sinned after the similitude of Adam's transgression, who is the figure of him that was to come.* [15] *But not as the offence, so also is the free gift. For if through the offence of one many be dead, much more the grace of God, and the gift by grace, which is by one*

man, Jesus Christ, hath abounded unto many. *¹⁶ And not as it was by one that sinned, so is the gift: for the judgment was by one to condemnation, but the free gift is of many offences unto justification. ¹⁷ For if by one man's offence death reigned by one; much more they which receive abundance of grace and of the gift of righteousness shall reign in life by one, Jesus Christ.) ¹⁸ Therefore as by the offence of one judgment came upon all men to condemnation; even so by the righteousness of one the free gift came upon all men unto justification of life. ¹⁹ For as by one man's disobedience many were made sinners, so by the obedience of one shall many be made righteous. ²⁰ Moreover the law entered, that the offence might abound. But where sin abounded, grace did much more abound: ²¹ That as sin hath reigned unto death, even so might grace reign through righteousness unto eternal life by Jesus Christ our Lord.*

Explanation

Christ's death fully accomplished justification through faith and redemption from sin.

Christ died in our place. **Romans 5:8-9**

Text

I Peter 2: 24

1 Peter 2

¹ Wherefore laying aside all malice, and all guile, and hypocrisies, and envies, all evil speakings, ² As newborn babes, desire the sincere milk of the word, that ye may grow thereby: ³ If so be ye have tasted that the Lord is gracious. ⁴ To whom coming, as unto a living stone, disallowed indeed of men, but chosen of God, and precious, ⁵ Ye also, as lively stones, are built up a spiritual house, an holy priesthood, to offer up spiritual sacrifices, acceptable to God by Jesus Christ. ⁶ Wherefore also it is contained in the scripture, Behold, I lay in Sion a chief corner stone, elect, precious: and he that believeth on him shall not be confounded. ⁷ Unto you therefore which believe he is precious: but unto them which be disobedient, the stone which the builders disallowed, the same is made the head of the corner, ⁸ And a stone of stumbling, and a rock of offence, even to them which stumble at the word, being disobedient: whereunto also they were appointed. ⁹ But ye are a chosen generation, a royal priesthood, an holy nation, a peculiar people; that ye should shew forth the praises of him who hath called you out of darkness into his marvellous light; ¹⁰ Which in

time past were not a people, but are now the people of God: which had not obtained mercy, but now have obtained mercy. [11] Dearly beloved, I beseech you as strangers and pilgrims, abstain from fleshly lusts, which war against the soul; [12] Having your conversation honest among the Gentiles: that, whereas they speak against you as evildoers, they may by your good works, which they shall behold, glorify God in the day of visitation. [13] Submit yourselves to every ordinance of man for the Lord's sake: whether it be to the king, as supreme; [14] Or unto governors, as unto them that are sent by him for the punishment of evildoers, and for the praise of them that do well. [15] For so is the will of God, that with well doing ye may put to silence the ignorance of foolish men: [16] As free, and not using your liberty for a cloke of maliciousness, but as the servants of God. [17] Honour all men. Love the brotherhood. Fear God. Honour the king. [18] Servants, be subject to your masters with all fear; not only to the good and gentle, but also to the froward. [19] For this is thankworthy, if a man for conscience toward God endure grief, suffering wrongfully. [20] For what glory is it, if, when ye be buffeted for your faults, ye shall take it patiently? but if, when ye do well, and suffer for it, ye take it patiently, this is acceptable with God. [21] For even hereunto were ye called: because Christ also suffered for us, leaving us an example, that ye should follow his steps: [22] Who did no sin, neither was guile found in his mouth: [23] Who, when he was reviled, reviled not again; when he suffered, he threatened not; but committed himself to him that judgeth righteously: [24] **Who his own self bare our sins in his own body on the tree, that we, being dead to sins, should live unto righteousness: by whose stripes ye were healed.** [25] For ye were as sheep going astray; but are now returned unto the Shepherd and Bishop of your souls.

Explanation

Christ, bore our sins in His own body. **I Peter 2: 24**

Conclusion

- All have a need for salvation, resulting from the first Adam's failure to obey God.
- Whether, we are Hebrew or Jewish, who are God's first to be chosen into the Kingdom of God or second, salvation becomes a gift from God to all mankind.

- Salvation was first a means of redemption for the Jews first, or the Hebrew Nation, descendents of Jacob or Israel, the father of the twelve tribes of Israel, who are the descendents from Jacobs' twelve sons to this day.
- Salvation was next offered to the Gentile Nations, who are all who are not of the Hebrew decent.

Questions

True or False

_____Man was made in the image and likeness of God

_____Man was therefore made with a conscience, which is in the image and likeness of God, of which he experience after committing sin

_____Man was made with free will, therefore being in the image and likeness of God

_____While we were yet sinners, Christ died for us and became our Redeemer, Personal Savior, and the Mediator, between God and man

_____Romans 6: 23, refers to death as being eternal separation from God, if studied and applied thoroughly.

_____Salvation is a gift of God's Grace, through Faith

_____Ephesians 2:8 & 9, states that we can get saved, by doing good deeds

Thought Question

Why do you think God made us from the beginning with the ability to have the freedom of choice?

Salvation
The Penalty and Judgment
Chapter 2

Text
Romans 3: 23 (See chapter text in previous chapter)
Romans 6: 23 (See chapter text in previous chapter)
Hebrews 9: 27, 28
Ephesians 2: 8 & 9 (See chapter text in previous chapter)
St. John 3: 16, 17
Romans 10: 9, 10

Introduction

In this segment we shall discover the need and purpose for salvation. In addition, we shall also come to realize that there are three tenses to salvation, past, present, and future. We shall discover that there is only one way to be saved. We will come to know the entrance to salvation is through one, as the passage to sin, was through one.

The Lesson
What Is Salvation and it's Need

Text
Romans 6:23: (Previous chapter, full text)
For the wages of sin is death; but the gift of God is eternal life through Jesus Christ our Lord.

Explanation

Death refers to eternal separation from God, in the Lake of Fire
Text
Romans 3:23 (Previous chapter, full text)

For all have sinned and come short of the Glory of God.

Explanation

All of mankind are sinners, resulting from all coming from the blood line of the first Adam, who disobeyed God. As a result, all have sinned. **Read Romans 5:14; 6:23**
Text
Hebrews 9: 27, 28

Hebrews 9

[1] Then verily the first covenant had also ordinances of divine service, and a worldly sanctuary. [2] For there was a tabernacle made; the first, wherein was the candlestick, and the table, and the shewbread; which is called the sanctuary. [3] And after the second veil, the tabernacle which is called the Holiest of all; [4] Which had the golden censer, and the ark of the covenant overlaid round about with gold, wherein was the golden pot that had manna, and Aaron's rod that budded, and the tables of the covenant; [5] And over it the cherubims of glory shadowing the mercyseat; of which we cannot now speak particularly. [6] Now when these things were thus ordained, the priests went always into the first tabernacle, accomplishing the service of God. [7] But into the second went the high priest alone once every year, not without blood, which he offered for himself, and for the errors of the people: [8] The Holy Ghost this signifying, that the way into the holiest of all was not yet made manifest, while as the first tabernacle was yet standing: [9] Which was a figure for the time then present, in which were offered both gifts and sacrifices, that could not make him that did the service perfect, as pertaining to the conscience; [10] Which stood only in meats and drinks, and divers washings, and carnal ordinances, imposed on them until the time of reformation. [11] But Christ being come an high priest of good things to come, by a greater and more perfect tabernacle, not made with hands, that is to say, not of this building; [12] Neither by the blood of goats and calves, but by his own blood he entered in once into the holy place, having obtained eternal redemption for us. [13] For if the blood of bulls and of goats, and the ashes of an heifer sprinkling the unclean, sanctifieth to the purifying of the flesh: [14] How much more shall the blood of Christ, who through the eternal Spirit offered himself without spot to God, purge your conscience from dead works to serve the living God? [15] And for this cause he is the mediator of the new

testament, that by means of death, for the redemption of the transgressions that were under the first testament, they which are called might receive the promise of eternal inheritance. ¹⁶ For where a testament is, there must also of necessity be the death of the testator. ¹⁷ For a testament is of force after men are dead: otherwise it is of no strength at all while the testator liveth. ¹⁸ Whereupon neither the first testament was dedicated without blood. ¹⁹ For when Moses had spoken every precept to all the people according to the law, he took the blood of calves and of goats, with water, and scarlet wool, and hyssop, and sprinkled both the book, and all the people, ²⁰ Saying, This is the blood of the testament which God hath enjoined unto you. ²¹ Moreover he sprinkled with blood both the tabernacle, and all the vessels of the ministry. ²² And almost all things are by the law purged with blood; and without shedding of blood is no remission. ²³ It was therefore necessary that the patterns of things in the heavens should be purified with these; but the heavenly things themselves with better sacrifices than these. ²⁴ For Christ is not entered into the holy places made with hands, which are the figures of the true; but into heaven itself, now to appear in the presence of God for us: ²⁵ Nor yet that he should offer himself often, as the high priest entereth into the holy place every year with blood of others; ²⁶ For then must he often have suffered since the foundation of the world: but now once in the end of the world hath he appeared to put away sin by the sacrifice of himself. ²⁷ **And as it is appointed unto men once to die, but after this the judgment: ²⁸ So Christ was once offered to bear the sins of many; and unto them that look for him shall he appear the second time without sin unto salvation.**

Explanation

Those who are not saved from their sins, and have the Lord Jesus Christ as their Personal Savior, will have the **penalty** of death, and judgment, resulting in **damnation** of their souls (Revelations 21:8).Christ was here the first time in the form of a man. (St. John 1: 14-15) The second time, all who sees Him, will know that He is the **Son of God.** So how do we get saved? **Hebrews 9: 27, 28**

Text

Ephesians 2:8-9 (See chapter 1, full text)

Explanation

Therefore: We are saved By Grace through the Lord Jesus Christ. We accept Him into our heart, realizing that we are sinners, lost without Christ. We need to be saved or redeemed which is defined as being brought back into fellowship with Christ, through believing that He is the once and for all sacrificial Lamb of God, who takes away the sins of the world that St. John saw. He did not see his biological cousin, He saw the Son of God, coming in the form of a man. St. John 1; **Ephesians 2:8-9**
Text
St. Johns 3:16, 17

John 3

*¹ There was a man of the Pharisees, named Nicodemus, a ruler of the Jews: ² The same came to Jesus by night, and said unto him, Rabbi, we know that thou art a teacher come from God: for no man can do these miracles that thou doest, except God be with him. ³ Jesus answered and said unto him, Verily, verily, I say unto thee, Except a man be born again, he cannot see the kingdom of God. ⁴ Nicodemus saith unto him, How can a man be born when he is old? can he enter the second time into his mother's womb, and be born? ⁵ Jesus answered, Verily, verily, I say unto thee, Except a man be born of water and of the Spirit, he cannot enter into the kingdom of God. ⁶ That which is born of the flesh is flesh; and that which is born of the Spirit is spirit. ⁷ Marvel not that I said unto thee, Ye must be born again. ⁸ The wind bloweth where it listeth, and thou hearest the sound thereof, but canst not tell whence it cometh, and whither it goeth: so is every one that is born of the Spirit. ⁹ Nicodemus answered and said unto him, How can these things be? ¹⁰ Jesus answered and said unto him, Art thou a master of Israel, and knowest not these things? ¹¹ Verily, verily, I say unto thee, We speak that we do know, and testify that we have seen; and ye receive not our witness. ¹² If I have told you earthly things, and ye believe not, how shall ye believe, if I tell you of heavenly things? ¹³ And no man hath ascended up to heaven, but he that came down from heaven, even the Son of man which is in heaven. ¹⁴ And as Moses lifted up the serpent in the wilderness, even so must the Son of man be lifted up: ¹⁵ That whosoever believeth in him should not perish, but have eternal life. ¹⁶ **For God so loved the world, that he gave his only begotten Son, that whosoever believeth in him should not perish, but have everlasting life. ¹⁷ For God sent***

not his Son into the world to condemn the world; but that the world through him might be saved. *[18] He that believeth on him is not condemned: but he that believeth not is condemned already, because he hath not believed in the name of the only begotten Son of God. [19] And this is the condemnation, that light is come into the world, and men loved darkness rather than light, because their deeds were evil. [20] For every one that doeth evil hateth the light, neither cometh to the light, lest his deeds should be reproved. [21] But he that doeth truth cometh to the light, that his deeds may be made manifest, that they are wrought in God. [22] After these things came Jesus and his disciples into the land of Judaea; and there he tarried with them, and baptized. [23] And John also was baptizing in Aenon near to Salim, because there was much water there: and they came, and were baptized. [24] For John was not yet cast into prison. [25] Then there arose a question between some of John's disciples and the Jews about purifying. [26] And they came unto John, and said unto him, Rabbi, he that was with thee beyond Jordan, to whom thou barest witness, behold, the same baptizeth, and all men come to him. [27] John answered and said, A man can receive nothing, except it be given him from heaven. [28] Ye yourselves bear me witness, that I said, I am not the Christ, but that I am sent before him. [29] He that hath the bride is the bridegroom: but the friend of the bridegroom, which standeth and heareth him, rejoiceth greatly because of the bridegroom's voice: this my joy therefore is fulfilled. [30] He must increase, but I must decrease. [31] He that cometh from above is above all: he that is of the earth is earthly, and speaketh of the earth: he that cometh from heaven is above all. [32] And what he hath seen and heard, that he testifieth; and no man receiveth his testimony. [33] He that hath received his testimony hath set to his seal that God is true. [34] For he whom God hath sent speaketh the words of God: for God giveth not the Spirit by measure unto him. [35] The Father loveth the Son, and hath given all things into his hand. [36] He that believeth on the Son hath everlasting life: and he that believeth not the Son shall not see life; but the wrath of God abideth on him.*

Explanation

This is the gift of everlasting life, described as being born again, this time spiritually, for the carnal man cannot please God, only when we are in tune to the Spirit of God, which can only be achieved through acceptance of Grace through redemptive works of Christ, placing us back into fellowship with God, as previously in the Garden of Eden in innocence. Everlasting

life refers to having in its true form, the gift of immortality with God, in heavenly places. Perish refers to the penalty and destination for all sinners, who are those who are lost, without Christ. **St. Johns 3:16, 17**
Text
Romans 10:9 & 10

Romans 10

¹ Brethren, my heart's desire and prayer to God for Israel is, that they might be saved. ² For I bear them record that they have a zeal of God, but not according to knowledge. ³ For they being ignorant of God's righteousness, and going about to establish their own righteousness, have not submitted themselves unto the righteousness of God. ⁴ For Christ is the end of the law for righteousness to every one that believeth. ⁵ For Moses describeth the righteousness which is of the law, That the man which doeth those things shall live by them. ⁶ But the righteousness which is of faith speaketh on this wise, Say not in thine heart, Who shall ascend into heaven? (that is, to bring Christ down from above:) ⁷ Or, Who shall descend into the deep? (that is, to bring up Christ again from the dead.) ⁸ But what saith it? The word is nigh thee, even in thy mouth, and in thy heart: that is, the word of faith, which we preach; ⁹ ***That if thou shalt confess with thy mouth the Lord Jesus, and shalt believe in thine heart that God hath raised him from the dead, thou shalt be saved.*** *¹⁰* ***For with the heart man believeth unto righteousness; and with the mouth confession is made unto salvation.*** *¹¹ For the scripture saith, Whosoever believeth on him shall not be ashamed. ¹² For there is no difference between the Jew and the Greek: for the same Lord over all is rich unto all that call upon him. ¹³ For whosoever shall call upon the name of the Lord shall be saved. ¹⁴ How then shall they call on him in whom they have not believed? and how shall they believe in him of whom they have not heard? and how shall they hear without a preacher? ¹⁵ And how shall they preach, except they be sent? as it is written, How beautiful are the feet of them that preach the gospel of peace, and bring glad tidings of good things! ¹⁶ But they have not all obeyed the gospel. For Esaias saith, Lord, who hath believed our report? ¹⁷ So then faith cometh by hearing, and hearing by the word of God. ¹⁸ But I say, Have they not heard? Yes verily, their sound went into all the earth, and their words unto the ends of the world. ¹⁹ But I say, Did not Israel know? First Moses saith, I will provoke you to jealousy by them that are no people, and by a foolish nation I will anger you. ²⁰ But Esaias is very bold, and saith, I was found of them that sought me*

not; I was made manifest unto them that asked not after me. [21] But to Israel he saith, All day long I have stretched forth my hands unto a disobedient and gainsaying people.

Explanation

Confession refers to not only believing, but repenting with the heart. Therefore, we have a change of heart. So, we have past from death unto life eternal in the heavens with the heavenly host. So be godly sorry and ask for forgiveness, of all sins, past and present. **Romans 10:9, 10**

Conclusion

* When we confess our sins to our Redeemer, we are stating that we believe in the power of the Lord Jesus Christ, as our Redeemer.
* Accepting salvation means that we believe that The Lord Jesus Christ paid the penalty for our sins, and redeemed us through His death, burial and resurrection, and ascension to eternal glory.
* Through salvation, Christ is our Day Star, and becomes our Personal Savior.

Questions

What is the one thing that we are appointed to do, if we do not accept Christ into our hearts, souls and minds, through repentance? Provide the scripture.

What does it imply to believe on the Lord Jesus Christ, and you will be saved? Provide scripture.

What type of assurance do we have, when we take on the gift of eternal life? Provide scripture.

Thought Question

What do you think will happen to your soul, the spirit of man that lives on forever, as your personality and identity that links your spirit with God, when, and if you should die, before the Messiah's return? What did He say to the thief on the cross, who got saved and was about to die. St. Luke 23:43.

Chapter 3

Week One: Review
Week Two: Open Book Test
Week Three: Review and Open Discussion of the Unit

Unit Three: The Need for Salvation
Practice for Review
And later
Unit Test
The Need for Salvation:
From the Creation to the Gentiles

True or False

_____Man was made in the image and likeness of God

_____Man was therefore made with a conscience, which is in the image and likeness of God, of which he experience after committing sin

_____Man was made with free will, therefore being in the image and likeness of God

_____While we are yet sinners, Christ died for us and became our Redeemer, Personal Savior, and the Mediator, between God and man

_____Romans 6: 23 refers to death as being eternal separation from God, if studied and applied thoroughly

_____Salvation is a gift of God's Grace, through Faith

_____Ephesians 2:8 & 9 states that we can get saved, by doing good deeds

The Need for Salvation:
The Penalty and Judgment

What is the one thing that we are appointed to do, if we do not accept Christ into our hearts, souls and minds, through repentance? Provide scripture.

What does it imply to believe on the Lord Jesus Christ, and we will be saved? Provide scripture.

What type of assurance do we have, when we take on the gift of eternal life? Provide scripture.

UNIT FOUR: SALVATION, PAST, PRESENT AND FUTURE

Contents

Unit Introduction

So now we have learned the need for salvation. We have learned that it is through the Gospel that we know and speak of Salvation. We also know that as a result of the manifest of the Gospel, it's purpose is to draw men, women, boys and girls into a saving knowledge of the Lord Jesus Christ as our Personal Savior and Redeemer, through the confession and acknowledgement, through Prayer.So with that in mind, therein lies the question of exactly what does it mean to be saved. We have learned the need in the previous unit. Now is this a quick fix, and remedy. In this unit, we shall discuss the meaning of salvation. We shall discover that it is not a quick fix. We shall discover that salvation begins with us and continues throughout our life time, until That Which Is Perfect shall come. So with that in mind, we present to you, ***Salvation, Past, Present, and Future*** . . .

Salvation Past
Have Been Saved From
Chapter 1

Text
Romans 6:23 (See previous unit, chapter 1 for scripture text)
Romans 3:23 (See previous unit, chapter for 1 scripture text)
Hebrews 9:27, 28 (See previous unit, chapter 2 for scripture text)
Ephesians 2:8, 9(See previous unit, chapter 1 for scripture text)
Saint Johns 3:16, 17 (See previous unit, chapter 2 for scripture text)
Romans 10:9,10 (See previous unit, chapter 2 for scripture text)

Introduction

Salvation is a process. It has a past, present and a future. We, as believers are not fully saved until we have endured to the very end, upon the Messiah's return. In this lesson, we shall learn from these three tenses of salvation, past, present and future, and what they actually mean. In this lesson we shall talk on salvation past. Past: Saved From In salvation past, believers are saved from the penalty of sin. Being saved from the penalty of sin is defined as eternal death, damnation in the lake of fire. However, the following is a summary of all tenses for review:

Tenses	Definition	Scripture
Salvation: Past	Saved from the penalty of sin.	Romans 6:23
Salvation: Present	Saved from the guilt of sin.	I John 1:9
Salvation: Future	Saved from the presence of sin.	I Corinthians 15: 51-58 I Thessalonians 4:13-18

The Lesson

Text
Romans 6:23 (Unit 3, chapter 1, full text)
For the wages of sin is death; but the gift of God is eternal life through Jesus Christ our Lord

Explanation

Death refers to **eternal separation** from God, in the Lake of Fire.
Revelations 21:8;
Romans 6:23
Text
Romans 3:23 (Unit 3, chapter 1, full text)
For all have sinned, and come short of the glory of God

Explanation

All of mankind are sinners, resulting from all of us coming from the blood line of Adam, who disobeyed God. As a result, all of us are sinners.
Romans 5:14; Romans 3:23
Text
Hebrews 9:27& 28 (Unit 3, chapter 2, full text)
[27] And as it is appointed unto men once to die, but after this the judgment: [28] So Christ was once offered to bear the sins of many; and unto them that look for him shall he appear the second time without sin unto salvation.

Explanation

Those who are not saved from their sins, and have the Lord Jesus Christ as their Personal Savior, will have the **penalty** of death, and judgment, resulting in damnation of their souls (Revelations 21:8). Christ was here the first time in the form of a **man**. (St. John 1: 14-15) During his second coming all who see Him, will know that He is the Son of God.
Hebrews 9:27& 28

So how do we get saved?

Text
Ephesians 2:8 & 9 (Unit 3, chapter 1, full text)
⁸ For by grace are ye saved through faith; and that not of yourselves: it is the gift of God: ⁹ Not of works, lest any man should boast.

Explanation

Therefore: We are saved by Grace, through the Lord Jesus Christ. We accept Him into our heart, realizing that we are sinners, lost without Christ. We need to be saved or redeemed which is defined as being brought back into fellowship with Christ, through believing that He is the once and for all sacrificial Lamb of God, who takes away the sins of the world that St. John saw. He did not see his biological cousin, He saw the Son of God, coming in the form of a man. **St. John 1; Ephesians 2:8 & 9**
Text
Saint Johns 3:16 & 17 (Unit 3, chapter 2 full text)

John 3

¹⁶ For God so loved the world, that he gave his only begotten Son, that whosoever believeth in him should not perish, but have everlasting life. ¹⁷ For God sent not his Son into the world to condemn the world; but that the world through him might be saved.

Explanation

Everlasting life refers to having in its true form, the gift of immortality with God, in heavenly places. Perish refers to the penalty and destination for all sinners, who are those who are lost, without Christ. **St. Johns 3:16 & 17**
Text
Romans 10:9 & 10 (Unit 3, chapter 2 full text)
⁹ That if thou shalt confess with thy mouth the Lord Jesus, and shalt believe in thine heart that God hath raised him from the dead, thou shalt be saved. ¹⁰ For with the heart man believeth unto righteousness; and with the mouth confession is made unto salvation.

Explanation

Confession refers to not only believing, but repenting with the heart. Therefore, we have a change of heart. So, we have past from death unto life eternal in the heavens with the heavenly host. So be godly sorry and ask for forgiveness, of all sins, past and present. **Romans 10:9 & 10**

Conclusion

- As we take on the gift of everlasting life, we are saved from the penalty of sin, which is eternal separation from the Lord.
- The separation goes further, consisting of eternal punishment in the lake of fire, prepared for the devil and his angels.
- Therefore, there is a two fold consequence.
- When, we accept Christ into our heart, as our Personal Savior, we are acknowledging that we are a sinner, lost without Christ in need of a Redeemer.
- We have been saved from the penalty of sin.

Questions

Salvation is a process, consisting of (3) levels or tenses to salvation. Complete the three tenses or phases to salvation. Also, provide scripture and definition.

Tenses/Phases	Definition	Scripture

Salvation:

Salvation:

Salvation:

List three things that Adam did in disobedience to God in the Garden, which resulted in sin.

As a result of Adam disobeying God, we read on to find there is now broken fellowship between God and man, in Genesis 2. Now, there is a need for mankind to be brought back into right standing with God, which defines redemption. List three ways that define the broken fellowship.

What does it mean to confess our sins?

_____ Ask God to forgive us from our sins

_____ Believe that Christ died, was buried and rose again for our redemption, taking our place on the Cross

_____ Realizing that we are a sinner lost without Christ

_____ All of the above

Thought Question

Where will you spend eternity? Why?

Salvation: Present
Are Being Saved From
Chapter 2

Text
1 John 1:9& 10
1 John 2:1 & 2

Introduction

Salvation: It is a process, Past, Present and Future. In this lesson, we shall expound upon salvation present. Present: We are saved from the guilt of sin, assuming that one has a conscience. We are saved daily, by confessing our sins daily to God **and man,** when applicable, before the close of the day However, here is a summary of all of the tenses to take note:

Tenses	Definition	Scripture
Salvation:	Past Saved from the penalty of sin.	Romans 6:23
Salvation:	Present Saved from the guilt of sin.	I John 1:9
Salvation:	Future Saved from the presence of sin.	I Corinthians 15: 51-58 I Thessalonians 4:13-18

The Lesson

Text
1 John 1:9, 10

1 John 1

¹ That which was from the beginning, which we have heard, which we have seen with our eyes, which we have looked upon, and our hands have handled,

of the Word of life; ² *(For the life was manifested, and we have seen it, and bear witness, and shew unto you that eternal life, which was with the Father, and was manifested unto us;)* ³ *That which we have seen and heard declare we unto you, that ye also may have fellowship with us: and truly our fellowship is with the Father, and with his Son Jesus Christ.* ⁴ *And these things write we unto you, that your joy may be full.* ⁵ *This then is the message which we have heard of him, and declare unto you, that God is light, and in him is no darkness at all.* ⁶ *If we say that we have fellowship with him, and walk in darkness, we lie, and do not the truth:* ⁷ *But if we walk in the light, as he is in the light, we have fellowship one with another, and the blood of Jesus Christ his Son cleanseth us from all sin.* ⁸ *If we say that we have no sin, we deceive ourselves, and the truth is not in us.* ⁹ ***If we confess our sins, he is faithful and just to forgive us our sins, and to cleanse us from all unrighteousness.*** ¹⁰ ***If we say that we have not sinned, we make him a liar, and his word is not in us.***

Explanation

All believers need to confess and ask for God and man's forgiveness, when ever it is applicable, DAILY. Then and only then will we not be, and or feel guilty at the close of the day. **1 John 1:9, 10**
Text
1John 2:1, 2

1 John 2

¹ ***My little children, these things write I unto you, that ye sin not. And if any man sin, we have an advocate with the Father, Jesus Christ the righteous:*** ² ***And he is the propitiation for our sins: and not for our's only, but also for the sins of the whole world.*** ³ *And hereby we do know that we know him, if we keep his commandments.* ⁴ *He that saith, I know him, and keepeth not his commandments, is a liar, and the truth is not in him.* ⁵ *But whoso keepeth his word, in him verily is the love of God perfected: hereby know we that we are in him.* ⁶ *He that saith he abideth in him ought himself also so to walk, even as he walked.* ⁷ *Brethren, I write no new commandment unto you, but an old commandment which ye had from the beginning. The old commandment is the word which ye have heard from the beginning.* ⁸ *Again, a new commandment I write unto you, which thing is true in him and in you: because the darkness is past, and the true light now shineth.* ⁹ *He that*

saith he is in the light, and hateth his brother, is in darkness even until now. ¹⁰ He that loveth his brother abideth in the light, and there is none occasion of stumbling in him. ¹¹ But he that hateth his brother is in darkness, and walketh in darkness, and knoweth not whither he goeth, because that darkness hath blinded his eyes. ¹² I write unto you, little children, because your sins are forgiven you for his name's sake. ¹³ I write unto you, fathers, because ye have known him that is from the beginning. I write unto you, young men, because ye have overcome the wicked one. I write unto you, little children, because ye have known the Father. ¹⁴ I have written unto you, fathers, because ye have known him that is from the beginning. I have written unto you, young men, because ye are strong, and the word of God abideth in you, and ye have overcome the wicked one. ¹⁵ Love not the world, neither the things that are in the world. If any man love the world, the love of the Father is not in him. ¹⁶ For all that is in the world, the lust of the flesh, and the lust of the eyes, and the pride of life, is not of the Father, but is of the world. ¹⁷ And the world passeth away, and the lust thereof: but he that doeth the will of God abideth for ever. ¹⁸ Little children, it is the last time: and as ye have heard that antichrist shall come, even now are there many antichrists; whereby we know that it is the last time. ¹⁹ They went out from us, but they were not of us; for if they had been of us, they would no doubt have continued with us: but they went out, that they might be made manifest that they were not all of us. ²⁰ But ye have an unction from the Holy One, and ye know all things. ²¹ I have not written unto you because ye know not the truth, but because ye know it, and that no lie is of the truth. ²² Who is a liar but he that denieth that Jesus is the Christ? He is antichrist, that denieth the Father and the Son. ²³ Whosoever denieth the Son, the same hath not the Father: he that acknowledgeth the Son hath the Father also. ²⁴ Let that therefore abide in you, which ye have heard from the beginning. If that which ye have heard from the beginning shall remain in you, ye also shall continue in the Son, and in the Father. ²⁵ And this is the promise that he hath promised us, even eternal life. ²⁶ These things have I written unto you concerning them that seduce you. ²⁷ But the anointing which ye have received of him abideth in you, and ye need not that any man teach you: but as the same anointing teacheth you of all things, and is truth, and is no lie, and even as it hath taught you, ye shall abide in him. ²⁸ And now, little children, abide in him; that, when he shall appear, we may have confidence, and not be ashamed before him at his coming. ²⁹ If ye know that he is righteous, ye know that every one that doeth righteousness is born of him.

Explanation

The Lord Jesus Christ is our daily intercessor. **1 John 2:1 & 2**

Conclusion

- We must confess our sins daily.
- Also, if we have an issue between another, the Word of God, states that we are to settle that dispute, before the end of day.
- In addition, in order to be in right standing with God, we must examine ourselves spiritually, daily.
- We are being saved from the guilt of sin.

Questions

If we daily confess our sins to Yahweh, or Almighty God, through His Son, the Lord Jesus Christ, what will He do for us according to I John 1:9?

Who is our daily intercessor or Mediator to God, our Savior and Day Star and why? Provide scripture.

Who is our Advocate and state two other names for Him, having the same meaning.

Thought Question

Once, you accept Christ into your heart as your personal Lord and Savior, you are being saved, day by day? What does that mean to you?

You are saved from the penalty of sin.
You are saved from the daily guilt of sin.
One day, you will be saved from the presence of sin.

Salvation Future
We Shall Be Saved From
Chapter 3

Text
I Thessalonians 4:13-18
I Corinthians 15: 51-58

Introduction

Salvation is a process: Past, Present and, Future.

Future: In the future, upon the Lord's return, we shall be saved from the presence (and the power) of sin over one's body. In order to be saved from the presence of sin and its continuous power that it has over our bodies of flesh, we will be changed, even those who sleep in Jesus. We shall be changed from mortality to immortality.

However here is a summary of all of the summaries to take note.

Tenses	Definition	Scripture
Salvation:	Past Saved from the penalty of sin.	Romans 6:23
Salvation:	Present Saved from the guilt of sin.	I John 1:9
Salvation:	Future Saved from the presence of sin.	I Corinthians 15: 51-58 I Thessalonians 4:13-18

The Lesson
The Messiah's Return in the Second Coming of Christ
Focused Upon: The Resurrection of the Sleeping Believers
Saved Eternally

Text
I Thessalonians 4:13-18

1 Thessalonians 4

*¹ Furthermore then we beseech you, brethren, and exhort you by the Lord Jesus, that as ye have received of us how ye ought to walk and to please God, so ye would abound more and more. ² For ye know what commandments we gave you by the Lord Jesus. ³ For this is the will of God, even your sanctification, that ye should abstain from fornication: ⁴ That every one of you should know how to possess his vessel in sanctification and honour; ⁵ Not in the lust of concupiscence, even as the Gentiles which know not God: ⁶ That no man go beyond and defraud his brother in any matter: because that the Lord is the avenger of all such, as we also have forewarned you and testified. ⁷ For God hath not called us unto uncleanness, but unto holiness. ⁸ He therefore that despiseth, despiseth not man, but God, who hath also given unto us his holy Spirit. ⁹ But as touching brotherly love ye need not that I write unto you: for ye yourselves are taught of God to love one another. ¹⁰ And indeed ye do it toward all the brethren which are in all Macedonia: but we beseech you, brethren, that ye increase more and more; ¹¹ And that ye study to be quiet, and to do your own business, and to work with your own hands, as we commanded you; ¹² That ye may walk honestly toward them that are without, and that ye may have lack of nothing. ¹³ **But I would not have you to be ignorant, brethren, concerning them which are asleep, that ye sorrow not, even as others which have no hope. ¹⁴ For if we believe that Jesus died and rose again, even so them also which sleep in Jesus will God bring with him. ¹⁵ For this we say unto you by the word of the Lord, that we which are alive and remain unto the coming of the Lord shall not prevent them which are asleep. ¹⁶ For the Lord himself shall descend from heaven with a shout, with the voice of the archangel, and with the trump of God: and the dead in Christ shall rise first: ¹⁷ Then we which are alive and remain shall be caught up together with them in the clouds, to meet the Lord in the air: and so shall we ever be with the Lord. ¹⁸ Wherefore comfort one another with these words.***

Explanation

The believers being caught up, as the Lord returns is described in two different ways, because even though both text were written by the same author, St. Paul is writing to a different group of people. He first writes to the church in Thessalonica, who has a problem believing entirely upon the

resurrection of the dead, defined as those believers, who are asleep, raised to heavenly eternal life. This text is self explanatory. However, it is to be noted that Christ will descend from heaven, because He now sits at the right hand of God the Father, making intercession, for our imperfections, short comings and out right actions of disobedience. Hebrews 10:12. The Word of God states that He was **tempted** in every way as we, while transformed on earth, visiting in the form of a man. What better way to intercede for others when you can understand them? **I Thessalonians 4:13-18**

Also

The Messiah's Return as a Thief in the Night
Focused Upon: The Living Believers, On the Day of Trumpets
Saved Eternally
Text
I Corinthians 15: 51-58

1 Corinthians 15

[1] Moreover, brethren, I declare unto you the gospel which I preached unto you, which also ye have received, and wherein ye stand; [2] By which also ye are saved, if ye keep in memory what I preached unto you, unless ye have believed in vain. [3] For I delivered unto you first of all that which I also received, how that Christ died for our sins according to the scriptures; [4] And that he was buried, and that he rose again the third day according to the scriptures: [5] And that he was seen of Cephas, then of the twelve: [6] After that, he was seen of above five hundred brethren at once; of whom the greater part remain unto this present, but some are fallen asleep. [7] After that, he was seen of James; then of all the apostles. [8] And last of all he was seen of me also, as of one born out of due time. [9] For I am the least of the apostles, that am not meet to be called an apostle, because I persecuted the church of God. [10] But by the grace of God I am what I am: and his grace which was bestowed upon me was not in vain; but I laboured more abundantly than they all: yet not I, but the grace of God which was with me. [11] Therefore whether it were I or they, so we preach, and so ye believed. [12] Now if Christ be preached that he rose from the dead, how say some among you that there is no resurrection of the dead? [13] But if there be no resurrection of the dead, then is Christ not risen: [14] And if Christ be not

risen, then is our preaching vain, and your faith is also vain. [15] *Yea, and we are found false witnesses of God; because we have testified of God that he raised up Christ: whom he raised not up, if so be that the dead rise not.* [16] *For if the dead rise not, then is not Christ raised:* [17] *And if Christ be not raised, your faith is vain; ye are yet in your sins.* [18] *Then they also which are fallen asleep in Christ are perished.* [19] *If in this life only we have hope in Christ, we are of all men most miserable.* [20] *But now is Christ risen from the dead, and become the firstfruits of them that slept.* [21] *For since by man came death, by man came also the resurrection of the dead.* [22] *For as in Adam all die, even so in Christ shall all be made alive.* [23] *But every man in his own order: Christ the firstfruits; afterward they that are Christ's at his coming.* [24] *Then cometh the end, when he shall have delivered up the kingdom to God, even the Father; when he shall have put down all rule and all authority and power.* [25] *For he must reign, till he hath put all enemies under his feet.* [26] *The last enemy that shall be destroyed is death.* [27] *For he hath put all things under his feet. But when he saith all things are put under him, it is manifest that he is excepted, which did put all things under him.* [28] *And when all things shall be subdued unto him, then shall the Son also himself be subject unto him that put all things under him, that God may be all in all.* [29] *Else what shall they do which are baptized for the dead, if the dead rise not at all? why are they then baptized for the dead?* [30] *And why stand we in jeopardy every hour?* [31] *I protest by your rejoicing which I have in Christ Jesus our Lord, I die daily.* [32] *If after the manner of men I have fought with beasts at Ephesus, what advantageth it me, if the dead rise not? let us eat and drink; for to morrow we die.* [33] *Be not deceived: evil communications corrupt good manners.* [34] *Awake to righteousness, and sin not; for some have not the knowledge of God: I speak this to your shame.* [35] *But some man will say, How are the dead raised up? and with what body do they come?* [36] *Thou fool, that which thou sowest is not quickened, except it die:* [37] *And that which thou sowest, thou sowest not that body that shall be, but bare grain, it may chance of wheat, or of some other grain:* [38] *But God giveth it a body as it hath pleased him, and to every seed his own body.* [39] *All flesh is not the same flesh: but there is one kind of flesh of men, another flesh of beasts, another of fishes, and another of birds.* [40] *There are also celestial bodies, and bodies terrestrial: but the glory of the celestial is one, and the glory of the terrestrial is another.* [41] *There is one glory of the sun, and another glory of the moon, and another glory of the stars: for one star differeth from another star in glory.* [42] *So also is the resurrection of the dead. It is sown in corruption; it is raised in incorruption:* [43] *It is sown in dishonour; it is raised in glory: it is*

sown in weakness; it is raised in power: [44] *It is sown a natural body; it is raised a spiritual body. There is a natural body, and there is a spiritual body.* [45] *And so it is written, The first man Adam was made a living soul; the last Adam was made a quickening spirit.* [46] *Howbeit that was not first which is spiritual, but that which is natural; and afterward that which is spiritual.* [47] *The first man is of the earth, earthy; the second man is the Lord from heaven.* [48] *As is the earthy, such are they also that are earthy: and as is the heavenly, such are they also that are heavenly.* [49] *And as we have borne the image of the earthy, we shall also bear the image of the heavenly.* [50] *Now this I say, brethren, that flesh and blood cannot inherit the kingdom of God; neither doth corruption inherit incorruption.* [51] ***Behold, I shew you a mystery; We shall not all sleep, but we shall all be changed,*** [52] ***In a moment, in the twinkling of an eye, at the last trump: for the trumpet shall sound, and the dead shall be raised incorruptible, and we shall be changed.*** [53] ***For this corruptible must put on incorruption, and this mortal must put on immortality.*** [54] ***So when this corruptible shall have put on incorruption, and this mortal shall have put on immortality, then shall be brought to pass the saying that is written, Death is swallowed up in victory.*** [55] ***O death, where is thy sting? O grave, where is thy victory?*** [56] ***The sting of death is sin; and the strength of sin is the law.*** [57] ***But thanks be to God, which giveth us the victory through our Lord Jesus Christ.*** [58] ***Therefore, my beloved brethren, be ye stedfast, unmoveable, always abounding in the work of the Lord, forasmuch as ye know that your labour is not in vain in the Lord.***

Explanation

The Second Coming of the Messiah is described in two viewpoints, resulting in the beliefs of the recipients of the writing, written by St. Paul, to the Church at Corinth, and also at the Church of Thessalonica. 51-52 What Apostle Paul needs to expound upon is the mystery of immortality to the church at Corinth, whom have unbelief in the gift of immortality. They do not believe that to be absent from the body is to be present with the Lord. 53-54 In addition, corruptible refers to our bodies of flesh, which possess the lust of the flesh, the lust of the eyes and the pride of life. We have victory over death, only at the last phase of our salvation, when the believers change in a twinkling of an eye, at the sound of the last trump, during the Day of Trumpets, into heavenly, immortality. 55-57 We will

no longer have a sting or a threat of death and its consequences, eternal damnation to our souls in the Lake of Fire. We will then have victory, passing to heavenly immortality. **I Corinthians 15: 51-58**

Conclusion

- Salvation is based upon the past: the Lord Jesus Christ paid the once and for all price for our sins. With that in mind, our salvation is in belief on the finished works of Christ, and acknowledging that we are sinners lost without Christ, in need of repentance. Therefore we are to repent and walk therein, in accordance to the Word of God.
- Salvation is based upon the present, day by day (we repent daily to God through our intercessor, the Lord Jesus Christ, and to others, as we remember, prior to the close of the day).
- Salvation is based upon the future, referring to what type of life we are living when the Lord returns known as the Return of Christ.
- Salvation future is explained in the scriptures in two ways. The first is found in I Thessalonians 4:13-18, with emphasis on those died in Christ, who will also be resurrected.
- In addition I Corinthians 15:51-58, focus upon the Lord' return, and those written in the Lamb's Book of Life, found in Revelation 20: 12 & 15. All believers will be changed from mortality to immortality, at the final Feast of Trumpets. All other celebrations were a mere a rehearsal of things to come.
- However, God does not need to record anything or anyone in a book. He uses human elements in which we can relate to. See Rev 3: 15 & 16
- We shall be saved from the presence of sin.

Questions

What two passages in the Bible speak of being caught up, which is identified in the secular church, as the rupturing up of the Church, composed of the body of born again believers, when the Messiah returns in the Second Coming?

From which of the two texts, describes what will happen to those who are asleep in Christ, Jesus, when the Messiah, the Christ, returns in His Second Coming?

From which of the two texts, describes what will happen to those who are alive, in Christ Jesus, the Messiah, when He returns, in His Second Coming? Where is the scripture located?

What is the term used in the secular Church to describe the Lord's return as a Thief in the Night which is not actually recorded in the Word of God.

Who is written in the Lamb's Book of Life? Where is this scripture located?

In the text, what does the term, incorruptible refer to?

What is the mystery? Is there more than one? Provide a scripture text.

Thought Question

If you had a preference of when the Lord would return for you, what time of the day would you prefer, and where would you prefer it to be, and with whom, if anyone?

Chapter 4

Week One: Review
Week Two: Open Book Test
Week Three: Review and Open Discussion of the Unit

Unit 4: Salvation, Past, Present and Future
Practice for Review
And later
Unit Test
Salvation: Past

Is salvation a process possessing three levels or phases to salvation; if so, why?

Name the three tenses to salvation, along with scripture, necessary to inherit the gift of eternal life.

Three Tenses of Salvation Scripture

Why is there a need for salvation for each individual based upon, the following three components? Provide scripture:

(1) Sin?

(2) The sin, resulting in broken fellowship with God, expounded upon in Genesis 2, in the Garden. Provide scripture.

(3) The need to be brought back into right standing with God, which defines redemption or returned fellowship and communion with God. as Elohim. Provide scripture.

What does it mean to confess our sins?

_____Ask God to forgive us from our sins

_____Believe that Christ died, was buried and rose again for our redemption, taking our places on the Cross

_____Realize that we are a sinner lost without Christ

_____All of the above

Salvation: Present

If we daily confess our sins to Yahweh, what will He do for us according to I John 1:9?

Who is our daily intercessor or Mediator to God, our Savior and Day Star and why?

Who is our Advocate and state two other names for Him. Provide scripture.

Salvation: Future

What two passages in the Bible speak of being caught up, which is identified in the secular church, as the rupturing up of the Church, composed of the body of born again believers, when the Messiah returns in the Second Coming?

From which of the two texts, describes what will happen to those who are asleep in Christ, Jesus, when the Messiah, the Christ, returns in His Second Coming?

From which of the two texts, describes what will happen to those who are alive, in Christ Jesus, the Messiah, when He returns, in His Second Coming? Where is the scripture located?

What is the term used in the secular Church to describe the Lord's return as a Thief in the Night which is not actually recorded in the Bible?

Who is written in the Lamb's Book of Life? Where is this scripture located?

In the text, what does the term, incorruptible refer to?

What is the mystery? Is there more than one? Provide a scripture text.

UNIT 5: JUSTIFICATION THROUGH SALVATION

Contents

Unit Introduction

Now, once we know how to pray, and we know that salvation comes forth, through the Gospel of the Lord Jesus Christ, as His finished works, and that there is a need, and exactly what the need is for mankind, it remains perhaps unclear. There still lies some puzzlement and some questions unanswered. In this unit, we shall attempt to clean up any puzzlement that you may have, resulting in the need for salvation, and not as a quick fix. We shall in this unit, expound upon why one man, who came in the flesh, through the line of time, consisting of forty two generations, as the Son of God, became personified as representing the world to himself, became the Atonement for our sins. We shall discuss this in unit that it is through His justification, that we know can obtain access to all things, in this life, and through life eternal. Therefore, with that in mind, we present to you, *Justification through Salvation* . . .

The First Adam
The Birth of the First Testator
Chapter 1

Text
Genesis Chapters one, two and three

Introduction

In order for the believer to remember the significance of why there is a need for salvation, we want to review those lessons pertaining to that topic in a clearer sense, using the label of the First Adam, labeled as the first testator, and the meaning of a testator, emphasizing these points, within the same previous texts, which were not emphasized, until now.

The Lesson
The Creation of Mankind
(The Age of Innocence)

Text
Genesis 1: 27-28, 31 (Unit 3, chapter 1, full text)

Genesis 1

²⁷ So God created man in his own image, in the image of God created he him; male and female created he them. ²⁸ And God blessed them, and *God said unto them, Be fruitful, and multiply, and replenish the earth, and subdue it: and have dominion over the fish of the sea, and over the fowl of the air, and over every living thing that moveth upon the earth. ²⁹ And God said, Behold, I have given you every herb bearing seed, which is upon the face of all the earth, and every tree, in the which is the fruit of a tree yielding seed; to you it shall be for meat. ³⁰ And to every beast of the earth, and to every fowl of the air, and to every thing that creepeth upon the earth, wherein there is life,*

I have given every green herb for meat: and it was so. ³¹ **And God saw every thing that he had made, and, behold, it was very good. And the evening and the morning were the sixth day.**

Explanation

In order to talk about man, we must first begin at the beginning. He was created in innocence. **Genesis 1: 27-28, 31**
Text
Genesis 2: 8-9; 15-17

Genesis 2

¹ Thus the heavens and the earth were finished and all the host of them. ² And on the seventh day God ended his work which he had made; and he rested on the seventh day from all his work which he had made. ³ And God blessed the seventh day, and sanctified it: because that in it he had rested from all his work which God created and made. ⁴ These are the generations of the heavens and of the earth when they were created, in the day that the LORD God made the earth and the heavens, ⁵ And every plant of the field before it was in the earth, and every herb of the field before it grew: for the LORD God had not caused it to rain upon the earth, and there was not a man to till the ground. ⁶ But there went up a mist from the earth, and watered the whole face of the ground. ⁷ And the LORD God formed man of the dust of the ground, and breathed into his nostrils the breath of life; and man became a living soul. ⁸ **And the LORD God planted a garden eastward in Eden; and there he put the man whom he had formed. ⁹ And out of the ground made the LORD God to grow every tree that is pleasant to the sight, and good for food; the tree of life also in the midst of the garden, and the tree of knowledge of good and evil.** *¹⁰ And a river went out of Eden to water the garden; and from thence it was parted, and became into four heads. ¹¹ The name of the first is Pison: that is it which compasseth the whole land of Havilah, where there is gold; ¹² And the gold of that land is good: there is bdellium and the onyx stone. ¹³ And the name of the second river is Gihon: the same is it that compasseth the whole land of Ethiopia. ¹⁴ And the name of the third river is Hiddekel: that is it which goeth toward the east of Assyria. And the fourth river is Euphrates.* ¹⁵ **And the LORD God took the man, and put him into the garden of Eden to dress it and to keep it. ¹⁶ And the LORD God commanded the man,**

saying, Of every tree of the garden thou mayest freely eat: [17] *But of the tree of the knowledge of good and evil, thou shalt not eat of it: for in the day that thou eatest thereof thou shalt surely die.* [18] *And the LORD God said, It is not good that the man should be alone; I will make him an help meet for him.* [19] *And out of the ground the LORD God formed every beast of the field, and every fowl of the air; and brought them unto Adam to see what he would call them: and whatsoever Adam called every living creature, that was the name thereof.* [20] *And Adam gave names to all cattle, and to the fowl of the air, and to every beast of the field; but for Adam there was not found an help meet for him.* [21] *And the LORD God caused a deep sleep to fall upon Adam, and he slept: and he took one of his ribs, and closed up the flesh instead thereof;* [22] *And the rib, which the LORD God had taken from man, made he a woman, and brought her unto the man.* [23] *And Adam said, This is now bone of my bones, and flesh of my flesh: she shall be called Woman, because she was taken out of Man.* [24] *Therefore shall a man leave his father and his mother, and shall cleave unto his wife: and they shall be one flesh.* [25] *And they were both naked, the man and his wife, and were not ashamed.*

Explanation

Adam was placed, instructed, and warned, after receiving dominion over all living things. **Genesis 2: 8-9; 15-17**

The fall of Man
(Into Sin and Consciousness)

Text
Genesis 3:6

Genesis 3

[1] *Now the serpent was more subtil than any beast of the field which the LORD God had made. And he said unto the woman, Yea, hath God said, Ye shall not eat of every tree of the garden?* [2] *And the woman said unto the serpent, We may eat of the fruit of the trees of the garden:* [3] *But of the fruit of the tree which is in the midst of the garden, God hath said, Ye shall not eat of it, neither shall ye touch it, lest ye die.* [4] *And the serpent said unto the woman, Ye shall not surely die:* [5] *For God doth know that in the day ye eat thereof, then your eyes shall*

be opened, and ye shall be as gods, knowing good and evil. **⁶ And when the woman saw that the tree was good for food, and that it was pleasant to the eyes, and a tree to be desired to make one wise, she took of the fruit thereof, and did eat, and gave also unto her husband with her; and he did eat.** *⁷ And the eyes of them both were opened, and they knew that they were naked; and they sewed fig leaves together, and made themselves aprons. ⁸ And they heard the voice of the LORD God walking in the garden in the cool of the day: and Adam and his wife hid themselves from the presence of the LORD God amongst the trees of the garden. ⁹ And the LORD God called unto Adam, and said unto him, Where art thou? ¹⁰ And he said, I heard thy voice in the garden, and I was afraid, because I was naked; and I hid myself. ¹¹ And he said, Who told thee that thou wast naked? Hast thou eaten of the tree, whereof I commanded thee that thou shouldest not eat? ¹² And the man said, The woman whom thou gavest to be with me, she gave me of the tree, and I did eat. ¹³ And the LORD God said unto the woman, What is this that thou hast done? And the woman said, The serpent beguiled me, and I did eat. ¹⁴ And the LORD God said unto the serpent, Because thou hast done this, thou art cursed above all cattle, and above every beast of the field; upon thy belly shalt thou go, and dust shalt thou eat all the days of thy life: ¹⁵ And I will put enmity between thee and the woman, and between thy seed and her seed; it shall bruise thy head, and thou shalt bruise his heel. ¹⁶ Unto the woman he said, I will greatly multiply thy sorrow and thy conception; in sorrow thou shalt bring forth children; and thy desire shall be to thy husband, and he shall rule over thee. ¹⁷ And unto Adam he said, Because thou hast hearkened unto the voice of thy wife, and hast eaten of the tree, of which I commanded thee, saying, Thou shalt not eat of it: cursed is the ground for thy sake; in sorrow shalt thou eat of it all the days of thy life; ¹⁸ Thorns also and thistles shall it bring forth to thee; and thou shalt eat the herb of the field; ¹⁹ In the sweat of thy face shalt thou eat bread, till thou return unto the ground; for out of it wast thou taken: for dust thou art, and unto dust shalt thou return. ²⁰ And Adam called his wife's name Eve; because she was the mother of all living. ²¹ Unto Adam also and to his wife did the LORD God make coats of skins, and clothed them. ²² And the LORD God said, Behold, the man is become as one of us, to know good and evil: and now, lest he put forth his hand, and take also of the tree of life, and eat, and live for ever: ²³ Therefore the LORD God sent him forth from the garden of Eden, to till the ground from whence he was taken. ²⁴ So he drove out the man; and he placed at the east of the garden of Eden Cherubims, and a flaming sword which turned every way, to keep the*

*way of the tree of life. And when the **woman saw** that the tree was good for food, and that it was **pleasant** to the eyes, and a tree **to be desired** to make one wise, she took of the fruit thereof, and did eat, and gave also unto **her husband** with her: and he did eat.*

Explanation

- Are they not only God conscience through the spirit
- But they now have a soul, or a personality with the presence and constant awareness of evil, but had no need to use it, therefore it was dormant. The awareness of good and evil begins the constant struggle, that all of mankind, throughout the ages must struggle with, as a result of Adam's sin against God. God did not give Eve, instructions. Adam was the head, stated as you read on. Adam was tempted by the appearance of evil. He observed the appearance, which was appealing and what it had to offer, of which he already had. Adam was made in the image of God; therefore, he was already royal, until the fall. Now he became spiritually dead. **Genesis 3:6**

Conclusion

The spiritual battle from within, for all mankind:

- Began, the minute that the first Adam, disobeyed God's instructions, whereby, planting the seed of disobedience throughout the seed of time, for all generations.
- Man became defiled, and could no longer commune with God. Disobedience is a sin.
- Once we are reborn, spiritually, the battle takes on a spiritual level of consciousness.
- Therefore, we now have the Age of Conscience, hence forth and forever more.

Questions

Who is the first Adam?_____

What type of sin did he perform? _____

What are the three witnesses to the human body which was made to fellowship with God, our Creator, Elohim.

Who was the third player amongst Adam and Eve, which showed them a different way and a different outlook on life?

Is he still present, performing the same tasks today, but centered upon those who have a direct fellowship with God?

If so, what are his continual tasks? Take a moment out and look up St. John 10:10 and name three assignments he focuses upon, for all believers, who are faithfully working in the vine yard of having their lives as a testimony to the world, that they, as St. Paul stated, may win some souls of mankind to Christ.

Thought Question:

Who do you think is the expert on the Word of God, as the Holy Scriptures and the Torah? Therefore, what must you be?

The Need for a Second Testator
Chapter 2

Text
Genesis Chapter 3 (See previous chapter for full text)

Introduction

In this text, we shall discover, other contents that need to be repeated and focused upon, regarding the failure now of the first Testator, Adam, who is now fallen from grace. We shall discover, therefore, that there was a need for a more excellent way, as we conclude, bringing in for the following lesson, The Lord Jesus Christ, who is the Mediator of the New Testament, who is The Amen, the conclusion of the whole matter, as the Messiah.

The Lesson

Text
Genesis Chapter 3:14-20
(Refer to the previous chapter for full text)

Genesis 3

14 And the LORD God said unto the serpent, Because thou hast done this, thou art cursed above all cattle, and above every beast of the field; upon thy belly shalt thou go, and dust shalt thou eat all the days of thy life: 15 And I will put enmity between thee and the woman, and between thy seed and her seed; it shall bruise thy head, and thou shalt bruise his heel. 16 Unto the woman he said, I will greatly multiply thy sorrow and thy conception; in sorrow thou shalt bring forth children; and thy desire shall be to thy husband, and he shall rule over thee. 17 And unto Adam he said, Because thou hast hearkened unto the voice of thy wife, and hast eaten of the tree, of which I commanded thee, saying, Thou shalt not eat of it: cursed is the ground for thy sake; in sorrow

shalt thou eat of it all the days of thy life; [18] *Thorns also and thistles shall it bring forth to thee; and thou shalt eat the herb of the field;* [19] *In the sweat of thy face shalt thou eat bread, till thou return unto the ground; for out of it wast thou taken: for dust thou art, and unto dust shalt thou return.* [20] *And Adam called his wife's name Eve; because she was the mother of all living.* [21] *Unto Adam also and to his wife did the LORD God make coats of skins, and clothed them.*

The Explanation

14-19 God pronounces punishment and tells in detail what will happen to all generations, beginning with them. The punishment or curse will follow mankind and the serpent, throughout the Ages, until the Lord's return. 20-21 God provided a covering for them, which also represents how God provides a temporary solution for our problems, as He shields and protects us, when we do not even deserve it. **Genesis 3: 14-21**

Conclusion

Adam, as the first Testator's, failure to obey Elohim's instructions, brought about, first, consequences to himself and his wife. Secondly, his disobedience began a cycle of generational curses, which continue, to this present day. Only, through the acceptance of our Lord and Savior Jesus Christ, can we, for ourselves, and for our generations, break the curse, of the consequences of sin.

Questions

Name the punishments that exist between Adam, Eve, and the Serpent, that exist to this day.

(1) Adam: three part punishment

(2) Eve: two part punishment

(3) The Serpent: two part punishment

Who was the originator of the generational curses?

What happened to bring on the generational curse for all humanity?

Thought Question

Even though God knows, as Omniscient, or All Wise, what we are going to do before we do it, He places constructs or objects in our way, so that we may play out a choice of our performance, either to the right or to the left. Could this have been the case with the planting of the Tree of Knowledge of Good and Evil? Did God really need that tree present? They were made in the image and likeness of God.

Christ: The Mediator of the New Testament
The New Testator Chapter 3

Text
Hebrews 9:11-28 (See previous unit, chapter 2 for chapter full text)

The Introduction

In order for there to be a testament, there must be a testator, a person, who is willing to die, to change the historical period and purpose, for the life cycle, evolving around that period for mankind. Adam died in the Old Testament, so that there would be a need for another testator, replacing the Old and bringing in the New. All of the dying of the Old and the rebirth of the New is explained in **Hebrews 9: 11-28.**

The Lesson

Hebrews 9:11-28 (Unit 3, chapter 2, full text)

The Explanation

11 Christ is:

- Our High Priest, who gave himself as the once and for all sacrifice, as the Saviour of the world.
- He is not only the Savior, the High Priest, who went into the tabernacle, representing the Holy of Holies.
- He is the Holy of Holies, of the New Testament.
- He is also The Tabernacle, not made with hands.

12 This passage begins by stating that once a year the high priest would come into the holy of holies to make a blood sacrifice for the people.

The Lord Jesus Christ, became the once and for all sacrifice, eliminating the yearly sacrifice.13 This verse tells of the type of blood sacrifice of animals.14.The guilt of sin, revealed by your conscience is eliminated daily, as we ask for forgiveness, through the works of the blood atoning sacrifice.15.Transgression is sin. Those called are the believers, who have asked Christ to come into their lives to save them from sin, who now receive the promise of eternal life.16-21 A Testament marks a new era, brought about from a new Adam, which creates the era, after his death as the blood sacrifice for the good. 22 Remission means forgiveness of sin, through a blood pure, spotless Lamb of God, the Son of God, as the atoning sacrifice. 23 These animals did not atone for mankind's sin. It was necessary for a more new and excellent way. 24. The Lord Jesus Christ is our intercessor, who goes before the Throne of God, asking for our daily forgiveness. 25-26 Christ is the one time blood atoning sacrifice for our sin. 27. So we are (1) saved from the penalty of sin, which is natural death and eternal punishment. We are saved from the (2) guilt of sin, which is daily asking God through His Son for daily forgiveness, as we repent for our sins. And one day, we shall be (3) saved from the presence of sin, when we change from this life to a heavenly body. 28 We shall be saved from the presence of sin, once we see the return of the Blessed Hope. **Hebrews 9:11-28**

Conclusion

So Christ is our eternal High Priest of the New Testament, resulting from his Blood Atoning Sacrifice in the New Testament, as the last and fulfilled the Tentative, as Christ. Therefore, He completed the need for one other testator; no other blood sacrifice is necessary for our sin forgiven. The Lord Jesus Christ, fulfills the New Testament, as written.

Questions

What is a testator? How does it relate to the New Testament?

Who is the High Priest of good things to come, the Mediator of the New Testament?

Who or What is the Holies of Holies, the Tabernacle, not to be made by hands?

What was performed once a year to atone for man's sin, in the Old Testament and by whom?

What type of sacrifice was made? For what purpose was the sacrifice made?

What made the sacrifice incomplete, and unsuccessful?

Why was it necessary to bring about a new testator, to bring about a New Testament?

Thought Question

What do you think would have happened by the 2nd Adam, the Lamb of God, from the Lion of the Tribe of Judah, the Chief Cornerstone, the Chief Sheppard, did not fulfill His destiny and assignment?

Chapter 4

Week One: Review
Week Two: Open Book Test
Week Three: Review and Open Discussion of the Unit

Unit Five: Justification through Salvation
Practice for Review
And later
Unit Test
The First Adam

Who is the first Adam?

What what type of sin did he perform?

What are the three witnesses to the human body which was made to fellowship with God, our Creator, as Elohim.

Who was the third player amongst Adam and Eve, which showed them a different way and a different outlook on life?

Is he still present, performing the same tasks today, but centered upon those who have a direct fellowship with God?

If so, what are his continual tasks? Take a moment out and look up St. John 10:10 and name three assignments he focuses upon, for all believers, who are faithfully working in the vine yard of having their lives as a testimony to the world, that they, as St. Paul stated, may win some souls of mankind to Christ.

The Second Adam

Name the punishments that exist between Adam, Eve, and the Serpent, that exist to this day.
(1) Adam: three part punishment

(2) Eve: two part punishment

(3) The Serpent: two part punishment

Who was the originator of the generational curses? _

What happened to bring on the generational curse for all humanity?

The Mediator of the New Testament

What is a testator? How does it relate to the New Testament?

Who is the High Priest of good things to come, the Mediator of the New Testament?

Who or What is the Holies of Holies, the Tabernacle, not to be made by hands?

What was performed once a year to atone for man's sin, in the Old Testament and by whom?

What type of sacrifice was made? For what purpose was the sacrifice made?

What made the sacrifice incomplete, and unsuccessful?

Why was it necessary to bring about a new testator, to bring about a New Testament?

UNIT SIX: INITIATING SPIRITUAL GROWTH

Contents

Unit Introduction

Once we have a complete understanding of the Salvation, as interpreted through the Gospel, by way of the Son of God, we have accepted Christ into our lives and hearts and began a Salvation Spiritual Walk with God, through our Lord and Savior, Jesus Christ. We are justified, through belief in the Gospel, as we exercise prayer for forgiveness of our sins. Now we are ready to begin to: ***Initiate Spiritual Growth*** . . .

The Fruit of the Spirit
Chapter 1

Text
Galatians 5:22-23

Introduction

There are nine fruit of the spirit, manifested or shown in the believer's life. The Word of God states that by this, ye shall know them, that they are my disciples. Another verse states, that a tree is known by the fruit it bears.

The Lesson

Text
Galatians 5:22-23

Galatians 5

¹ Stand fast therefore in the liberty wherewith Christ hath made us free, and be not entangled again with the yoke of bondage. ² Behold, I Paul say unto you, that if ye be circumcised, Christ shall profit you nothing. ³ For I testify again to every man that is circumcised, that he is a debtor to do the whole law. ⁴ Christ is become of no effect unto you, whosoever of you are justified by the law; ye are fallen from grace. ⁵ For we through the Spirit wait for the hope of righteousness by faith. ⁶ For in Jesus Christ neither circumcision availeth any thing, nor uncircumcision; but faith which worketh by love. ⁷ Ye did run well; who did hinder you that ye should not obey the truth? ⁸ This persuasion cometh not of him that calleth you. ⁹ A little leaven leaveneth the whole lump. ¹⁰ I have confidence in you through the Lord, that ye will be none otherwise minded: but he that troubleth you shall bear his judgment, whosoever he be. ¹¹ And I, brethren, if I yet preach circumcision, why do I yet suffer persecution? then is the offence of the cross ceased. ¹² I would they were even cut off which trouble you. ¹³ For, brethren, ye have been called unto

*liberty; only use not liberty for an occasion to the flesh, but by love serve one another. ¹⁴ For all the law is fulfilled in one word, even in this; Thou shalt love thy neighbour as thyself. ¹⁵ But if ye bite and devour one another, take heed that ye be not consumed one of another. ¹⁶ This I say then, Walk in the Spirit, and ye shall not fulfil the lust of the flesh. ¹⁷ For the flesh lusteth against the Spirit, and the Spirit against the flesh: and these are contrary the one to the other: so that ye cannot do the things that ye would. ¹⁸ But if ye be led of the Spirit, ye are not under the law. ¹⁹ Now the works of the flesh are manifest, which are these; Adultery, fornication, uncleanness, lasciviousness, ²⁰ Idolatry, witchcraft, hatred, variance, emulations, wrath, strife, seditions, heresies, ²¹ Envyings, murders, drunkenness, revellings, and such like: of the which I tell you before, as I have also told you in time past, that they which do such things shall not inherit the kingdom of God. ²² **But the fruit of the Spirit is love, joy, peace, longsuffering, gentleness, goodness, faith, ²³ Meekness, temperance: against such there is no law.** ²⁴ And they that are Christ's have crucified the flesh with the affections and lusts. ²⁵ If we live in the Spirit, let us also walk in the Spirit. ²⁶ Let us not be desirous of vain glory, provoking one another, envying one another.*

Explanation

Verses 24 and 25 provide the conclusion of the whole matter. These scriptures actually give the introduction as well as the conclusion of why the Fruit of the Spirit is necessary. **Galatians 5:22-23**

Love

Text
Deuteronomy 6:5

Deuteronomy 6

¹ Now these are the commandments, the statutes, and the judgments, which the LORD your God commanded to teach you, that ye might do them in the land whither ye go to possess it: ² That thou mightest fear the LORD thy God, to keep all his statutes and his commandments, which I command thee, thou, and thy son, and thy son's son, all the days of thy life; and that thy days may be prolonged. ³ Hear therefore, O Israel, and observe to do it; that it may be well

with thee, and that ye may increase mightily, as the LORD God of thy fathers hath promised thee, in the land that floweth with milk and honey. ⁴ *Hear, O Israel: The LORD our God is one LORD:* ⁵ ***And thou shalt love the LORD thy God with all thine heart, and with all thy soul, and with all thy might.*** ⁶ *And these words, which I command thee this day, shall be in thine heart:* ⁷ *And thou shalt teach them diligently unto thy children, and shalt talk of them when thou sittest in thine house, and when thou walkest by the way, and when thou liest down, and when thou risest up.* ⁸ *And thou shalt bind them for a sign upon thine hand, and they shall be as frontlets between thine eyes.* ⁹ *And thou shalt write them upon the posts of thy house, and on thy gates.* ¹⁰ *And it shall be, when the LORD thy God shall have brought thee into the land which he sware unto thy fathers, to Abraham, to Isaac, and to Jacob, to give thee great and goodly cities, which thou buildedst not,* ¹¹ *And houses full of all good things, which thou filledst not, and wells digged, which thou diggedst not, vineyards and olive trees, which thou plantedst not; when thou shalt have eaten and be full;* ¹² *Then beware lest thou forget the LORD, which brought thee forth out of the land of Egypt, from the house of bondage.* ¹³ *Thou shalt fear the LORD thy God, and serve him, and shalt swear by his name.* ¹⁴ *Ye shall not go after other gods, of the gods of the people which are round about you;* ¹⁵ *(For the LORD thy God is a jealous God among you) lest the anger of the LORD thy God be kindled against thee, and destroy thee from off the face of the earth.* ¹⁶ *Ye shall not tempt the LORD your God, as ye tempted him in Massah.* ¹⁷ *Ye shall diligently keep the commandments of the LORD your God, and his testimonies, and his statutes, which he hath commanded thee.* ¹⁸ *And thou shalt do that which is right and good in the sight of the LORD: that it may be well with thee, and that thou mayest go in and possess the good land which the LORD sware unto thy fathers.* ¹⁹ *To cast out all thine enemies from before thee, as the LORD hath spoken.* ²⁰ *And when thy son asketh thee in time to come, saying, What mean the testimonies, and the statutes, and the judgments, which the LORD our God hath commanded you?* ²¹ *Then thou shalt say unto thy son, We were Pharaoh's bondmen in Egypt; and the LORD brought us out of Egypt with a mighty hand:* ²² *And the LORD shewed signs and wonders, great and sore, upon Egypt, upon Pharaoh, and upon all his household, before our eyes:* ²³ *And he brought us out from thence, that he might bring us in, to give us the land which he sware unto our fathers.* ²⁴ *And the LORD commanded us to do all these statutes, to fear the LORD our God, for our good always, that he might preserve us alive, as it is at this day.* ²⁵ *And it*

shall be our righteousness, if we observe to do all these commandments before the LORD our God, as he hath commanded us.

Explanation

Without love for one another, we cannot expect to be eternally saved. **Deuteronomy 6:5**

Joy

Text
James 1: 2-3

James 1

¹ James, a servant of God and of the Lord Jesus Christ, to the twelve tribes which are scattered abroad, greeting. ² My brethren, count it all joy when ye fall into divers temptations; ³ Knowing this, that the trying of your faith worketh patience. ⁴ But let patience have her perfect work, that ye may be perfect and entire, wanting nothing. ⁵ If any of you lack wisdom, let him ask of God, that giveth to all men liberally, and upbraideth not; and it shall be given him. ⁶ But let him ask in faith, nothing wavering. For he that wavereth is like a wave of the sea driven with the wind and tossed. ⁷ For let not that man think that he shall receive any thing of the Lord. ⁸ A double minded man is unstable in all his ways. ⁹ Let the brother of low degree rejoice in that he is exalted: ¹⁰ But the rich, in that he is made low: because as the flower of the grass he shall pass away. ¹¹ For the sun is no sooner risen with a burning heat, but it withereth the grass, and the flower thereof falleth, and the grace of the fashion of it perisheth: so also shall the rich man fade away in his ways. ¹² Blessed is the man that endureth temptation: for when he is tried, he shall receive the crown of life, which the Lord hath promised to them that love him. ¹³ Let no man say when he is tempted, I am tempted of God: for God cannot be tempted with evil, neither tempteth he any man: ¹⁴ But every man is tempted, when he is drawn away of his own lust, and enticed. ¹⁵ Then when lust hath conceived, it bringeth forth sin: and sin, when it is finished, bringeth forth death. ¹⁶ Do not err, my beloved brethren. ¹⁷ Every good gift and every perfect gift is from above, and cometh down from the Father of lights, with whom is no variableness, neither shadow of turning. ¹⁸ Of his own will*

begat he us with the word of truth, that we should be a kind of firstfruits of his creatures. [19] *Wherefore, my beloved brethren, let every man be swift to hear, slow to speak, slow to wrath:* [20] *For the wrath of man worketh not the righteousness of God.* [21] *Wherefore lay apart all filthiness and superfluity of naughtiness, and receive with meekness the engrafted word, which is able to save your souls.* [22] *But be ye doers of the word, and not hearers only, deceiving your own selves.* [23] *For if any be a hearer of the word, and not a doer, he is like unto a man beholding his natural face in a glass:* [24] *For he beholdeth himself, and goeth his way, and straightway forgetteth what manner of man he was.* [25] *But whoso looketh into the perfect law of liberty, and continueth therein, he being not a forgetful hearer, but a doer of the work, this man shall be blessed in his deed.* [26] *If any man among you seem to be religious, and bridleth not his tongue, but deceiveth his own heart, this man's religion is vain.* [27] *Pure religion and undefiled before God and the Father is this, To visit the fatherless and widows in their affliction, and to keep himself unspotted from the world.*

Explanation

This **joy** refers to being able to be thankful and rejoice, in the midst of what is **undesirable,** that we are faced with for a season. **James 1: 2-3**

Peace

Text
Philippians 4:7

Philippians 4

[1] *Therefore, my brethren dearly beloved and longed for, my joy and crown, so stand fast in the Lord, my dearly beloved.* [2] *I beseech Euodias, and beseech Syntyche, that they be of the same mind in the Lord.* [3] *And I intreat thee also, true yokefellow, help those women which laboured with me in the gospel, with Clement also, and with other my fellowlabourers, whose names are in the book of life.* [4] *Rejoice in the Lord alway: and again I say, Rejoice.* [5] *Let your moderation be known unto all men. The Lord is at hand.* [6] *Be careful for nothing; but in every thing by prayer and supplication with thanksgiving let your requests be made known unto God.* [7] ***And the peace of God, which passeth all understanding, shall keep your hearts and minds through***

Christ Jesus. *⁸ Finally, brethren, whatsoever things are true, whatsoever things are honest, whatsoever things are just, whatsoever things are pure, whatsoever things are lovely, whatsoever things are of good report; if there be any virtue, and if there be any praise, think on these things. ⁹ Those things, which ye have both learned, and received, and heard, and seen in me, do: and the God of peace shall be with you. ¹⁰ But I rejoiced in the Lord greatly, that now at the last your care of me hath flourished again; wherein ye were also careful, but ye lacked opportunity. ¹¹ Not that I speak in respect of want: for I have learned, in whatsoever state I am, therewith to be content. ¹² I know both how to be abased, and I know how to abound: every where and in all things I am instructed both to be full and to be hungry, both to abound and to suffer need. ¹³ I can do all things through Christ which strengtheneth me. ¹⁴ Notwithstanding ye have well done, that ye did communicate with my affliction. ¹⁵ Now ye Philippians know also, that in the beginning of the gospel, when I departed from Macedonia, no church communicated with me as concerning giving and receiving, but ye only. ¹⁶ For even in Thessalonica ye sent once and again unto my necessity. ¹⁷ Not because I desire a gift: but I desire fruit that may abound to your account. ¹⁸ But I have all, and abound: I am full, having received of Epaphroditus the things which were sent from you, an odour of a sweet smell, a sacrifice acceptable, wellpleasing to God. ¹⁹ But my God shall supply all your need according to his riches in glory by Christ Jesus. ²⁰ Now unto God and our Father be glory for ever and ever. Amen. ²¹ Salute every saint in Christ Jesus. The brethren which are with me greet you. ²² All the saints salute you, chiefly they that are of Caesar's household. ²³ The grace of our Lord Jesus Christ be with you all. Amen.*

Explanation

When we do those things which are pleasing in God's sight, God gives us peace, that we, nor others can understand. We have peace because we know that God will work the problem or situation out for us, as we wait on Him, through faith. **Philippians 4:7**

Longsuffering

Text
Hebrew 12:1

Hebrews 12

¹ Wherefore seeing we also are compassed about with so great a cloud of witnesses, let us lay aside every weight, and the sin which doth so easily beset us, and let us run with patience the race that is set before us, ² *Looking unto Jesus the author and finisher of our faith; who for the joy that was set before him endured the cross, despising the shame, and is set down at the right hand of the throne of God.* ³ *For consider him that endured such contradiction of sinners against himself, lest ye be wearied and faint in your minds.* ⁴ *Ye have not yet resisted unto blood, striving against sin.* ⁵ *And ye have forgotten the exhortation which speaketh unto you as unto children, My son, despise not thou the chastening of the Lord, nor faint when thou art rebuked of him:* ⁶ *For whom the Lord loveth he chasteneth, and scourgeth every son whom he receiveth.* ⁷ *If ye endure chastening, God dealeth with you as with sons; for what son is he whom the father chasteneth not?* ⁸ *But if ye be without chastisement, whereof all are partakers, then are ye bastards, and not sons.* ⁹ *Furthermore we have had fathers of our flesh which corrected us, and we gave them reverence: shall we not much rather be in subjection unto the Father of spirits, and live?* ¹⁰ *For they verily for a few days chastened us after their own pleasure; but he for our profit, that we might be partakers of his holiness.* ¹¹ *Now no chastening for the present seemeth to be joyous, but grievous: nevertheless afterward it yieldeth the peaceable fruit of righteousness unto them which are exercised thereby.* ¹² *Wherefore lift up the hands which hang down, and the feeble knees;* ¹³ *And make straight paths for your feet, lest that which is lame be turned out of the way; but let it rather be healed.* ¹⁴ *Follow peace with all men, and holiness, without which no man shall see the Lord:* ¹⁵ *Looking diligently lest any man fail of the grace of God; lest any root of bitterness springing up trouble you, and thereby many be defiled;* ¹⁶ *Lest there be any fornicator, or profane person, as Esau, who for one morsel of meat sold his birthright.* ¹⁷ *For ye know how that afterward, when he would have inherited the blessing, he was rejected: for he found no place of repentance, though he sought it carefully with tears.* ¹⁸ *For ye are not come unto the mount that might be touched, and that burned with fire, nor unto blackness, and darkness, and tempest,* ¹⁹ *And the sound of a trumpet, and the voice of words; which voice they that heard intreated that the word should not be spoken to them any more:* ²⁰ *(For they could not endure that which was commanded, And if so much as a beast touch the mountain, it shall be stoned, or thrust through with a dart:* ²¹ *And so terrible was the sight, that Moses said, I exceedingly*

fear and quake:) ²² *But ye are come unto mount Sion, and unto the city of the living God, the heavenly Jerusalem, and to an innumerable company of angels,* ²³ *To the general assembly and church of the firstborn, which are written in heaven, and to God the Judge of all, and to the spirits of just men made perfect,* ²⁴ *And to Jesus the mediator of the new covenant, and to the blood of sprinkling, that speaketh better things than that of Abel.* ²⁵ *See that ye refuse not him that speaketh. For if they escaped not who refused him that spake on earth, much more shall not we escape, if we turn away from him that speaketh from heaven:* ²⁶ *Whose voice then shook the earth: but now he hath promised, saying, Yet once more I shake not the earth only, but also heaven.* ²⁷ *And this word, Yet once more, signifieth the removing of those things that are shaken, as of things that are made, that those things which cannot be shaken may remain.* ²⁸ *Wherefore we receiving a kingdom which cannot be moved, let us have grace, whereby we may serve God acceptably with reverence and godly fear:* ²⁹ *For our God is a consuming fire.*

Explanation

Without patience, we cannot walk the walk. **Hebrew 12:1**

Gentleness

Text
Titus 3:2

Titus 3

¹ **Put them in mind to be subject to principalities and powers, to obey magistrates, to be ready to every good work,** ² **To speak evil of no man, to be no brawlers, but gentle, shewing all meekness unto all men.** ³ *For we ourselves also were sometimes foolish, disobedient, deceived, serving divers lusts and pleasures, living in malice and envy, hateful, and hating one another.* ⁴ *But after that the kindness and love of God our Saviour toward man appeared,* ⁵ *Not by works of righteousness which we have done, but according to his mercy he saved us, by the washing of regeneration, and renewing of the Holy Ghost;* ⁶ *Which he shed on us abundantly through Jesus Christ our Saviour;* ⁷ *That being justified by his grace, we should be made heirs according to the hope of eternal life.* ⁸ *This is a faithful saying, and these things I will*

that thou affirm constantly, that they which have believed in God might be careful to maintain good works. These things are good and profitable unto men. ⁹ But avoid foolish questions, and genealogies, and contentions, and strivings about the law; for they are unprofitable and vain. ¹⁰ A man that is an heretick after the first and second admonition reject; ¹¹ Knowing that he that is such is subverted, and sinneth, being condemned of himself. ¹² When I shall send Artemas unto thee, or Tychicus, be diligent to come unto me to Nicopolis: for I have determined there to winter. ¹³ Bring Zenas the lawyer and Apollos on their journey diligently, that nothing be wanting unto them. ¹⁴ And let our's also learn to maintain good works for necessary uses, that they be not unfruitful. ¹⁵ All that are with me salute thee. Greet them that love us in the faith. Grace be with you all. Amen.

Explanation

To possess gentleness is to have compassion and empathy for one another, as we remember, had it not been for the Grace of God, we could be that individual, or be in that circumstance. **Titus 3:2**

Goodness

Text
St. Luke 19:17

Luke 19

¹ And Jesus entered and passed through Jericho. ² And, behold, there was a man named Zacchaeus, which was the chief among the publicans, and he was rich. ³ And he sought to see Jesus who he was; and could not for the press, because he was little of stature. ⁴ And he ran before, and climbed up into a sycomore tree to see him: for he was to pass that way. ⁵ And when Jesus came to the place, he looked up, and saw him, and said unto him, Zacchaeus, make haste, and come down; for to day I must abide at thy house. ⁶ And he made haste, and came down, and received him joyfully. ⁷ And when they saw it, they all murmured, saying, That he was gone to be guest with a man that is a sinner. ⁸ And Zacchaeus stood, and said unto the Lord: Behold, Lord, the half of my goods I give to the poor; and if I have taken any thing from any man by false accusation, I restore him fourfold. ⁹ And Jesus said unto him, This

day is salvation come to this house, forsomuch as he also is a son of Abraham. ¹⁰ *For the Son of man is come to seek and to save that which was lost.* ¹¹ *And as they heard these things, he added and spake a parable, because he was nigh to Jerusalem, and because they thought that the kingdom of God should immediately appear.* ¹² *He said therefore, A certain nobleman went into a far country to receive for himself a kingdom, and to return.* ¹³ *And he called his ten servants, and delivered them ten pounds, and said unto them, Occupy till I come.* ¹⁴ *But his citizens hated him, and sent a message after him, saying, We will not have this man to reign over us.* ¹⁵ *And it came to pass, that when he was returned, having received the kingdom, then he commanded these servants to be called unto him, to whom he had given the money, that he might know how much every man had gained by trading.* ¹⁶ *Then came the first, saying, Lord, thy pound hath gained ten pounds.* ¹⁷ **And he said unto him, Well, thou good servant: because thou hast been faithful in a very little, have thou authority over ten cities.** ¹⁸ *And the second came, saying, Lord, thy pound hath gained five pounds.* ¹⁹ *And he said likewise to him, Be thou also over five cities.* ²⁰ *And another came, saying, Lord, behold, here is thy pound, which I have kept laid up in a napkin:* ²¹ *For I feared thee, because thou art an austere man: thou takest up that thou layedst not down, and reapest that thou didst not sow.* ²² *And he saith unto him, Out of thine own mouth will I judge thee, thou wicked servant. Thou knewest that I was an austere man, taking up that I laid not down, and reaping that I did not sow:* ²³ *Wherefore then gavest not thou my money into the bank, that at my coming I might have required mine own with usury?* ²⁴ *And he said unto them that stood by, Take from him the pound, and give it to him that hath ten pounds.* ²⁵ *(And they said unto him, Lord, he hath ten pounds.)* ²⁶ *For I say unto you, That unto every one which hath shall be given; and from him that hath not, even that he hath shall be taken away from him.* ²⁷ *But those mine enemies, which would not that I should reign over them, bring hither, and slay them before me.* ²⁸ *And when he had thus spoken, he went before, ascending up to Jerusalem.* ²⁹ *And it came to pass, when he was come nigh to Bethphage and Bethany, at the mount called the mount of Olives, he sent two of his disciples,* ³⁰ *Saying, Go ye into the village over against you; in the which at your entering ye shall find a colt tied, whereon yet never man sat: loose him, and bring him hither.* ³¹ *And if any man ask you, Why do ye loose him? thus shall ye say unto him, Because the Lord hath need of him.* ³² *And they that were sent went their way, and found even as he had said unto them.* ³³ *And as they were loosing the colt, the owners thereof said unto them, Why loose ye the colt?* ³⁴ *And they said, The Lord hath*

need of him. ³⁵ *And they brought him to Jesus: and they cast their garments upon the colt, and they set Jesus thereon.* ³⁶ *And as he went, they spread their clothes in the way.* ³⁷ *And when he was come nigh, even now at the descent of the mount of Olives, the whole multitude of the disciples began to rejoice and praise God with a loud voice for all the mighty works that they had seen;* ³⁸ *Saying, Blessed be the King that cometh in the name of the Lord: peace in heaven, and glory in the highest.* ³⁹ *And some of the Pharisees from among the multitude said unto him, Master, rebuke thy disciples.* ⁴⁰ *And he answered and said unto them, I tell you that, if these should hold their peace, the stones would immediately cry out.* ⁴¹ *And when he was come near, he beheld the city, and wept over it,* ⁴² *Saying, If thou hadst known, even thou, at least in this thy day, the things which belong unto thy peace! but now they are hid from thine eyes.* ⁴³ *For the days shall come upon thee, that thine enemies shall cast a trench about thee, and compass thee round, and keep thee in on every side,* ⁴⁴ *And shall lay thee even with the ground, and thy children within thee; and they shall not leave in thee one stone upon another; because thou knewest not the time of thy visitation.* ⁴⁵ *And he went into the temple, and began to cast out them that sold therein, and them that bought;* ⁴⁶ *Saying unto them, It is written, My house is the house of prayer: but ye have made it a den of thieves.* ⁴⁷ *And he taught daily in the temple. But the chief priests and the scribes and the chief of the people sought to destroy him,* ⁴⁸ *And could not find what they might do: for all the people were very attentive to hear him.*

Explanation

Goodness is having a **quality within** an individual serving as a means to a purpose. **St. Luke 19:17**

Faith

Text
St. James 1:5-6 (Refer to Joy, above for full text)
⁵*If any of you lack wisdom, let him ask of God, that giveth to all men liberally, and upbraideth not; and it shall be given him.* ⁶ *But let him ask in faith, nothing wavering. For he that wavereth is like a wave of the sea driven with the wind and tossed.*

145

Explanation

Faith is defined as to what we as believers cannot see, however, we know it exist. It exists, because we exist, through our Creator. **St. James 1:5-6**

Meekness

Text
St. Matthew 5:5

Matthew 5

*¹ And seeing the multitudes, he went up into a mountain: and when he was set, his disciples came unto him: ² And he opened his mouth, and taught them, saying, ³ Blessed are the poor in spirit: for theirs is the kingdom of heaven. ⁴ Blessed are they that mourn: for they shall be comforted. ⁵ **Blessed are the meek: for they shall inherit the earth.** ⁶ Blessed are they which do hunger and thirst after righteousness: for they shall be filled. ⁷ Blessed are the merciful: for they shall obtain mercy. ⁸ Blessed are the pure in heart: for they shall see God. ⁹ Blessed are the peacemakers: for they shall be called the children of God. ¹⁰ Blessed are they which are persecuted for righteousness' sake: for theirs is the kingdom of heaven. ¹¹ Blessed are ye, when men shall revile you, and persecute you, and shall say all manner of evil against you falsely, for my sake. ¹² Rejoice, and be exceeding glad: for great is your reward in heaven: for so persecuted they the prophets which were before you. ¹³ Ye are the salt of the earth: but if the salt have lost his savour, wherewith shall it be salted? it is thenceforth good for nothing, but to be cast out, and to be trodden under foot of men. ¹⁴ Ye are the light of the world. A city that is set on an hill cannot be hid. ¹⁵ Neither do men light a candle, and put it under a bushel, but on a candlestick; and it giveth light unto all that are in the house. ¹⁶ Let your light so shine before men, that they may see your good works, and glorify your Father which is in heaven. ¹⁷ Think not that I am come to destroy the law, or the prophets: I am not come to destroy, but to fulfil. ¹⁸ For verily I say unto you, Till heaven and earth pass, one jot or one tittle shall in no wise pass from the law, till all be fulfilled. ¹⁹ Whosoever therefore shall break one of these least commandments, and shall teach men so, he shall be called the least in the kingdom of heaven: but whosoever shall do and teach them, the same shall be called great in the kingdom of heaven. ²⁰ For I say unto you, That except your righteousness shall*

exceed the righteousness of the scribes and Pharisees, ye shall in no case enter into the kingdom of heaven. *²¹* Ye have heard that it was said of them of old time, Thou shalt not kill; and whosoever shall kill shall be in danger of the judgment: *²²* But I say unto you, That whosoever is angry with his brother without a cause shall be in danger of the judgment: and whosoever shall say to his brother, Raca, shall be in danger of the council: but whosoever shall say, Thou fool, shall be in danger of hell fire. *²³* Therefore if thou bring thy gift to the altar, and there rememberest that thy brother hath ought against thee; *²⁴* Leave there thy gift before the altar, and go thy way; first be reconciled to thy brother, and then come and offer thy gift. *²⁵* Agree with thine adversary quickly, whiles thou art in the way with him; lest at any time the adversary deliver thee to the judge, and the judge deliver thee to the officer, and thou be cast into prison. *²⁶* Verily I say unto thee, Thou shalt by no means come out thence, till thou hast paid the uttermost farthing. *²⁷* Ye have heard that it was said by them of old time, Thou shalt not commit adultery: *²⁸* But I say unto you, That whosoever looketh on a woman to lust after her hath committed adultery with her already in his heart. *²⁹* And if thy right eye offend thee, pluck it out, and cast it from thee: for it is profitable for thee that one of thy members should perish, and not that thy whole body should be cast into hell. *³⁰* And if thy right hand offend thee, cut it off, and cast it from thee: for it is profitable for thee that one of thy members should perish, and not that thy whole body should be cast into hell. *³¹* It hath been said, Whosoever shall put away his wife, let him give her a writing of divorcement: *³²* But I say unto you, That whosoever shall put away his wife, saving for the cause of fornication, causeth her to commit adultery: and whosoever shall marry her that is divorced committeth adultery. *³³* Again, ye have heard that it hath been said by them of old time, Thou shalt not forswear thyself, but shalt perform unto the Lord thine oaths: *³⁴* But I say unto you, Swear not at all; neither by heaven; for it is God's throne: *³⁵* Nor by the earth; for it is his footstool: neither by Jerusalem; for it is the city of the great King. *³⁶* Neither shalt thou swear by thy head, because thou canst not make one hair white or black. *³⁷* But let your communication be, Yea, yea; Nay, nay: for whatsoever is more than these cometh of evil. *³⁸* Ye have heard that it hath been said, An eye for an eye, and a tooth for a tooth: *³⁹* But I say unto you, That ye resist not evil: but whosoever shall smite thee on thy right cheek, turn to him the other also. *⁴⁰* And if any man will sue thee at the law, and take away thy coat, let him have thy cloak also. *⁴¹* And whosoever shall compel thee to go a mile, go with him twain. *⁴²* Give to him that asketh thee, and from him that would borrow of thee turn not thou away. *⁴³* Ye have heard that it hath been

said, Thou shalt love thy neighbour, and hate thine enemy. [44] But I say unto you, Love your enemies, bless them that curse you, do good to them that hate you, and pray for them which despitefully use you, and persecute you; [45] That ye may be the children of your Father which is in heaven: for he maketh his sun to rise on the evil and on the good, and sendeth rain on the just and on the unjust. [46] For if ye love them which love you, what reward have ye? do not even the publicans the same? [47] And if ye salute your brethren only, what do ye more than others? do not even the publicans so? [48] Be ye therefore perfect, even as your Father which is in heaven is perfect.

Explanation

Meekness is knowing that we do not have to win in every conversation, or outdo someone else. Let the other person have the last word. Let the other person win, even though we know that we have the ability to do so. This is defined as meekness or humility. **St. Matthew 5:5**

Temperance

Text
Philippians 4:5 (See beginning of the chapter for full text)
Let your moderation be known unto all men. The Lord is at hand.

Explanation

Temperance may be defined as not doing anything in excess, by maintaining a balance in our lives. Temperance knows when there is enough. **Philippians 4:5**

Conclusion

- There are nine fruit of the spirit that should be operating in the life of the believer, daily.
- These spiritual manifestations of goodness and spirituality in the believer's life, tells others that you are a servant of the Most High God, who is called El Elyon.
- We are the light of the world, surrounded by a world of darkness, clouded by evil.

- Jesus is the Light of the World, and as followers of Christ, we are also called the light of the world. Why are we, also called the light of the world, according to St. Matthew?
- Read St. Matthew 5:16
- Let your light so shine before men, that they might see your good works and glorify the Father which is in heaven.
- The light is God the Holy Spirit, illuminating through the body of the believer, as he walks by faith and not by sight, in accordance to the Word of God.
- In abiding by the Word of God, the Fruit of the Spirit will manifest itself, through the daily life of the believers and others will see what that persons possesses: goodness faith meekness longsuffering peace love joy

1. goodness
2. faith
3. meekness
4. longsuffering
5. peace
6. love
7. 7oy

Questions

Name eight components of the Fruit of the Spirit. What is the scripture text?

The Fruit of the Spirit Scripture

Why is our spiritual walk, a walk by faith, according to Hebrews 11: 1 and 16? Hebrews 11:1, which states:

Now faith is the substance of things hoped for and the evidence of things not seen. We walk by faith and not by sight. We were not eye witnesses to:

From what was previously stated, also explain Hebrews 11:6 Hebrews 11:6 states, But without faith, it is impossible to please him, for he that cometh to God must believe that he is, and that he is a rewarder of them that diligently seek him.

Thought Question

Why do you think the fruit of the Spirit, manifest in the believer's life is called the Fruit?

It is grown. It begins as a seed, branches proceed, and the final result a product is produced. Therefore the believers have then achieved spiritual maturity. If someone does us wrong, we can forgive. This is an example of spiritual maturity.

The Whole Armor of God
Chapter 2

Text
Ephesians 6: 13-17

Introduction

Once we accept the gift of eternal life, and the Day Star becomes our Lord and Personal Savior, and our Redeemer, we find that we have been indoctrinated into a spiritual warfare. This spiritual ware fare is against: sin, flesh, and the devil. The mission of the Adversary is found in St. John 10:10 which states that he comes to kill, to steal, and to destroy. The mission of our flesh is to remind us of how things use to be, and to entice the believers with those thoughts. Finally, we commit sin, by doing what is contrary to the will of God. Consequently, we perform an unrighteous act. Therefore, since we are at war with ourselves, consisting of the carnal man, and the spiritual man, Romans 7:14-25 along with being at war with the desires of the flesh, we are also at war with the Adversary. Therefore, it be woes us to put on the Whole Amour of God, so that we may be able to stand in that evil day, as the Word of God states. In this lesson we shall connect each amour of God with a cross reference text.

The Lesson

Text
Ephesians 6: 13-17

Ephesians 6

¹ Children, obey your parents in the Lord: for this is right. ² Honour thy father and mother; which is the first commandment with promise; ³ That it may be well with thee, and thou mayest live long on the earth. ⁴ And, ye fathers, provoke not your children to wrath: but bring them up in the nurture and

*admonition of the Lord. ⁵ Servants, be obedient to them that are your masters according to the flesh, with fear and trembling, in singleness of your heart, as unto Christ; ⁶ Not with eyeservice, as menpleasers; but as the servants of Christ, doing the will of God from the heart; ⁷ With good will doing service, as to the Lord, and not to men: ⁸ Knowing that whatsoever good thing any man doeth, the same shall he receive of the Lord, whether he be bond or free. ⁹ And, ye masters, do the same things unto them, forbearing threatening: knowing that your Master also is in heaven; neither is there respect of persons with him. ¹⁰ Finally, my brethren, be strong in the Lord, and in the power of his might. ¹¹ Put on the whole armour of God, that ye may be able to stand against the wiles of the devil. ¹² For we wrestle not against flesh and blood, but against principalities, against powers, against the rulers of the darkness of this world, against spiritual wickedness in high places. ¹³ **Wherefore take unto you the whole armour of God, that ye may be able to withstand in the evil day, and having done all, to stand. ¹⁴ Stand therefore, having your loins girt about with truth, and having on the breastplate of righteousness; ¹⁵ And your feet shod with the preparation of the gospel of peace; ¹⁶ Above all, taking the shield of faith, wherewith ye shall be able to quench all the fiery darts of the wicked. ¹⁷ And take the helmet of salvation, and the sword of the Spirit, which is the word of God:** ¹⁸ Praying always with all prayer and supplication in the Spirit, and watching thereunto with all perseverance and supplication for all saints; ¹⁹ And for me, that utterance may be given unto me, that I may open my mouth boldly, to make known the mystery of the gospel, ²⁰ For which I am an ambassador in bonds: that therein I may speak boldly, as I ought to speak. ²¹ But that ye also may know my affairs, and how I do, Tychicus, a beloved brother and faithful minister in the Lord, shall make known to you all things: ²² Whom I have sent unto you for the same purpose, that ye might know our affairs, and that he might comfort your hearts. ²³ Peace be to the brethren, and love with faith, from God the Father and the Lord Jesus Christ. ²⁴ Grace be with all them that love our Lord Jesus Christ in sincerity. Amen.*

Explanation

12-13 First, we need the Whole Armor of God to be able to stand in this evil day, states these two verses. Each main part of our **bodies must be covered** by what is needed. **Ephesians 6: 13-17**

Loins girt about with Truth

Text
St. John 14:6

John 14

¹ Let not your heart be troubled: ye believe in God, believe also in me. ² In my Father's house are many mansions: if it were not so, I would have told you. I go to prepare a place for you. ³ And if I go and prepare a place for you, I will come again, and receive you unto myself; that where I am, there ye may be also. ⁴ And whither I go ye know, and the way ye know. ⁵ Thomas saith unto him, Lord, we know not whither thou goest; and how can we know the way?
⁶ *Jesus saith unto him, I am the way, the truth, and the life: no man cometh unto the Father, but by me.* *⁷ If ye had known me, ye should have known my Father also: and from henceforth ye know him, and have seen him. ⁸ Philip saith unto him, Lord, shew us the Father, and it sufficeth us. ⁹ Jesus saith unto him, Have I been so long time with you, and yet hast thou not known me, Philip? he that hath seen me hath seen the Father; and how sayest thou then, Shew us the Father? ¹⁰ Believest thou not that I am in the Father, and the Father in me? the words that I speak unto you I speak not of myself: but the Father that dwelleth in me, he doeth the works. ¹¹ Believe me that I am in the Father, and the Father in me: or else believe me for the very works' sake. ¹² Verily, verily, I say unto you, He that believeth on me, the works that I do shall he do also; and greater works than these shall he do; because I go unto my Father. ¹³ And whatsoever ye shall ask in my name, that will I do, that the Father may be glorified in the Son. ¹⁴ If ye shall ask any thing in my name, I will do it. ¹⁵ If ye love me, keep my commandments. ¹⁶ And I will pray the Father, and he shall give you another Comforter, that he may abide with you for ever; ¹⁷ Even the Spirit of truth; whom the world cannot receive, because it seeth him not, neither knoweth him: but ye know him; for he dwelleth with you, and shall be in you. ¹⁸ I will not leave you comfortless: I will come to you. ¹⁹ Yet a little while, and the world seeth me no more; but ye see me: because I live, ye shall live also. ²⁰ At that day ye shall know that I am in my Father, and ye in me, and I in you. ²¹ He that hath my commandments, and keepeth them, he it is that loveth me: and he that loveth me shall be loved of my Father, and I will love him, and will manifest myself to him. ²² Judas saith unto him, not Iscariot, Lord, how is it that thou wilt manifest thyself unto us,*

and not unto the world? [23] *Jesus answered and said unto him, If a man love me, he will keep my words: and my Father will love him, and we will come unto him, and make our abode with him.* [24] *He that loveth me not keepeth not my sayings: and the word which ye hear is not mine, but the Father's which sent me.* [25] *These things have I spoken unto you, being yet present with you.* [26] *But the Comforter, which is the Holy Ghost, whom the Father will send in my name, he shall teach you all things, and bring all things to your remembrance, whatsoever I have said unto you.* [27] *Peace I leave with you, my peace I give unto you: not as the world giveth, give I unto you. Let not your heart be troubled, neither let it be afraid.* [28] *Ye have heard how I said unto you, I go away, and come again unto you. If ye loved me, ye would rejoice, because I said, I go unto the Father: for my Father is greater than I.* [29] *And now I have told you before it come to pass, that, when it is come to pass, ye might believe.* [30] *Hereafter I will not talk much with you: for the prince of this world cometh, and hath nothing in me.* [31] *But that the world may know that I love the Father; and as the Father gave me commandment, even so I do. Arise, let us go hence.*

Explanation

This is the covering for the **back** and the lower sides of the back. **Ephesians 6: 13-17**

The Breastplate of Righteousness

Text
I John 1:7

1 John 1

[1] *That which was from the beginning, which we have heard, which we have seen with our eyes, which we have looked upon, and our hands have handled, of the Word of life;* [2] *(For the life was manifested, and we have seen it, and bear witness, and shew unto you that eternal life, which was with the Father, and was manifested unto us;)* [3] *That which we have seen and heard declare we unto you, that ye also may have fellowship with us: and truly our fellowship is with the Father, and with his Son Jesus Christ.* [4] *And these things write we unto you, that your joy may be full.* [5] *This then is the message which we have heard of him, and declare unto you, that God is light, and in him is*

*no darkness at all. ⁶ If we say that we have fellowship with him, and walk in darkness, we lie, and do not the truth: ⁷ **But if we walk in the light, as he is in the light, we have fellowship one with another, and the blood of Jesus Christ his Son cleanseth us from all sin.** ⁸ If we say that we have no sin, we deceive ourselves, and the truth is not in us. ⁹ If we confess our sins, he is faithful and just to forgive us our sins, and to cleanse us from all unrighteousness. ¹⁰ If we say that we have not sinned, we make him a liar, and his word is not in us.*

Explanation

Our hearts need to be protected by the **covering of righteousness. I John 1:7**

Gospel of peace

Text
Romans 11:15

Romans 11

¹ I say then, Hath God cast away his people? God forbid. For I also am an Israelite, of the seed of Abraham, of the tribe of Benjamin. ² God hath not cast away his people which he foreknew. Wot ye not what the scripture saith of Elias? how he maketh intercession to God against Israel saying, ³ Lord, they have killed thy prophets, and digged down thine altars; and I am left alone, and they seek my life. ⁴ But what saith the answer of God unto him? I have reserved to myself seven thousand men, who have not bowed the knee to the image of Baal. ⁵ Even so then at this present time also there is a remnant according to the election of grace. ⁶ And if by grace, then is it no more of works: otherwise grace is no more grace. But if it be of works, then it is no more grace: otherwise work is no more work. ⁷ What then? Israel hath not obtained that which he seeketh for; but the election hath obtained it, and the rest were blinded. ⁸ (According as it is written, God hath given them the spirit of slumber, eyes that they should not see, and ears that they should not hear;) unto this day. ⁹ And David saith, Let their table be made a snare, and a trap, and a stumblingblock, and a recompence unto them: ¹⁰ Let their eyes be darkened, that they may not see, and bow down their back alway. ¹¹ I say

then, Have they stumbled that they should fall? God forbid: but rather through their fall salvation is come unto the Gentiles, for to provoke them to jealousy. *¹² Now if the fall of them be the riches of the world, and the diminishing of them the riches of the Gentiles; how much more their fulness? ¹³ For I speak to you Gentiles, inasmuch as I am the apostle of the Gentiles, I magnify mine office: ¹⁴ If by any means I may provoke to emulation them which are my flesh, and might save some of them.* **¹⁵For if the casting away of them be the reconciling of the world, what shall the receiving of them be, but life from the dead?** *¹⁶ For if the firstfruit be holy, the lump is also holy: and if the root be holy, so are the branches. ¹⁷ And if some of the branches be broken off, and thou, being a wild olive tree, wert graffed in among them, and with them partakest of the root and fatness of the olive tree; ¹⁸ Boast not against the branches. But if thou boast, thou bearest not the root, but the root thee. ¹⁹ Thou wilt say then, the branches were broken off, that I might be graffed in. ²⁰ Well; because of unbelief they were broken off, and thou standest by faith. Be not highminded, but fear: ²¹ For if God spared not the natural branches, take heed lest he also spare not thee. ²² Behold therefore the goodness and severity of God: on them which fell, severity; but toward thee, goodness, if thou continue in his goodness: otherwise thou also shalt be cut off. ²³ And they also, if they abide not still in unbelief, shall be graffed in: for God is able to graff them in again. ²⁴ For if thou wert cut out of the olive tree which is wild by nature, and wert graffed contrary to nature into a good olive tree: how much more shall these, which be the natural branches, be graffed into their own olive tree? ²⁵ For I would not, brethren, that ye should be ignorant of this mystery, lest ye should be wise in your own conceits; that blindness in part is happened to Israel, until the fulness of the Gentiles be come in. ²⁶ And so all Israel shall be saved: as it is written, There shall come out of Sion the Deliverer, and shall turn away ungodliness from Jacob: ²⁷ For this is my covenant unto them, when I shall take away their sins. ²⁸ As concerning the gospel, they are enemies for your sakes: but as touching the election, they are beloved for the father's sakes. ²⁹ For the gifts and calling of God are without repentance. ³⁰ For as ye in times past have not believed God, yet have now obtained mercy through their unbelief: ³¹ Even so have these also now not believed, that through your mercy they also may obtain mercy. ³² For God hath concluded them all in unbelief, that he might have mercy upon all. ³³ O the depth of the riches both of the wisdom and knowledge of God! how unsearchable are his judgments, and his ways past finding out! ³⁴ For who hath known the mind of the Lord? or who hath been his counsellor? ³⁵ Or who hath first given to him, and it shall be*

recompensed unto him again? [36] *For of him, and through him, and to him, are all things: to whom be glory for ever. Amen.*

Explanation

Gospel of Peace is what we, as believers carry in our minds and hearts, as we spread the Good News that Jesus saves, heals delivers and sets the captives free through the salvation of the redemptive blood, shed on the Cross for the sins of mankind. **Romans 11:15**

Shield of faith

Text
Hebrew 11: 1, 6

Hebrews 11

[1] *Now faith is the substance of things hoped for, the evidence of things not seen.* [2] *For by it the elders obtained a good report.* [3] *Through faith we understand that the worlds were framed by the word of God, so that things which are seen were not made of things which do appear.* [4] *By faith Abel offered unto God a more excellent sacrifice than Cain, by which he obtained witness that he was righteous, God testifying of his gifts: and by it he being dead yet speaketh.* [5] *By faith Enoch was translated that he should not see death; and was not found, because God had translated him: for before his translation he had this testimony, that he pleased God.* [6] **But without faith it is impossible to please him: for he that cometh to God must believe that he is, and that he is a rewarder of them that diligently seek him.** [7] *By faith Noah, being warned of God of things not seen as yet, moved with fear, prepared an ark to the saving of his house; by the which he condemned the world, and became heir of the righteousness which is by faith.* [8] *By faith Abraham, when he was called to go out into a place which he should after receive for an inheritance, obeyed; and he went out, not knowing whither he went.* [9] *By faith he sojourned in the land of promise, as in a strange country, dwelling in tabernacles with Isaac and Jacob, the heirs with him of the same promise:* [10] *For he looked for a city which hath foundations, whose builder and maker is God.* [11] *Through faith also Sara herself received strength to conceive seed, and was delivered of a child when she was past age, because she judged him faithful who had promised.*

[12] Therefore sprang there even of one, and him as good as dead, so many as the stars of the sky in multitude, and as the sand which is by the sea shore innumerable. [13] These all died in faith, not having received the promises, but having seen them afar off, and were persuaded of them, and embraced them, and confessed that they were strangers and pilgrims on the earth. [14] For they that say such things declare plainly that they seek a country. [15] And truly, if they had been mindful of that country from whence they came out, they might have had opportunity to have returned. [16] But now they desire a better country, that is, an heavenly: wherefore God is not ashamed to be called their God: for he hath prepared for them a city. [17] By faith Abraham, when he was tried, offered up Isaac: and he that had received the promises offered up his only begotten son, [18] Of whom it was said, That in Isaac shall thy seed be called: [19] Accounting that God was able to raise him up, even from the dead; from whence also he received him in a figure. [20] By faith Isaac blessed Jacob and Esau concerning things to come. [21] By faith Jacob, when he was a dying, blessed both the sons of Joseph; and worshipped, leaning upon the top of his staff. [22] By faith Joseph, when he died, made mention of the departing of the children of Israel; and gave commandment concerning his bones. [23] By faith Moses, when he was born, was hid three months of his parents, because they saw he was a proper child; and they were not afraid of the king's commandment. [24] By faith Moses, when he was come to years, refused to be called the son of Pharaoh's daughter; [25] Choosing rather to suffer affliction with the people of God, than to enjoy the pleasures of sin for a season; [26] Esteeming the reproach of Christ greater riches than the treasures in Egypt: for he had respect unto the recompence of the reward. [27] By faith he forsook Egypt, not fearing the wrath of the king: for he endured, as seeing him who is invisible. [28] Through faith he kept the passover, and the sprinkling of blood, lest he that destroyed the firstborn should touch them. [29] By faith they passed through the Red sea as by dry land: which the Egyptians assaying to do were drowned. [30] By faith the walls of Jericho fell down, after they were compassed about seven days. [31] By faith the harlot Rahab perished not with them that believed not, when she had received the spies with peace. [32] And what shall I more say? for the time would fail me to tell of Gedeon, and of Barak, and of Samson, and of Jephthae; of David also, and Samuel, and of the prophets: [33] Who through faith subdued kingdoms, wrought righteousness, obtained promises, stopped the mouths of lions. [34] Quenched the violence of fire, escaped the edge of the sword, out of weakness were made strong, waxed valiant in fight, turned to flight the armies of the aliens. [35] Women received their dead raised to life again: and

others were tortured, not accepting deliverance; that they might obtain a better resurrection: ³⁶ And others had trial of cruel mockings and scourgings, yea, moreover of bonds and imprisonment: ³⁷ They were stoned, they were sawn asunder, were tempted, were slain with the sword: they wandered about in sheepskins and goatskins; being destitute, afflicted, tormented; ³⁸ (Of whom the world was not worthy:) they wandered in deserts, and in mountains, and in dens and caves of the earth. ³⁹ And these all, having obtained a good report through faith, received not the promise: ⁴⁰ God having provided some better thing for us, that they without us should not be made perfect.

Explanation

Faith is what we cannot see, but what we, as believers, believe in. **Hebrew 11: 1, 6**

Helmet of Salvation

Text
Ephesians 2:8-9 (Unit 3, chapter 1, full text)
⁸ For by grace are ye saved through faith; and that not of yourselves: it is the gift of God: ⁹ Not of works, lest any man should boast.

Explanation

The helmet is to protect the mind from **having doubts** pertaining to the believer's salvation. Doubts are what enter the mind; therefore, a protective covering is needed for the head. **Ephesians 2:8-9**

Sword of the Spirit

Text
Hebrews 4:12

Hebrews 4

¹ Let us therefore fear, lest, a promise being left us of entering into his rest, any of you should seem to come short of it. ² For unto us was the gospel preached, as well as unto them: but the word preached did not profit them, not being

*mixed with faith in them that heard it. ³ For we which have believed do enter into rest, as he said, As I have sworn in my wrath, if they shall enter into my rest: although the works were finished from the foundation of the world. ⁴ For he spake in a certain place of the seventh day on this wise, And God did rest the seventh day from all his works. ⁵ And in this place again, If they shall enter into my rest. ⁶ Seeing therefore it remaineth that some must enter therein, and they to whom it was first preached entered not in because of unbelief: ⁷ Again, he limiteth a certain day, saying in David, To day, after so long a time; as it is said, To day if ye will hear his voice, harden not your hearts. ⁸ For if Jesus had given them rest, then would he not afterward have spoken of another day. ⁹ There remaineth therefore a rest to the people of God. ¹⁰ For he that is entered into his rest, he also hath ceased from his own works, as God did from his. ¹¹ Let us labour therefore to enter into that rest, lest any man fall after the same example of unbelief. ¹² **For the word of God is quick, and powerful, and sharper than any twoedged sword, piercing even to the dividing asunder of soul and spirit, and of the joints and marrow, and is a discerner of the thoughts and intents of the heart.** ¹³ Neither is there any creature that is not manifest in his sight: but all things are naked and opened unto the eyes of him with whom we have to do. ¹⁴ Seeing then that we have a great high priest, that is passed into the heavens, Jesus the Son of God, let us hold fast our profession. ¹⁵ For we have not an high priest which cannot be touched with the feeling of our infirmities; but was in all points tempted like as we are, yet without sin. ¹⁶ Let us therefore come boldly unto the throne of grace, that we may obtain mercy, and find grace to help in time of need.*

Explanation

This is the Word of God, which believers must learn how to use to ward off the very **appearance** of sin, evil and trespassing against God. **Hebrews 4:12**

Conclusion

- We as believers in Christ Jesus are in a spiritual warfare.
- Therefore, we can grow spiritually, if we know the importance of having on the Whole Amour of God.
- Having on the Whole Amour of God also consists with knowing the basic principle and teachings of the Word of God.

Questions

Name the seven parts of the whole armor of God and their purposes. Where is the text located in the bible?

Names Purpose Text

What is it that we must do, when we do not know what to do, or seem to have gone our limit?

_____Give up, and feel sorry for ourselves

_____Constantly talk to God about it all day and all night while we are awake

_____Have the shield of faith to believe that things will work out, once we give it to the

_____Lord in prayer and stand our ground, having unwavering faith

_____Take matters into our own hand.

_____All of the above

According to Hebrew 9:12, what are the tasks of the sword of the spirit? Name three things that identify its tasks.

Once we accept the Lord Jesus Christ as our Personal Savior, we embark against a spiritual journey, which can also be defined as a w___f___

As believers in Christ Jesus, we daily war against _____ , _____ and the _____.

The daily job of the Adversary can be divided into three categories, in which he goes about deceiving, and enticing the believer. Therefore he _____, _____, and _____.Where is it located?

There are two types of man in our body of flesh that war against each other constantly. Therefore, there is a need to put on the_____ of _____. These two forces that war inwardly are called the _____man and the_____man.

Thought Questions

If you had a picture of you being dressed in the whole armor of God, what do you think you would look like?

Seven Categories of Sin
Chapter 3

Text
Proverbs 6: 16-19

Introduction

In accordance to the Holy Spirits or the word of God, all sin can be characterized into (7) basic categories. Sin is any act that we perform that defies the teachings and principles of the word of God. In this text, we shall expound upon them.

The Lesson

Text
Proverbs 6: 16-19

Proverbs 6

*¹ My son, if thou be surety for thy friend, if thou hast stricken thy hand with a stranger, ² Thou art snared with the words of thy mouth, thou art taken with the words of thy mouth. ³ Do this now, my son, and deliver thyself, when thou art come into the hand of thy friend; go, humble thyself, and make sure thy friend. ⁴ Give not sleep to thine eyes, nor slumber to thine eyelids. ⁵ Deliver thyself as a roe from the hand of the hunter, and as a bird from the hand of the fowler. ⁶ Go to the ant, thou sluggard; consider her ways, and be wise: ⁷ Which having no guide, overseer, or ruler, ⁸ Provideth her meat in the summer, and gathereth her food in the harvest. ⁹ How long wilt thou sleep, O sluggard? when wilt thou arise out of thy sleep? ¹⁰ Yet a little sleep, a little slumber, a little folding of the hands to sleep: ¹¹ So shall thy poverty come as one that travelleth, and thy want as an armed man. ¹² A naughty person, a wicked man, walketh with a froward mouth. ¹³ He winketh with his eyes, he speaketh with his feet, he teacheth with his fingers; **¹⁴ Frowardness is in his heart, he deviseth***

mischief continually; he soweth discord. [15] *Therefore shall his calamity come suddenly; suddenly shall he be broken without remedy.* [16] **These six things doth the LORD hate: yea, seven are an abomination unto him:** [17] **A proud look, a lying tongue, and hands that shed innocent blood,** [18] **An heart that deviseth wicked imaginations, feet that be swift in running to mischief,** [19] **A false witness that speaketh lies, and he that soweth discord among brethren.** [20] *My son, keep thy father's commandment, and forsake not the law of thy mother:* [21] *Bind them continually upon thine heart, and tie them about thy neck.* [22] *When thou goest, it shall lead thee; when thou sleepest, it shall keep thee; and when thou awakest, it shall talk with thee.* [23] *For the commandment is a lamp; and the law is light; and reproofs of instruction are the way of life:* [24] *To keep thee from the evil woman, from the flattery of the tongue of a strange woman.* [25] *Lust not after her beauty in thine heart; neither let her take thee with her eyelids.* [26] *For by means of a whorish woman a man is brought to a piece of bread: and the adultress will hunt for the precious life.* [27] *Can a man take fire in his bosom, and his clothes not be burned?* [28] *Can one go upon hot coals, and his feet not be burned?* [29] *So he that goeth in to his neighbour's wife; whosoever toucheth her shall not be innocent.* [30] *Men do not despise a thief, if he steal to satisfy his soul when he is hungry;* [31] *But if he be found, he shall restore sevenfold; he shall give all the substance of his house.* [32] *But whoso committeth adultery with a woman lacketh understanding: he that doeth it destroyeth his own soul.* [33] *A wound and dishonour shall he get; and his reproach shall not be wiped away.* [34] *For jealousy is the rage of a man: therefore he will not spare in the day of vengeance.* [35] *He will not regard any ransom; neither will he rest content, though thou givest many gifts.*

Explanation

This text provides a guideline for each category of sin. Those that enjoy stirring up trouble, who are also called busy bodies are classified as one of the worse sins committed. We will not fully understand why, however this we do know:

- God is not the author of confusion. (**I Corinthians 14:33**)
- A servant of God's witness and testimony, in a symbol of his repetition. (**St. Matthew 5:16**)
- Servants of God cannot be living epistles for God, with a marred testimony. (**II Corinthians 3:2**)

- The Word of God further states, that the testimony of Jesus is the Spirit of Prophecy. **Revelation 19:10; Proverbs 6: 16-19**

A proud look

Text
St. Matthew 19:17

Matthew 19

[1] And it came to pass, that when Jesus had finished these sayings, he departed from Galilee, and came into the coasts of Judaea beyond Jordan; [2] And great multitudes followed him; and he healed them there. [3] The Pharisees also came unto him, tempting him, and saying unto him, Is it lawful for a man to put away his wife for every cause? [4] And he answered and said unto them, Have ye not read, that he which made them at the beginning made them male and female, [5] And said, For this cause shall a man leave father and mother, and shall cleave to his wife: and they twain shall be one flesh? [6] Wherefore they are no more twain, but one flesh. What therefore God hath joined together, let not man put asunder. [7] They say unto him, Why did Moses then command to give a writing of divorcement, and to put her away? [8] He saith unto them, Moses because of the hardness of your hearts suffered you to put away your wives: but from the beginning it was not so. [9] And I say unto you, Whosoever shall put away his wife, except it be for fornication, and shall marry another, committeth adultery: and whoso marrieth her which is put away doth commit adultery. [10] His disciples say unto him, If the case of the man be so with his wife, it is not good to marry. [11] But he said unto them, All men cannot receive this saying, save they to whom it is given. [12] For there are some eunuchs, which were so born from their mother's womb: and there are some eunuchs, which were made eunuchs of men: and there be eunuchs, which have made themselves eunuchs for the kingdom of heaven's sake. He that is able to receive it, let him receive it. [13] Then were there brought unto him little children, that he should put his hands on them, and pray: and the disciples rebuked them. [14] But Jesus said, Suffer little children, and forbid them not, to come unto me: for of such is the kingdom of heaven. [15] And he laid his hands on them, and departed thence. [16] And, behold, one came and said unto him, Good Master, what good thing shall I do, that I may have eternal life? **[17] And he said unto him, Why callest thou me good? there is none good but one, that is, God: but if**

thou wilt enter into life, keep the commandments. *[18] He saith unto him, Which? Jesus said, Thou shalt do no murder, Thou shalt not commit adultery, Thou shalt not steal, Thou shalt not bear false witness, [19] Honour thy father and thy mother: and, Thou shalt love thy neighbour as thyself. [20] The young man saith unto him, All these things have I kept from my youth up: what lack I yet? [21] Jesus said unto him, If thou wilt be perfect, go and sell that thou hast, and give to the poor, and thou shalt have treasure in heaven: and come and follow me. [22] But when the young man heard that saying, he went away sorrowful: for he had great possessions. [23] Then said Jesus unto his disciples, Verily I say unto you, That a rich man shall hardly enter into the kingdom of heaven. [24] And again I say unto you, It is easier for a camel to go through the eye of a needle, than for a rich man to enter into the kingdom of God. [25] When his disciples heard it, they were exceedingly amazed, saying, Who then can be saved? [26] But Jesus beheld them, and said unto them, with men this is impossible; but with God all things are possible. [27] Then answered Peter and said unto him, Behold, we have forsaken all, and followed thee; what shall we have therefore? [28] And Jesus said unto them, Verily I say unto you, That ye which have followed me, in the regeneration when the Son of man shall sit in the throne of his glory, ye also shall sit upon twelve thrones, judging the twelve tribes of Israel. [29] And every one that hath forsaken houses, or brethren, or sisters, or father, or mother, or wife, or children, or lands, for my name's sake, shall receive an hundredfold, and shall inherit everlasting life. [30] But many that are first shall be last; and the last shall be first.*

Explanation
Proud may be defined in two ways

There are some of us who think that everything we have accomplished, we have accomplished on our own. Therefore we are proud, because we think that we donot need God, when it was God who woke us up this morning. We could not do that on our own. We who think that we are better than others is defined as a proud look. The Word of God says that all of us are as unrighteous. It is only through the blood of The Lord and Savior Jesus Christ that we are counted righteous. **St. Matthew 19:17**

A lying tongue
Psalms 34

Text

Psalm 34:13

*¹ I will bless the LORD at all times: his praise shall continually be in my mouth. ² My soul shall make her boast in the LORD: the humble shall hear thereof, and be glad. ³ O magnify the LORD with me, and let us exalt his name together. ⁴ I sought the LORD, and he heard me, and delivered me from all my fears. ⁵ They looked unto him, and were lightened: and their faces were not ashamed. ⁶ This poor man cried, and the LORD heard him, and saved him out of all his troubles. ⁷ The angel of the LORD encampeth round about them that fear him, and delivereth them. ⁸ O taste and see that the LORD is good: blessed is the man that trusteth in him. ⁹ O fear the LORD, ye his saints: for there is no want to them that fear him. ¹⁰ The young lions do lack, and suffer hunger: but they that seek the LORD shall not want any good thing. ¹¹ Come, ye children, hearken unto me: I will teach you the fear of the LORD. ¹² What man is he that desireth life, and loveth many days, that he may see good? ¹³ **Keep thy tongue from evil, and thy lips from speaking guile.** ¹⁴ Depart from evil, and do good; seek peace, and pursue it. ¹⁵ The eyes of the LORD are upon the righteous, and his ears are open unto their cry. ¹⁶ The face of the LORD is against them that do evil, to cut off the remembrance of them from the earth. ¹⁷ The righteous cry, and the LORD heareth, and delivereth them out of all their troubles. ¹⁸ The LORD is nigh unto them that are of a broken heart; and saveth such as be of a contrite spirit. ¹⁹ Many are the afflictions of the righteous: but the LORD delivereth him out of them all. ²⁰ He keepeth all his bones: not one of them is broken. ²¹ Evil shall slay the wicked: and they that hate the righteous shall be desolate. ²² The LORD redeemeth the soul of his servants: and none of them that trust in him shall be desolate.*

Explanation

Keep thy tongue from evil, and thy lips from speaking guile. Religious in this passage, implies to those who are spiritual. Therefore, we should watch and think about what **we say** and should be **slow to speak**. This is defined as putting a bridle on our tongue.**Psalm 34:13**

Hands that shed innocent blood

Text
Exodus 20:13

Exodus 20

*¹ And God spake all these words, saying, ² I am the LORD thy God, which have brought thee out of the land of Egypt, out of the house of bondage. ³ Thou shalt have no other gods before me. ⁴ Thou shalt not make unto thee any graven image, or any likeness of any thing that is in heaven above, or that is in the earth beneath, or that is in the water under the earth. ⁵ Thou shalt not bow down thyself to them, nor serve them: for I the LORD thy God am a jealous God, visiting the iniquity of the fathers upon the children unto the third and fourth generation of them that hate me; ⁶ And shewing mercy unto thousands of them that love me, and keep my commandments. ⁷ Thou shalt not take the name of the LORD thy God in vain; for the LORD will not hold him guiltless that taketh his name in vain. ⁸ Remember the sabbath day, to keep it holy. ⁹ Six days shalt thou labour, and do all thy work: ¹⁰ But the seventh day is the sabbath of the LORD thy God: in it thou shalt not do any work, thou, nor thy son, nor thy daughter, thy manservant, nor thy maidservant, nor thy cattle, nor thy stranger that is within thy gates: ¹¹ For in six days the LORD made heaven and earth, the sea, and all that in them is, and rested the seventh day: wherefore the LORD blessed the sabbath day, and hallowed it. ¹² Honour thy father and thy mother: that thy days may be long upon the land which the LORD thy God giveth thee. ¹³ **Thou shalt not kill.** ¹⁴ Thou shalt not commit adultery. ¹⁵ Thou shalt not steal. ¹⁶ Thou shalt not bear false witness against thy neighbour. ¹⁷ Thou shalt not covet thy neighbour's house, thou shalt not covet thy neighbour's wife, nor his manservant, nor his maidservant, nor his ox, nor his ass, nor any thing that is thy neighbour's. ¹⁸ And all the people saw the thunderings, and the lightnings, and the noise of the trumpet, and the mountain smoking: and when the people saw it, they removed, and stood afar off. ¹⁹ And they said unto Moses, Speak thou with us, and we will hear: but let not God speak with us, lest we die. ²⁰ And Moses said unto the people, Fear not: for God is come to prove you, and that his fear may be before your faces, that ye sin not. ²¹ And the people stood afar off, and Moses drew near unto the thick darkness where God was. ²² And the LORD said unto Moses, Thus thou shalt say unto the children of Israel, Ye have seen that I have talked with you*

from heaven. [23] *Ye shall not make with me gods of silver, neither shall ye make unto you gods of gold.* [24] *An altar of earth thou shalt make unto me, and shalt sacrifice thereon thy burnt offerings, and thy peace offerings, thy sheep, and thine oxen: in all places where I record my name I will come unto thee, and I will bless thee.* [25] *And if thou wilt make me an altar of stone, thou shalt not build it of hewn stone: for if thou lift up thy tool upon it, thou hast polluted it.* [26] *Neither shalt thou go up by steps unto mine altar, that thy nakedness be not discovered thereon.*

Explanation

This refers to killing the innocent. However, we can take it a step further. We as believers in Christ Jesus are not to wish anyone dead, as well. There is another scripture in the Word of God that states: As a man thinketh in his heart, so is he. **Exodus 20:13**

A heart that deviseth wicked imaginations

Text
Genesis 6:5-7

Genesis 6

[1] *And it came to pass, when men began to multiply on the face of the earth, and daughters were born unto them,* [2] *That the sons of God saw the daughters of men that they were fair; and they took them wives of all which they chose.* [3] *And the LORD said, My spirit shall not always strive with man, for that he also is flesh: yet his days shall be an hundred and twenty years.* [4] *There were giants in the earth in those days; and also after that, when the sons of God came in unto the daughters of men, and they bare children to them, the same became mighty men which were of old, men of renown.* [5] **And God saw that the wickedness of man was great in the earth, and that every imagination of the thoughts of his heart was only evil continually.** [6] **And it repented the LORD that he had made man on the earth, and it grieved him at his heart.** [7] **And the LORD said, I will destroy man whom I have created from the face of the earth; both man, and beast, and the creeping thing, and the fowls of the air; for it repenteth me that I have made them.** [8] *But Noah found grace in the eyes of the LORD.*

⁹ These are the generations of Noah: Noah was a just man and perfect in his generations, and Noah walked with God. ¹⁰ And Noah begat three sons, Shem, Ham, and Japheth. ¹¹ The earth also was corrupt before God, and the earth was filled with violence. ¹² And God looked upon the earth, and, behold, it was corrupt; for all flesh had corrupted his way upon the earth. ¹³ And God said unto Noah, The end of all flesh is come before me; for the earth is filled with violence through them; and, behold, I will destroy them with the earth. ¹⁴ Make thee an ark of gopher wood; rooms shalt thou make in the ark, and shalt pitch it within and without with pitch. ¹⁵ And this is the fashion which thou shalt make it of: The length of the ark shall be three hundred cubits, the breadth of it fifty cubits, and the height of it thirty cubits. ¹⁶ A window shalt thou make to the ark, and in a cubit shalt thou finish it above; and the door of the ark shalt thou set in the side thereof; with lower, second, and third stories shalt thou make it. ¹⁷ And, behold, I, even I, do bring a flood of waters upon the earth, to destroy all flesh, wherein is the breath of life, from under heaven; and every thing that is in the earth shall die. ¹⁸ But with thee will I establish my covenant; and thou shalt come into the ark, thou, and thy sons, and thy wife, and thy sons' wives with thee. ¹⁹ And of every living thing of all flesh, two of every sort shalt thou bring into the ark, to keep them alive with thee; they shall be male and female. ²⁰ Of fowls after their kind, and of cattle after their kind, of every creeping thing of the earth after his kind, two of every sort shall come unto thee, to keep them alive. ²¹ And take thou unto thee of all food that is eaten, and thou shalt gather it to thee; and it shall be for food for thee, and for them. ²² Thus did Noah; according to all that God commanded him, so did he.

Explanation

The Word of God states that even to **think** evil in our heart is a sin. **Genesis 6:5-7**

Feet that be swift in running to mischief

Text
Proverbs 10:23

Proverbs 10

¹ The proverbs of Solomon. A wise son maketh a glad father: but a foolish son is the heaviness of his mother. ² Treasures of wickedness profit nothing: but righteousness delivereth from death. ³ The LORD will not suffer the soul of the righteous to famish: but he casteth away the substance of the wicked. ⁴ He becometh poor that dealeth with a slack hand: but the hand of the diligent maketh rich. ⁵ He that gathereth in summer is a wise son: but he that sleepeth in harvest is a son that causeth shame. ⁶ Blessings are upon the head of the just: but violence covereth the mouth of the wicked. ⁷ The memory of the just is blessed: but the name of the wicked shall rot. ⁸ The wise in heart will receive commandments: but a prating fool shall fall. ⁹ He that walketh uprightly walketh surely: but he that perverteth his ways shall be known. ¹⁰ He that winketh with the eye causeth sorrow: but a prating fool shall fall. ¹¹ The mouth of a righteous man is a well of life: but violence covereth the mouth of the wicked. ¹² Hatred stirreth up strifes: but love covereth all sins. ¹³ In the lips of him that hath understanding wisdom is found: but a rod is for the back of him that is void of understanding. ¹⁴ Wise men lay up knowledge: but the mouth of the foolish is near destruction. ¹⁵ The rich man's wealth is his strong city: the destruction of the poor is their poverty. ¹⁶ The labour of the righteous tendeth to life: the fruit of the wicked to sin. ¹⁷ He is in the way of life that keepeth instruction: but he that refuseth reproof erreth. ¹⁸ He that hideth hatred with lying lips, and he that uttereth a slander, is a fool. ¹⁹ In the multitude of words there wanteth not sin: but he that refraineth his lips is wise. ²⁰ The tongue of the just is as choice silver: the heart of the wicked is little worth. ²¹ The lips of the righteous feed many: but fools die for want of wisdom. ²² The blessing of the LORD, it maketh rich, and he addeth no sorrow with it. **²³ It is as sport to a fool to do mischief: but a man of understanding hath wisdom.** *²⁴ The fear of the wicked, it shall come upon him: but the desire of the righteous shall be granted. ²⁵ As the whirlwind passeth, so is the wicked no more: but the righteous is an everlasting foundation. ²⁶ As vinegar to the teeth, and as smoke to the eyes, so is the sluggard to them that send him. ²⁷ The fear of the LORD prolongeth days: but the years of the wicked shall be shortened. ²⁸ The hope of the righteous shall be gladness: but the expectation of the wicked shall perish. ²⁹ The way of the LORD is strength to the upright: but destruction shall be to the workers of iniquity. ³⁰ The righteous shall never be removed: but the wicked shall not inhabit the earth. ³¹ The mouth of the just bringeth forth wisdom:*

but the froward tongue shall be cut out. ³² The lips of the righteous know what is acceptable: but the mouth of the wicked speaketh frowardness

Example

When we run quickly to do **mischief, it is** because that is what we desire to do. God is not pleased with that. That is unrighteousness in the eyes of the Lord. **Proverbs 10:23**

A false witness that speaketh lies

Text
II Timothy 3: 1-3

2 Timothy 3

¹ This know also, that in the last days perilous times shall come. ² For men shall be lovers of their own selves, covetous, boasters, proud, blasphemers, disobedient to parents, unthankful, unholy, ³ Without natural affection, trucebreakers, false accusers, incontinent, fierce, despisers of those that are good, ⁴ Traitors, heady, highminded, lovers of pleasures more than lovers of God; ⁵ Having a form of godliness, but denying the power thereof: from such turn away. ⁶ For of this sort are they which creep into houses, and lead captive silly women laden with sins, led away with divers lusts, ⁷ Ever learning, and never able to come to the knowledge of the truth. ⁸ Now as Jannes and Jambres withstood Moses, so do these also resist the truth: men of corrupt minds, reprobate concerning the faith. ⁹ But they shall proceed no further: for their folly shall be manifest unto all men, as their's also was. ¹⁰ But thou hast fully known my doctrine, manner of life, purpose, faith, longsuffering, charity, patience, ¹¹ Persecutions, afflictions, which came unto me at Antioch, at Iconium, at Lystra; what persecutions I endured: but out of them all the Lord delivered me. ¹² Yea, and all that will live godly in Christ Jesus shall suffer persecution. ¹³ But evil men and seducers shall wax worse and worse, deceiving, and being deceived. ¹⁴ But continue thou in the things which thou hast learned and hast been assured of, knowing of whom thou hast learned them; ¹⁵ And that from a child thou hast known the holy scriptures, which are able to make thee wise unto salvation through faith which is in Christ Jesus. ¹⁶ All scripture is given by inspiration of God, and is profitable

for doctrine, for reproof, for correction, for instruction in righteousness: [17] *That the man of God may be perfect, thoroughly furnished unto all good works.*

Explanation

The Word of God states that when we falsely accuse any one, it is a sin. **II Timothy 3: 1-3**

He that soweth discord among brethren

Text
Proverbs 6:14 (See top of chapter for full text)
Forwardness is in his heart, he dispiseth mischief continually; he soweth discord.

Explanation

God does not like confusion. The bible states that He is not the author of **confusion.**
Those of us who continue to do so, God will destroy. Such people can be labeled as:

- Busybodies
- Gossipers
- Trouble makers,
- Sow discord among others.
- **Discord** can be defined as: confusion, trouble, making disturbances, and mischief. **Proverbs 6:14**

Conclusion

- There are (6) components of sin that the Lord hates, when committed.
- Also, there is a 7th component of sin, when committed is call an abomination.
- Therefore, we can grow spiritually, if we remember the things that the Lord hates, and walk accordingly to the ways of our Lord and

Savior Jesus Christ, as our Chief Shepherd, through the teachings in the Word of God.

Questions

Name and define the seven categories of sin. Where are they located in the scriptures?

Name_____Define_____ Scripture

God hates and despises these categories of sin, because they are the root of all

_____Unrighteousness

_____Transgression, knowing what is right and performing what is unrighteous

_____That is contrary to the Word of God

_____Sin

_____All of the above

What does it mean to put a bridle on our tongue?

_____Watch what we say and think before you spea

_____Do not say, anything that may be in any way offensive to another

_____Get in a practice of thinking before you speak

_____Watch the company that you keep, to avoid foolishness and vain jesters regarding others, states the Word of God

Check all that it applies

Thought Question

Do you believe that you are mindful of what you say, regarding others, the majority of the time? Or are you influenced by the company that you keep?

Chapter 4

Week One: Review
Week Two: Open Book Test
Week Three: Review and Open Discussion of the Unit

Unit Six: Initiating Spiritual Growth
Practice for Review
And later
Unit Test
The Fruit of the Spirit

Jesus is the Light of the World, and as followers of Christ, who are we? Provide scripture.

Why are we, also called the light of the world? Provide scripture.

Name eight components of the Fruit of the Spirit. What is the scripture text?

The Fruit Scripture

Why is our spiritual walk, a walk by faith? Provide scripture.

The Whole Amour of God

Name the seven parts of the Whole Armor of God and their purposes. Where is the text located in the Word of God?

What is it that we must do, when we do not know what to do, or seem to have gone our limit?

_____Give up, and feel sorry for ourselves

_____Constantly talking to God about it all day and all night that we are awake

_____Have the shield of faith to believe that things will work out, once we give it to the

Lord in prayer and stand our ground, having unwavering faith

_____Take matters into our own hand

_____ All of the above

According to Hebrew 9:12, what are the tasks of the sword of the spirit? Name three things that identify its tasks.

Once we accept the Lord Jesus Christ as our Personal Savior, we embark against a spiritual journey, which can also be defined as:

As believers in Christ Jesus, we daily war against:

_____, _____,and the _____.

The daily job of the Adversary can be divided into a three categories, in which he goes about deceiving, and enticing the believer. Therefore, he:

_____, _____,and _____

There are two types of man in our body of flesh that war against each other constantly. Therefore, there is a need to put on the

_____ of_____.These two forces that war

inwardly are called the _____ man and the _____man.

The Seven Categories of Sin

Name and define the seven categories of sin. Where are they located in the scriptures?

Name Define Text

God hates and despises these categories of sin, because they are the root of all

_____Unrighteousness

_____Transgression, knowing what is right and performing what is unrighteous

_____That is contrary to the Word of God

_____Sin

_____All of the above

What does it mean to put a bridle on our tongue?

_____Watch what we say and think before you speak

_____Do not say, anything that may be in any way offensive to another

_____Get into practice of thinking before we speak

_____Watch the company that we keep, to avoid foolishness and vain jesters regarding others, states the Word of God

_____Check all that it applies

UNIT SEVEN: BIBLE COMPOSITION AND USAGE

Contents

Unit Introduction

We have learned, thus far, that in order to be saved eternally, we must accept, the Written Word of God, as the Gospel. We have also learned that in order to be ready we must daily repeat asking God for continually forgiveness of our sins, as we are in this body of flesh. Now we have began to grow spiritually, exercising daily the fruit of the spirit in our lives.

We continue to grow daily, also as we remember the need and the usage for the whole, and not part of the spiritual army of God. Also, we have learned in the previous chapter, that we continue to grow as we shun from the appearance of evil, and draws us into the seven and also the eighth category of sin.So with that in mind exactly what is it that we are now missing? We need to have now a working knowledge of the Word of God, in composition and outline. Therefore, with that in mind, we bring to you, *Bible Composition and Usage* . . .

The Bible's Composition
The Old and New In Contrast
Chapter 1

Text
I I Peter 1:19-21

Introduction

When we become disciples of our Lord Jesus Christ, we must have a general knowledge of the Bible's outline, needed to be able to carry on the great commission, to evangelize. We then have a responsibility of telling others the gospel; the saving grace of our Lord and Savior, Jesus Christ, (Read: St. John 3: 16 & 17, and Roman 10: 9 & 10). Therefore, with that in mind, our scripture lesson prepares us in understanding that, the Bible can be defined as prophecy or forth telling as the Word of God, which is the message from God. It was written by holy men of God, as they were inspired or moved by the Holy Ghost or the Holy Spirit. In this section, we shall look at the general composition of the Bible, which was written by holy men of God.

The Lesson

Text
I I Peter 1:19-21

2 Peter 1

¹ Simon Peter, a servant and an apostle of Jesus Christ, to them that have obtained like precious faith with us through the righteousness of God and our Saviour Jesus Christ: ² Grace and peace be multiplied unto you through the knowledge of God, and of Jesus our Lord, ³ According as his divine power hath given unto us all things that pertain unto life and godliness, through

the knowledge of him that hath called us to glory and virtue: ⁴ *Whereby are given unto us exceeding great and precious promises: that by these ye might be partakers of the divine nature, having escaped the corruption that is in the world through lust.* ⁵ *And beside this, giving all diligence, add to your faith virtue; and to virtue knowledge;* ⁶ *And to knowledge temperance; and to temperance patience; and to patience godliness;* ⁷ *And to godliness brotherly kindness; and to brotherly kindness charity.* ⁸ *For if these things be in you, and abound, they make you that ye shall neither be barren nor unfruitful in the knowledge of our Lord Jesus Christ.* ⁹ *But he that lacketh these things is blind, and cannot see afar off, and hath forgotten that he was purged from his old sins.* ¹⁰ *Wherefore the rather, brethren, give diligence to make your calling and election sure: for if ye do these things, ye shall never fall:* ¹¹ *For so an entrance shall be ministered unto you abundantly into the everlasting kingdom of our Lord and Saviour Jesus Christ.* ¹² *Wherefore I will not be negligent to put you always in remembrance of these things, though ye know them, and be established in the present truth.* ¹³ *Yea, I think it meet, as long as I am in this tabernacle, to stir you up by putting you in remembrance;* ¹⁴ *Knowing that shortly I must put off this my tabernacle, even as our Lord Jesus Christ hath shewed me.* ¹⁵ *Moreover I will endeavour that ye may be able after my decease to have these things always in remembrance.* ¹⁶ *For we have not followed cunningly devised fables, when we made known unto you the power and coming of our Lord Jesus Christ, but were eyewitnesses of his majesty.* ¹⁷ *For he received from God the Father honour and glory, when there came such a voice to him from the excellent glory, This is my beloved Son, in whom I am well pleased.* ¹⁸ *And this voice which came from heaven we heard, when we were with him in the holy mount.* ¹⁹ ***We have also a more sure word of prophecy; whereunto ye do well that ye take heed, as unto a light that shineth in a dark place, until the day dawn, and the day star arise in your hearts:*** ²⁰ ***Knowing this first, that no prophecy of the scripture is of any private interpretation.*** ²¹ ***For the prophecy came not in old time by the will of man: but holy men of God spake as they were moved by the Holy Ghost.***

The Explanation

19. The Day Dawn or the Day Star refers to the Lord God. We, as believers are to take heed to the Word of God, until the Lord returns. 20 In order to fully understand the Holy Scriptures, the reader must understand that

the entire bible tells the complete revelation of the knowledge and the doctrine of God. The Old Testament speaks of theGospel,being the good news of things to come; through salvation, fulfilled in the New Testament writings. However, the basic rules and standards for living began in the Old Testament. **I I Peter 1:19-21**
The following is a summary of the bible in outline form, and should be memorized:

* The Bible consists of 66 Books.
* The Holy Bible was written by 40 authors.
* It is considered the revelation of God.
* It provides instruction and guidance in the ways of life.
* The Bible is God's Word.
* It is divided into two parts.
 1. The Old Testament
 2. The New Testament
* There are 39 Books in the Old Testament
* There are 27 Books in the New Testament
* The Old Testament tells of things to come by forth telling or bible prophecy of historical events.
* The New Testament fulfills the prophecy and events.
* The Old Testament prepares the way for the New Testament.
* The Old Testament was written for the sake of the Hebrew Nation, God's first or foremost chosen people.
* The New Testament was written for the Gentiles to be engrafted in (everyone who is not a Jew) and for all of mankind, regardless of nationality, which defines all as either Jew or Hebrew population and the Gentile population.
* The Old Testament expounds upon rituals, purposes and customs of teachings and instructions in the Word of God. They are the foundation for Christian living.
* The New Testament teaches that all who take on the new birth, the spiritual birth, through our Lord and Savior Jesus Christ, make up a body of believers called the Church, and each believer is responsible for obeying the teachings of God.
* The New Testament therefore is the Church Age.
* The Old Testament deals with groups, cities, nations, and locations.

- The New Testament deals with individuals. There are no cities. There are no nations. Where ever believers are, individually and collectively, that is the location or focal point of God's interest, in the New Testament.
- He deals with individuals.
- The Old Testament deals with (1) prophets (2) priest and (3) kings.
- The New Testament fulfils all three, through the Son of God, who came as the Savior, who fulfills all prophecy and the Advocate or Mediator/Priest for all mankind, as the Kind of Kings and the Lord of Lords.
- The Old Testament speaks and is built upon laws, through attempting to bring about salivation, through animal scarifies.
- The New Testament is founded upon Grace, which is unmerited favor with_God. It is therefore defined as salvation; and heavenly eternal life is not based upon obeying laws and rituals, it is based upon the condition or state of our heart.
- Salvation in the New Testament is built upon accepting of the shed blood of_our Lord and Savior Jesus Christ, as the blood atoning sacrifice for our sins.

So we ask ourselves a question: Why do we read the Old Testament, when we live in the New Testament, during the Church Age: which is a melting pot of believers?

- The Old Testament speaks of two types of people, the Hebrew Nation or Jews and the Gentile Nation, also classified as heathens, during the Old Testament times.
- The New Testament deals with two types of people, the believers or the Church composed and represented as the body of believers, and the non-believers or sinners, destined for damnation.

Therefore:

- The Old Testament helps us to understand the New Testament.
- The Old Testament is defined as Part 1 of the Bible and the New Testament is defined as Part 2.
- One is not complete, without the other.

Conclusion

- In this lesson, we have learned that the bible is composed of the Old and the New Testament.
- There are 39 books in the Old Testament and 27 Books in the New Testament.
- The Bible is written by 40 holy men of God, through the unction of the Holy Ghost.
- We have learned that Old Testament is not complete without the New Testament.
- Both the Old and the New Testament compliment each other.

Questions

Name two types of people that the Old Testament deals with, based upon your knowledge up to this point.

The New Testament introduces what age, and what type of people?

The Bible is divided into how many parts? What are they?

Name the basic four components/categories of the Old Testament.

Thought Question:

According to God's originally intent that all would be of the Hebrew descent, originating from the Garden of Eden, representing innocence, why are you yet thankful for who you are?

You have been engrafted into all of the promises from Abraham's decent, through the 2nd Adam.

The Word of God as Outline of the Old Testament Books
Chapter 2

Text
The Old Testament

Introduction

In this 2nd part of Bible Composition, we shall give a brief outline of the Old Testament, in their order and category. We have contrasted the Old and the New Testament, in the previous lesson, now, let us look at the Old Testament Books of the Bible in their order and category. As already stated, there are 39 books, which make up the Old Testament.

The Lesson

- The first five books in the Old Testament are called the Books of Law or
 Pent etude, or through Hebrew definition, the Torah are originally, the Books of Law.
 Genesis
 Exodus
 Leviticus
 Numbers
 Deuteronomy
- The second group are a set of 12 Historical books:
 Joshua
 Judges
 Ruth
 I Samuel
 II Samuel
 I Kings

II Kings
I Chronicles
II Chronicles
Ezra
Nehemiah
Esther
Job
- The third group are called the 5 Poetical books:
Job
Psalms
Proverbs
Ecclesiastes
Song of Solomon
The last sections of books in the Old Testament are called the Prophetic books. They are divided into major and minor prophets:
The 5 Major Prophets:
Isaiah
Jeremiah
Lamentations
Ezekiel
Daniel
- Lastly in the Old Testament composition, there are 12 Minor Prophets (books). The names are also the authors.
Hosea
Joel
Amos
Obadiah
Jonah
Micah
Nahum
Habakkuk
Zephaniah
Haggai
Zechariah
Malachi

The Conclusion

- The Old Testament is a testimony of things to come.
- The laws prove that it is impossible to reach heaven, by attempting to abide by all of the 613 principles of instruction, written in the first (5) books of Law, since we are in this body of flesh.
- Therefore, a more excellent way was needed, by the way of Grace and Truth, through our Lord and Savior, Jesus Christ, the Messiah, who is the Mediator of the New Testament.

Questions

How many books are there in the Old Testament?
How many books are there in the New Testament?
What two numbered amounts are the books usually grouped into, within each category?

Name the five categories of books in the Old Testament.

Thought Question

How do you plan to reach or obtain the heavenly gift of salvation? Or have you already obtained?

The Bible's Composition
The Word of God as Outlined in the New Testament Books
Chapter 3

Text
St. John 1:17

Introduction

As a Bible School student, it is necessary to have a general knowledge of the outlined structure of the bible and its components. Therefore, in this lessons, we shall learn the brief outline of the books and their categories. As the Old Testament is divided into various parts, so also is the New Testament.

The New Testament is divided into five sections:

- The four Gospels
- The Acts of the Apostles
- 21 Epistles or Letters
- And Revelations, written by John the Revelator

The Lesson

Text
St. John 1:17

John 1

In the beginning was the Word, and the Word was with God, and the Word was God. ² The same was in the beginning with God. ³ All things were made by him; and without him was not any thing made that was made. ⁴ In him

was life; and the life was the light of men. ⁵ *And the light shineth in darkness; and the darkness comprehended it not.* ⁶ *There was a man sent from God, whose name was John.* ⁷ *The same came for a witness, to bear witness of the Light, that all men through him might believe.* ⁸ *He was not that Light, but was sent to bear witness of that Light.* ⁹ *That was the true Light, which lighteth every man that cometh into the world.* ¹⁰ *He was in the world, and the world was made by him, and the world knew him not.* ¹¹ *He came unto his own, and his own received him not.* ¹² *But as many as received him, to them gave he power to become the sons of God, even to them that believe on his name:* ¹³ *Which were born, not of blood, nor of the will of the flesh, nor of the will of man, but of God.* ¹⁴ *And the Word was made flesh, and dwelt among us, (and we beheld his glory, the glory as of the only begotten of the Father,) full of grace and truth.* ¹⁵ *John bare witness of him, and cried, saying, This was he of whom I spake, He that cometh after me is preferred before me: for he was before me.* ¹⁶ *And of his fulness have all we received, and grace for grace.* ¹⁷ **For the law was given by Moses, but grace and truth came by Jesus Christ.** ¹⁸ *No man hath seen God at any time, the only begotten Son, which is in the bosom of the Father, he hath declared him.* ¹⁹ *And this is the record of John, when the Jews sent priests and Levites from Jerusalem to ask him, Who art thou?* ²⁰ *And he confessed, and denied not; but confessed, I am not the Christ.* ²¹ *And they asked him, What then? Art thou Elias? And he saith, I am not. Art thou that prophet? And he answered, No.* ²² *Then said they unto him, Who art thou? that we may give an answer to them that sent us. What sayest thou of thyself?* ²³ *He said, I am the voice of one crying in the wilderness, Make straight the way of the Lord, as said the prophet Esaias.* ²⁴ *And they which were sent were of the Pharisees.* ²⁵ *And they asked him, and said unto him, Why baptizest thou then, if thou be not that Christ, nor Elias, neither that prophet?* ²⁶ *John answered them, saying, I baptize with water: but there standeth one among you, whom ye know not;* ²⁷ *He it is, who coming after me is preferred before me, whose shoe's latchet I am not worthy to unloose.* ²⁸ *These things were done in Bethabara beyond Jordan, where John was baptizing.* ²⁹ *The next day John seeth Jesus coming unto him, and saith, Behold the Lamb of God, which taketh away the sin of the world.* ³⁰ *This is he of whom I said, After me cometh a man which is preferred before me: for he was before me.* ³¹ *And I knew him not: but that he should be made manifest to Israel, therefore am I come baptizing with water.* ³² *And John bare record, saying, I saw the Spirit descending from heaven like a dove, and it abode upon him.* ³³ *And I knew him not: but he that sent me to baptize with water, the same said unto*

me, Upon whom thou shalt see the Spirit descending, and remaining on him, the same is he which baptizeth with the Holy Ghost. [34] And I saw, and bare record that this is the Son of God. [35] Again the next day after John stood, and two of his disciples; [36] And looking upon Jesus as he walked, he saith, Behold the Lamb of God! [37] And the two disciples heard him speak, and they followed Jesus. [38] Then Jesus turned, and saw them following, and saith unto them, What seek ye? They said unto him, Rabbi, (which is to say, being interpreted, Master,) where dwellest thou? [39] He saith unto them, Come and see. They came and saw where he dwelt, and abode with him that day: for it was about the tenth hour. [40] One of the two which heard John speak, and followed him, was Andrew, Simon Peter's brother. [41] He first findeth his own brother Simon, and saith unto him, We have found the Messias, which is, being interpreted, the Christ. [42] And he brought him to Jesus. And when Jesus beheld him, he said, Thou art Simon the son of Jona: thou shalt be called Cephas, which is by interpretation, A stone. [43] The day following Jesus would go forth into Galilee, and findeth Philip, and saith unto him, Follow me. [44] Now Philip was of Bethsaida, the city of Andrew and Peter. [45] Philip findeth Nathanael, and saith unto him, We have found him, of whom Moses in the law, and the prophets, did write, Jesus of Nazareth, the son of Joseph. [46] And Nathanael said unto him, Can there any good thing come out of Nazareth? Philip saith unto him, Come and see. [47] Jesus saw Nathanael coming to him, and saith of him, Behold an Israelite indeed, in whom is no guile! [48] Nathanael saith unto him, Whence knowest thou me? Jesus answered and said unto him, Before that Philip called thee, when thou wast under the fig tree, I saw thee. [49] Nathanael answered and saith unto him, Rabbi, thou art the Son of God; thou art the King of Israel. [50] Jesus answered and said unto him, Because I said unto thee, I saw thee under the fig tree, believest thou? thou shalt see greater things than these. [51] And he saith unto him, Verily, verily, I say unto you, Hereafter ye shall see heaven open, and the angels of God ascending and descending upon the Son of man

Explanation

The scripture is self explanatory. Therefore we will look at the New Testament composition of its 27 Books of the Bible. **St. John 1:17**

The Four Gospels

The first four books of the New Testament are called the gospels.
They tell the good news of salvation. Salvation is free. Christ paid for it with His death, burial and resurrection. Each was written by an apostle, who was an eyewitness of the life and working of miracles of Christ, which defines the original definition of an apostle.

• One of the gospels focus upon people: the gospel according to St Luke.
• Another focuses upon events, which defines the gospel according to St. John.
• A third focuses upon what has meaning, which is defined as the gospel according to St. Matthew. These are the stories, and words of wisdom, in the form of parables.
• A fourth gospel focuses upon works, which is defined as the gospel according to St. Mark.

Therefore, the four gospels are: **St. Matthew, St. Mark, St. Luke, and St. John.**

Acts of the Apostles

The Acts of the Apostles is the second section of the New Testament writings.
This book is in a class of its own. Acts tells of the formation of the 1st Church which also consist of signs and wonders from the Apostles, after Christ' ascension, as the testator of the New Testament.

The Epistles: Major and Minor

The third section of the New Testament consist of 21 Epistles (or Letters)

Major Epistles

The major Epistles which begin with Romans and end with II Thessalonians were written by the Apostle Paul. These major Epistle, books were written

to the churches in these locations which were named after the church. For example, the two books of Corinthians were written to the Church in Corinth, which was one of the largest churches in Asia.

- Romans
- I Corinthians
- II Corinthians
- Galatians
- Ephesians
- Philippians
- Colossians
- I Thessalonians
- II Thessalonians

The Minor Epistle

The minor Epistles were written by Apostle Paul to the disciples who are also the title of the epistle or letter. These are letters that Paul wrote to these spiritual leaders.

- I Timothy
- II Timothy
- Titus
- Philemon
- Hebrews
- James
- I Peter
- II Peter
- I John
- II John
- III John
- Jude

Revelation

The last section of the books of the New Testament is called Revelation. It, like Acts is the only one of its kind. This last book, Revelation, foretells in the Old Testament the things to come, up to the Church Age. It also tells prophecies of things to come, consisting of the Second Coming of Christ

and what is to follow, leading up and concluding the New Heaven and the New Earth. We are in the Church Age, and the Age of Grace, through the New Testament.

Conclusion

* The Bible composition is our roadmap to inherit eternal life from beginning to end.
* Read it.
* Study it.
* And abide by it.
* And share what you know, as believers in Christ.

Questions

The Law was given by whom? Who is the Giver of Grace and Truth?

The Four Gospels tell the Good

What is Grace?

_____Unmerited favor with God

_____Underserved favor with God

_____ Being in the right standing with God, thereby counted righteous before God

 All of the above

Name four things that the four gospels focus upon.

The Gospels (4) Things that it focus upon

Name three things that define the Book of Acts.

The major Epistles are written to what church? What was the location of
the church? (Note, the name of each body of believer is the name of the
book). Look in the book and find the name of the location of each group
of people or believers. The location is the root word for each title. (For
example, when writing to the Romans, the location of the church would
be in Rome).

Epistle Name of the Church Location

Name three things that define the Book of Revelation.

Thought Question

What is the Bible to you?

Chapter 4

Week One: Review
Week Two: Open Book Test
Week Three: Review and Open Discussion of the Unit

Unit 7: Bible Composition and Usage
Practice for Review
And later
Unit Test
The Old and the New In Contrast

Name two types of people that the Old Testament deals with, based upon your knowledge up to this point.

The New Testament introduces what age, and what type of people?

The Bible is divided into how many parts? What are they?

Name four components of the Old Testament.

Outline of the Old Testament Books

How many books are there in the Old Testament?
How many books are there in the New Testament?

What two numbered amounts are the books usually grouped into, within each category?

Name the five categories of books in the Old Testament.

What is the more excellent way? What is a Testament of things to come?

Outlined in the New Testament

The Law was given by whom? Who is the Giver of Grace and Truth?

The Four Gospels tell the Good

What is Grace?
_____Unmerited favor with God
_____Underserved favor with God
_____Being in the right standing with God, thereby counted righteous before God
 All of the above
Name four things that the four Gospels focus upon.
The Gospel (4) Things that it focus upon

Name three things that define the Book of Acts.

The major Epistles are written to what church? What was the location of the church? (Note, the name of each body of believer is the name of the book). Look in the book and find the name of the location of each group of people or believers. The location is the root word for each title. (For example, when writing to the Romans, the location of the church would be in Rome).

Epistle Name of the Church Location

Name three things that define the Book of Revelation.

UNIT EIGHT: THE FULLNESS OF GOD

Contents

Unit Introduction

In order to be able to begin to understand the mysteries of God, as we continue our spiritual growth, we must now begin to stop for a few minutes to mediate on the mystery on the *Fullness of God.* The Word of God states that God is the Word of God and **God the Son** and God the Holy Spirit. The Word of God states that all that is formed was formed through the mystery of the elements brought forth through the Spirit of God. In this segment, we shall expound upon that God is very God and was very man. We shall also expound that I AM was and is and is to come, always in existence. We shall also expound that through the Spirit of God, we move, we breathe, we have our existence. It is with the those initial thoughts that we bring to you, ***the Fullness, the Role and the Oneness of God in one, as the Fullness of God*** . . .

The Fullness of God
God the Father
Chapter 1

Text
Genesis 1:1
Revelations 22:13
St. John 3:16
Psalms 8:2
Genesis 31:13
St. Luke 1:49
Genesis 17:1
Numbers 24:4
St. Luke 1:32
Psalms 8:1
St. John 5:26
Psalms 68:4
Psalms 64 :1
I John 5:6-8

Introduction

In order to understand salvation, past, present, future, we must understand that there are three persons in the Godhead. God the Father, God the Son, and God the Holy Spirit, and these three are one. In this segment we shall discuss the Fullness of God in definition and title.

The Lesson

Text
Genesis 1:1 (See Unit 3, chapter 1, full text)
In the beginning God created the heaven and the earth.

Explanation

God has always been in existence. **Genesis 1:1**
Text
I John 5:6-8 (See Unit 1, chapter 1, full text)

I John 5

⁶ This is he that came by water and blood, even Jesus Christ; not by water only, but by water and blood. And it is the Spirit that beareth witness, because the Spirit is truth. ⁷ For there are three that bear record in heaven, the Father, the Word, and the Holy Ghost: and these three are one. ⁸ And there are three that bear witness in earth, the Spirit, and the water, and the blood: and these three agree in one.

Explanation

6 The evidence of God's existence is through the water and the blood, in the Person of His Son, the Lord Jesus Christ. 7 This documents that there are three in the God Head, God the Father, God the Son, and God the Holy Spirit, which are three in One. No one fully can understand. It is a mystery. The believers will understand it, when we pass from this life onto heavenly eternal life. 8. The three represented here, make up the life composition of mankind. Spirit: is what is God conscience along with the spirit of man, there is also a body and a soul.

- The body is the vessel, comprised of flesh and blood.
- The soul is the personality of man.
- And there is the spirit of man, the God conscience, and is used to have fellowship with Christ. **I John 5:6-8**

Text
Revelations 22:13

Revelation 22

¹ And he shewed me a pure river of water of life, clear as crystal, proceeding out of the throne of God and of the Lamb. ² In the midst of the street of it, and

on either side of the river, was there the tree of life, which bare twelve manner of fruits, and yielded her fruit every month: and the leaves of the tree were for the healing of the nations. *3* And there shall be no more curse: but the throne of God and of the Lamb shall be in it; and his servants shall serve him: *4* And they shall see his face; and his name shall be in their foreheads. *5* And there shall be no night there; and they need no candle, neither light of the sun; for the Lord God giveth them light: and they shall reign for ever and ever. *6* And he said unto me, These sayings are faithful and true: and the Lord God of the holy prophets sent his angel to shew unto his servants the things which must shortly be done. *7* Behold, I come quickly: blessed is he that keepeth the sayings of the prophecy of this book. *8* And I John saw these things, and heard them. And when I had heard and seen, I fell down to worship before the feet of the angel which shewed me these things. *9* Then saith he unto me, See thou do it not: for I am thy fellowservant, and of thy brethren the prophets, and of them which keep the sayings of this book: worship God. *10* And he saith unto me, Seal not the sayings of the prophecy of this book: for the time is at hand. *11* He that is unjust, let him be unjust still: and he which is filthy, let him be filthy still: and he that is righteous, let him be righteous still: and he that is holy, let him be holy still. *12* And, behold, I come quickly; and my reward is with me, to give every man according as his work shall be. *13* **I am Alpha and Omega, the beginning and the end, the first and the last.** *14* Blessed are they that do his commandments, that they may have right to the tree of life, and may enter in through the gates into the city. *15* For without are dogs, and sorcerers, and whoremongers, and murderers, and idolaters, and whosoever loveth and maketh a lie. *16* I Jesus have sent mine angel to testify unto you these things in the churches. I am the root and the offspring of David, and the bright and morning star. *17* And the Spirit and the bride say, Come. And let him that heareth say, Come. And let him that is athirst come. And whosoever will, let him take the water of life freely. *18* For I testify unto every man that heareth the words of the prophecy of this book, If any man shall add unto these things, God shall add unto him the plagues that are written in this book: *19* And if any man shall take away from the words of the book of this prophecy, God shall take away his part out of the book of life, and out of the holy city, and from the things which are written in this book. *20* He which testifieth these things saith, Surely I come quickly. Amen. Even so, come, Lord Jesus. *21* The grace of our Lord Jesus Christ be with you all. Amen.

Explanation

This is the primary definition of God the Father, God Almighty, and our Sovereign God. **Revelations 22:13**
Text
St. John 3:16 (See Unit 3, chapter 2, full text)
¹⁶ For God so loved the world, that he gave his only begotten Son, that whosoever believeth in him should not perish, but have everlasting life. ¹⁷ For God sent not his Son into the world to condemn the world; but that the world through him might be saved.

Explanation

Begotten refers to being taken from God the Father. God the Son was in the Father. He and the Father are as one. **St. John 3:16**

Also
Eight Titles of Definition of God

God the Father has eight distinctive names, which identify Him as Almighty God. They are as follows, supported by scripture:

God the Father

There are eight names in the bible, which assist us in bringing meaning to the identity of God.
Text

Psalms 8:2
Elohim

Psalms 8
*¹ O LORD, our Lord, how excellent is thy name in all the earth! who hast set thy glory above the heavens. ² **Out of the mouth of babes and sucklings hast thou ordained strength because of thine enemies, that thou mightest still the enemy and the avenger. ³ When I consider thy heavens, the work of thy fingers, the moon and the stars, which thou hast ordained;** ⁴ What is man, that thou art mindful of him? and the son of man, that thou*

visitest him? ⁵ *For thou hast made him a little lower than the angels, and hast crowned him with glory and honour.* ⁶ *Thou madest him to have dominion over the works of thy hands; thou hast put all things under his feet:* ⁷ *All sheep and oxen, yea, and the beasts of the field;* ⁸ *The fowl of the air, and the fish of the sea, and whatsoever passeth through the paths of the seas.* ⁹ *O LORD our Lord, how excellent is thy name in all the earth!*

Explanation

Elohim: He is the Fullness of God as a supernatural being, interpreted as One God and plural in Hebrew meaning. Singular is Eloach. **Psalms 8:2**
Text
Genesis 31:13

El
Genesis 31

¹ *And he heard the words of Laban's sons, saying, Jacob hath taken away all that was our father's; and of that which was our father's hath he gotten all this glory.* ² *And Jacob beheld the countenance of Laban, and, behold, it was not toward him as before.* ³ *And the LORD said unto Jacob, Return unto the land of thy fathers, and to thy kindred; and I will be with thee.* ⁴ *And Jacob sent and called Rachel and Leah to the field unto his flock,* ⁵ *And said unto them, I see your father's countenance, that it is not toward me as before; but the God of my father hath been with me.* ⁶ *And ye know that with all my power I have served your father.* ⁷ *And your father hath deceived me, and changed my wages ten times; but God suffered him not to hurt me.* ⁸ *If he said thus, The speckled shall be thy wages; then all the cattle bare speckled: and if he said thus, The ringstraked shall be thy hire; then bare all the cattle ringstraked.* ⁹ *Thus God hath taken away the cattle of your father, and given them to me.* ¹⁰ *And it came to pass at the time that the cattle conceived, that I lifted up mine eyes, and saw in a dream, and, behold, the rams which leaped upon the cattle were ringstraked, speckled, and grisled.* ¹¹ *And the angel of God spake unto me in a dream, saying, Jacob: And I said, Here am I.* ¹² *And he said, Lift up now thine eyes, and see, all the rams which leap upon the cattle are ringstraked, speckled, and grisled: for I have seen all that Laban doeth unto thee.* ¹³ ***I am the God of Bethel, where thou anointedst the pillar, and where thou vowedst a vow unto me: now arise, get thee out from this land, and return unto***

the land of thy kindred. ¹⁴ ***And Rachel and Leah answered and said unto him, Is there yet any portion or inheritance for us in our father's house?*** ¹⁵ ***Are we not counted of him strangers? for he hath sold us, and hath quite devoured also our money.*** ¹⁶ ***For all the riches which God hath taken from our father, that is ours, and our children's: now then, whatsoever God hath said unto thee, do.*** ¹⁷ ***Then Jacob rose up, and set his sons and his wives upon camels;*** ¹⁸ *And he carried away all his cattle, and all his goods which he had gotten, the cattle of his getting, which he had gotten in Padanaram, for to go to Isaac his father in the land of Canaan.* ¹⁹ *And Laban went to shear his sheep: and Rachel had stolen the images that were her father's.* ²⁰ *And Jacob stole away unawares to Laban the Syrian, in that he told him not that he fled.* ²¹ *So he fled with all that he had; and he rose up, and passed over the river, and set his face toward the mount Gilead.* ²² *And it was told Laban on the third day that Jacob was fled.* ²³ *And he took his brethren with him, and pursued after him seven days' journey; and they overtook him in the mount Gilead.* ²⁴ *And God came to Laban the Syrian in a dream by night, and said unto him, Take heed that thou speak not to Jacob either good or bad.* ²⁵ *Then Laban overtook Jacob. Now Jacob had pitched his tent in the mount: and Laban with his brethren pitched in the mount of Gilead.* ²⁶ *And Laban said to Jacob, What hast thou done, that thou hast stolen away unawares to me, and carried away my daughters, as captives taken with the sword?* ²⁷ *Wherefore didst thou flee away secretly, and steal away from me; and didst not tell me, that I might have sent thee away with mirth, and with songs, with tabret, and with harp?* ²⁸ *And hast not suffered me to kiss my sons and my daughters? thou hast now done foolishly in so doing.* ²⁹ *It is in the power of my hand to do you hurt: but the God of your father spake unto me yesternight, saying, Take thou heed that thou speak not to Jacob either good or bad.* ³⁰ *And now, though thou wouldest needs be gone, because thou sore longedst after thy father's house, yet wherefore hast thou stolen my gods?* ³¹ *And Jacob answered and said to Laban, Because I was afraid: for I said, Peradventure thou wouldest take by force thy daughters from me.* ³² *With whomsoever thou findest thy gods, let him not live: before our brethren discern thou what is thine with me, and take it to thee. For Jacob knew not that Rachel had stolen them.* ³³ *And Laban went into Jacob's tent, and into Leah's tent, and into the two maidservants' tents; but he found them not. Then went he out of Leah's tent, and entered into Rachel's tent.* ³⁴ *Now Rachel had taken the images, and put them in the camel's furniture, and sat upon them. And Laban searched all the tent, but found them not.* ³⁵ *And she said to her father, Let it not displease my*

lord that I cannot rise up before thee; for the custom of women is upon me. And he searched but found not the images. [36] *And Jacob was wroth, and chode with Laban: and Jacob answered and said to Laban, What is my trespass? what is my sin, that thou hast so hotly pursued after me?* [37] *Whereas thou hast searched all my stuff, what hast thou found of all thy household stuff? set it here before my brethren and thy brethren, that they may judge betwixt us both.* [38] *This twenty years have I been with thee; thy ewes and thy she goats have not cast their young, and the rams of thy flock have I not eaten.* [39] *That which was torn of beasts I brought not unto thee; I bare the loss of it; of my hand didst thou require it, whether stolen by day, or stolen by night.* [40] *Thus I was; in the day the drought consumed me, and the frost by night; and my sleep departed from mine eyes.* [41] *Thus have I been twenty years in thy house; I served thee fourteen years for thy two daughters, and six years for thy cattle: and thou hast changed my wages ten times.* [42] *Except the God of my father, the God of Abraham, and the fear of Isaac, had been with me, surely thou hadst sent me away now empty. God hath seen mine affliction and the labour of my hands, and rebuked thee yesternight.* [43] *And Laban answered and said unto Jacob, These daughters are my daughters, and these children are my children, and these cattle are my cattle, and all that thou seest is mine: and what can I do this day unto these my daughters, or unto their children which they have born?* [44] *Now therefore come thou, let us make a covenant, I and thou; and let it be for a witness between me and thee.* [45] *And Jacob took a stone, and set it up for a pillar.* [46] *And Jacob said unto his brethren, Gather stones; and they took stones, and made an heap: and they did eat there upon the heap.* [47] *And Laban called it Jegarsahadutha: but Jacob called it Galeed.* [48] *And Laban said, This heap is a witness between me and thee this day. Therefore was the name of it called Galeed;* [49] *And Mizpah; for he said, The LORD watch between me and thee, when we are absent one from another.* [50] *If thou shalt afflict my daughters, or if thou shalt take other wives beside my daughters, no man is with us; see, God is witness betwixt me and thee.* [51] *And Laban said to Jacob, Behold this heap, and behold this pillar, which I have cast betwixt me and thee:* [52] *This heap be witness, and this pillar be witness, that I will not pass over this heap to thee, and that thou shalt not pass over this heap and this pillar unto me, for harm.* [53] *The God of Abraham, and the God of Nahor, the God of their father, judge betwixt us. And Jacob sware by the fear of his father Isaac.* [54] *Then Jacob offered sacrifice upon the mount, and called his brethren to eat bread: and they did eat bread, and tarried all night in the mount.* [55] *And early in the morning*

Laban rose up, and kissed his sons and his daughters, and blessed them: and Laban departed, and returned unto his place.

Explanation

El: The Strong One or the Ruler. It can be used as a compound title: El Shaddai
It can be used as a epithet or descriptive word as God of Behel or El-Bethel
Genesis 31:13
Text
Genesis 17:1

El Shaddai
Genesis 17

[1] And when Abram was ninety years old and nine, the LORD appeared to Abram, and said unto him, I am the Almighty God; walk before me, and be thou perfect. *[2] And I will make my covenant between me and thee, and will multiply thee exceedingly.* *[3] And Abram fell on his face: and God talked with him, saying,* *[4] As for me, behold, my covenant is with thee, and thou shalt be a father of many nations.* *[5] Neither shall thy name any more be called Abram, but thy name shall be Abraham; for a father of many nations have I made thee.* *[6] And I will make thee exceeding fruitful, and I will make nations of thee, and kings shall come out of thee.* *[7] And I will establish my covenant between me and thee and thy seed after thee in their generations for an everlasting covenant, to be a God unto thee, and to thy seed after thee.* *[8] And I will give unto thee, and to thy seed after thee, the land wherein thou art a stranger, all the land of Canaan, for an everlasting possession; and I will be their God.* *[9] And God said unto Abraham, Thou shalt keep my covenant therefore, thou, and thy seed after thee in their generations.* *[10] This is my covenant, which ye shall keep, between me and you and thy seed after thee; Every man child among you shall be circumcised.* *[11] And ye shall circumcise the flesh of your foreskin; and it shall be a token of the covenant betwixt me and you.* *[12] And he that is eight days old shall be circumcised among you, every man child in your generations, he that is born in the house, or bought with money of any stranger, which is not of thy seed.* *[13] He that is born in thy house, and he that is bought with thy money, must needs be circumcised: and my covenant shall be in your flesh for an everlasting covenant.* *[14] And the*

uncircumcised man child whose flesh of his foreskin is not circumcised, that soul shall be cut off from his people; he hath broken my covenant. *¹⁵ And God said unto Abraham, As for Sarai thy wife, thou shalt not call her name Sarai, but Sarah shall her name be. ¹⁶ And I will bless her, and give thee a son also of her: yea, I will bless her, and she shall be a mother of nations; kings of people shall be of her. ¹⁷ Then Abraham fell upon his face, and laughed, and said in his heart, Shall a child be born unto him that is an hundred years old? and shall Sarah, that is ninety years old, bear? ¹⁸ And Abraham said unto God, O that Ishmael might live before thee! ¹⁹ And God said, Sarah thy wife shall bear thee a son indeed; and thou shalt call his name Isaac: and I will establish my covenant with him for an everlasting covenant, and with his seed after him. ²⁰ And as for Ishmael, I have heard thee: Behold, I have blessed him, and will make him fruitful, and will multiply him exceedingly; twelve princes shall he beget, and I will make him a great nation. ²¹ But my covenant will I establish with Isaac, which Sarah shall bear unto thee at this set time in the next year. ²² And he left off talking with him, and God went up from Abraham. ²³ And Abraham took Ishmael his son, and all that were born in his house, and all that were bought with his money, every male among the men of Abraham's house; and circumcised the flesh of their foreskin in the selfsame day, as God had said unto him. ²⁴ And Abraham was ninety years old and nine, when he was circumcised in the flesh of his foreskin. ²⁵ And Ishmael his son was thirteen years old, when he was circumcised in the flesh of his foreskin. ²⁶ In the selfsame day was Abraham circumcised, and Ishmael his son. ²⁷ And all the men of his house, born in the house, and bought with money of the stranger, were circumcised with him.*

Explanation

- El Shaddai: The Root meaning means to overthrow as the Destroyer and also from the root meaning the Rain-giver. In addition, it is interpreted as My Mountain or My Lord and God Almighty.

Also

Genesis 17:1
Also
Text
Numbers 24:4

Shaddai
Numbers 24

¹ And when Balaam saw that it pleased the LORD to bless Israel, he went not, as at other times, to seek for enchantments, but he set his face toward the wilderness. ² And Balaam lifted up his eyes, and he saw Israel abiding in his tents according to their tribes; and the spirit of God came upon him. ³ And he took up his parable, and said, Balaam the son of Beor hath said, and the man whose eyes are open hath said: **⁴ He hath said, which heard the words of God, which saw the vision of the Almighty, falling into a trance, but having his eyes open:** *⁵ How goodly are thy tents, O Jacob, and thy tabernacles, O Israel! ⁶ As the valleys are they spread forth, as gardens by the river's side, as the trees of lign aloes which the LORD hath planted, and as cedar trees beside the waters. ⁷ He shall pour the water out of his buckets, and his seed shall be in many waters, and his king shall be higher than Agag, and his kingdom shall be exalted. ⁸ God brought him forth out of Egypt; he hath as it were the strength of an unicorn: he shall eat up the nations his enemies, and shall break their bones, and pierce them through with his arrows. ⁹ He couched, he lay down as a lion, and as a great lion: who shall stir him up? Blessed is he that blesseth thee, and cursed is he that curseth thee. ¹⁰ And Balak's anger was kindled against Balaam, and he smote his hands together: and Balak said unto Balaam, I called thee to curse mine enemies, and, behold, thou hast altogether blessed them these three times. ¹¹ Therefore now flee thou to thy place: I thought to promote thee unto great honour; but, lo, the LORD hath kept thee back from honour. ¹² And Balaam said unto Balak, Spake I not also to thy messengers which thou sentest unto me, saying, ¹³ If Balak would give me his house full of silver and gold, I cannot go beyond the commandment of the LORD, to do either good or bad of mine own mind; but what the LORD saith, that will I speak? ¹⁴ And now, behold, I go unto my people: come therefore, and I will advertise thee what this people shall do to thy people in the latter days. ¹⁵ And he took up his parable, and said, Balaam the son of Beor hath said, and the man whose eyes are open hath said: ¹⁶ He hath said, which heard the words of God, and knew the knowledge of the most High, which saw the vision of the Almighty, falling into a trance, but having his eyes open: ¹⁷ I shall see him, but not now: I shall behold him, but not nigh: there shall come a Star out of Jacob, and a Sceptre shall rise out of Israel, and shall smite the corners of Moab, and destroy all the children of Sheth. ¹⁸ And Edom shall be a possession, Seir also shall be a possession for his enemies; and Israel shall do*

valiantly. [19] *Out of Jacob shall come he that shall have dominion, and shall destroy him that remaineth of the city.* [20] *And when he looked on Amalek, he took up his parable, and said, Amalek was the first of the nations; but his latter end shall be that he perish for ever.* [21] *And he looked on the Kenites, and took up his parable, and said, Strong is thy dwellingplace, and thou puttest thy nest in a rock.* [22] *Nevertheless the Kenite shall be wasted, until Asshur shall carry thee away captive.* [23] *And he took up his parable, and said, Alas, who shall live when God doeth this!* [24] *And ships shall come from the coast of Chittim, and shall afflict Asshur, and shall afflict Eber, and he also shall perish for ever.* [25] *And Balaam rose up, and went and returned to his place: and Balak also went his way.*

Explanation

Shaddai is used often in the Old Testament as a poetical name of God It concludes as the Almighty he hath said, which heard the words of God, which saw the vision of the Almighty, falling into a trance, but having his eyes open: **Numbers 24:4**
Text
St. Luke 1:32

EL Elyon
Luke 1

[1] *Forasmuch as many have taken in hand to set forth in order a declaration of those things which are most surely believed among us,* [2] *Even as they delivered them unto us, which from the beginning were eyewitnesses, and ministers of the word;* [3] *It seemed good to me also, having had perfect understanding of all things from the very first, to write unto thee in order, most excellent Theophilus,* [4] *That thou mightest know the certainty of those things, wherein thou hast been instructed.* [5] *THERE was in the days of Herod, the king of Judaea, a certain priest named Zacharias, of the course of Abia: and his wife was of the daughters of Aaron, and her name was Elisabeth.* [6] *And they were both righteous before God, walking in all the commandments and ordinances of the Lord blameless.* [7] *And they had no child, because that Elisabeth was barren, and they both were now well stricken in years.* [8] *And it came to pass, that while he executed the priest's office before God in the order of his course,* [9] *According to the custom of the priest's office, his lot was to burn incense when he went into*

*the temple of the Lord. ¹⁰ And the whole multitude of the people were praying without at the time of incense. ¹¹ And there appeared unto him an angel of the Lord standing on the right side of the altar of incense. ¹² And when Zacharias saw him, he was troubled, and fear fell upon him. ¹³ But the angel said unto him, Fear not, Zacharias: for thy prayer is heard; and thy wife Elisabeth shall bear thee a son, and thou shalt call his name John. ¹⁴ And thou shalt have joy and gladness; and many shall rejoice at his birth. ¹⁵ For he shall be great in the sight of the Lord, and shall drink neither wine nor strong drink; and he shall be filled with the Holy Ghost, even from his mother's womb. ¹⁶ And many of the children of Israel shall he turn to the Lord their God. ¹⁷ And he shall go before him in the spirit and power of Elias, to turn the hearts of the fathers to the children, and the disobedient to the wisdom of the just; to make ready a people prepared for the Lord. ¹⁸ And Zacharias said unto the angel, Whereby shall I know this? for I am an old man, and my wife well stricken in years. ¹⁹ And the angel answering said unto him, I am Gabriel, that stand in the presence of God; and am sent to speak unto thee, and to shew thee these glad tidings. ²⁰ And, behold, thou shalt be dumb, and not able to speak, until the day that these things shall be performed, because thou believest not my words, which shall be fulfilled in their season. ²¹ And the people waited for Zacharias, and marvelled that he tarried so long in the temple. ²² And when he came out, he could not speak unto them: and they perceived that he had seen a vision in the temple: for he beckoned unto them, and remained speechless. ²³ And it came to pass, that, as soon as the days of his ministration were accomplished, he departed to his own house. ²⁴ And after those days his wife Elisabeth conceived, and hid herself five months, saying, ²⁵ Thus hath the Lord dealt with me in the days wherein he looked on me, to take away my reproach among men. ²⁶ And in the sixth month the angel Gabriel was sent from God unto a city of Galilee, named Nazareth, ²⁷ To a virgin espoused to a man whose name was Joseph, of the house of David; and the virgin's name was Mary. ²⁸ And the angel came in unto her, and said, Hail, thou that art highly favoured, the Lord is with thee: blessed art thou among women. ²⁹ And when she saw him, she was troubled at his saying, and cast in her mind what manner of salutation this should be. ³⁰ And the angel said unto her, Fear not, Mary: for thou hast found favour with God. ³¹ **And, behold, thou shalt conceive in thy womb, and bring forth a son, and shalt call his name JESUS. ³² He shall be great, and shall be called the Son of the Highest: and the Lord God shall give unto him the throne of his father David: ³³ And he shall reign over the house of Jacob for ever; and of his kingdom there shall be***

no end. ³⁴ **Then said Mary unto the angel, How shall this be, seeing I know not a man?** ³⁵ **And the angel answered and said unto her, The Holy Ghost shall come upon thee, and the power of the Highest shall overshadow thee: therefore also that holy thing which shall be born of thee shall be called the Son of God.** ³⁶ *And, behold, thy cousin Elisabeth, she hath also conceived a son in her old age: and this is the sixth month with her, who was called barren.* ³⁷ *For with God nothing shall be impossible.* ³⁸ *And Mary said, Behold the handmaid of the Lord; be it unto me according to thy word. And the angel departed from her.* ³⁹ *And Mary arose in those days, and went into the hill country with haste, into a city of Juda;* ⁴⁰ *And entered into the house of Zacharias, and saluted Elisabeth.* ⁴¹ *And it came to pass, that, when Elisabeth heard the salutation of Mary, the babe leaped in her womb; and Elisabeth was filled with the Holy Ghost:* ⁴² *And she spake out with a loud voice, and said, Blessed art thou among women, and blessed is the fruit of thy womb.* ⁴³ *And whence is this to me, that the mother of my Lord should come to me?* ⁴⁴ *For, lo, as soon as the voice of thy salutation sounded in mine ears, the babe leaped in my womb for joy.* ⁴⁵ *And blessed is she that believed: for there shall be a performance of those things which were told her from the Lord.* ⁴⁶ *And Mary said, My soul doth magnify the Lord,* ⁴⁷ *And my spirit hath rejoiced in God my Saviour.* ⁴⁸ *For he hath regarded the low estate of his handmaiden: for, behold, from henceforth all generations shall call me blessed.* ⁴⁹ *For he that is mighty hath done to me great things; and holy is his name.* ⁵⁰ *And his mercy is on them that fear him from generation to generation.* ⁵¹ *He hath shewed strength with his arm; he hath scattered the proud in the imagination of their hearts.* ⁵² *He hath put down the mighty from their seats, and exalted them of low degree.* ⁵³ *He hath filled the hungry with good things; and the rich he hath sent empty away.* ⁵⁴ *He hath holpen his servant Israel, in remembrance of his mercy;* ⁵⁵ *As he spake to our fathers, to Abraham, and to his seed for ever.* ⁵⁶ *And Mary abode with her about three months, and returned to her own house.* ⁵⁷ *Now Elisabeth's full time came that she should be delivered; and she brought forth a son.* ⁵⁸ *And her neighbours and her cousins heard how the Lord had shewed great mercy upon her; and they rejoiced with her.* ⁵⁹ *And it came to pass, that on the eighth day they came to circumcise the child; and they called him Zacharias, after the name of his father.* ⁶⁰ *And his mother answered and said, Not so; but he shall be called John.* ⁶¹ *And they said unto her, There is none of thy kindred that is called by this name.* ⁶² *And they made signs to his father, how he would have him called.* ⁶³ *And he asked for a writing table, and wrote, saying, His name is John. And they marvelled all.* ⁶⁴ *And his*

mouth was opened immediately, and his tongue loosed, and he spake, and praised God. ⁶⁵ And fear came on all that dwelt round about them: and all these sayings were noised abroad throughout all the hill country of Judaea. ⁶⁶ And all they that heard them laid them up in their hearts, saying, What manner of child shall this be! And the hand of the Lord was with him. ⁶⁷ And his father Zacharias was filled with the Holy Ghost, and prophesied, saying, ⁶⁸ Blessed be the Lord God of Israel; for he hath visited and redeemed his people, ⁶⁹ And hath raised up an horn of salvation for us in the house of his servant David; ⁷⁰ As he spake by the mouth of his holy prophets, which have been since the world began: ⁷¹ That we should be saved from our enemies, and from the hand of all that hate us; ⁷² To perform the mercy promised to our fathers, and to remember his holy covenant; ⁷³ The oath which he sware to our father Abraham, ⁷⁴ That he would grant unto us, that we being delivered out of the hand of our enemies might serve him without fear, ⁷⁵ In holiness and righteousness before him, all the days of our life. ⁷⁶ And thou, child, shalt be called the prophet of the Highest: for thou shalt go before the face of the Lord to prepare his ways; ⁷⁷ To give knowledge of salvation unto his people by the remission of their sins, ⁷⁸ Through the tender mercy of our God; whereby the dayspring from on high hath visited us, ⁷⁹ To give light to them that sit in darkness and in the shadow of death, to guide our feet into the way of peace. ⁸⁰ And the child grew, and waxed strong in spirit, and was in the deserts till the day of his shewing unto Israel.

Explanation

EL Elyon: God Most High. **St. Luke 1:32**
Text
Psalms 8:1

Adonai Lord
Psalms 8

¹ O LORD, our Lord, how excellent is thy name in all the earth! who hast set thy glory above the heavens. ² Out of the mouth of babes and sucklings hast thou ordained strength because of thine enemies, that thou mightest still the enemy and the avenger. ³ When I consider thy heavens, the work of thy fingers, the moon and the stars, which thou hast ordained; ⁴ What is man, that thou art mindful of him? and the son of man, that thou visitest him? ⁵

For thou hast made him a little lower than the angels, and hast crowned him with glory and honour. ⁶ *Thou madest him to have dominion over the works of thy hands; thou hast put all things under his feet:* ⁷ *All sheep and oxen, yea, and the beasts of the field;* ⁸ *The fowl of the air, and the fish of the sea, and whatsoever passeth through the paths of the seas.* ⁹ *O LORD our Lord, how excellent is thy name in all the earth!*

Explanation

Adonai Lord, Servant to His Master. Jehovah or properly name Yahweh or Jahweh: I AM OR I WILL **Psalm 8:1**
Text
Psalms 68:4

Jah
Psalms 68

¹ *Let God arise, let his enemies be scattered: let them also that hate him flee before him.* ² *As smoke is driven away, so drive them away: as wax melteth before the fire, so let the wicked perish at the presence of God.* ³ *But let the righteous be glad; let them rejoice before God: yea, let them exceedingly rejoice.* ⁴ **Sing unto God, sing praises to his name: extol him that rideth upon the heavens by his name JAH, and rejoice before him.** ⁵ *A father of the fatherless, and a judge of the widows, is God in his holy habitation.* ⁶ *God setteth the solitary in families: he bringeth out those which are bound with chains: but the rebellious dwell in a dry land.* ⁷ *O God, when thou wentest forth before thy people, when thou didst march through the wilderness; Selah:* ⁸ *The earth shook, the heavens also dropped at the presence of God: even Sinai itself was moved at the presence of God, the God of Israel.* ⁹ *Thou, O God, didst send a plentiful rain, whereby thou didst confirm thine inheritance, when it was weary.* ¹⁰ *Thy congregation hath dwelt therein: thou, O God, hast prepared of thy goodness for the poor.* ¹¹ *The Lord gave the word: great was the company of those that published it.* ¹² *Kings of armies did flee apace: and she that tarried at home divided the spoil.* ¹³ *Though ye have lien among the pots, yet shall ye be as the wings of a dove covered with silver, and her feathers with yellow gold.* ¹⁴ *When the Almighty scattered kings in it, it was white as snow in Salmon.* ¹⁵ *The hill of God is as the hill of Bashan; an high hill as the hill of Bashan.* ¹⁶ *Why leap ye, ye high hills? this is the hill which God*

desireth to dwell in; yea, the LORD will dwell in it for ever. [17] The chariots of God are twenty thousand, even thousands of angels: the Lord is among them, as in Sinai, in the holy place. [18] Thou hast ascended on high, thou hast led captivity captive: thou hast received gifts for men; yea, for the rebellious also, that the LORD God might dwell among them. [19] Blessed be the Lord, who daily loadeth us with benefits, even the God of our salvation. Selah. [20] He that is our God is the God of salvation; and unto GOD the Lord belong the issues from death. [21] But God shall wound the head of his enemies, and the hairy scalp of such an one as goeth on still in his trespasses. [22] The Lord said, I will bring again from Bashan, I will bring my people again from the depths of the sea: [23] That thy foot may be dipped in the blood of thine enemies, and the tongue of thy dogs in the same. [24] They have seen thy goings, O God; even the goings of my God, my King, in the sanctuary. [25] The singers went before, the players on instruments followed after; among them were the damsels playing with timbrels. [26] Bless ye God in the congregations, even the Lord, from the fountain of Israel. [27] There is little Benjamin with their ruler, the princes of Judah and their council, the princes of Zebulun, and the princes of Naphtali. [28] Thy God hath commanded thy strength: strengthen, O God, that which thou hast wrought for us. [29] Because of thy temple at Jerusalem shall kings bring presents unto thee. [30] Rebuke the company of spearmen, the multitude of the bulls, with the calves of the people, till every one submit himself with pieces of silver: scatter thou the people that delight in war. [31] Princes shall come out of Egypt; Ethiopia shall soon stretch out her hands unto God. [32] Sing unto God, ye kingdoms of the earth; O sing praises unto the Lord; Selah: [33] To him that rideth upon the heavens of heavens, which were of old; lo, he doth send out his voice, and that a mighty voice. [34] Ascribe ye strength unto God: his excellency is over Israel, and his strength is in the clouds. [35] O God, thou art terrible out of thy holy places: the God of Israel is he that giveth strength and power unto his people. Blessed be God.

Explanation

Jah, has this form of the word Jahweh, which appears in poetry. It is used in the place of Hallelujah and in proper names. **Psalms 68:4**
Text
Psalms 64:1

Jahweh Tsebaoth
Psalms 64

¹ Hear my voice, O God, in my prayer: preserve my life from fear of the enemy. ² *Hide me from the secret counsel of the wicked; from the insurrection of the workers of iniquity:* ³ *Who whet their tongue like a sword, and bend their bows to shoot their arrows, even bitter words:* ⁴ *That they may shoot in secret at the perfect: suddenly do they shoot at him, and fear not.* ⁵ *They encourage themselves in an evil matter: they commune of laying snares privily; they say, Who shall see them?* ⁶ *They search out iniquities; they accomplish a diligent search: both the inward thought of every one of them, and the heart, is deep.* ⁷ *But God shall shoot at them with an arrow; suddenly shall they be wounded.* ⁸ *So they shall make their own tongue to fall upon themselves: all that see them shall flee away.* ⁹ *And all men shall fear, and shall declare the work of God; for they shall wisely consider of his doing.* ¹⁰ *The righteous shall be glad in the LORD, and shall trust in him; and all the upright in heart shall glory.*

Explanation

Jahweh Tsebaoth The Lord of Host appears prophetically and post-exilic literature. Also, it is the name known to the armies of Israel and the host in heaven.**Psalms 64:1**

Conclusion

Within the Old Testament, The Lord God, God the Father is identified in (8) distinctly roles, in this lesson, associated with a name, labeling God for:
- Ability.
- Performance Rating
- Quality
- Identifying service to whom
- Identifying service to what time period, or dispensation of time

Questions

Who are the three that bare record in heaven and agree as one? Provide the scripture.
What is this text explaining?

Who are the three that bare record on earth, making up the key components of the composition of mankind? Provide the scripture.

Who is the begotten of the Father? What does begotten mean. Provide scripture.

Name seven titles of God which also defines His identity, and role within the Holy Scriptures. Supply the following:

Title Role Scripture

Thought Question

Why is it important to note that Jesus came by water and blood?

The Role of God
God: Yahweh
Chapter 2

Text
Psalm 90:2
I Timothy 1:17
Psalm 93:1
Psalm139: 1-2
Psalm 139: 7-8
Revelation 19:6
Malachi 3:6
Deuteronomy 32:4
Exodus 9:27
Ephesians 2:8
I John 4:8
I Peter 1:3
Romans 8:28

Introduction

This lesson is a continuation of Part 1, of God the Father and consists of our statement of faith, or mission statement regarding the doctrine of God the Father. We shall expound upon some more titles of God, which also identify what He is to the body of believers, defining various roles within each title of who God the Father is to the Church, as the Creator as, Elohim of all, who has revealed Himself in three distinct Persons—Father, Son, and Holy Spirit yet who is One in Being, essence, and glory, as Adoni.

The Lesson

Text
Psalms 90:2 (See previous chapter for full text)

Jehovah Sabaoth
Psalms 90

[2] Before the mountains were brought forth, or ever thou hadst formed the earth and the world, even from everlasting to everlasting, thou art God.

Explanation

God is eternal, as Jehovah Sabaoth. **Psalm 90:2**
Text

I Timothy 1:17
El Olam

1 Timothy 1

[1] Paul, an apostle of Jesus Christ by the commandment of God our Saviour, and Lord Jesus Christ, which is our hope; [2] Unto Timothy, my own son in the faith: Grace, mercy, and peace, from God our Father and Jesus Christ our Lord. [3] As I besought thee to abide still at Ephesus, when I went into Macedonia, that thou mightest charge some that they teach no other doctrine, [4] Neither give heed to fables and endless genealogies, which minister questions, rather than godly edifying which is in faith: so do. [5] Now the end of the commandment is charity out of a pure heart, and of a good conscience, and of faith unfeigned: [6] From which some having swerved have turned aside unto vain jangling; [7] Desiring to be teachers of the law; understanding neither what they say, nor whereof they affirm. [8] But we know that the law is good, if a man use it lawfully; [9] Knowing this, that the law is not made for a righteous man, but for the lawless and disobedient, for the ungodly and for sinners, for unholy and profane, for murderers of fathers and murderers of mothers, for manslayers, [10] For whoremongers, for them that defile themselves with mankind, for menstealers, for liars, for perjured persons, and if there be any other thing that is contrary to sound doctrine; [11] According to the glorious gospel of the blessed God, which was committed to my trust. [12] And I thank Christ Jesus our Lord, who hath enabled me, for that he counted me faithful, putting me into the ministry; [13] Who was before a blasphemer, and a persecutor, and injurious: but I obtained mercy, because I did it ignorantly in unbelief. [14] And the grace of our Lord was exceeding abundant with faith and love which is in Christ Jesus. [15] This is a faithful saying, and worthy of all acceptation, that Christ Jesus came into the

world to save sinners; of whom I am chief. [16] *Howbeit for this cause I obtained mercy, that in me first Jesus Christ might shew forth all longsuffering, for a pattern to them which should hereafter believe on him to life everlasting.* [17] **Now unto the King eternal, immortal, invisible, the only wise God, be honour and glory for ever and ever. Amen.** [18] *This charge I commit unto thee, son Timothy, according to the prophecies which went before on thee, that thou by them mightest war a good warfare;* [19] *Holding faith, and a good conscience; which some having put away concerning faith have made shipwreck:* [20] *Of whom is Hymenaeus and Alexander; whom I have delivered unto Satan, that they may learn not to blaspheme.*

Explanation

God is Infinite, as El Olam. **I Timothy 1:17**

Jehovah
Palms 93

Text
Psalms 93:1 (See previous chapter, full text)
[1] *The LORD reigneth, he is clothed with majesty; the LORD is clothed with strength, wherewith he hath girded himself: the world also is stablished, that it cannot be moved.*

Explanation

God is Sovereign, as Jehovah. He is King of all Kings and Lord of all Lord. Psalm **93:1**
Text
Psalm139: 1-2; 7, 8

Jehovah Rohi.
And
Jehovah Shammah
Psalms 139

[1] **O lord, thou hast searched me, and known me.** [2] **Thou knowest my downsitting and mine uprising, thou understandest my thought afar**

off. *³ Thou compassest my path and my lying down, and art acquainted with all my ways. ⁴ For there is not a word in my tongue, but, lo, O LORD, thou knowest it altogether. ⁵ Thou hast beset me behind and before, and laid thine hand upon me. ⁶ Such knowledge is too wonderful for me; it is high, I cannot attain unto it.* **⁷ Whither shall I go from thy spirit? or whither shall I flee from thy presence? ⁸ If I ascend up into heaven, thou art there: if I make my bed in hell, behold, thou art there.** *⁹ If I take the wings of the morning, and dwell in the uttermost parts of the sea; ¹⁰ Even there shall thy hand lead me, and thy right hand shall hold me. ¹¹ If I say, Surely the darkness shall cover me; even the night shall be light about me. ¹² Yea, the darkness hideth not from thee; but the night shineth as the day: the darkness and the light are both alike to thee. ¹³ For thou hast possessed my reins: thou hast covered me in my mother's womb. ¹⁴ I will praise thee; for I am fearfully and wonderfully made: marvellous are thy works; and that my soul knoweth right well. ¹⁵ My substance was not hid from thee, when I was made in secret, and curiously wrought in the lowest parts of the earth. ¹⁶ Thine eyes did see my substance, yet being unperfect; and in thy book all my members were written, which in continuance were fashioned, when as yet there was none of them. ¹⁷ How precious also are thy thoughts unto me, O God! how great is the sum of them! ¹⁸ If I should count them, they are more in number than the sand: when I awake, I am still with thee. ¹⁹ Surely thou wilt slay the wicked, O God: depart from me therefore, ye bloody men. ²⁰ For they speak against thee wickedly, and thine enemies take thy name in vain. ²¹ Do not I hate them, O LORD, that hate thee? and am not I grieved with those that rise up against thee? ²² I hate them with perfect hatred: I count them mine enemies. ²³ Search me, O God, and know my heart: try me, and know my thoughts: ²⁴ And see if there be any wicked way in me, and lead me in the way everlasting.*

Explanation

God is omniscient, as our Jehovah Rohi. God knows everything. He is all wise. **Psalm 139: 1-2**

Also

Text
Palmns 139: 7-8

⁷ Whither shall I go from thy spirit? or whither shall I flee from thy presence? ⁸ If I ascend up into heaven, thou art there: if I make my bed in hell, behold, thou art there.

Explanation

God is Omnipresent, as Jehovah Shammah, God is everywhere at the same time.
Psalm 139:7-8
Text
Revelation 19:6

El Shaddai.
Revelation 19

*¹ And after these things I heard a great voice of much people in heaven, saying, Alleluia; Salvation, and glory, and honour, and power, unto the Lord our God: ² For true and righteous are his judgments: for he hath judged the great whore, which did corrupt the earth with her fornication, and hath avenged the blood of his servants at her hand. ³ And again they said, Alleluia And her smoke rose up for ever and ever. ⁴ And the four and twenty elders and the four beasts fell down and worshipped God that sat on the throne, saying, Amen; Alleluia. ⁵ And a voice came out of the throne, saying, Praise our God, all ye his servants, and ye that fear him, both small and great. **⁶ And I heard as it were the voice of a great multitude, and as the voice of many waters, and as the voice of mighty thunderings, saying, Alleluia: for the Lord God omnipotent reigneth.** ⁷ Let us be glad and rejoice, and give honour to him: for the marriage of the Lamb is come, and his wife hath made herself ready. ⁸ And to her was granted that she should be arrayed in fine linen, clean and white: for the fine linen is the righteousness of saints. ⁹ And he saith unto me, Write, Blessed are they which are called unto the marriage supper of the Lamb. And he saith unto me, These are the true sayings of God. ¹⁰ And I fell at his feet to worship him. And he said unto me, See thou do it not: I am thy fellowservant, and of thy brethren that have the testimony of Jesus: worship God: for the testimony of Jesus is the spirit of prophecy. ¹¹ And I saw heaven opened, and behold a white horse; and he that sat upon him was called Faithful and True, and in righteousness he doth judge and make war. ¹² His eyes were as a flame of fire, and on his head were many crowns; and he had a*

name written, that no man knew, but he himself. ¹³ *And he was clothed with a vesture dipped in blood: and his name is called The Word of God.* ¹⁴ *And the armies which were in heaven followed him upon white horses, clothed in fine linen, white and clean.* ¹⁵ *And out of his mouth goeth a sharp sword, that with it he should smite the nations: and he shall rule them with a rod of iron: and he treadeth the winepress of the fierceness and wrath of Almighty God.* ¹⁶ *And he hath on his vesture and on his thigh a name written, KING OF KINGS, AND LORD OF LORDS.* ¹⁷ *And I saw an angel standing in the sun; and he cried with a loud voice, saying to all the fowls that fly in the midst of heaven, Come and gather yourselves together unto the supper of the great God;* ¹⁸ *That ye may eat the flesh of kings, and the flesh of captains, and the flesh of mighty men, and the flesh of horses, and of them that sit on them, and the flesh of all men, both free and bond, both small and great.* ¹⁹ *And I saw the beast, and the kings of the earth, and their armies, gathered together to make war against him that sat on the horse, and against his army.* ²⁰ *And the beast was taken, and with him the false prophet that wrought miracles before him, with which he deceived them that had received the mark of the beast, and them that worshipped his image. These both were cast alive into a lake of fire burning with brimstone.* ²¹ *And the remnant were slain with the sword of him that sat upon the horse, which sword proceeded out of his mouth: and all the fowls were filled with their flesh.*

Explanation

God is Omnipotent, as El Shaddai. God is all powerful **Revelation 19:6**
Text
Malachi 3:6

Jehovah Nissi
Malachi 3

¹ *Behold, I will send my messenger, and he shall prepare the way before me: and the LORD, whom ye seek, shall suddenly come to his temple, even the messenger of the covenant, whom ye delight in: behold, he shall come, saith the LORD of hosts.* ² *But who may abide the day of his coming? and who shall stand when he appeareth? for he is like a refiner's fire, and like fullers' soap:* ³ *And he shall sit as a refiner and purifier of silver: and he shall purify the sons of Levi, and purge them as gold and silver, that they may offer unto the LORD*

an offering in righteousness. *⁴ Then shall the offering of Judah and Jerusalem be pleasant unto the LORD, as in the days of old, and as in former years. ⁵ And I will come near to you to judgment; and I will be a swift witness against the sorcerers, and against the adulterers, and against false swearers, and against those that oppress the hireling in his wages, the widow, and the fatherless, and that turn aside the stranger from his right, and fear not me, saith the LORD of hosts. ⁶* **For I am the LORD, I change not; therefore ye sons of Jacob are not consumed.** *⁷ Even from the days of your fathers ye are gone away from mine ordinances, and have not kept them. Return unto me, and I will return unto you, saith the LORD of hosts. But ye said, Wherein shall we return? ⁸ Will a man rob God? Yet ye have robbed me. But ye say, Wherein have we robbed thee? In tithes and offerings. ⁹ Ye are cursed with a curse: for ye have robbed me, even this whole nation. ¹⁰ Bring ye all the tithes into the storehouse, that there may be meat in mine house, and prove me now herewith, saith the LORD of hosts, if I will not open you the windows of heaven, and pour you out a blessing, that there shall not be room enough to receive it. ¹¹ And I will rebuke the devourer for your sakes, and he shall not destroy the fruits of your ground; neither shall your vine cast her fruit before the time in the field, saith the LORD of hosts. ¹² And all nations shall call you blessed: for ye shall be a delightsome land, saith the LORD of hosts. ¹³ Your words have been stout against me, saith the LORD. Yet ye say, What have we spoken so much against thee? ¹⁴ Ye have said, It is vain to serve God: and what profit is it that we have kept his ordinance, and that we have walked mournfully before the LORD of hosts? ¹⁵ And now we call the proud happy; yea, they that work wickedness are set up; yea, they that tempt God are even delivered. ¹⁶ Then they that feared the LORD spake often one to another: and the LORD hearkened, and heard it, and a book of remembrance was written before him for them that feared the LORD, and that thought upon his name. ¹⁷ And they shall be mine, saith the LORD of hosts, in that day when I make up my jewels; and I will spare them, as a man spareth his own son that serveth him. ¹⁸ Then shall ye return, and discern between the righteous and the wicked, between him that serveth God and him that serveth him not.*

Explanation

God is Unchanging, as Jehovah Nissi. **Malachi 3:6**
Text
Deuteronomy 32:4

Jehovah Rohi
Deuteronomy 32

¹ Give ear, O ye heavens, and I will speak; and hear, O earth, the words of my mouth. ² My doctrine shall drop as the rain, my speech shall distil as the dew, as the small rain upon the tender herb, and as the showers upon the grass: ³ Because I will publish the name of the LORD: ascribe ye greatness unto our God. **⁴ He is the Rock, his work is perfect: for all his ways are judgment: a God of truth and without iniquity, just and right is he.** *⁵ They have corrupted themselves, their spot is not the spot of his children: they are a perverse and crooked generation. ⁶ Do ye thus requite the LORD, O foolish people and unwise? is not he thy father that hath bought thee? hath he not made thee, and established thee? ⁷ Remember the days of old, consider the years of many generations: ask thy father, and he will shew thee; thy elders, and they will tell thee. ⁸ When the Most High divided to the nations their inheritance, when he separated the sons of Adam, he set the bounds of the people according to the number of the children of Israel. ⁹ For the LORD's portion is his people; Jacob is the lot of his inheritance. ¹⁰ He found him in a desert land, and in the waste howling wilderness; he led him about, he instructed him, he kept him as the apple of his eye. ¹¹ As an eagle stirreth up her nest, fluttereth over her young, spreadeth abroad her wings, taketh them, beareth them on her wings: ¹² So the LORD alone did lead him, and there was no strange god with him. ¹³ He made him ride on the high places of the earth, that he might eat the increase of the fields; and he made him to suck honey out of the rock, and oil out of the flinty rock; ¹⁴ Butter of kine, and milk of sheep, with fat of lambs, and rams of the breed of Bashan, and goats, with the fat of kidneys of wheat; and thou didst drink the pure blood of the grape. ¹⁵ But Jeshurun waxed fat, and kicked: thou art waxen fat, thou art grown thick, thou art covered with fatness; then he forsook God which made him, and lightly esteemed the Rock of his salvation. ¹⁶ They provoked him to jealousy with strange gods, with abominations provoked they him to anger. ¹⁷ They sacrificed unto devils, not to God; to gods whom they knew not, to new gods that came newly up, whom your fathers feared not. ¹⁸ Of the Rock that begat thee thou art unmindful, and hast forgotten God that formed thee. ¹⁹ And when the LORD saw it, he abhorred them, because of the provoking of his sons, and of his daughters. ²⁰ And he said, I will hide my face from them, I will see what their end shall be: for they are a very froward generation, children in whom is no faith. ²¹ They have moved me to jealousy with that which is not God; they have provoked*

me to anger with their vanities: and I will move them to jealousy with those which are not a people; I will provoke them to anger with a foolish nation. ²² *For a fire is kindled in mine anger, and shall burn unto the lowest hell, and shall consume the earth with her increase, and set on fire the foundations of the mountains.* ²³ *I will heap mischiefs upon them; I will spend mine arrows upon them.* ²⁴ *They shall be burnt with hunger, and devoured with burning heat, and with bitter destruction: I will also send the teeth of beasts upon them, with the poison of serpents of the dust.* ²⁵ *The sword without, and terror within, shall destroy both the young man and the virgin, the suckling also with the man of gray hairs.* ²⁶ *I said, I would scatter them into corners, I would make the remembrance of them to cease from among men:* ²⁷ *Were it not that I feared the wrath of the enemy, lest their adversaries should behave themselves strangely, and lest they should say, Our hand is high, and the LORD hath not done all this.* ²⁸ *For they are a nation void of counsel, neither is there any understanding in them.* ²⁹ *O that they were wise, that they understood this, that they would consider their latter end!* ³⁰ *How should one chase a thousand, and two put ten thousand to flight, except their Rock had sold them, and the LORD had shut them up?* ³¹ *For their rock is not as our Rock, even our enemies themselves being judges.* ³² *For their vine is of the vine of Sodom, and of the fields of Gomorrah: their grapes are grapes of gall, their clusters are bitter:* ³³ *Their wine is the poison of dragons, and the cruel venom of asps.* ³⁴ *Is not this laid up in store with me, and sealed up among my treasures?* ³⁵ *To me belongeth vengeance and recompence; their foot shall slide in due time: for the day of their calamity is at hand, and the things that shall come upon them make haste.* ³⁶ *For the LORD shall judge his people, and repent himself for his servants, when he seeth that their power is gone, and there is none shut up, or left.* ³⁷ *And he shall say, Where are their gods, their rock in whom they trusted,* ³⁸ *Which did eat the fat of their sacrifices, and drank the wine of their drink offerings? let them rise up and help you, and be your protection.* ³⁹ *See now that I, even I, am he, and there is no god with me: I kill, and I make alive; I wound, and I heal: neither is there any that can deliver out of my hand.* ⁴⁰ *For I lift up my hand to heaven, and say, I live for ever.* ⁴¹ *If I whet my glittering sword, and mine hand take hold on judgment; I will render vengeance to mine enemies, and will reward them that hate me.* ⁴² *I will make mine arrows drunk with blood, and my sword shall devour flesh; and that with the blood of the slain and of the captives, from the beginning of revenges upon the enemy.* ⁴³ *Rejoice, O ye nations, with his people: for he will avenge the blood of his servants, and will render vengeance to his adversaries, and will be merciful*

unto his land, and to his people. ⁴⁴ *And Moses came and spake all the words of this song in the ears of the people, he, and Hoshea the son of Nun.* ⁴⁵ *And Moses made an end of speaking all these words to all Israel:* ⁴⁶ *And he said unto them, Set your hearts unto all the words which I testify among you this day, which ye shall command your children to observe to do, all the words of this law.* ⁴⁷ *For it is not a vain thing for you; because it is your life: and through this thing ye shall prolong your days in the land, whither ye go over Jordan to possess it.* ⁴⁸ *And the LORD spake unto Moses that selfsame day, saying,* ⁴⁹ *Get thee up into this mountain Abarim, unto mount Nebo, which is in the land of Moab, that is over against Jericho; and behold the land of Canaan, which I give unto the children of Israel for a possession:* ⁵⁰ *And die in the mount whither thou goest up, and be gathered unto thy people; as Aaron thy brother died in mount Hor, and was gathered unto his people:* ⁵¹ *Because ye trespassed against me among the children of Israel at the waters of MeribahKadesh, in the wilderness of Zin; because ye sanctified me not in the midst of the children of Israel.* ⁵² *Yet thou shalt see the land before thee; but thou shalt not go thither unto the land which I give the children of Israel.*

Explanation

God is Just as Jehovah Rohi. He extends Grace or unmerited favor to all day by day, through our mere existence. **Deuteronomy 32:4**
Text
Exodus 9:27

Jehovah Tsidkenu
Exodus 9

¹ *Then the LORD said unto Moses, Go in unto Pharaoh, and tell him, Thus saith the LORD God of the Hebrews, Let my people go, that they may serve me.* ² *For if thou refuse to let them go, and wilt hold them still,* ³ *Behold, the hand of the LORD is upon thy cattle which is in the field, upon the horses, upon the asses, upon the camels, upon the oxen, and upon the sheep: there shall be a very grievous murrain.* ⁴ *And the LORD shall sever between the cattle of Israel and the cattle of Egypt: and there shall nothing die of all that is the children's of Israel.* ⁵ *And the LORD appointed a set time, saying, To morrow the LORD shall do this thing in the land.* ⁶ *And the LORD did that thing on the morrow, and all the cattle of Egypt died: but of the cattle of the children*

of Israel died not one. ⁷ *And Pharaoh sent, and, behold, there was not one of the cattle of the Israelites dead. And the heart of Pharaoh was hardened, and he did not let the people go.* ⁸ *And the LORD said unto Moses and unto Aaron, Take to you handfuls of ashes of the furnace, and let Moses sprinkle it toward the heaven in the sight of Pharaoh.* ⁹ *And it shall become small dust in all the land of Egypt, and shall be a boil breaking forth with blains upon man, and upon beast, throughout all the land of Egypt.* ¹⁰ *And they took ashes of the furnace, and stood before Pharaoh; and Moses sprinkled it up toward heaven; and it became a boil breaking forth with blains upon man, and upon beast.* ¹¹ *And the magicians could not stand before Moses because of the boils; for the boil was upon the magicians, and upon all the Egyptians.* ¹² *And the LORD hardened the heart of Pharaoh, and he hearkened not unto them; as the LORD had spoken unto Moses.* ¹³ *And the LORD said unto Moses, Rise up early in the morning, and stand before Pharaoh, and say unto him, Thus saith the LORD God of the Hebrews, Let my people go, that they may serve me.* ¹⁴ *For I will at this time send all my plagues upon thine heart, and upon thy servants, and upon thy people; that thou mayest know that there is none like me in all the earth.* ¹⁵ *For now I will stretch out my hand, that I may smite thee and thy people with pestilence; and thou shalt be cut off from the earth.* ¹⁶ *And in very deed for this cause have I raised thee up, for to shew in thee my power; and that my name may be declared throughout all the earth.* ¹⁷ *As yet exaltest thou thyself against my people, that thou wilt not let them go?* ¹⁸ *Behold, to morrow about this time I will cause it to rain a very grievous hail, such as hath not been in Egypt since the foundation thereof even until now.* ¹⁹ *Send therefore now, and gather thy cattle, and all that thou hast in the field; for upon every man and beast which shall be found in the field, and shall not be brought home, the hail shall come down upon them, and they shall die.* ²⁰ *He that feared the word of the LORD among the servants of Pharaoh made his servants and his cattle flee into the houses:* ²¹ *And he that regarded not the word of the LORD left his servants and his cattle in the field.* ²² *And the LORD said unto Moses, Stretch forth thine hand toward heaven, that there may be hail in all the land of Egypt, upon man, and upon beast, and upon every herb of the field, throughout the land of Egypt.* ²³ *And Moses stretched forth his rod toward heaven: and the LORD sent thunder and hail, and the fire ran along upon the ground; and the LORD rained hail upon the land of Egypt.* ²⁴ *So there was hail, and fire mingled with the hail, very grievous, such as there was none like it in all the land of Egypt since it became a nation.* ²⁵ *And the hail smote throughout all the land of Egypt all that was in the field,*

both man and beast; and the hail smote every herb of the field, and brake every tree of the field. ²⁶ *Only in the land of Goshen, where the children of Israel were, was there no hail.* ²⁷ **And Pharaoh sent, and called for Moses and Aaron, and said unto them, I have sinned this time: the LORD is righteous, and I and my people are wicked.** ²⁸ *Intreat the LORD (for it is enough) that there be no more mighty thunderings and hail; and I will let you go, and ye shall stay no longer.* ²⁹ *And Moses said unto him, As soon as I am gone out of the city, I will spread abroad my hands unto the LORD; and the thunder shall cease, neither shall there be any more hail; that thou mayest know how that the earth is the LORD's.* ³⁰ *But as for thee and thy servants, I know that ye will not yet fear the LORD God.* ³¹ *And the flax and the barley was smitten: for the barley was in the ear, and the flax was bolled.* ³² *But the wheat and the rie were not smitten: for they were not grown up.* ³³ *And Moses went out of the city from Pharaoh, and spread abroad his hands unto the LORD: and the thunders and hail ceased, and the rain was not poured upon the earth.* ³⁴ *And when Pharaoh saw that the rain and the hail and the thunders were ceased, he sinned yet more, and hardened his heart, he and his servants.* ³⁵ *And the heart of Pharaoh was hardened, neither would he let the children of Israel go; as the LORD had spoken by Moses.*

Explanation

God is righteous as Jehovah Tsidkenu. God is pure and holy. **Exodus 9:27**
Text
I John 4:8

Jehovah Rophe
1 John 4

¹ *Beloved, believe not every spirit, but try the spirits whether they are of God: because many false prophets are gone out into the world.* ² *Hereby know ye the Spirit of God: Every spirit that confesseth that Jesus Christ is come in the flesh is of God:* ³ *And every spirit that confesseth not that Jesus Christ is come in the flesh is not of God: and this is that spirit of antichrist, whereof ye have heard that it should come; and even now already is it in the world.* ⁴ *Ye are of God, little children, and have overcome them: because greater is he that is in you, than he that is in the world.* ⁵ *They are of the world: therefore speak they of*

*the world, and the world heareth them. ⁶ We are of God: he that knoweth God heareth us; he that is not of God heareth not us. Hereby know we the spirit of truth, and the spirit of error. ⁷ Beloved, let us love one another: for love is of God; and every one that loveth is born of God, and knoweth God. ⁸ **He that loveth not knoweth not God; for God is love.** ⁹ In this was manifested the love of God toward us, because that God sent his only begotten Son into the world, that we might live through him. ¹⁰ Herein is love, not that we loved God, but that he loved us, and sent his Son to be the propitiation for our sins. ¹¹ Beloved, if God so loved us, we ought also to love one another. ¹² No man hath seen God at any time. If we love one another, God dwelleth in us, and his love is perfected in us. ¹³ Hereby know we that we dwell in him, and he in us, because he hath given us of his Spirit. ¹⁴ And we have seen and do testify that the Father sent the Son to be the Saviour of the world. ¹⁵ Whosoever shall confess that Jesus is the Son of God, God dwelleth in him, and he in God. ¹⁶ And we have known and believed the love that God hath to us. God is love; and he that dwelleth in love dwelleth in God, and God in him. ¹⁷ Herein is our love made perfect, that we may have boldness in the day of judgment: because as he is, so are we in this world. ¹⁸ There is no fear in love; but perfect love casteth out fear: because fear hath torment. He that feareth is not made perfect in love. ¹⁹ We love him, because he first loved us. ²⁰ If a man say, I love God, and hateth his brother, he is a liar: for he that loveth not his brother whom he hath seen, how can he love God whom he hath not seen? ²¹ And this commandment have we from him, That he who loveth God love his brother also.*

Explanation

God is love, as Jehovah Rophe. God loves us all, the saint and the sinner or the unbeliever. **I John 4:8**

Text

Ephesians 2:8 (See Unit 3, chapter 1 full text)

Jehovah Shammah
Ephesians 2

For by grace are ye saved, through faith and not by works. It is the gift of God.

Explanation

God is Gracious, as Jehovah Shammah. God allows all to come into his presence, through his Son, the Lord Jesus Christ. **Ephesians 2:8**
Text
I Peter 1:3

Jehovah Jireh
1 Peter 1

¹ Peter, an apostle of Jesus Christ, to the strangers scattered throughout Pontus, Galatia, Cappadocia, Asia, and Bithynia, ² Elect according to the foreknowledge of God the Father, through sanctification of the Spirit, unto obedience and sprinkling of the blood of Jesus Christ: Grace unto you, and peace, be multiplied. ***³ Blessed be the God and Father of our Lord Jesus Christ, which according to his abundant mercy hath begotten us again unto a lively hope by the resurrection of Jesus Christ from the dead,*** *⁴ To an inheritance incorruptible, and undefiled, and that fadeth not away, reserved in heaven for you, ⁵ Who are kept by the power of God through faith unto salvation ready to be revealed in the last time. ⁶ Wherein ye greatly rejoice, though now for a season, if need be, ye are in heaviness through manifold temptations: ⁷ That the trial of your faith, being much more precious than of gold that perisheth, though it be tried with fire, might be found unto praise and honour and glory at the appearing of Jesus Christ: ⁸ Whom having not seen, ye love; in whom, though now ye see him not, yet believing, ye rejoice with joy unspeakable and full of glory: ⁹ Receiving the end of your faith, even the salvation of your souls. ¹⁰ Of which salvation the prophets have enquired and searched diligently, who prophesied of the grace that should come unto you: ¹¹ Searching what, or what manner of time the Spirit of Christ which was in them did signify, when it testified beforehand the sufferings of Christ, and the glory that should follow. ¹² Unto whom it was revealed, that not unto themselves, but unto us they did minister the things, which are now reported unto you by them that have preached the gospel unto you with the Holy Ghost sent down from heaven; which things the angels desire to look into. ¹³ Wherefore gird up the loins of your mind, be sober, and hope to the end for the grace that is to be brought unto you at the revelation of Jesus Christ; ¹⁴ As obedient children, not fashioning yourselves according to the former lusts in your ignorance: ¹⁵ But as he which hath called you is holy, so be ye holy in all manner of conversation;*

¹⁶ Because it is written, Be ye holy; for I am holy. ¹⁷ And if ye call on the Father, who without respect of persons judgeth according to every man's work, pass the time of your sojourning here in fear: ¹⁸ Forasmuch as ye know that ye were not redeemed with corruptible things, as silver and gold, from your vain conversation received by tradition from your fathers; ¹⁹ But with the precious blood of Christ, as of a lamb without blemish and without spot: ²⁰ Who verily was foreordained before the foundation of the world, but was manifest in these last times for you, ²¹ Who by him do believe in God, that raised him up from the dead, and gave him glory; that your faith and hope might be in God. ²² Seeing ye have purified your souls in obeying the truth through the Spirit unto unfeigned love of the brethren, see that ye love one another with a pure heart fervently: ²³ Being born again, not of corruptible seed, but of incorruptible, by the word of God, which liveth and abideth for ever. ²⁴ For all flesh is as grass, and all the glory of man as the flower of grass. The grass withereth, and the flower thereof falleth away: ²⁵ But the word of the Lord endureth for ever. And this is the word which by the gospel is preached unto you.

Explanation

God is merciful, as Jehovah Jireh. He is a forgiving God to all to come in child like faith, asking for forgivness. **I Peter 1:3**
Text
Romans 8:28

Jehovah M'Kaddesh
Romans 8

¹ There is therefore now no condemnation to them which are in Christ Jesus, who walk not after the flesh, but after the Spirit. ² For the law of the Spirit of life in Christ Jesus hath made me free from the law of sin and death. ³ For what the law could not do, in that it was weak through the flesh, God sending his own Son in the likeness of sinful flesh, and for sin, condemned sin in the flesh: ⁴ That the righteousness of the law might be fulfilled in us, who walk not after the flesh, but after the Spirit. ⁵ For they that are after the flesh do mind the things of the flesh; but they that are after the Spirit the things of the Spirit. ⁶ For to be carnally minded is death; but to be spiritually minded is life and peace. ⁷ Because the carnal mind is enmity against God: for it is not subject to the law of God, neither indeed can be. ⁸ So then they that are in the

*flesh cannot please God. ⁹ But ye are not in the flesh, but in the Spirit, if so be that the Spirit of God dwell in you. Now if any man have not the Spirit of Christ, he is none of his. ¹⁰ And if Christ be in you, the body is dead because of sin; but the Spirit is life because of righteousness. ¹¹ But if the Spirit of him that raised up Jesus from the dead dwell in you, he that raised up Christ from the dead shall also quicken your mortal bodies by his Spirit that dwelleth in you. ¹² Therefore, brethren, we are debtors, not to the flesh, to live after the flesh. ¹³ For if ye live after the flesh, ye shall die: but if ye through the Spirit do mortify the deeds of the body, ye shall live. ¹⁴ For as many as are led by the Spirit of God, they are the sons of God. ¹⁵ For ye have not received the spirit of bondage again to fear; but ye have received the Spirit of adoption, whereby we cry, Abba, Father. ¹⁶ The Spirit itself beareth witness with our spirit, that we are the children of God: ¹⁷ And if children, then heirs; heirs of God, and joint-heirs with Christ; if so be that we suffer with him, that we may be also glorified together. ¹⁸ For I reckon that the sufferings of this present time are not worthy to be compared with the glory which shall be revealed in us. ¹⁹ For the earnest expectation of the creature waiteth for the manifestation of the sons of God. ²⁰ For the creature was made subject to vanity, not willingly, but by reason of him who hath subjected the same in hope, ²¹ Because the creature itself also shall be delivered from the bondage of corruption into the glorious liberty of the children of God. ²² For we know that the whole creation groaneth and travaileth in pain together until now. ²³ And not only they, but ourselves also, which have the firstfruits of the Spirit, even we ourselves groan within ourselves, waiting for the adoption, to wit, the redemption of our body. ²⁴ For we are saved by hope: but hope that is seen is not hope: for what a man seeth, why doth he yet hope for? ²⁵ But if we hope for that we see not, then do we with patience wait for it. ²⁶ Likewise the Spirit also helpeth our infirmities: for we know not what we should pray for as we ought: but the Spirit itself maketh intercession for us with groanings which cannot be uttered. ²⁷ And he that searcheth the hearts knoweth what is the mind of the Spirit, because he maketh intercession for the saints according to the will of God. ²⁸ **And we know that all things work together for good to them that love God, to them who are the called according to his purpose. ²⁹ For whom he did foreknow, he also did predestinate to be conformed to the image of his Son, that he might be the firstborn among many brethren.** ³⁰ Moreover whom he did predestinate, them he also called: and whom he called, them he also justified: and whom he justified, them he also glorified. ³¹ What shall we then say to these things? If God be for us, who can be against us? ³² He that*

spared not his own Son, but delivered him up for us all, how shall he not with him also freely give us all things? ³³ Who shall lay any thing to the charge of God's elect? It is God that justifieth. ³⁴ Who is he that condemneth? It is Christ that died, yea rather, that is risen again, who is even at the right hand of God, who also maketh intercession for us. ³⁵ Who shall separate us from the love of Christ? shall tribulation, or distress, or persecution, or famine, or nakedness, or peril, or sword? ³⁶ As it is written, For thy sake we are killed all the day long; we are accounted as sheep for the slaughter. ³⁷ Nay, in all these things we are more than conquerors through him that loved us. ³⁸ For I am persuaded, that neither death, nor life, nor angels, nor principalities, nor powers, nor things present, nor things to come, ³⁹ Nor height, nor depth, nor any other creature, shall be able to separate us from the love of God, which is in Christ Jesus our Lord.

Explanation

God is Good, as our Jehovah M'Kaddesh. He looks at the intentions of man's heart, as opposed to the isolated act of unrighteousness. **Romans 8:28**

Conclusion

- In order to find ourselves in a secured place in glory, or heaven, we must feel that we need to be saved from our sins, and act upon it, through belief in God, through the finished salvation works of Christ our Redeemer.
- Also, we should have some type of creed of general principles of faith, which is classified as the believer's statement of faith.
- These definitions of God, known to define Elohim, our Creator and Lord, combine the doctrinal principles of God, for all Christian believers.

Questions

Name seven, (a) titles, with (b) definitions and (c) scriptures for Almighty God, Jehovah.

Title_____ Definition_____ Scripture

As a new convert, joining a church one of the first things that the instructor or minister should provide the believer with is the doctrinal principles of what the church and the congregational beliefs are associated with for that denomination defined as the _____ of _____

It is just as important to have a generalized knowledge of key components of the W____of ____in the areas of salvation. It is also important to know what is needed to walk daily by faith, and what will take believers to the last phase of their salvation which is everlasting_____or immortality with_____.

Thought Question

Do you know enough not to doubt your salvation, having read and studied up to this point, the, Introductory Class on ***Salvation and Spiritual Growth.***

God the Father, Our Sovereign God
The Oneness of God
Chapter 3

Text
St. Luke 11:2
Isaiah 45:9
Romans 9:20
Revelations 19:16
I Corinthians 8:6

Introduction

God is our Supreme God and ruler over all. He is the Creator of all things. He has always been in existence. In this lesson, we shall expound upon some of these scriptures that support the doctrine of our Sovereign God. This doctrine is expounded upon in the Statement of Faith.

The Lesson

Text
St. Luke 11:2

Luke 11

¹ And it came to pass, that, as he was praying in a certain place, when he ceased, one of his disciples said unto him, Lord, teach us to pray, as John also taught his disciples. **² And he said unto them, When ye pray, say, Our Father which art in heaven, Hallowed be thy name. Thy kingdom come. Thy will be done, as in heaven, so in earth.** *³ Give us day by day our daily bread. ⁴ And forgive us our sins; for we also forgive every one that is indebted to us. And lead us not into temptation; but deliver us from evil. ⁵ And he said unto them, Which of you shall have a friend, and shall go unto*

him at midnight, and say unto him, Friend, lend me three loaves; ⁶ For a friend of mine in his journey is come to me, and I have nothing to set before him? ⁷ And he from within shall answer and say, Trouble me not: the door is now shut, and my children are with me in bed; I cannot rise and give thee. ⁸ I say unto you, Though he will not rise and give him, because he is his friend, yet because of his importunity he will rise and give him as many as he needeth. ⁹ And I say unto you, Ask, and it shall be given you; seek, and ye shall find; knock, and it shall be opened unto you. ¹⁰ For every one that asketh receiveth; and he that seeketh findeth; and to him that knocketh it shall be opened. ¹¹ If a son shall ask bread of any of you that is a father, will he give him a stone? or if he ask a fish, will he for a fish give him a serpent? ¹² Or if he shall ask an egg, will he offer him a scorpion? ¹³ If ye then, being evil, know how to give good gifts unto your children: how much more shall your heavenly Father give the Holy Spirit to them that ask him? ¹⁴ And he was casting out a devil, and it was dumb. And it came to pass, when the devil was gone out, the dumb spake; and the people wondered. ¹⁵ But some of them said, He casteth out devils through Beelzebub the chief of the devils. ¹⁶ And others, tempting him, sought of him a sign from heaven. ¹⁷ But he, knowing their thoughts, said unto them, Every kingdom divided against itself is brought to desolation; and a house divided against a house falleth. ¹⁸ If Satan also be divided against himself, how shall his kingdom stand? because ye say that I cast out devils through Beelzebub. ¹⁹ And if I by Beelzebub cast out devils, by whom do your sons cast them out? therefore shall they be your judges. ²⁰ But if I with the finger of God cast out devils, no doubt the kingdom of God is come upon you. ²¹ When a strong man armed keepeth his palace, his goods are in peace: ²² But when a stronger than he shall come upon him, and overcome him, he taketh from him all his armour wherein he trusted, and divideth his spoils. ²³ He that is not with me is against me: and he that gathereth not with me scattereth. ²⁴ When the unclean spirit is gone out of a man, he walketh through dry places, seeking rest; and finding none, he saith, I will return unto my house whence I came out. ²⁵ And when he cometh, he findeth it swept and garnished. ²⁶ Then goeth he, and taketh to him seven other spirits more wicked than himself; and they enter in, and dwell there: and the last state of that man is worse than the first. ²⁷ And it came to pass, as he spake these things, a certain woman of the company lifted up her voice, and said unto him, Blessed is the womb that bare thee, and the paps which thou hast sucked. ²⁸ But he said, Yea rather, blessed are they that hear the word of God, and keep it. ²⁹ And when the people were gathered thick together, he began to say, This is an evil generation: they seek a sign; and there

shall no sign be given it, but the sign of Jonas the prophet. ³⁰ *For as Jonas was a sign unto the Ninevites, so shall also the Son of man be to this generation.* ³¹ *The queen of the south shall rise up in the judgment with the men of this generation, and condemn them: for she came from the utmost parts of the earth to hear the wisdom of Solomon; and, behold, a greater than Solomon is here.* ³² *The men of Nineve shall rise up in the judgment with this generation, and shall condemn it: for they repented at the preaching of Jonas; and, behold, a greater than Jonas is here.* ³³ *No man, when he hath lighted a candle, putteth it in a secret place, neither under a bushel, but on a candlestick, that they which come in may see the light.* ³⁴ *The light of the body is the eye: therefore when thine eye is single, thy whole body also is full of light; but when thine eye is evil, thy body also is full of darkness.* ³⁵ *Take heed therefore that the light which is in thee be not darkness.* ³⁶ *If thy whole body therefore be full of light, having no part dark, the whole shall be full of light, as when the bright shining of a candle doth give thee light.* ³⁷ *And as he spake, a certain Pharisee besought him to dine with him: and he went in, and sat down to meat.* ³⁸ *And when the Pharisee saw it, he marvelled that he had not first washed before dinner.* ³⁹ *And the Lord said unto him, Now do ye Pharisees make clean the outside of the cup and the platter; but your inward part is full of ravening and wickedness.* ⁴⁰ *Ye fools, did not he that made that which is without make that which is within also?* ⁴¹ *But rather give alms of such things as ye have; and, behold, all things are clean unto you.* ⁴² *But woe unto you, Pharisees! for ye tithe mint and rue and all manner of herbs, and pass over judgment and the love of God: these ought ye to have done, and not to leave the other undone.* ⁴³ *Woe unto you, Pharisees! for ye love the uppermost seats in the synagogues, and greetings in the markets.* ⁴⁴ *Woe unto you, scribes and Pharisees, hypocrites! for ye are as graves which appear not, and the men that walk over them are not aware of them.* ⁴⁵ *Then answered one of the lawyers, and said unto him, Master, thus saying thou reproachest us also.* ⁴⁶ *And he said, Woe unto you also, ye lawyers! for ye lade men with burdens grievous to be borne, and ye yourselves touch not the burdens with one of your fingers.* ⁴⁷ *Woe unto you! for ye build the sepulchres of the prophets, and your fathers killed them.* ⁴⁸ *Truly ye bear witness that ye allow the deeds of your fathers: for they indeed killed them, and ye build their sepulchres.* ⁴⁹ *Therefore also said the wisdom of God, I will send them prophets and apostles, and some of them they shall slay and persecute:* ⁵⁰ *That the blood of all the prophets, which was shed from the foundation of the world, may be required of this generation;* ⁵¹ *From the blood of Abel unto the blood of Zacharias which perished between the altar and the temple: verily I*

say unto you, It shall be required of this generation. ⁵² Woe unto you, lawyers! for ye have taken away the key of knowledge: ye entered not in yourselves, and them that were entering in ye hindered. ⁵³ And as he said these things unto them, the scribes and the Pharisees began to urge him vehemently, and to provoke him to speak of many things: ⁵⁴ Laying wait for him, and seeking to catch something out of his mouth, that they might accuse him. And he said unto them when ye pray, say, Our Father, which art in heaven, Hallowed, be thy name. Thy kingdom come thou will be done, as in heaven, so in earth.

Explanation

God our Creator and Lord reigns from heaven. We want him to care for us here on earth, as if he were present with us. However, the God **Jehovah** is present with the believers in the **person of God the Holy Spirit. St Luke 11:2**
Text
Isaiah 45:9

Isaiah 45

*¹ Thus saith the LORD to his anointed, to Cyrus, whose right hand I have holden, to subdue nations before him; and I will loose the loins of kings, to open before him the two leaved gates; and the gates shall not be shut; ² I will go before thee, and make the crooked places straight: I will break in pieces the gates of brass, and cut in sunder the bars of iron: ³ And I will give thee the treasures of darkness, and hidden riches of secret places, that thou mayest know that I, the LORD, which call thee by thy name, am the God of Israel. ⁴ For Jacob my servant's sake, and Israel mine elect, I have even called thee by thy name: I have surnamed thee, though thou hast not known me. ⁵ I am the LORD, and there is none else, there is no God beside me: I girded thee, though thou hast not known me: ⁶ That they may know from the rising of the sun, and from the west, that there is none beside me. I am the LORD, and there is none else. ⁷ I form the light, and create darkness: I make peace, and create evil: I the LORD do all these things. ⁸ Drop down, ye heavens, from above, and let the skies pour down righteousness: let the earth open, and let them bring forth salvation, and let righteousness spring up together; I the LORD have created it. ⁹ **Woe unto him that striveth with his Maker! Let the potsherd strive with the potsherds of the earth. Shall the clay say to him that fashioneth**

it, What makest thou? or thy work, He hath no hands? ¹⁰ *Woe unto him that saith unto his father, What begettest thou? or to the woman, What hast thou brought forth?* ¹¹ *Thus saith the LORD, the Holy One of Israel, and his Maker, Ask me of things to come concerning my sons, and concerning the work of my hands command ye me.* ¹² *I have made the earth, and created man upon it: I, even my hands, have stretched out the heavens, and all their host have I commanded.* ¹³ *I have raised him up in righteousness, and I will direct all his ways: he shall build my city, and he shall let go my captives, not for price nor reward, saith the LORD of hosts.* ¹⁴ *Thus saith the LORD, The labour of Egypt, and merchandise of Ethiopia and of the Sabeans, men of stature, shall come over unto thee, and they shall be thine: they shall come after thee; in chains they shall come over, and they shall fall down unto thee, they shall make supplication unto thee, saying, Surely God is in thee; and there is none else, there is no God.* ¹⁵ *Verily thou art a God that hidest thyself, O God of Israel, the Saviour.* ¹⁶ *They shall be ashamed, and also confounded, all of them: they shall go to confusion together that are makers of idols.* ¹⁷ *But Israel shall be saved in the LORD with an everlasting salvation: ye shall not be ashamed nor confounded world without end.* ¹⁸ *For thus saith the LORD that created the heavens; God himself that formed the earth and made it; he hath established it, he created it not in vain, he formed it to be inhabited: I am the LORD; and there is none else.* ¹⁹ *I have not spoken in secret, in a dark place of the earth: I said not unto the seed of Jacob, Seek ye me in vain: I the LORD speak righteousness, I declare things that are right.* ²⁰ *Assemble yourselves and come; draw near together, ye that are escaped of the nations: they have no knowledge that set up the wood of their graven image, and pray unto a god that cannot save.* ²¹ *Tell ye, and bring them near; yea, let them take counsel together: who hath declared this from ancient time? who hath told it from that time? have not I the LORD? and there is no God else beside me; a just God and a Saviour; there is none beside me.* ²² *Look unto me, and be ye saved, all the ends of the earth: for I am God, and there is none else.* ²³ *I have sworn by myself, the word is gone out of my mouth in righteousness, and shall not return, That unto me every knee shall bow, every tongue shall swear.* ²⁴ *Surely, shall one say, in the LORD have I righteousness and strength: even to him shall men come; and all that are incensed against him shall be ashamed.* ²⁵ *In the LORD shall all the seed of Israel be justified, and shall glory.*

Explanation

The Lord is our maker and creator of all things. **Isaiah 45:9**
Text
Romans 9:20

Romans 9

¹ I say the truth in Christ, I lie not, my conscience also bearing me witness in the Holy Ghost, ² That I have great heaviness and continual sorrow in my heart. ³ For I could wish that myself were accursed from Christ for my brethren, my kinsmen according to the flesh: ⁴ Who are Israelites; to whom pertaineth the adoption, and the glory, and the covenants, and the giving of the law, and the service of God, and the promises; ⁵ Whose are the fathers, and of whom as concerning the flesh Christ came, who is over all, God blessed for ever. Amen. ⁶ Not as though the word of God hath taken none effect. For they are not all Israel, which are of Israel: ⁷ Neither, because they are the seed of Abraham, are they all children: but, In Isaac shall thy seed be called. ⁸ That is, They which are the children of the flesh, these are not the children of God: but the children of the promise are counted for the seed. ⁹ For this is the word of promise, At this time will I come, and Sarah shall have a son. ¹⁰ And not only this; but when Rebecca also had conceived by one, even by our father Isaac; ¹¹ (For the children being not yet born, neither having done any good or evil, that the purpose of God according to election might stand, not of works, but of him that calleth;) ¹² It was said unto her, The elder shall serve the younger. ¹³ As it is written, Jacob have I loved, but Esau have I hated. ¹⁴ What shall we say then? Is there unrighteousness with God? God forbid. ¹⁵ For he saith to Moses, I will have mercy on whom I will have mercy, and I will have compassion on whom I will have compassion. ¹⁶ So then it is not of him that willeth, nor of him that runneth, but of God that sheweth mercy. ¹⁷ For the scripture saith unto Pharaoh, Even for this same purpose have I raised thee up, that I might shew my power in thee, and that my name might be declared throughout all the earth. ¹⁸ Therefore hath he mercy on whom he will have mercy, and whom he will he hardeneth. ¹⁹ Thou wilt say then unto me, Why doth he yet find fault? For who hath resisted his will? ²⁰ ***Nay but, O man, who art thou that repliest against God? Shall the thing formed say to him that formed it, Why hast thou made me thus?*** *²¹ Hath not the potter power over the clay, of the same lump to make one vessel unto honour, and another*

unto dishonour? *²²* *What if God, willing to shew his wrath, and to make his power known, endured with much longsuffering the vessels of wrath fitted to destruction:* *²³* *And that he might make known the riches of his glory on the vessels of mercy, which he had afore prepared unto glory,* *²⁴* *Even us, whom he hath called, not of the Jews only, but also of the Gentiles?* *²⁵* *As he saith also in Osee, I will call them my people, which were not my people; and her beloved, which was not beloved.* *²⁶* *And it shall come to pass, that in the place where it was said unto them, Ye are not my people; there shall they be called the children of the living God.* *²⁷* *Esaias also crieth concerning Israel, Though the number of the children of Israel be as the sand of the sea, a remnant shall be saved:* *²⁸* *For he will finish the work, and cut it short in righteousness: because a short work will the Lord make upon the earth.* *²⁹* *And as Esaias said before, Except the Lord of Sabaoth had left us a seed, we had been as Sodoma, and been made like unto Gomorrha.* *³⁰* *What shall we say then? That the Gentiles, which followed not after righteousness, have attained to righteousness, even the righteousness which is of faith.* *³¹* *But Israel, which followed after the law of righteousness, hath not attained to the law of righteousness.* *³²* *Wherefore? Because they sought it not by faith, but as it were by the works of the law. For they stumbled at that stumblingstone;* *³³* *As it is written, Behold, I lay in Sion a stumblingstone and rock of offence: and whosoever believeth on him shall not be ashamed.*

Explanation

Not only is **God** our Creator and Lord, but we, as believers in Christ Jesus are not to question God. The Word of God states that our ways are not God's ways, and His ways are pass finding out. We will know and understand all things, in a twinkling of an eye, at the sound of the last trump, during the final Feast of Trumpets. **Romans 9:20**

Text

Revelations 19:16 (See chapter 1 for full text)
And he hath on his vesture and on his thigh name written, King of Kings and Lord of Lords.

Explanation

This passage is referring to as the Second Coming of the Lord Jesus Christ, when he returns to Judge the unbelievers, during the Great White Throne

Judgment. He is God, in the beginning, and he remains God to the end. He is personified as the Son of God, and he is exemplified, by the Holy Ghost in signs, and wonders, and through the edification of the body of Christ. **Revelations 19:16**

Text

I Corinthians 8:6

1 Corinthians 8

*¹ Now as touching things offered unto idols, we know that we all have knowledge. Knowledge puffeth up, but charity edifieth. ² And if any man think that he knoweth any thing, he knoweth nothing yet as he ought to know. ³ But if any man love God, the same is known of him. ⁴ As concerning therefore the eating of those things that are offered in sacrifice unto idols, we know that an idol is nothing in the world, and that there is none other God but one. ⁵ For though there be that are called gods, whether in heaven or in earth, (as there be gods many, and lords many,) ⁶ **But to us there is but one God, the Father, of whom are all things, and we in him; and one Lord Jesus Christ, by whom are all things, and we by him.** ⁷ Howbeit there is not in every man that knowledge: for some with conscience of the idol unto this hour eat it as a thing offered unto an idol; and their conscience being weak is defiled. ⁸ But meat commendeth us not to God: for neither, if we eat, are we the better; neither, if we eat not, are we the worse. ⁹ But take heed lest by any means this liberty of your's become a stumbling block to them that are weak. ¹⁰ For if any man see thee which hast knowledge sit at meat in the idol's temple, shall not the conscience of him which is weak be emboldened to eat those things which are offered to idols; ¹¹ And through thy knowledge shall the weak brother perish, for whom Christ died? ¹² But when ye sin so against the brethren, and wound their weak conscience, ye sin against Christ. ¹³ Wherefore, if meat make my brother to offend, I will eat no flesh while the world standeth, lest I make my brother to offend.*

Explanation

Our Sovereign God, consist of God the Father and God the Son, and **these are one,** and **agree as one,** along with God the Holy Spirit. **I Corinthians 8:6**

Conclusion:

- In conclusion, God is Sovereign.
- He is the King of all Kings and the Lord of all Lords.
- He is Jehovah God. God is our Creator and Maker of all things that were and is to come.
- He was in the beginning and the ending, the first and the last, the I AM and the Amen.

Questions

Provide three scriptures stating that God is our Creator.

Provide three Names for the Maker of all things.

Who is God?

_____Jehovah

_____God the Son

_____God the Holy Spirit

_____All of the above

When will the Great White Throne Judgment take place?

_____After the Second Coming of Christ

_____When the Messiah returns to judge the earth

_____After the King of Kings and the Lord of Lords return to receive all of the believers

_____All of the above

Thought Question

Do you understand the fullness of God, personified within three Entities, as one?

Or do you believe that you will not fully understand, until *That which is Perfect Shall Come,* and you as a believer, will be changed to immortality, and then and only then, do you believe that you will understand all things.

God the Son, the Fullness of God
The Oneness of God
Chapter 4

Text
St John 8:16, 18
St John 8:23
St. John 10:9
St. John 14:6
St. John 8:12
St. John 10:11
St. John 15:1
St. John 6: 35, 51-58
St. John 11: 25-26
St. John 1:29
I Timothy 2:5
Romans 10: 9, 10
Hebrews 9:11
St. Matthew 28: 18:18-20

Introduction

The Fullness of God is personified within three Entities: God the Father, His Begotten Son, and God the Holy Spirit. To some, they are known as the Tribune God. To others, they are known as the God head. Whatever your understanding may be, to help you to better define the Oneness and the Fullness of God, know this, they operate together as one. When we came into existence in Genesis, Chapter 2, the Word of God states that: One spoke life into existence: Almighty God, One formed the vessel or body, from the dust of the earth. The Son of God, personified as the Word of God, becoming Flesh, St. John 1:14. One breathed into the nostrils of God's creation: The Holy Spirit, **Genesis 2.**

The Lesson

Behold, the Fullness of God, explained, through the **Son of God.**
Text
St. John 1:14

John 1

¹ In the beginning was the Word, and the Word was with God, and the Word was God. ² The same was in the beginning with God. ³ All things were made by him; and without him was not any thing made that was made. ⁴ In him was life; and the life was the light of men. ⁵ And the light shineth in darkness; and the darkness comprehended it not. ⁶ *There was a man sent from God, whose name was John.* ⁷ *The same came for a witness,* to *bear witness of the Light, that all men through him might believe.* ⁸ *He was not that Light, but was sent to bear witness of that Light.* ⁹ *That was the true Light, which lighteth every man that cometh into the world.* ¹⁰ *He was in the world, and the world was made by him, and the world knew him not.* ¹¹ *He came unto his own, and his own received him not.* ¹² *But as many as received him, to them gave he power to become the sons of God, even to them that believe on his name:* ¹³ *Which were born, not of blood, nor of the will of the flesh, nor of the will of man, but of God.* ¹⁴ *And the Word was made flesh, and dwelt among us, (and we beheld his glory, the glory as of the only begotten of the Father,) full of grace and truth.* ¹⁵ *John bare witness of him, and cried, saying, This was he of whom I spake, He that cometh after me is preferred before me: for he was before me.* ¹⁶ *And of his fulness have all we received, and grace for grace.* ¹⁷ *For the law was given by Moses, but grace and truth came by Jesus Christ.* ¹⁸ *No man hath seen God at any time, the only begotten Son, which is in the bosom of the Father, he hath declared him.* ¹⁹ *And this is the record of John, when the Jews sent priests and Levites from Jerusalem to ask him, Who art thou?* ²⁰ *And he confessed, and denied not; but confessed, I am not the Christ.* ²¹ *And they asked him, What then? Art thou Elias? And he saith, I am not. Art thou that prophet? And he answered, No.* ²² *Then said they unto him, Who art thou? that we may give an answer to them that sent us. What sayest thou of thyself?* ²³ *He said, I am the voice of one crying in the wilderness, Make straight the way of the Lord, as said the prophet Esaias.* ²⁴ *And they which were sent were of the Pharisees.* ²⁵ *And they asked him, and said unto*

him, Why baptizest thou then, if thou be not that Christ, nor Elias, neither that prophet? [26] *John answered them, saying, I baptize with water: but there standeth one among you, whom ye know not;* [27] *He it is, who coming after me is preferred before me, whose shoe's latchet I am not worthy to unloose.* [28] *These things were done in Bethabara beyond Jordan, where John was baptizing.* [29] *The next day John seeth Jesus coming unto him, and saith, Behold the Lamb of God, which taketh away the sin of the world.* [30] *This is he of whom I said, After me cometh a man which is preferred before me: for he was before me.* [31] *And I knew him not: but that he should be made manifest to Israel, therefore am I come baptizing with water.* [32] *And John bare record, saying, I saw the Spirit descending from heaven like a dove, and it abode upon him.* [33] *And I knew him not: but he that sent me to baptize with water, the same said unto me, Upon whom thou shalt see the Spirit descending, and remaining on him, the same is he which baptizeth with the Holy Ghost.* [34] *And I saw, and bare record that this is the Son of God.* [35] *Again the next day after John stood, and two of his disciples;* [36] *And looking upon Jesus as he walked, he saith, Behold the Lamb of God!* [37] *And the two disciples heard him speak, and they followed Jesus.* [38] *Then Jesus turned, and saw them following, and saith unto them, What seek ye? They said unto him, Rabbi, (which is to say, being interpreted, Master,) where dwellest thou?* [39] *He saith unto them, Come and see. They came and saw where he dwelt, and abode with him that day: for it was about the tenth hour.* [40] *One of the two which heard John speak, and followed him, was Andrew, Simon Peter's brother.* [41] *He first findeth his own brother Simon, and saith unto him, We have found the Messias, which is, being interpreted, the Christ.* [42] *And he brought him to Jesus. And when Jesus beheld him, he said, Thou art Simon the son of Jona: thou shalt be called Cephas, which is by interpretation, A stone.* [43] *The day following Jesus would go forth into Galilee, and findeth Philip, and saith unto him, Follow me.* [44] *Now Philip was of Bethsaida, the city of Andrew and Peter.* [45] *Philip findeth Nathanael, and saith unto him, We have found him, of whom Moses in the law, and the prophets, did write, Jesus of Nazareth, the son of Joseph.* [46] *And Nathanael said unto him, Can there any good thing come out of Nazareth? Philip saith unto him, Come and see.* [47] *Jesus saw Nathanael coming to him, and saith of him, Behold an Israelite indeed, in whom is no guile!* [48] *Nathanael saith unto him, Whence knowest thou me? Jesus answered and said unto him, Before that Philip called thee, when thou wast under the fig tree, I saw thee.* [49] *Nathanael answered and saith unto him, Rabbi, thou art the Son of God; thou art the King of Israel.* [50] *Jesus answered and said unto him, Because I said unto thee,*

I saw thee under the fig tree, believest thou? thou shalt see greater things than these. ⁵¹ *And he saith unto him, Verily, verily, I say unto you, Hereafter ye shall see heaven open, and the angels of God ascending and descending upon the Son of man.*

Explanation

God has always been in existence. His Son was taken from Him, who is and was and is to come. **I John 1:14**
Text
St John 8:16, 18, 23

John 8

¹ *Jesus went unto the mount of Olives.* ² *And early in the morning he came again into the temple, and all the people came unto him; and he sat down, and taught them.* ³ *And the scribes and Pharisees brought unto him a woman taken in adultery; and when they had set her in the midst,* ⁴ *They say unto him, Master, this woman was taken in adultery, in the very act.* ⁵ *Now Moses in the law commanded us, that such should be stoned: but what sayest thou?* ⁶ *This they said, tempting him, that they might have to accuse him. But Jesus stooped down, and with his finger wrote on the ground, as though he heard them not.* ⁷ *So when they continued asking him, he lifted up himself, and said unto them, He that is without sin among you, let him first cast a stone at her.* ⁸ *And again he stooped down, and wrote on the ground.* ⁹ *And they which heard it, being convicted by their own conscience, went out one by one, beginning at the eldest, even unto the last: and Jesus was left alone, and the woman standing in the midst.* ¹⁰ *When Jesus had lifted up himself, and saw none but the woman, he said unto her, Woman, where are those thine accusers? hath no man condemned thee?* ¹¹ *She said, No man, Lord. And Jesus said unto her, Neither do I condemn thee: go, and sin no more.* ¹² *Then spake Jesus again unto them, saying, I am the light of the world: he that followeth me shall not walk in darkness, but shall have the light of life.* ¹³ *The Pharisees therefore said unto him, Thou bearest record of thyself; thy record is not true.* ¹⁴ *Jesus answered and said unto them, Though I bear record of myself, yet my record is true: for I know whence I came, and whither I go; but ye cannot tell whence I come, and whither I go.* ¹⁵ *Ye judge after the flesh; I judge no man.* ¹⁶ ***And yet if I judge, my judgment is true: for I am not alone, but I and the Father***

that sent me. [17] *It is also written in your law, that the testimony of two men is true.* [18] **I am one that bear witness of myself, and the Father that sent me beareth witness of me.** [19] *Then said they unto him, Where is thy Father? Jesus answered, Ye neither know me, nor my Father: if ye had known me, ye should have known my Father also.* [20] *These words spake Jesus in the treasury, as he taught in the temple: and no man laid hands on him; for his hour was not yet come.* [21] *Then said Jesus again unto them, I go my way, and ye shall seek me, and shall die in your sins: whither I go, ye cannot come.* [22] *Then said the Jews, Will he kill himself? because he saith, Whither I go, ye cannot come.* [23] **And he said unto them, Ye are from beneath; I am from above: ye are of this world; I am not of this world.** [24] **I said therefore unto you, that ye shall die in your sins: for if ye believe not that I am he, ye shall die in your sins.** [25] *Then said they unto him, Who art thou? And Jesus saith unto them, Even the same that I said unto you from the beginning.* [26] *I have many things to say and to judge of you: but he that sent me is true; and I speak to the world those things which I have heard of him.* [27] *They understood not that he spake to them of the Father.* [28] *Then said Jesus unto them, When ye have lifted up the Son of man, then shall ye know that I am he, and that I do nothing of myself; but as my Father hath taught me, I speak these things.* [29] *And he that sent me is with me: the Father hath not left me alone; for I do always those things that please him.* [30] *As he spake these words, many believed on him.* [31] *Then said Jesus to those Jews which believed on him, If ye continue in my word, then are ye my disciples indeed;* [32] *And ye shall know the truth, and the truth shall make you free.* [33] *They answered him, We be Abraham's seed, and were never in bondage to any man: how sayest thou, Ye shall be made free?* [34] *Jesus answered them, Verily, verily, I say unto you, Whosoever committeth sin is the servant of sin.* [35] *And the servant abideth not in the house for ever: but the Son abideth ever.* [36] *If the Son therefore shall make you free, ye shall be free indeed.* [37] *I know that ye are Abraham's seed; but ye seek to kill me, because my word hath no place in you.* [38] *I speak that which I have seen with my Father: and ye do that which ye have seen with your father.* [39] *They answered and said unto him, Abraham is our father. Jesus saith unto them, If ye were Abraham's children, ye would do the works of Abraham.* [40] *But now ye seek to kill me, a man that hath told you the truth, which I have heard of God: this did not Abraham.* [41] *Ye do the deeds of your father. Then said they to him, We be not born of fornication; we have one Father, even God.* [42] *Jesus said unto them, If God were your Father, ye would love me: for I proceeded forth and came from God; neither came I of myself, but he sent me.* [43] *Why do ye not*

understand my speech? even because ye cannot hear my word. ⁴⁴ Ye are of your father the devil, and the lusts of your father ye will do. He was a murderer from the beginning, and abode not in the truth, because there is no truth in him. When he speaketh a lie, he speaketh of his own: for he is a liar, and the father of it. ⁴⁵ And because I tell you the truth, ye believe me not. ⁴⁶ Which of you convinceth me of sin? And if I say the truth, why do ye not believe me? ⁴⁷ He that is of God heareth God's words: ye therefore hear them not, because ye are not of God. ⁴⁸ Then answered the Jews, and said unto him, Say we not well that thou art a Samaritan, and hast a devil? ⁴⁹ Jesus answered, I have not a devil; but I honour my Father, and ye do dishonour me. ⁵⁰ And I seek not mine own glory: there is one that seeketh and judgeth. ⁵¹ Verily, verily, I say unto you, If a man keep my saying, he shall never see death. ⁵² Then said the Jews unto him, Now we know that thou hast a devil. Abraham is dead, and the prophets; and thou sayest, If a man keep my saying, he shall never taste of death. ⁵³ Art thou greater than our father Abraham, which is dead? and the prophets are dead: whom makest thou thyself? ⁵⁴ Jesus answered, If I honour myself, my honour is nothing: it is my Father that honoureth me; of whom ye say, that he is your God: ⁵⁵ Yet ye have not known him; but I know him: and if I should say, I know him not, I shall be a liar like unto you: but I know him, and keep his saying. ⁵⁶ Your father Abraham rejoiced to see my day: and he saw it, and was glad. ⁵⁷ Then said the Jews unto him, Thou art not yet fifty years old, and hast thou seen Abraham? ⁵⁸ Jesus said unto them, Verily, verily, I say unto you, Before Abraham was, I am. ⁵⁹ Then took they up stones to cast at him: but Jesus hid himself, and went out of the temple, going through the midst of them, and so passed by.

(Refer to full text for all (3) proceeding scriptures)

Text
St. John 8:16
¹⁶ And yet if I judge, my judgment is true: for I am not alone, but I and the Father that sent me.

Explanation

God the Son is a Just Advocate, who is the Mediator between God and man. **St. John 8:16**

Also

Text
St. John 8:18
I am one that bears witness of myself, and the Father that sent me beareth witness of me.

Explanation

God the Father and God the Son are one. **St. John 8: 18**
Text
St. John 8:23

In Addition

And he said unto them, Ye are from beneath; I am from above: ye are of this world; I am not of this world.

Explanation

God the Son is speaking to the believers. **St John 8:23**

The Seven I AM's of Christ
Scripture with Explanation

The Lord Jesus Christ is identified as: (7) I AM's of Christ. They are as follows.
Text
St. John 10:9, 11

THE DOOR
THE GOOD SHEPHERD
John 10

[1] *Verily, verily, I say unto you, He that entereth not by the door into the sheepfold, but climbeth up some other way, the same is a thief and a robber.* [2] *But he that entereth in by the door is the shepherd of the sheep.* [3] *To him the porter openeth; and the sheep hear his voice: and he calleth his own sheep by*

name, and leadeth them out. ⁴ *And when he putteth forth his own sheep, he goeth before them, and the sheep follow him: for they know his voice.* ⁵ *And a stranger will they not follow, but will flee from him: for they know not the voice of strangers.* ⁶ *This parable spake Jesus unto them: but they understood not what things they were which he spake unto them.* ⁷ *Then said Jesus unto them again, Verily, verily, I say unto you, I am the door of the sheep.* ⁸ *All that ever came before me are thieves and robbers: but the sheep did not hear them.* ⁹ **I am the door: by me if any man enter in, he shall be saved, and shall go in and out, and find pasture.** ¹⁰ *The thief cometh not, but for to steal, and to kill, and to destroy: I am come that they might have life, and that they might have it more abundantly.* ¹¹ **I am the good shepherd: the good shepherd giveth his life for the sheep.** ¹² *But he that is an hireling, and not the shepherd, whose own the sheep are not, seeth the wolf coming, and leaveth the sheep, and fleeth: and the wolf catcheth them, and scattereth the sheep.* ¹³ *The hireling fleeth, because he is an hireling, and careth not for the sheep.* ¹⁴ *I am the good shepherd, and know my sheep, and am known of mine.* ¹⁵ *As the Father knoweth me, even so know I the Father: and I lay down my life for the sheep.* ¹⁶ *And other sheep I have, which are not of this fold: them also I must bring, and they shall hear my voice; and there shall be one fold, and one shepherd.* ¹⁷ *Therefore doth my Father love me, because I lay down my life, that I might take it again.* ¹⁸ *No man taketh it from me, but I lay it down of myself. I have power to lay it down, and I have power to take it again. This commandment have I received of my Father.* ¹⁹ *There was a division therefore again among the Jews for these sayings.* ²⁰ *And many of them said, He hath a devil, and is mad; why hear ye him?* ²¹ *Others said, These are not the words of him that hath a devil. Can a devil open the eyes of the blind?* ²² *And it was at Jerusalem the feast of the dedication, and it was winter.* ²³ *And Jesus walked in the temple in Solomon's porch.* ²⁴ *Then came the Jews round about him, and said unto him, How long dost thou make us to doubt? If thou be the Christ, tell us plainly.* ²⁵ *Jesus answered them, I told you, and ye believed not: the works that I do in my Father's name, they bear witness of me.* ²⁶ *But ye believe not, because ye are not of my sheep, as I said unto you.* ²⁷ *My sheep hear my voice, and I know them, and they follow me:* ²⁸ *And I give unto them eternal life; and they shall never perish, neither shall any man pluck them out of my hand.* ²⁹ *My Father, which gave them me, is greater than all; and no man is able to pluck them out of my Father's hand.* ³⁰ *I and my Father are one.* ³¹ *Then the Jews took up stones again to stone him.* ³² *Jesus answered them, Many good works have I shewed you from my Father; for which of those works do ye stone*

me? ³³ The Jews answered him, saying, For a good work we stone thee not; but for blasphemy; and because that thou, being a man, makest thyself God. ³⁴ Jesus answered them, Is it not written in your law, I said, Ye are gods? ³⁵ If he called them gods, unto whom the word of God came, and the scripture cannot be broken; ³⁶ Say ye of him, whom the Father hath sanctified, and sent into the world, Thou blasphemest; because I said, I am the Son of God? ³⁷ If I do not the works of my Father, believe me not. ³⁸ But if I do, though ye believe not me, believe the works: that ye may know, and believe, that the Father is in me, and I in him. ³⁹ Therefore they sought again to take him: but he escaped out of their hand, ⁴⁰ And went away again beyond Jordan into the place where John at first baptized; and there he abode. ⁴¹ And many resorted unto him, and said, John did no miracle: but all things that John spake of this man were true. ⁴² And many believed on him there.

Explanation

I AM THE DOOR. **St. John 10:9**

Also

Text
St. John 10:11 (Refer above)

GOOD SHEPHERD

¹¹ I am the good shepherd: the good shepherd giveth his life for the sheep.

Explanation

I AM THE GOOD SHEPHERD. **St. John 10:11**
Text
St. John 14:6

THE WAY
John 14

¹ Let not your heart be troubled: ye believe in God, believe also in me. ² In my Father's house are many mansions: if it were not so, I would have told you. I

go to prepare a place for you. ³ *And if I go and prepare a place for you, I will come again, and receive you unto myself; that where I am, there ye may be also.* ⁴ *And whither I go ye know, and the way ye know.* ⁵ *Thomas saith unto him, Lord, we know not whither thou goest; and how can we know the way?* **⁶ Jesus saith unto him, I am the way, the truth, and the life: no man cometh unto the Father, but by me.** ⁷ *If ye had known me, ye should have known my Father also: and from henceforth ye know him, and have seen him.* ⁸ *Philip saith unto him, Lord, shew us the Father, and it sufficeth us.* ⁹ *Jesus saith unto him, Have I been so long time with you, and yet hast thou not known me, Philip? he that hath seen me hath seen the Father; and how sayest thou then, Shew us the Father?* ¹⁰ *Believest thou not that I am in the Father, and the Father in me? the words that I speak unto you I speak not of myself: but the Father that dwelleth in me, he doeth the works.* ¹¹ *Believe me that I am in the Father, and the Father in me: or else believe me for the very works' sake.* ¹² *Verily, verily, I say unto you, He that believeth on me, the works that I do shall he do also; and greater works than these shall he do; because I go unto my Father.* ¹³ *And whatsoever ye shall ask in my name, that will I do, that the Father may be glorified in the Son.* ¹⁴ *If ye shall ask any thing in my name, I will do it.* ¹⁵ *If ye love me, keep my commandments.* ¹⁶ *And I will pray the Father, and he shall give you another Comforter, that he may abide with you for ever;* ¹⁷ *Even the Spirit of truth; whom the world cannot receive, because it seeth him not, neither knoweth him: but ye know him; for he dwelleth with you, and shall be in you.* ¹⁸ *I will not leave you comfortless: I will come to you.* ¹⁹ *Yet a little while, and the world seeth me no more; but ye see me: because I live, ye shall live also.* ²⁰ *At that day ye shall know that I am in my Father, and ye in me, and I in you.* ²¹ *He that hath my commandments, and keepeth them, he it is that loveth me: and he that loveth me shall be loved of my Father, and I will love him, and will manifest myself to him.* ²² *Judas saith unto him, not Iscariot, Lord, how is it that thou wilt manifest thyself unto us, and not unto the world?* ²³ *Jesus answered and said unto him, If a man love me, he will keep my words: and my Father will love him, and we will come unto him, and make our abode with him.* ²⁴ *He that loveth me not keepeth not my sayings: and the word which ye hear is not mine, but the Father's which sent me.* ²⁵ *These things have I spoken unto you, being yet present with you.* ²⁶ *But the Comforter, which is the Holy Ghost, whom the Father will send in my name, he shall teach you all things, and bring all things to your remembrance, whatsoever I have said unto you.* ²⁷ *Peace I leave with you, my peace I give unto you: not as the world giveth, give I unto you. Let not your heart be troubled, neither let*

it be afraid. ²⁸ Ye have heard how I said unto you, I go away, and come again

it be afraid. ²⁸ Ye have heard how I said unto you, I go away, and come again unto you. If ye loved me, ye would rejoice, because I said, I go unto the Father: for my Father is greater than I. ²⁹ And now I have told you before it come to pass, that, when it is come to pass, ye might believe. ³⁰ Hereafter I will not talk much with you: for the prince of this world cometh, and hath nothing in me. ³¹ But that the world may know that I love the Father; and as the Father gave me commandment, even so I do. Arise, let us go hence.

Explanation

I AM THE WAY, THE TRUTH AND THE LIFE. **St. John 14:6**
Text
St. John 8:12

LIGHT OF THE WORLD
John 8

*¹ Jesus went unto the mount of Olives. ² And early in the morning he came again into the temple, and all the people came unto him; and he sat down, and taught them. ³ And the scribes and Pharisees brought unto him a woman taken in adultery; and when they had set her in the midst, ⁴ They say unto him, Master, this woman was taken in adultery, in the very act. ⁵ Now Moses in the law commanded us, that such should be stoned: but what sayest thou? ⁶ This they said, tempting him, that they might have to accuse him. But Jesus stooped down, and with his finger wrote on the ground, as though he heard them not. ⁷ So when they continued asking him, he lifted up himself, and said unto them, He that is without sin among you, let him first cast a stone at her. ⁸ And again he stooped down, and wrote on the ground. ⁹ And they which heard it, being convicted by their own conscience, went out one by one, beginning at the eldest, even unto the last: and Jesus was left alone, and the woman standing in the midst. ¹⁰ When Jesus had lifted up himself, and saw none but the woman, he said unto her, Woman, where are those thine accusers? hath no man condemned thee? ¹¹ She said, No man, Lord. And Jesus said unto her, Neither do I condemn thee: go, and sin no more. ¹² **Then spake Jesus again unto them, saying, I am the light of the world: he that followeth me shall not walk in darkness, but shall have the light of life.** ¹³ The Pharisees therefore said unto him, Thou bearest record of thyself; thy record is not true. ¹⁴ Jesus answered and said unto them, Though I bear record of myself, yet my*

record is true: for I know whence I came, and whither I go; but ye cannot tell whence I come, and whither I go. ¹⁵ Ye judge after the flesh; I judge no man. ¹⁶ And yet if I judge, my judgment is true: for I am not alone, but I and the Father that sent me. ¹⁷ It is also written in your law, that the testimony of two men is true. ¹⁸ I am one that bear witness of myself, and the Father that sent me beareth witness of me. ¹⁹ Then said they unto him, Where is thy Father? Jesus answered, Ye neither know me, nor my Father: if ye had known me, ye should have known my Father also. ²⁰ These words spake Jesus in the treasury, as he taught in the temple: and no man laid hands on him; for his hour was not yet come. ²¹ Then said Jesus again unto them, I go my way, and ye shall seek me, and shall die in your sins: whither I go, ye cannot come. ²² Then said the Jews, Will he kill himself? because he saith, Whither I go, ye cannot come. ²³ And he said unto them, Ye are from beneath; I am from above: ye are of this world; I am not of this world. ²⁴ I said therefore unto you, that ye shall die in your sins: for if ye believe not that I am he, ye shall die in your sins. ²⁵ Then said they unto him, Who art thou? And Jesus saith unto them, Even the same that I said unto you from the beginning. ²⁶ I have many things to say and to judge of you: but he that sent me is true; and I speak to the world those things which I have heard of him. ²⁷ They understood not that he spake to them of the Father. ²⁸ Then said Jesus unto them, When ye have lifted up the Son of man, then shall ye know that I am he, and that I do nothing of myself; but as my Father hath taught me, I speak these things. ²⁹ And he that sent me is with me: the Father hath not left me alone; for I do always those things that please him. ³⁰ As he spake these words, many believed on him. ³¹ Then said Jesus to those Jews which believed on him, If ye continue in my word, then are ye my disciples indeed; ³² And ye shall know the truth, and the truth shall make you free. ³³ They answered him, We be Abraham's seed, and were never in bondage to any man: how sayest thou, Ye shall be made free? ³⁴ Jesus answered them, Verily, verily, I say unto you, Whosoever committeth sin is the servant of sin. ³⁵ And the servant abideth not in the house for ever: but the Son abideth ever. ³⁶ If the Son therefore shall make you free, ye shall be free indeed. ³⁷ I know that ye are Abraham's seed; but ye seek to kill me, because my word hath no place in you. ³⁸ I speak that which I have seen with my Father: and ye do that which ye have seen with your father. ³⁹ They answered and said unto him, Abraham is our father. Jesus saith unto them, If ye were Abraham's children, ye would do the works of Abraham. ⁴⁰ But now ye seek to kill me, a man that hath told you the truth, which I have heard of God: this did not Abraham. ⁴¹ Ye do the deeds of your father. Then said they to him, We be not born of fornication; we

have one Father, even God. ⁴² *Jesus said unto them, If God were your Father, ye would love me: for I proceeded forth and came from God; neither came I of myself, but he sent me.* ⁴³ *Why do ye not understand my speech? even because ye cannot hear my word.* ⁴⁴ *Ye are of your father the devil, and the lusts of your father ye will do. He was a murderer from the beginning, and abode not in the truth, because there is no truth in him. When he speaketh a lie, he speaketh of his own: for he is a liar, and the father of it.* ⁴⁵ *And because I tell you the truth, ye believe me not.* ⁴⁶ *Which of you convinceth me of sin? And if I say the truth, why do ye not believe me?* ⁴⁷ *He that is of God heareth God's words: ye therefore hear them not, because ye are not of God.* ⁴⁸ *Then answered the Jews, and said unto him, Say we not well that thou art a Samaritan, and hast a devil?* ⁴⁹ *Jesus answered, I have not a devil; but I honour my Father, and ye do dishonour me.* ⁵⁰ *And I seek not mine own glory: there is one that seeketh and judgeth.* ⁵¹ *Verily, verily, I say unto you, If a man keep my saying, he shall never see death.* ⁵² *Then said the Jews unto him, Now we know that thou hast a devil. Abraham is dead, and the prophets; and thou sayest, If a man keep my saying, he shall never taste of death.* ⁵³ *Art thou greater than our father Abraham, which is dead? and the prophets are dead: whom makest thou thyself?* ⁵⁴ *Jesus answered, If I honour myself, my honour is nothing: it is my Father that honoureth me; of whom ye say, that he is your God:* ⁵⁵ *Yet ye have not known him; but I know him: and if I should say, I know him not, I shall be a liar like unto you: but I know him, and keep his saying.* ⁵⁶ *Your father Abraham rejoiced to see my day: and he saw it, and was glad.* ⁵⁷ *Then said the Jews unto him, Thou art not yet fifty years old, and hast thou seen Abraham?* ⁵⁸ *Jesus said unto them, Verily, verily, I say unto you, Before Abraham was, I am.* ⁵⁹ *Then took they up stones to cast at him: but Jesus hid himself, and went out of the temple, going through the midst of them, and so passed by.*

Explanation

I AM THE LIGHT OF THE WORLD: **St. John 8:12**
Text
St. John 15:1

TRUE VINE
John 15

*¹ **I am the true vine, and my Father is the husbandman.** ² Every branch in me that beareth not fruit he taketh away: and every branch that beareth fruit, he purgeth it, that it may bring forth more fruit. ³ Now ye are clean through the word which I have spoken unto you. ⁴ Abide in me, and I in you. As the branch cannot bear fruit of itself, except it abide in the vine; no more can ye, except ye abide in me. ⁵ I am the vine, ye are the branches: He that abideth in me, and I in him, the same bringeth forth much fruit: for without me ye can do nothing. ⁶ If a man abide not in me, he is cast forth as a branch, and is withered; and men gather them, and cast them into the fire, and they are burned. ⁷ If ye abide in me, and my words abide in you, ye shall ask what ye will, and it shall be done unto you. ⁸ Herein is my Father glorified, that ye bear much fruit; so shall ye be my disciples. ⁹ As the Father hath loved me, so have I loved you: continue ye in my love. ¹⁰ If ye keep my commandments, ye shall abide in my love; even as I have kept my Father's commandments, and abide in his love. ¹¹ These things have I spoken unto you, that my joy might remain in you, and that your joy might be full. ¹² This is my commandment, That ye love one another, as I have loved you. ¹³ Greater love hath no man than this, that a man lay down his life for his friends. ¹⁴ Ye are my friends, if ye do whatsoever I command you. ¹⁵ Henceforth I call you not servants; for the servant knoweth not what his lord doeth: but I have called you friends; for all things that I have heard of my Father I have made known unto you. ¹⁶ Ye have not chosen me, but I have chosen you, and ordained you, that ye should go and bring forth fruit, and that your fruit should remain: that whatsoever ye shall ask of the Father in my name, he may give it you. ¹⁷ These things I command you, that ye love one another. ¹⁸ If the world hate you, ye know that it hated me before it hated you. ¹⁹ If ye were of the world, the world would love his own: but because ye are not of the world, but I have chosen you out of the world, therefore the world hateth you. ²⁰ Remember the word that I said unto you, The servant is not greater than his lord. If they have persecuted me, they will also persecute you; if they have kept my saying, they will keep yours also. ²¹ But all these things will they do unto you for my name's sake, because they know not him that sent me. ²² If I had not come and spoken unto them, they had not had sin: but now they have no cloak for their sin. ²³ He that hateth me hateth my Father also. ²⁴ If I had not done among them the works which none other man did, they had not had sin: but now have they both seen and hated both*

me and my Father. ²⁵ *But this cometh to pass, that the word might be fulfilled that is written in their law, They hated me without a cause.* ²⁶ *But when the Comforter is come, whom I will send unto you from the Father, even the Spirit of truth, which proceedeth from the Father, he shall testify of me:* ²⁷ *And ye also shall bear witness, because ye have been with me from the beginning.*

Explanation

I AM THE TRUE VINE. **St. John 15:1**
Text
St. John 6: 35, 51

BREAD OF LIFE
John 6

¹ *After these things Jesus went over the sea of Galilee, which is the sea of Tiberias.* ² *And a great multitude followed him, because they saw his miracles which he did on them that were diseased.* ³ *And Jesus went up into a mountain, and there he sat with his disciples.* ⁴ *And the passover, a feast of the Jews, was nigh.* ⁵ *When Jesus then lifted up his eyes, and saw a great company come unto him, he saith unto Philip, Whence shall we buy bread, that these may eat?* ⁶ *And this he said to prove him: for he himself knew what he would do.* ⁷ *Philip answered him, Two hundred pennyworth of bread is not sufficient for them, that every one of them may take a little.* ⁸ *One of his disciples, Andrew, Simon Peter's brother, saith unto him,* ⁹ *There is a lad here, which hath five barley loaves, and two small fishes: but what are they among so many?* ¹⁰ *And Jesus said, Make the men sit down. Now there was much grass in the place. So the men sat down, in number about five thousand.* ¹¹ *And Jesus took the loaves; and when he had given thanks, he distributed to the disciples, and the disciples to them that were set down; and likewise of the fishes as much as they would.* ¹² *When they were filled, he said unto his disciples, Gather up the fragments that remain, that nothing be lost.* ¹³ *Therefore they gathered them together, and filled twelve baskets with the fragments of the five barley loaves, which remained over and above unto them that had eaten.* ¹⁴ *Then those men, when they had seen the miracle that Jesus did, said, This is of a truth that prophet that should come into the world.* ¹⁵ *When Jesus therefore perceived that they would come and take him by force, to make him a king, he departed again into a mountain himself alone.* ¹⁶ *And when even was now come, his disciples*

went down unto the sea, ¹⁷ And entered into a ship, and went over the sea toward Capernaum. And it was now dark, and Jesus was not come to them. ¹⁸ And the sea arose by reason of a great wind that blew. ¹⁹ So when they had rowed about five and twenty or thirty furlongs, they see Jesus walking on the sea, and drawing nigh unto the ship: and they were afraid. ²⁰ But he saith unto them, It is I; be not afraid. ²¹ Then they willingly received him into the ship: and immediately the ship was at the land whither they went. ²² The day following, when the people which stood on the other side of the sea saw that there was none other boat there, save that one whereinto his disciples were entered, and that Jesus went not with his disciples into the boat, but that his disciples were gone away alone; ²³ (Howbeit there came other boats from Tiberias nigh unto the place where they did eat bread, after that the Lord had given thanks:) ²⁴ When the people therefore saw that Jesus was not there, neither his disciples, they also took shipping, and came to Capernaum, seeking for Jesus. ²⁵ And when they had found him on the other side of the sea, they said unto him, Rabbi, when camest thou hither? ²⁶ Jesus answered them and said, Verily, verily, I say unto you, Ye seek me, not because ye saw the miracles, but because ye did eat of the loaves, and were filled. ²⁷ Labour not for the meat which perisheth, but for that meat which endureth unto everlasting life, which the Son of man shall give unto you: for him hath God the Father sealed. ²⁸ Then said they unto him, What shall we do, that we might work the works of God? ²⁹ Jesus answered and said unto them, This is the work of God, that ye believe on him whom he hath sent. ³⁰ They said therefore unto him, What sign shewest thou then, that we may see, and believe thee? what dost thou work? ³¹ Our fathers did eat manna in the desert; as it is written, He gave them bread from heaven to eat. ³² Then Jesus said unto them, Verily, verily, I say unto you, Moses gave you not that bread from heaven; but my Father giveth you the true bread from heaven. ³³ For the bread of God is he which cometh down from heaven, and giveth life unto the world. ³⁴ Then said they unto him, Lord, evermore give us this bread. ³⁵ **And Jesus said unto them, I am the bread of life: he that cometh to me shall never hunger; and he that believeth on me shall never thirst.** *³⁶ But I said unto you, That ye also have seen me, and believe not. ³⁷ All that the Father giveth me shall come to me; and him that cometh to me I will in no wise cast out. ³⁸ For I came down from heaven, not to do mine own will, but the will of him that sent me. ³⁹ And this is the Father's will which hath sent me, that of all which he hath given me I should lose nothing, but should raise it up again at the last day. ⁴⁰ And this is the will of him that sent me, that every one which seeth the Son, and believeth on him,*

may have everlasting life: and I will raise him up at the last day. [41] *The Jews then murmured at him, because he said, I am the bread which came down from heaven.* [42] *And they said, Is not this Jesus, the son of Joseph, whose father and mother we know? how is it then that he saith, I came down from heaven?* [43] *Jesus therefore answered and said unto them, Murmur not among yourselves.* [44] *No man can come to me, except the Father which hath sent me draw him: and I will raise him up at the last day.* [45] *It is written in the prophets, And they shall be all taught of God. Every man therefore that hath heard, and hath learned of the Father, cometh unto me.* [46] *Not that any man hath seen the Father, save he which is of God, he hath seen the Father.* [47] *Verily, verily, I say unto you, He that believeth on me hath everlasting life.* [48] *I am that bread of life.* [49] *Your fathers did eat manna in the wilderness, and are dead.* [50] *This is the bread which cometh down from heaven, that a man may eat thereof, and not die.* [51] ***I am the living bread which came down from heaven: if any man eat of this bread, he shall live for ever: and the bread that I will give is my flesh, which I will give for the life of the world.*** [52] *The Jews therefore strove among themselves, saying, How can this man give us his flesh to eat?* [53] *Then Jesus said unto them, Verily, verily, I say unto you, Except ye eat the flesh of the Son of man, and drink his blood, ye have no life in you.* [54] *Whoso eateth my flesh, and drinketh my blood, hath eternal life; and I will raise him up at the last day.* [55] *For my flesh is meat indeed, and my blood is drink indeed.* [56] *He that eateth my flesh, and drinketh my blood, dwelleth in me, and I in him.* [57] *As the living Father hath sent me, and I live by the Father: so he that eateth me, even he shall live by me.* [58] *This is that bread which came down from heaven: not as your fathers did eat manna, and are dead: he that eateth of this bread shall live for ever.* [59] *These things said he in the synagogue, as he taught in Capernaum.* [60] *Many therefore of his disciples, when they had heard this, said, This is an hard saying; who can hear it?* [61] *When Jesus knew in himself that his disciples murmured at it, he said unto them, Doth this offend you?* [62] *What and if ye shall see the Son of man ascend up where he was before?* [63] *It is the spirit that quickeneth; the flesh profiteth nothing: the words that I speak unto you, they are spirit, and they are life.* [64] *But there are some of you that believe not. For Jesus knew from the beginning who they were that believed not, and who should betray him.* [65] *And he said, Therefore said I unto you, that no man can come unto me, except it were given unto him of my Father.* [66] *From that time many of his disciples went back, and walked no more with him.* [67] *Then said Jesus unto the twelve, Will ye also go away?* [68] *Then Simon Peter answered him, Lord, to whom shall we go? thou*

hast the words of eternal life. ⁶⁹ *And we believe and are sure that thou art that Christ, the Son of the living God.* ⁷⁰ *Jesus answered them, Have not I chosen you twelve, and one of you is a devil?* ⁷¹ *He spake of Judas Iscariot the son of Simon: for he it was that should betray him, being one of the twelve.*

Explanation

I AM THE BREAD OF LIFE. **St. John 6: 35, 51**
Text
St. John 11: 25-26

RESURRECTION AND THE LIFE
John 11

¹ *Now a certain man was sick, named Lazarus, of Bethany, the town of Mary and her sister Martha.* ² *(It was that Mary which anointed the Lord with ointment, and wiped his feet with her hair, whose brother Lazarus was sick.)* ³ *Therefore his sisters sent unto him, saying, Lord, behold, he whom thou lovest is sick.* ⁴ *When Jesus heard that, he said, This sickness is not unto death, but for the glory of God, that the Son of God might be glorified thereby.* ⁵ *Now Jesus loved Martha, and her sister, and Lazarus.* ⁶ *When he had heard therefore that he was sick, he abode two days still in the same place where he was.* ⁷ *Then after that saith he to his disciples, Let us go into Judaea again.* ⁸ *His disciples say unto him, Master, the Jews of late sought to stone thee; and goest thou thither again?* ⁹ *Jesus answered, Are there not twelve hours in the day? If any man walk in the day, he stumbleth not, because he seeth the light of this world.* ¹⁰ *But if a man walk in the night, he stumbleth, because there is no light in him.* ¹¹ *These things said he: and after that he saith unto them, Our friend Lazarus sleepeth; but I go, that I may awake him out of sleep.* ¹² *Then said his disciples, Lord, if he sleep, he shall do well.* ¹³ *Howbeit Jesus spake of his death: but they thought that he had spoken of taking of rest in sleep.* ¹⁴ *Then said Jesus unto them plainly, Lazarus is dead.* ¹⁵ *And I am glad for your sakes that I was not there, to the intent ye may believe; nevertheless let us go unto him.* ¹⁶ *Then said Thomas, which is called Didymus, unto his fellowdisciples, Let us also go, that we may die with him.* ¹⁷ *Then when Jesus came, he found that he had lain in the grave four days already.* ¹⁸ *Now Bethany was nigh unto Jerusalem, about fifteen furlongs off:* ¹⁹ *And many of the Jews came to Martha and Mary, to comfort them concerning their brother.* ²⁰ *Then Martha, as soon as she heard*

that Jesus was coming, went and met him: but Mary sat still in the house. *²¹ Then said Martha unto Jesus, Lord, if thou hadst been here, my brother had not died. ²² But I know, that even now, whatsoever thou wilt ask of God, God will give it thee. ²³ Jesus saith unto her, Thy brother shall rise again. ²⁴ Martha saith unto him, I know that he shall rise again in the resurrection at the last day.* **²⁵ Jesus said unto her, I am the resurrection, and the life: he that believeth in me, though he were dead, yet shall he live: ²⁶ And whosoever liveth and believeth in me shall never die. Believest thou this?** *²⁷ She saith unto him, Yea, Lord: I believe that thou art the Christ, the Son of God, which should come into the world. ²⁸ And when she had so said, she went her way, and called Mary her sister secretly, saying, The Master is come, and calleth for thee. ²⁹ As soon as she heard that, she arose quickly, and came unto him. ³⁰ Now Jesus was not yet come into the town, but was in that place where Martha met him. ³¹ The Jews then which were with her in the house, and comforted her, when they saw Mary, that she rose up hastily and went out, followed her, saying, She goeth unto the grave to weep there. ³² Then when Mary was come where Jesus was, and saw him, she fell down at his feet, saying unto him, Lord, if thou hadst been here, my brother had not died. ³³ When Jesus therefore saw her weeping, and the Jews also weeping which came with her, he groaned in the spirit, and was troubled. ³⁴ And said, Where have ye laid him? They said unto him, Lord, come and see. ³⁵ Jesus wept. ³⁶ Then said the Jews, Behold how he loved him! ³⁷ And some of them said, Could not this man, which opened the eyes of the blind, have caused that even this man should not have died? ³⁸ Jesus therefore again groaning in himself cometh to the grave. It was a cave, and a stone lay upon it. ³⁹ Jesus said, Take ye away the stone. Martha, the sister of him that was dead, saith unto him, Lord, by this time he stinketh: for he hath been dead four days. ⁴⁰ Jesus saith unto her, Said I not unto thee, that, if thou wouldest believe, thou shouldest see the glory of God? ⁴¹ Then they took away the stone from the place where the dead was laid. And Jesus lifted up his eyes, and said, Father, I thank thee that thou hast heard me. ⁴² And I knew that thou hearest me always: but because of the people which stand by I said it, that they may believe that thou hast sent me. ⁴³ And when he thus had spoken, he cried with a loud voice, Lazarus, come forth. ⁴⁴ And he that was dead came forth, bound hand and foot with graveclothes: and his face was bound about with a napkin. Jesus saith unto them, Loose him, and let him go. ⁴⁵ Then many of the Jews which came to Mary, and had seen the things which Jesus did, believed on him. ⁴⁶ But some of them went their ways to the Pharisees, and told them what things Jesus had done. ⁴⁷ Then gathered the*

chief priests and the Pharisees a council, and said, What do we? for this man doeth many miracles. [48] If we let him thus alone, all men will believe on him: and the Romans shall come and take away both our place and nation. [49] And one of them, named Caiaphas, being the high priest that same year, said unto them, Ye know nothing at all, [50] Nor consider that it is expedient for us, that one man should die for the people, and that the whole nation perish not. [51] And this spake he not of himself: but being high priest that year, he prophesied that Jesus should die for that nation; [52] And not for that nation only, but that also he should gather together in one the children of God that were scattered abroad. [53] Then from that day forth they took counsel together for to put him to death. [54] Jesus therefore walked no more openly among the Jews; but went thence unto a country near to the wilderness, into a city called Ephraim, and there continued with his disciples. [55] And the Jews' passover was nigh at hand: and many went out of the country up to Jerusalem before the passover, to purify themselves. [56] Then sought they for Jesus, and spake among themselves, as they stood in the temple, What think ye, that he will not come to the feast? [57] Now both the chief priests and the Pharisees had given a commandment, that, if any man knew where he were, he should shew it, that they might take him.

Explanation

I AM THE RESURRECTION AND THE LIFE. **St. John 11: 25-26**

Conclusion

- These are the (7) I AM's of Christ, who also aid in identifying the Fullness of God, personified as the Son of God, who was always in existence from the beginning with God.
- All things were made by Him, with God the Father.
- The Fullness of God can never be fully understood, until we pass from this life to life eternal.
- Until then, the Word of God states that we see through a glass partly, within our carnal state in this body of flesh.
- However, the Word of God states that there will come a day, when we as believers in Christ Jesus will understand all things, in a moment, in a twinkling of an eye. (Prefer to Salvation Future, Unit 4).

Questions

Why is the Oneness of God considered a mystery?

_____A mystery is something that we will not fully understand in our carnal state

_____A mystery is something that we can only begin to comprehend in the spirit man

_____ A mystery may not be clearly understood, until the Day of Trumpets, in a twinkling of an eye, we shall change from mortal/carnal to immortal/celestial

_____All of the above

The Oneness of God is explained by some as:

_____God the Father, God the Son, God the Holy Spirit

_____The Tribune God

_____The Godhead or an Entity to others

_____Yahweh, (Almighty God Yashua Hanutzrel, (Jesus Christ) and the Holy Ghost

_____ All of the above

Notice that there are (7) I AM's of Christ, the term, I AM refers to God's ever present existence, as Jehovah Shammah, therefore, through these I AM's of Christ, what does that imply?

_____I AM has no beginning nor ending

_____ I AM is a state of existence

_____ I AM is also associated with God the Father, when Moses asked God whom shall I say sent me? Therefore, here, as spoken of in (7) realms, places God the Father and God the Son, as the fullness of God, with the Holy Spirit

_____ All of the above

Thought Question

What do you, as a believer consider the most important I AM's for you in the text and why?

God the Son
The Role of the Son of God
Chapter 5

Text
St. John 1:29
I Timothy 2:5
Romans 10:9 & 10; 9
I John 1:9
Hebrews 9:11
Hebrews 4: 14-16
St. Matthew 28: 18-20

Introduction

In the previous lesson, we learned that there are (7) I AM's that identify the Lord Jesus Christ. We also reviewed some general terms we already knew from the New Testament that helps to identify the title and roles of Christ. In this lesson we shall add onto other terms which help to identify The Lord Jesus Christ as the Mediator, the High Priest, and the Lamb of God, as the Son of God, and Savior of the World.

The Lesson
The Lamb of God: Our Redeemer

Text
St. John 1:29 (See chapter 1 full text)
The next day John seeth Jesus coming unto him, and saith, Behold the Lamb of God, which taketh away the sin of the world!

Explanation

The Messiah is the Lamb of God
John the Baptist is the forerunner of Christ, who announces the way and introduces him to all, who come in his path. He is announcing to

the world, that Jesus is the Savior of the world. He is the once and for all Sacrifice for our Sins. No longer will the priest go into, the Holy of Holies, in the Temple, behind the veil, to offer up yearly sacrifices for the atonement of our sins. No longer will there be a need for a confession booth. St. John 1:29

Also

Text
Romans 10:9 & 10 (Unit 3, chapter 1 full text)
⁹ That if thou shalt confess with thy mouth the Lord Jesus, and shalt believe in thine heart that God hath raised him from the dead, thou shalt be saved. ¹⁰ For with the heart man believeth unto righteousness; and with the mouth confession is made unto salvation.

Explanation

Jesus Christ is our Personal Savior, and our Intercessor, as the Ultimate High Priest. As we witness to unbelievers to try to win them to Christ, we use, as a witness these two scriptures, **St. John 3:16 & 17.** (Refer to Unit 3, chapter 2 full text).
9. Confess refers to

- Believing that Christ died for our sins
- That He resurrected from the dead, so that we one day, as believers would be resurrected from the dead
- He ascended on High, so that one day, we, as believers could ascend on High
- As he ascended Christ was transfigured, back to immortality, so that we could be:transfigured to a heavenly celestial body, once ascended, also
- Therefore, He was transfigured back to immortality, so that we would on the Day of Atonement, be transfigured, from death, to immortality, having the gift of everlasting life

10. Believe in thine heart refers to:
Our actions are based upon what we believe. Therefore, if we believe in the finished works of Christ, death, burial and resurrection, and He, as the

Redeemer of the world, then we as believers will act accordingly. **Romans 10:9, 10**

The Mediator, Advocate and High Priest

Text
I Timothy 2:5 (Chapter 1 full text)
For there is one God, and one mediator between God and men, the man Christ Jesus;

Explanation

God the Son is now, therefore our only Mediator. **I Timothy 2:5**

The Lord Jesus Christ is our Intercessor

Text
I John 1:9: (Unit 3, chapter 1 for full text)
If we confess our sins, he is faithful and just to forgive us our sins, and to cleanse us from all unrighteousness.

Explanation
The Lord Jesus Christ is our Intercessor

Once we as believers accept Christ as the Lord and Savior of our lives, then we have a daily responsibility. That task is to daily confess our sins, before God, and let **not the** sun go down upon our wrath. Therefore, do not go to sleep, without correcting what is wrong, on our behalf, to the brethren. **I John 1:9**:

Text
Hebrews 9:11 (Unit 3, chapter 2 for full text)
But Christ being come a high priest of good things to come, by a greater and more perfect tabernacle, not made with hands, that is to say, not of this building.

Explanation

The Lord Jesus Christ is now our Chief High Priest. **Hebrews 9:11**

Text
Hebrews 4: 14-16 (Unit 6, chapter 2 full text)
¹⁴ Seeing then that we have a great high priest, that is passed into the heavens, Jesus the Son of God, let us hold fast our profession. ¹⁵ For we have not an high priest which cannot be touched with the feeling of our infirmities; but was in all points tempted like as we are, yet without sin. ¹⁶ Let us therefore come boldly unto the throne of grace, that we may obtain mercy, and find grace to help in time of need.

Explanation
The Lord Jesus Christ is now our Chief High Priest

14 As a result of our belief in God, we can come to God, through His Son and speak whatever is on our mind. 15 Christ came down from heaven, and took on the form of flesh, to experience all of our weaknesses, to better understand, why we do what we do, so that He can fully advocate for our souls, to God the Father. 16 The throne of Grace refers to Praying to God, through His Son. It also refers to just communicating to God.
Hebrews 4: 14-16

The Last Adam is our Judge

Text
St. Matthew 28: 18-20

Matthew 28

¹ In the end of the sabbath, as it began to dawn toward the first day of the week, came Mary Magdalene and the other Mary to see the sepulchre. ² And, behold, there was a great earthquake: for the angel of the Lord descended from heaven, and came and rolled back the stone from the door, and sat upon it. ³ His countenance was like lightning, and his raiment white as snow: ⁴ And for fear of him the keepers did shake, and became as dead men. ⁵ And the angel answered and said unto the women, Fear not ye: for I know that ye seek Jesus, which was crucified. ⁶ He is not here: for he is risen, as he said. Come, see the place where the Lord lay. ⁷ And go quickly, and tell his disciples that he is risen from the dead; and, behold, he goeth before you into Galilee; there shall ye see him: lo, I have told you. ⁸ And they departed quickly from the sepulchre with

*fear and great joy; and did run to bring his disciples word. ⁹ And as they went to tell his disciples, behold, Jesus met them, saying, All hail. And they came and held him by the feet, and worshipped him. ¹⁰ Then said Jesus unto them, Be not afraid: go tell my brethren that they go into Galilee, and there shall they see me. ¹¹ Now when they were going, behold, some of the watch came into the city, and shewed unto the chief priests all the things that were done. ¹² And when they were assembled with the elders, and had taken counsel, they gave large money unto the soldiers, ¹³ Saying, Say ye, His disciples came by night, and stole him away while we slept. ¹⁴ And if this come to the governor's ears, we will persuade him, and secure you. ¹⁵ So they took the money, and did as they were taught: and this saying is commonly reported among the Jews until this day. ¹⁶ Then the eleven disciples went away into Galilee, into a mountain where Jesus had appointed them. ¹⁷ And when they saw him, they worshipped him: but some doubted. ¹⁸ **And Jesus came and spake unto them, saying, All power is given unto me in heaven and in earth. ¹⁹ Go ye therefore, and teach all nations, baptizing them in the name of the Father, and of the Son, and of the Holy Ghost: ²⁰ Teaching them to observe all things whatsoever I have commanded you: and, lo, I am with you alway, even unto the end of the world. Amen.***

Explanation
The Last Adam is, Our Judge

These scriptures from verse 18 to 20 are known as The Great Commission. Christ commissions the believers to:18. Not to be afraid. The believers have been now endowed with power from on High. They can do whatever God speaks to them to do, without fear. 19 Teach all nations that there are three that bare record in heaven, the Father, the Son and the Holy Ghost, and these are one, (See lesson on the Tribune God). Baptism is simply an outward show to the world that we have been redeemed, through believing in the shed blood in our Lord Jesus Christ. **St. Matthew 28: 18-20**

Conclusion

- St. John 1:15, states that all things were made by the Word of God.
- There are 7 I AM's that identify the Lord Jesus Christ in the New Testament.
- No one can be saved unless they enter in at the Door.

Questions

Name three roles defined also as titles for the Lord Jesus Christ. Provide scripture.

Why is there no longer a need for a confession booth? State the reason and provide the scripture.

In Romans 10:9 & 10
What does confessing with your mouth refer to?

_____Confession to God that we are sinners, lost without Christ, in need of a Savior

_____Therefore, if we confess, then we believe. So we believe that Jesus became the
Sacrifice for our sins

_____Also, we believe, refers to believing, that God raised Jesus from the dead

_____We are saved by faith, in believing in the Promises of God

_____All of the above

Who is our Chief High Priest and why? Provide scripture.

Who is the Intercessor, or Mediator, and the Advocate, who stands before God continually, asking for forgiveness of our sins, daily? Provide scripture.

Not only is there a throne of God, in the heavenlies, but we as believers should come to the throne of God daily to _____ our_____in the presence of God.

During the last words of instruction with this lesson, which is entitled the Great Commission to all believers, God is with us always in the person of God_____Holy_____

Thought Question

Why do you think that in some denominations there remains a confession booth, in some locations and regions of the world?

God the Son
The Oneness of God
Chapter 6

Text
Colossians 1:15
St. Matthew 1:21
I John 2:2
St. Matthew 1:23
St. John 1:12
Acts 16:31
St. Matthews 28:6
Acts 1: 9 & 10
Hebrews 7:25

Introduction
Jesus Christ: Yerusha

We believe in the deity of the Lord Jesus Christ. He is God incarnate, as the King of Kings and the Lord of Lord, the Lion of the Tribe of Judah, the Root of David, the Chief Corner Stone, the Chief Shepherd, and the Amen. The Lord Jesus Christ is God in human form, the expressed image of the Father, who, without ceasing to be God, became man in order that He might demonstrate who God is. Jesus Christ as Yerusha, provides the means of salvation for humanity, as The Lamb of God, the Last Adam, The Redeemer, Rabbi, The Prince of Peace, Faithful, True, Immanuel, Jesus, and lastly, as the Messiah.

The Lesson

Text
Colossians 1:15

Colossians 1

¹ Paul, an apostle of Jesus Christ by the will of God, and Timotheus our brother, ² To the saints and faithful brethren in Christ which are at Colosse: Grace be unto you, and peace, from God our Father and the Lord Jesus Christ. ³ We give thanks to God and the Father of our Lord Jesus Christ, praying always for you, ⁴ Since we heard of your faith in Christ Jesus, and of the love which ye have to all the saints, ⁵ For the hope which is laid up for you in heaven, whereof ye heard before in the word of the truth of the gospel; ⁶ Which is come unto you, as it is in all the world; and bringeth forth fruit, as it doth also in you, since the day ye heard of it, and knew the grace of God in truth: ⁷ As ye also learned of Epaphras our dear fellowservant, who is for you a faithful minister of Christ; ⁸ Who also declared unto us your love in the Spirit. ⁹ For this cause we also, since the day we heard it, do not cease to pray for you, and to desire that ye might be filled with the knowledge of his will in all wisdom and spiritual understanding; ¹⁰ That ye might walk worthy of the Lord unto all pleasing, being fruitful in every good work, and increasing in the knowledge of God; ¹¹ Strengthened with all might, according to his glorious power, unto all patience and longsuffering with joyfulness; ¹² Giving thanks unto the Father, which hath made us meet to be partakers of the inheritance of the saints in light: ¹³ Who hath delivered us from the power of darkness, and hath translated us into the kingdom of his dear Son: ¹⁴ In whom we have redemption through his blood, even the forgiveness of sins: **¹⁵ Who is the image of the invisible God, the firstborn of every creature: ¹⁶ For by him were all things created, that are in heaven, and that are in earth, visible and invisible, whether they be thrones, or dominions, or principalities, or powers: all things were created by him, and for him:** *¹⁷ And he is before all things, and by him all things consist. ¹⁸ And he is the head of the body, the church: who is the beginning, the firstborn from the dead; that in all things he might have the preeminence. ¹⁹ For it pleased the Father that in him should all fulness dwell; ²⁰ And, having made peace through the blood of his cross, by him to reconcile all things unto himself; by him, I say, whether they be things in earth, or things in heaven. ²¹ And you, that were sometime alienated and enemies in your mind by wicked works, yet now hath he reconciled ²² In the body of his flesh through death, to present you holy and unblameable and unreproveable in his sight: ²³ If ye continue in the faith grounded and settled, and be not moved away from the hope of the gospel, which ye have heard, and which was preached to every creature which is under heaven; whereof I Paul am made a minister; ²⁴*

Who now rejoice in my sufferings for you, and fill up that which is behind of the afflictions of Christ in my flesh for his body's sake, which is the church: ²⁵ Whereof I am made a minister, according to the dispensation of God which is given to me for you, to fulfil the word of God; ²⁶ Even the mystery which hath been hid from ages and from generations, but now is made manifest to his saints: ²⁷ To whom God would make known what is the riches of the glory of this mystery among the Gentiles; which is Christ in you, the hope of glory: ²⁸ Whom we preach, warning every man, and teaching every man in all wisdom; that we may present every man perfect in Christ Jesus: ²⁹ Whereunto I also labour, striving according to his working, which worketh in me mightily.

Explanation

The Savior, our Redeemer of all mankind, was called the first fruits. As a result of Christ resurrection from the dead, one day we as believers will also resurrect from the darkness of this carnal body and sinful nature to everlasting life in the heavens, glory to God, what a day of rejoicing that will be. **Colossians 1:15**
Text
I John 2:2 (See Unit 4, chapter 2 for full text)
And he is the propitiation for our sins and not for ours only, but for the sins of the whole world.

Explanation

The Lord Jesus Christ is the Savior of the whole world. **I John 2:2**
Text
St. Matthew 1: 21, 23

Matthew 1

¹ The book of the generation of Jesus Christ, the son of David, the son of Abraham. ² Abraham begat Isaac; and Isaac begat Jacob; and Jacob begat Judas and his brethren; ³ And Judas begat Phares and Zara of Thamar; and Phares begat Esrom; and Esrom begat Aram; ⁴ And Aram begat Aminadab; and Aminadab begat Naasson; and Naasson begat Salmon; ⁵ And Salmon begat Booz of Rachab; and Booz begat Obed of Ruth; and Obed begat Jesse; ⁶ And Jesse begat David the king; and David the king begat Solomon of her

that had been the wife of Urias; ⁷ *And Solomon begat Roboam; and Roboam begat Abia; and Abia begat Asa;* ⁸ *And Asa begat Josaphat; and Josaphat begat Joram; and Joram begat Ozias;* ⁹ *And Ozias begat Joatham; and Joatham begat Achaz; and Achaz begat Ezekias;* ¹⁰ *And Ezekias begat Manasses; and Manasses begat Amon; and Amon begat Josias;* ¹¹ *And Josias begat Jechonias and his brethren, about the time they were carried away to Babylon:* ¹² *And after they were brought to Babylon, Jechonias begat Salathiel; and Salathiel begat Zorobabel;* ¹³ *And Zorobabel begat Abiud; and Abiud begat Eliakim; and Eliakim begat Azor;* ¹⁴ *And Azor begat Sadoc; and Sadoc begat Achim; and Achim begat Eliud;* ¹⁵ *And Eliud begat Eleazar; and Eleazar begat Matthan; and Matthan begat Jacob;* ¹⁶ *And Jacob begat Joseph the husband of Mary, of whom was born Jesus, who is called Christ.* ¹⁷ *So all the generations from Abraham to David are fourteen generations; and from David until the carrying away into Babylon are fourteen generations; and from the carrying away into Babylon unto Christ are fourteen generations.* ¹⁸ **Now the birth of Jesus Christ was on this wise: When as his mother Mary was espoused to Joseph, before they came together, she was found with child of the Holy Ghost.** ¹⁹ **Then Joseph her husband, being a just man, and not willing to make her a publick example, was minded to put her away privily.** ²⁰ **But while he thought on these things, behold, the angel of the LORD appeared unto him in a dream, saying, Joseph, thou son of David, fear not to take unto thee Mary thy wife: for that which is conceived in her is of the Holy Ghost.** ²¹ **And she shall bring forth a son, and thou shalt call his name JESUS: for he shall save his people from their sins.** ²² **Now all this was done, that it might be fulfilled which was spoken of the Lord by the prophet, saying,** ²³ **Behold, a virgin shall be with child, and shall bring forth a son, and they shall call his name Emmanuel, which being interpreted is, God with us.** ²⁴ *Then Joseph being raised from sleep did as the angel of the Lord had bidden him, and took unto him his wife:* ²⁵ *And knew her not till she had brought forth her firstborn son: and he called his name JESUS.*

Explanation

The angel Gabriel came to Mary, while she was not married, but betrothed to Joseph, informing her that she would have a child, and Joseph would not be the father. The child would be conceived by the Holy Ghost. All

Mary could think about was if this were true, how could she explain this to her family and her husband to be? **St. Matthew 1:21**

Also

Text
St. Matthew 1:23
²³ Behold, a virgin shall be with child, and shall bring forth a son, and they shall call his name Emmanuel, which being interpreted is, God with us.

Explanation

Christ was predicted in Old Testament Times to come in the Times of the Gentiles, to redeem mankind from all walks of life. Mankind consists of the Gentiles and the lost house of Israel, who is yet looking for the Lord to return, as a King, with natural wealth and glory. Everything we have is His. He dose not have to display His Majesty. It is because of our Redeemer that we live, we move, and we have our being. We walk by faith and not by sight. **St. Matthew 1:23**
Text
St. John 1:12 (Refer to chapter 4 full text)
But as many as received him, to him gave he power to become the sons of God, even to them that believe on his name.

Explanation

The Word of God states that whosoever will, let him come and be saved from their sins. God has no respect of persons. Receive here refers to accepting the Messiah as our Redeemer. **St. John 1:12**
Text
Acts 16:31

Acts 16

¹ Then came he to Derbe and Lystra: and, behold, a certain disciple was there, named Timotheus, the son of a certain woman, which was a Jewess, and believed; but his father was a Greek: ² Which was well reported of by the brethren that were at Lystra and Iconium. ³ Him would Paul have to go forth

with him; and took and circumcised him because of the Jews which were in those quarters: for they knew all that his father was a Greek. ⁴ And as they went through the cities, they delivered them the decrees for to keep, that were ordained of the apostles and elders which were at Jerusalem. ⁵ And so were the churches established in the faith, and increased in number daily. ⁶ Now when they had gone throughout Phrygia and the region of Galatia, and were forbidden of the Holy Ghost to preach the word in Asia, ⁷ After they were come to Mysia, they assayed to go into Bithynia: but the Spirit suffered them not. ⁸ And they passing by Mysia came down to Troas. ⁹ And a vision appeared to Paul in the night; There stood a man of Macedonia, and prayed him, saying, Come over into Macedonia, and help us. ¹⁰ And after he had seen the vision, immediately we endeavoured to go into Macedonia, assuredly gathering that the Lord had called us for to preach the gospel unto them. ¹¹ Therefore loosing from Troas, we came with a straight course to Samothracia, and the next day to Neapolis; ¹² And from thence to Philippi, which is the chief city of that part of Macedonia, and a colony: and we were in that city abiding certain days. ¹³ And on the sabbath we went out of the city by a river side, where prayer was wont to be made; and we sat down, and spake unto the women which resorted thither. ¹⁴ And a certain woman named Lydia, a seller of purple, of the city of Thyatira, which worshipped God, heard us: whose heart the Lord opened, that she attended unto the things which were spoken of Paul. ¹⁵ And when she was baptized, and her household, she besought us, saying, If ye have judged me to be faithful to the Lord, come into my house, and abide there. And she constrained us. ¹⁶ And it came to pass, as we went to prayer, a certain damsel possessed with a spirit of divination met us, which brought her masters much gain by soothsaying: ¹⁷ The same followed Paul and us, and cried, saying, These men are the servants of the most high God, which shew unto us the way of salvation. ¹⁸ And this did she many days. But Paul, being grieved, turned and said to the spirit, I command thee in the name of Jesus Christ to come out of her. And he came out the same hour. ¹⁹ And when her masters saw that the hope of their gains was gone, they caught Paul and Silas, and drew them into the marketplace unto the rulers, ²⁰ And brought them to the magistrates, saying, These men, being Jews, do exceedingly trouble our city, ²¹ And teach customs, which are not lawful for us to receive, neither to observe, being Romans. ²² And the multitude rose up together against them: and the magistrates rent off their clothes, and commanded to beat them. ²³ And when they had laid many stripes upon them, they cast them into prison, charging the jailor to keep them safely: ²⁴ Who, having received such a charge, thrust them

into the inner prison, and made their feet fast in the stocks. ²⁵ *And at midnight Paul and Silas prayed, and sang praises unto God: and the prisoners heard them.* ²⁶ *And suddenly there was a great earthquake, so that the foundations of the prison were shaken: and immediately all the doors were opened, and every one's bands were loosed.* ²⁷ *And the keeper of the prison awaking out of his sleep, and seeing the prison doors open, he drew out his sword, and would have killed himself, supposing that the prisoners had been fled.* ²⁸ *But Paul cried with a loud voice, saying, Do thyself no harm: for we are all here.* ²⁹ *Then he called for a light, and sprang in, and came trembling, and fell down before Paul and Silas,* ³⁰ *And brought them out, and said, Sirs, what must I do to be saved?* ³¹ ***And they said, Believe on the Lord Jesus Christ, and thou shalt be saved, and thy house.*** ³² *And they spake unto him the word of the Lord, and to all that were in his house.* ³³ *And he took them the same hour of the night, and washed their stripes; and was baptized, he and all his, straightway.* ³⁴ *And when he had brought them into his house, he set meat before them, and rejoiced, believing in God with all his house.* ³⁵ *And when it was day, the magistrates sent the serjeants, saying, Let those men go.* ³⁶ *And the keeper of the prison told this saying to Paul, The magistrates have sent to let you go: now therefore depart, and go in peace.* ³⁷ *But Paul said unto them, They have beaten us openly uncondemned, being Romans, and have cast us into prison; and now do they thrust us out privily? nay verily; but let them come themselves and fetch us out.* ³⁸ *And the serjeants told these words unto the magistrates: and they feared, when they heard that they were Romans.* ³⁹ *And they came and besought them, and brought them out, and desired them to depart out of the city.* ⁴⁰ *And they went out of the prison, and entered into the house of Lydia: and when they had seen the brethren, they comforted them, and departed.*

Explanation

This is a promise that not only will we, as believers be saved from our sins, but if we will hold to our profession of faith, without wavering, one by one, all of our household will be saved, as we live the life before them.
Acts 16:31
Text
St. Matthew 28:6

Matthew 28

¹ *In the end of the Sabbath, as it began to dawn toward the first day of the week, came Mary Magdalene and the other Mary to see the sepulchre.* ² *And, behold, there was a great earthquake: for the angel of the Lord descended from heaven, and came and rolled back the stone from the door, and sat upon it.* ³ *His countenance was like lightning, and his raiment white as snow:* ⁴ *And for fear of him the keepers did shake, and became as dead men.* ⁵ *And the angel answered and said unto the women, Fear not ye: for I know that ye seek Jesus, which was crucified.* **⁶ He is not here: for he is risen, as he said. Come, see the place where the Lord lay.** ⁷ *And go quickly, and tell his disciples that he is risen from the dead; and, behold, he goeth before you into Galilee; there shall ye see him: lo, I have told you.* ⁸ *And they departed quickly from the sepulchre with fear and great joy; and did run to bring his disciples word.* ⁹ *And as they went to tell his disciples, behold, Jesus met them, saying, All hail. And they came and held him by the feet, and worshipped him.* ¹⁰ *Then said Jesus unto them, Be not afraid: go tell my brethren that they go into Galilee, and there shall they see me.* ¹¹ *Now when they were going, behold, some of the watch came into the city, and shewed unto the chief priests all the things that were done.* ¹² *And when they were assembled with the elders, and had taken counsel, they gave large money unto the soldiers,* ¹³ *Saying, Say ye, His disciples came by night, and stole him away while we slept.* ¹⁴ *And if this come to the governor's ears, we will persuade him, and secure you.* ¹⁵ *So they took the money, and did as they were taught: and this saying is commonly reported among the Jews until this day.* ¹⁶ *Then the eleven disciples went away into Galilee, into a mountain where Jesus had appointed them.* ¹⁷ *And when they saw him, they worshipped him: but some doubted.* ¹⁸ *And Jesus came and spake unto them, saying, All power is given unto me in heaven and in earth.* ¹⁹ *Go ye therefore, and teach all nations, baptizing them in the name of the Father, and of the Son, and of the Holy Ghost:* ²⁰ *Teaching them to observe all things whatsoever I have commanded you: and, lo, I am with you alway, even unto the end of the world. Amen.*

Explanation

This is the day of Resurrection, when the Messiah rose from the dead, and was seen first by Mary Madeline, and then 50 in an assembly and later 500, before his ascension. **St. Matthew 28:6**

Text
Acts 1: 9-10

Acts 1

*¹ The former treatise have I made, O Theophilus, of all that Jesus began both to do and teach, ² Until the day in which he was taken up, after that he through the Holy Ghost had given commandments unto the apostles whom he had chosen: ³ To whom also he shewed himself alive after his passion by many infallible proofs, being seen of them forty days, and speaking of the things pertaining to the kingdom of God: ⁴ And, being assembled together with them, commanded them that they should not depart from Jerusalem, but wait for the promise of the Father, which, saith he, ye have heard of me. ⁵ For John truly baptized with water; but ye shall be baptized with the Holy Ghost not many days hence. ⁶ When they therefore were come together, they asked of him, saying, Lord, wilt thou at this time restore again the kingdom to Israel? ⁷ And he said unto them, It is not for you to know the times or the seasons, which the Father hath put in his own power. ⁸ But ye shall receive power, after that the Holy Ghost is come upon you: and ye shall be witnesses unto me both in Jerusalem, and in all Judaea, and in Samaria, and unto the uttermost part of the earth. ⁹ **And when he had spoken these things, while they beheld, he was taken up; and a cloud received him out of their sight. ¹⁰ And while they looked stedfastly toward heaven as he went up, behold, two men stood by them in white apparel; ¹¹ Which also said, Ye men of Galilee, why stand ye gazing up into heaven? this same Jesus, which is taken up from you into heaven, shall so come in like manner as ye have seen him go into heaven.** ¹² Then returned they unto Jerusalem from the mount called Olivet, which is from Jerusalem a sabbath day's journey. ¹³ And when they were come in, they went up into an upper room, where abode both Peter, and James, and John, and Andrew, Philip, and Thomas, Bartholomew, and Matthew, James the son of Alphaeus, and Simon Zelotes, and Judas the brother of James. ¹⁴ These all continued with one accord in prayer and supplication, with the women, and Mary the mother of Jesus, and with his brethren. ¹⁵ And in those days Peter stood up in the midst of the disciples, and said, (the number of names together were about an hundred and twenty,) ¹⁶ Men and brethren, this scripture must needs have been fulfilled, which the Holy Ghost by the mouth of David spake before concerning Judas, which was guide to them that took Jesus. ¹⁷ For he was numbered with us, and had obtained part of this*

ministry. [18] *Now this man purchased a field with the reward of iniquity; and falling headlong, he burst asunder in the midst, and all his bowels gushed out.* [19] *And it was known unto all the dwellers at Jerusalem; insomuch as that field is called in their proper tongue, Aceldama, that is to say, The field of blood.* [20] *For it is written in the book of Psalms, Let his habitation be desolate, and let no man dwell therein: and his bishoprick let another take.* [21] *Wherefore of these men which have companied with us all the time that the Lord Jesus went in and out among us,* [22] *Beginning from the baptism of John, unto that same day that he was taken up from us, must one be ordained to be a witness with us of his resurrection.* [23] *And they appointed two, Joseph called Barsabas, who was surnamed Justus, and Matthias.* [24] *And they prayed, and said, Thou, Lord, which knowest the hearts of all men, shew whether of these two thou hast chosen,* [25] *That he may take part of this ministry and apostleship, from which Judas by transgression fell, that he might go to his own place.* [26] *And they gave forth their lots; and the lot fell upon Matthias; and he was numbered with the eleven apostles.*

Explanation

These are the witnesses that saw the resurrection of the Savior, first hand, for all believers to later believe by faith. What a privilege it must have been to witness, such an event. It is implied that the men in white apparel were angels. **Acts 1: 9-10**
Text
Hebrews 7:25

Hebrews 7

[1] *For this Melchisedec, king of Salem, priest of the most high God, who met Abraham returning from the slaughter of the kings, and blessed him;* [2] *To whom also Abraham gave a tenth part of all; first being by interpretation King of righteousness, and after that also King of Salem, which is, King of peace;* [3] *Without father, without mother, without descent, having neither beginning of days, nor end of life; but made like unto the Son of God; abideth a priest continually.* [4] *Now consider how great this man was, unto whom even the patriarch Abraham gave the tenth of the spoils.* [5] *And verily they that are of the sons of Levi, who receive the office of the priesthood, have a commandment to take tithes of the people according to the law, that is, of their brethren,*

though they come out of the loins of Abraham: ⁶ *But he whose descent is not counted from them received tithes of Abraham, and blessed him that had the promises.* ⁷ *And without all contradiction the less is blessed of the better.* ⁸ *And here men that die receive tithes; but there he receiveth them, of whom it is witnessed that he liveth.* ⁹ *And as I may so say, Levi also, who receiveth tithes, payed tithes in Abraham.* ¹⁰ *For he was yet in the loins of his father, when Melchisedec met him.* ¹¹ *If therefore perfection were by the Levitical priesthood, (for under it the people received the law,) what further need was there that another priest should rise after the order of Melchisedec, and not be called after the order of Aaron?* ¹² *For the priesthood being changed, there is made of necessity a change also of the law.* ¹³ *For he of whom these things are spoken pertaineth to another tribe, of which no man gave attendance at the altar.* ¹⁴ *For it is evident that our Lord sprang out of Juda; of which tribe Moses spake nothing concerning priesthood.* ¹⁵ *And it is yet far more evident: for that after the similitude of Melchisedec there ariseth another priest,* ¹⁶ *Who is made, not after the law of a carnal commandment, but after the power of an endless life.* ¹⁷ *For he testifieth, Thou art a priest for ever after the order of Melchisedec.* ¹⁸ *For there is verily a disannulling of the commandment going before for the weakness and unprofitableness thereof.* ¹⁹ *For the law made nothing perfect, but the bringing in of a better hope did; by the which we draw nigh unto God.* ²⁰ *And inasmuch as not without an oath he was made priest:* ²¹ *(For those priests were made without an oath; but this with an oath by him that said unto him, The Lord sware and will not repent, Thou art a priest for ever after the order of Melchisedec:)* ²² *By so much was Jesus made a surety of a better testament.* ²³ *And they truly were many priests, because they were not suffered to continue by reason of death:* ²⁴ *But this man, because he continueth ever, hath an unchangeable priesthood.* ²⁵ ***Wherefore he is able also to save them to the uttermost that come unto God by him, seeing he ever liveth to make intercession for them.*** ²⁶ *For such an high priest became us, who is holy, harmless, undefiled, separate from sinners, and made higher than the heavens;* ²⁷ *Who needeth not daily, as those high priests, to offer up sacrifice, first for his own sins, and then for the people's: for this he did once, when he offered up himself.* ²⁸ *For the law maketh men high priests which have infirmity; but the word of the oath, which was since the law, maketh the Son, who is consecrated for evermore.*

Explanation

We believe that the Lord Jesus Christ ascended to Heaven in His glorified body and is now seated at the Right Hand of God as our High Priest and Advocate. **Hebrews 7:25**

Conclusion

- In our Statement of Faith, we believe that Jesus Christ was conceived of the Holy Spirit and was born of the Virgin Mary.
- Jesus is truly fully God and truly fully man.
- Jesus Christ lived a perfect, sinless life; and all of His teachings are true.
- We believe that the Lord Jesus Christ died on the cross for all humanity as a substitution sacrifice, for the sins of all mankind.
- He is the Savior for all mankind that our justification is grounded in the shedding of His blood and his resurrection from the dead.

Questions

Mary was informed that she would bring forth a Son. What does the name Jesus mean? What scripture location supports this?

What does the name Immanuel mean? Who does it refer to? Provide the scripture.

Provide three statements that we know that refer to the Times of the Gentiles or the Church Age.

The Lost House of Israel, refers to the Jewish Nation, composed of all descendents from the (12) tribes of Judah or Israel. What facts do we know help to support that they are yet looking for the Messiah? Select.

_____They crucified the Lord

_____They called Christ the King of the Jews while He hang on the Cross for our sins

_____They said, while He was on the cross, that if thou be the Son of God, (as a Prince) save yourself

_____ However, Christ did not come to save Himself

_____None of the above

_____All of the above

According to St. John 1:12 who can be saved?

Not only can anyone be saved, but according to Acts 16:31 God gives all the promise, if we hold fast to our profession of faith, without wavering all of our, _____shall also be saved.

What did we learn happened to the Bright and Morning Star, in Acts 1:9 & 10?

Who were the eye witnesses that witnessed Christ's ascension?

Thought Question

In accordance to the Word of God Jesus means Savior and Immanuel means God is with us, so with that in mind, should we as parents bring meaning to the names of our children and or grandchildren and carefully select names?

The Fullness God through the Holy Spirit
God the Holy Spirit
Chapter 7

Text
St. John 15:26
St. John 16:7
St John 16:14
St. John 16:12
St. John 16:13
St. John 16:8
St. John 15:26
St. John 14:26

Introduction

God, the Holy Spirit is the believer's Comforter, Teacher, and Personal spiritual friend. He works with the believer's God conscience, to inform the believer as to what is right and what is wrong, as we go about our daily routine. He gives us strength and courage, in the face of impossible odds, as we call upon Him for deliverance and assistance.

The Lesson

The Third Entity in the Fullness of God is the Holy Spirit or the Holy Ghost. He is a Gift from God
Text
St. John 15:26 (See chapter 4 for full text)
But when the Comforter is come, whom I will send unto you from the Father, even the Spirit of truth, which proceedeth, from the Father, he will testify of me.

Explanation

The Teacher is a Gift from God. He will reveal to the believer, things that are heavenly truths that only God can reveal in the hearts and minds of believers. The Guide testifies of God, resulting in the believer's ability to continue the works that God, in the person of His Son began, while here on earth. Through the teachings of Christ, began the Church of believers from all nationalities. Through Christ, He commissioned the saints, or believers to continue the work, in evangelizing to the world, of the saving grace and knowledge of the Lord Jesus Christ, the Giver of Heavenly eternal life. **St. John 15:26**

God the Holy Spirit:
Abides

Text
St. John 14:16 (See chapter 4 for full text)
And I will pray the Father, and He shall give you another Comforter, that he may abide with you forever.

Explanation

The Comforter is a gift from God, who will abide with us forever. He will never leave the believer's heart, mind and soul, which defines his personality and god conscience.
St. John 14:16

God the Holy Spirit
Forbids

Text
St. John 16:7
St John 16:14
St. John 16:12
St. John 16:13
St. John 16:8-11

John 16

¹ These things have I spoken unto you, that ye should not be offended. ² They shall put you out of the synagogues: yea, the time cometh, that whosoever killeth you will think that he doeth God service. ³ And these things will they do unto you, because they have not known the Father, nor me. ⁴ But these things have I told you, that when the time shall come, ye may remember that I told you of them. And these things I said not unto you at the beginning, because I was with you. ⁵ But now I go my way to him that sent me; and none of you asketh me, Whither goest thou? ⁶ But because I have said these things unto you, sorrow hath filled your heart. **⁷ Nevertheless I tell you the truth; It is expedient for you that I go away: for if I go not away, the Comforter will not come unto you; but if I depart, I will send him unto you. ⁸ And when he is come, he will reprove the world of sin, and of righteousness, and of judgment: ⁹ Of sin, because they believe not on me; ¹⁰ Of righteousness, because I go to my Father, and ye see me no more; ¹¹ Of judgment, because the prince of this world is judged. ¹² I have yet many things to say unto you, but ye cannot bear them now. ¹³ Howbeit when he, the Spirit of truth, is come, he will guide you into all truth: for he shall not speak of himself; but whatsoever he shall hear, that shall he speak: and he will shew you things to come. ¹⁴ He shall glorify me: for he shall receive of mine, and shall shew it unto you.** *¹⁵ All things that the Father hath are mine: therefore said I, that he shall take of mine, and shall shew it unto you. ¹⁶ A little while, and ye shall not see me: and again, a little while, and ye shall see me, because I go to the Father. ¹⁷ Then said some of his disciples among themselves, What is this that he saith unto us, A little while, and ye shall not see me: and again, a little while, and ye shall see me: and, Because I go to the Father? ¹⁸ They said therefore, What is this that he saith, A little while? we cannot tell what he saith. ¹⁹ Now Jesus knew that they were desirous to ask him, and said unto them, Do ye enquire among yourselves of that I said, A little while, and ye shall not see me: and again, a little while, and ye shall see me? ²⁰ Verily, verily, I say unto you, That ye shall weep and lament, but the world shall rejoice: and ye shall be sorrowful, but your sorrow shall be turned into joy. ²¹ A woman when she is in travail hath sorrow, because her hour is come: but as soon as she is delivered of the child, she remembereth no more the anguish, for joy that a man is born into the world. ²² And ye now therefore have sorrow: but I will see you again, and your heart shall rejoice, and your joy no man taketh from you. ²³ And in that day ye shall ask me nothing.*

Verily, verily, I say unto you, Whatsoever ye shall ask the Father in my name, he will give it you. ²⁴ Hitherto have ye asked nothing in my name: ask, and ye shall receive, that your joy may be full. ²⁵ These things have I spoken unto you in proverbs: but the time cometh, when I shall no more speak unto you in proverbs, but I shall shew you plainly of the Father. ²⁶ At that day ye shall ask in my name: and I say not unto you, that I will pray the Father for you: ²⁷ For the Father himself loveth you, because ye have loved me, and have believed that I came out from God. ²⁸ I came forth from the Father, and am come into the world: again, I leave the world, and go to the Father. ²⁹ His disciples said unto him, Lo, now speakest thou plainly, and speakest no proverb. ³⁰ Now are we sure that thou knowest all things, and needest not that any man should ask thee: by this we believe that thou camest forth from God. ³¹ Jesus answered them, Do ye now believe? ³² Behold, the hour cometh, yea, is now come, that ye shall be scattered, every man to his own, and shall leave me alone: and yet I am not alone, because the Father is with me. ³³ These things I have spoken unto you, that in me ye might have peace. In the world ye shall have tribulation: but be of good cheer; I have overcome the world.

Explanation

God the Son, imparts the Holy Spirit, and forbid another to come or enter therein, in His place. **St. John 16:7**

Also
God the Holy Spirit
Glorifies God the Son

Text
St John 16:14
He shall glorify me; for he shall receive of mine, and shall show it unto you.

Explanation

The Spirit of Truth glorifies God the Son. Whatever the believer is able to perform, it is through Christ, who enables the believer to stand before Almighty God, in right standing. It is now through Christ's finished works, when He ascended on High and now sits at the Right Hand of

God the father, that He makes intersession for the saints or believers. **St John 16:14**

In addition
God the Holy Spirit
Guides, Appoints, and Decides

Text
St. John 16:12
I have yet many things to say unto you, but you cannot bear them now.

Explanation

The Word of God declares that God, in the Person of God the Holy Ghost, guides, directs and appoints, as believers are obedient to the Word of God and wait on their calling and instruction.
Text
St. John 16:12

Add 4th Text
Text God the Holy Spirit
Foretells

Text
St. John 16:13
Howbeit when he, the Spirit of truth, is come, he will guide you into all truth: for He shall not speak of himself; but whatsoever he shall hear, that shall he speak: and he will show you things to come.

Explanation

The Holy Spirit is also called the Spirit of Truth. Not only does it represent Truth, it is defined as Truth, it is the mouthpiece of the Spirit of Christ in the person of the Spirit of God. Also, as The Third Person in the Tribune God, He will also show you things to come, known as foretelling. **St. John 16:13**

Add 5ᵗʰ Text
God the Holy Spirit
Convicts

Text
St. John 16:8-11

⁸ And when he is come, he will reprove the world of sin, and of righteousness, and of judgment: ⁹ Of sin, because they believe not on me; ¹⁰ Of righteousness, because I go to my Father, and ye see me no more; ¹¹ Of judgment, because the prince of this world is judged.

Explanation

The Holy Spirit resides in the body or vessel of the believers. As the believers or saints of God walk in the midst of evil, the Holy Spirit convicts those of evil and unrighteousness within the earth. It can also be defined as the anointing of God, upon the believer's life. **St. John 16:8-11**

God the Holy Spirit
Witness

Text
St. John 15:26 (See chapter 4 for full text)

But when the Comforter is come, whom I shall send unto you from the Father, even the Spirit of Truth, which proceedeth from the Father, he will testify of me.

Explanation

We as believers in Christ Jesus know when we have the Comforter. For we will then have the ability to live a godly life, which we never thought humanly possible. This is only performed, through the workings of the indwelling of the Holy Spirit, or the Holy Ghost within the body of the believer. **St. John 15:26**

God the Holy Spirit
Teach and Recall

Text

St. John 14:26(See chapter 4 for full text)

But the Comforter, which is the Holy Ghost, whom the Father will send in my name, he shall teach you all things, and bring all things to your remembrance, whatsoever, I have said unto you.

Explanation

The Holy Spirit, or the Holy Ghost, the Comforter, will teach and bring to our remembrance what is needed at the appointed time. **St. John 14:26**

Conclusion

- God the Holy Spirit is what lives in the body of the believer, which enables the believer to live for Christ, even in the midst of ungodliness.
- He is called the Keeper.
- However, the Holy Spirit will only keep the believer, if the believer wants to be kept.

Questions

Name twelve tasks that God the Holy Spirit performs for and in the believer's life. Provide scripture.

Tasks Scripture

What are (4) titles for God the Holy Spirit?

C_____

S_____ O _____ T _____

T_____

G_____

The Holy Spirit convicts and reproves the world of sin. What does that mean? Provide scripture.

Thought Question:

When you come to the Lord Jesus Christ to ask for forgiveness from your sins, so that you can take on, by faith, the gift of heavenly eternal life, Do you have to wait, until you get yourself all cleaned up?

Or do you come as you are, and let the Holy Spirit, begin to tell you, one thing at a time, what you must do, to continue on the straight and narrow path of salvation, all the way to changing from this life to immortality at the end?

God the Holy Spirit
The Role of the Holy Spirit
The Anointing of God, through the Holy Ghost Chapter 8

Text
I Corinthians 15:31
I Corinthians 12:13
St Matthew 28:19-20
Acts 2:41
Acts 1: 4-8
St. Matthew 3: 11-12
Acts 2: 1-4 & verses 15-21

Introduction

Once we, as the believer receive the Lord Jesus Christ into our hearts as our personal Lord and Savior, we have received one of three baptisms. We shall study the other two components of baptism, that of water and that of fire in this lesson.

The Lesson
The First Baptism

Text
1 Corinthians 12:13

1 Corinthians 12

¹ Now concerning spiritual gifts, brethren, I would not have you ignorant. ² Ye know that ye were Gentiles, carried away unto these dumb idols, even as ye were led. ³ Wherefore I give you to understand, that no man speaking by the

*Spirit of God calleth Jesus accursed: and that no man can say that Jesus is the Lord, but by the Holy Ghost. ⁴ Now there are diversities of gifts, but the same Spirit. ⁵ And there are differences of administrations, but the same Lord. ⁶ And there are diversities of operations, but it is the same God which worketh all in all. ⁷ But the manifestation of the Spirit is given to every man to profit withal. ⁸ For to one is given by the Spirit the word of wisdom; to another the word of knowledge by the same Spirit; ⁹ To another faith by the same Spirit; to another the gifts of healing by the same Spirit; ¹⁰ To another the working of miracles; to another prophecy; to another discerning of spirits; to another divers kinds of tongues; to another the interpretation of tongues: ¹¹ But all these worketh that one and the selfsame Spirit, dividing to every man severally as he will. ¹² For as the body is one, and hath many members, and all the members of that one body, being many, are one body: so also is Christ. ¹³ **For by one Spirit are we all baptized into one body, whether we be Jews or Gentiles, whether we be bond or free; and have been all made to drink into one Spirit.** ¹⁴ For the body is not one member, but many. ¹⁵ If the foot shall say, Because I am not the hand, I am not of the body; is it therefore not of the body? ¹⁶ And if the ear shall say, Because I am not the eye, I am not of the body; is it therefore not of the body? ¹⁷ If the whole body were an eye, where were the hearing? If the whole were hearing, where were the smelling? ¹⁸ But now hath God set the members every one of them in the body, as it hath pleased him. ¹⁹ And if they were all one member, where were the body? ²⁰ But now are they many members, yet but one body. ²¹ And the eye cannot say unto the hand, I have no need of thee: nor again the head to the feet, I have no need of you. ²² Nay, much more those members of the body, which seem to be more feeble, are necessary: ²³ And those members of the body, which we think to be less honourable, upon these we bestow more abundant honour; and our uncomely parts have more abundant comeliness. ²⁴ For our comely parts have no need: but God hath tempered the body together, having given more abundant honour to that part which lacked. ²⁵ That there should be no schism in the body; but that the members should have the same care one for another. ²⁶ And whether one member suffer, all the members suffer with it; or one member be honoured, all the members rejoice with it. ²⁷ Now ye are the body of Christ, and members in particular. ²⁸ And God hath set some in the church, first apostles, secondarily prophets, thirdly teachers, after that miracles, then gifts of healings, helps, governments, diversities of tongues. ²⁹ Are all apostles? are all prophets? are all teachers? are all workers of miracles? ³⁰ Have all the gifts of healing? do all speak with*

tongues? do all interpret? ³¹ But covet earnestly the best gifts: and yet shew I unto you a more excellent way.

Explanation

The first baptism is being born again into the body of Christ, made up of a body of all believers, who strive to walk by faith daily, taking hold to the gift of everlasting life stated in St. John 3:16-17. The process of believing and forgiving is stated in Romans 10:9-10. (See units on Salvation). **1 Corinthians 12:13**

The Second Baptism

Text
St. Matthew 28: 19-20

Matthew 28

¹ In the end of the sabbath, as it began to dawn toward the first day of the week, came Mary Magdalene and the other Mary to see the sepulchre. ² And, behold, there was a great earthquake: for the angel of the Lord descended from heaven, and came and rolled back the stone from the door, and sat upon it. ³ His countenance was like lightning, and his raiment white as snow: ⁴ And for fear of him the keepers did shake, and became as dead men. ⁵ And the angel answered and said unto the women, Fear not ye: for I know that ye seek Jesus, which was crucified. ⁶ He is not here: for he is risen, as he said. Come, see the place where the Lord lay. ⁷ And go quickly, and tell his disciples that he is risen from the dead; and, behold, he goeth before you into Galilee; there shall ye see him: lo, I have told you. ⁸ And they departed quickly from the sepulchre with fear and great joy; and did run to bring his disciples word. ⁹ And as they went to tell his disciples, behold, Jesus met them, saying, All hail. And they came and held him by the feet, and worshipped him. ¹⁰ Then said Jesus unto them, Be not afraid: go tell my brethren that they go into Galilee, and there shall they see me. ¹¹ Now when they were going, behold, some of the watch came into the city, and shewed unto the chief priests all the things that were done. ¹² And when they were assembled with the elders, and had taken counsel, they gave large money unto the soldiers, ¹³ Saying, Say ye, His disciples came by night, and stole him away while we slept. ¹⁴ And if this come to the governor's ears,

we will persuade him, and secure you. ¹⁵ *So they took the money, and did as they were taught: and this saying is commonly reported among the Jews until this day.* ¹⁶ *Then the eleven disciples went away into Galilee, into a mountain where Jesus had appointed them.* ¹⁷ *And when they saw him, they worshipped him: but some doubted.* ¹⁸ *And Jesus came and spake unto them, saying, All power is given unto me in heaven and in earth.* ¹⁹ **Go ye therefore, and teach all nations, baptizing them in the name of the Father, and of the Son, and of the Holy Ghost:** ²⁰ **Teaching them to observe all things whatsoever I have commanded you: and, lo, I am with you alway, even unto the end of the world. Amen.**

Explanation

The method of speech accompanied with the ritual of water baptism is to state that the new convert is baptized in the name of the Father, and of the Son and of the Holy Ghost or the Holy Spirit, while being immersed into a body of water. **St. Matthew 28: 19-20**
Text
Acts 2:41

Acts 2

¹ *And when the day of Pentecost was fully come, they were all with one accord in one place.* ² *And suddenly there came a sound from heaven as of a rushing mighty wind, and it filled all the house where they were sitting.* ³ *And there appeared unto them cloven tongues like as of fire, and it sat upon each of them.* ⁴ *And they were all filled with the Holy Ghost, and began to speak with other tongues, as the Spirit gave them utterance.* ⁵ *And there were dwelling at Jerusalem Jews, devout men, out of every nation under heaven.* ⁶ *Now when this was noised abroad, the multitude came together, and were confounded, because that every man heard them speak in his own language.* ⁷ *And they were all amazed and marvelled, saying one to another, Behold, are not all these which speak Galilaeans?* ⁸ *And how hear we every man in our own tongue, wherein we were born?* ⁹ *Parthians, and Medes, and Elamites, and the dwellers in Mesopotamia, and in Judaea, and Cappadocia, in Pontus, and Asia,* ¹⁰ *Phrygia, and Pamphylia, in Egypt, and in the parts of Libya about Cyrene, and strangers of Rome, Jews and proselytes,* ¹¹ *Cretes and Arabians, we do hear them speak in our tongues the wonderful works of God.* ¹² *And they*

were all amazed, and were in doubt, saying one to another, What meaneth this? ¹³ *Others mocking said, These men are full of new wine.* ¹⁴ *But Peter, standing up with the eleven, lifted up his voice, and said unto them, Ye men of Judaea, and all ye that dwell at Jerusalem, be this known unto you, and hearken to my words:* ¹⁵ *For these are not drunken, as ye suppose, seeing it is but the third hour of the day.* ¹⁶ *But this is that which was spoken by the prophet Joel;* ¹⁷ *And it shall come to pass in the last days, saith God, I will pour out of my Spirit upon all flesh: and your sons and your daughters shall prophesy, and your young men shall see visions, and your old men shall dream dreams:* ¹⁸ *And on my servants and on my handmaidens I will pour out in those days of my Spirit; and they shall prophesy:* ¹⁹ *And I will shew wonders in heaven above, and signs in the earth beneath; blood, and fire, and vapour of smoke:* ²⁰ *The sun shall be turned into darkness, and the moon into blood, before the great and notable day of the Lord come:* ²¹ *And it shall come to pass, that whosoever shall call on the name of the Lord shall be saved.* ²² *Ye men of Israel, hear these words; Jesus of Nazareth, a man approved of God among you by miracles and wonders and signs, which God did by him in the midst of you, as ye yourselves also know:* ²³ *Him, being delivered by the determinate counsel and foreknowledge of God, ye have taken, and by wicked hands have crucified and slain:* ²⁴ *Whom God hath raised up, having loosed the pains of death: because it was not possible that he should be holden of it.* ²⁵ *For David speaketh concerning him, I foresaw the Lord always before my face, for he is on my right hand, that I should not be moved:* ²⁶ *Therefore did my heart rejoice, and my tongue was glad; moreover also my flesh shall rest in hope:* ²⁷ *Because thou wilt not leave my soul in hell, neither wilt thou suffer thine Holy One to see corruption.* ²⁸ *Thou hast made known to me the ways of life; thou shalt make me full of joy with thy countenance.* ²⁹ *Men and brethren, let me freely speak unto you of the patriarch David, that he is both dead and buried, and his sepulchre is with us unto this day.* ³⁰ *Therefore being a prophet, and knowing that God had sworn with an oath to him, that of the fruit of his loins, according to the flesh, he would raise up Christ to sit on his throne;* ³¹ *He seeing this before spake of the resurrection of Christ, that his soul was not left in hell, neither his flesh did see corruption.* ³² *This Jesus hath God raised up, whereof we all are witnesses.* ³³ *Therefore being by the right hand of God exalted, and having received of the Father the promise of the Holy Ghost, he hath shed forth this, which ye now see and hear.* ³⁴ *For David is not ascended into the heavens: but he saith himself, The Lord said unto my Lord, Sit thou on my right hand,* ³⁵ *Until I make thy foes thy footstool.* ³⁶ *Therefore let all the*

house of Israel know assuredly, that God hath made the same Jesus, whom ye have crucified, both Lord and Christ. ³⁷ Now when they heard this, they were pricked in their heart, and said unto Peter and to the rest of the apostles, Men and brethren, what shall we do? ³⁸ Then Peter said unto them, Repent, and be baptized every one of you in the name of Jesus Christ for the remission of sins, and ye shall receive the gift of the Holy Ghost. ³⁹ For the promise is unto you, and to your children, and to all that are afar off, even as many as the LORD our God shall call. ⁴⁰ And with many other words did he testify and exhort, saying, Save yourselves from this untoward generation. **⁴¹ Then they that gladly received his word were baptized: and the same day there were added unto them about three thousand souls.** *⁴² And they continued stedfastly in the apostles' doctrine and fellowship, and in breaking of bread, and in prayers. ⁴³ And fear came upon every soul: and many wonders and signs were done by the apostles. ⁴⁴ And all that believed were together, and had all things common; ⁴⁵ And sold their possessions and goods, and parted them to all men, as every man had need. ⁴⁶ And they, continuing daily with one accord in the temple, and breaking bread from house to house, did eat their meat with gladness and singleness of heart, ⁴⁷ Praising God, and having favour with all the people. And the Lord added to the church daily such as should be saved.*

Explanation

This was the beginning of the first church, made up of believers, recorded in the book of Acts. Once converted, the believers are baptized into the body of Christ. The Lord **Jesus** Christ becomes their Personal Savior, and now they witness to the world, through an outward showing, the new birth, through the second baptism, called water baptism. The old nature begins to burn out daily, through the obedience to the Word of God, and the new nature, begins to take on residency more and more daily**.** Paul states in another passage, I Corinthians 15: 31, I die daily. Through the second baptism or water baptism the believer's goes down in the water, signifying death of the old nature. He then by immersion provides a testimony to all that he is reborn, spiritually in Christ. Therefore, it is a dying out to the old man and being born again anew, spiritually of the new man. This is therefore, an outward sign to the world that we have turned from a life of sin, and now walk in the newness of life, through a rebirth. This salvation is called being born again**,** (St. John Ch. 3). Therefore, once we have been born again, we receive the water baptism, as already stated, wherein our

pastor or another immerses the believer in water as an outward sign to the world of the new birth. However, there is no evidence in the scripture that the thief on the Cross was ever baptized, before his soul entered paradise, after the death of his body on the cross. **St. Luke 23:43; Acts 2:41**

The Third Baptism
The Promise of the gift of the Baptism of the Holy Ghost and with Fire

Text
Acts 1: 4-8

Acts 1

¹ The former treatise have I made, O Theophilus, of all that Jesus began both to do and teach, ² Until the day in which he was taken up, after that he through the Holy Ghost had given commandments unto the apostles whom he had chosen: ³ To whom also he shewed himself alive after his passion by many infallible proofs, being seen of them forty days, and speaking of the things pertaining to the kingdom of God: ⁴ ***And, being assembled together with them, commanded them that they should not depart from Jerusalem, but wait for the promise of the Father, which, saith he, ye have heard of me.*** ⁵ ***For John truly baptized with water; but ye shall be baptized with the Holy Ghost not many days hence.*** ⁶ ***When they therefore were come together, they asked of him, saying, Lord, wilt thou at this time restore again the kingdom to Israel?*** ⁷ ***And he said unto them, It is not for you to know the times or the seasons, which the Father hath put in his own power.*** ⁸ ***But ye shall receive power, after that the Holy Ghost is come upon you: and ye shall be witnesses unto me both in Jerusalem, and in all Judaea, and in Samaria, and unto the uttermost part of the earth.*** *⁹ And when he had spoken these things, while they beheld, he was taken up; and a cloud received him out of their sight. ¹⁰ And while they looked stedfastly toward heaven as he went up, behold, two men stood by them in white apparel; ¹¹ Which also said, Ye men of Galilee, why stand ye gazing up into heaven? this same Jesus, which is taken up from you into heaven, shall so come in like manner as ye have seen him go into heaven. ¹² Then returned they unto Jerusalem from the mount called Olivet, which is from Jerusalem a sabbath day's journey. ¹³ And when they were come in, they went up into*

an upper room, where abode both Peter, and James, and John, and Andrew, Philip, and Thomas, Bartholomew, and Matthew, James the son of Alphaeus, and Simon Zelotes, and Judas the brother of James. ¹⁴ These all continued with one accord in prayer and supplication, with the women, and Mary the mother of Jesus, and with his brethren. ¹⁵ And in those days Peter stood up in the midst of the disciples, and said, (the number of names together were about an hundred and twenty,) ¹⁶ Men and brethren, this scripture must needs have been fulfilled, which the Holy Ghost by the mouth of David spake before concerning Judas, which was guide to them that took Jesus. ¹⁷ For he was numbered with us, and had obtained part of this ministry. ¹⁸ Now this man purchased a field with the reward of iniquity; and falling headlong, he burst asunder in the midst, and all his bowels gushed out. ¹⁹ And it was known unto all the dwellers at Jerusalem; insomuch as that field is called in their proper tongue, Aceldama, that is to say, The field of blood. ²⁰ For it is written in the book of Psalms, Let his habitation be desolate, and let no man dwell therein: and his bishoprick let another take. ²¹ Wherefore of these men which have companied with us all the time that the Lord Jesus went in and out among us, ²² Beginning from the baptism of John, unto that same day that he was taken up from us, must one be ordained to be a witness with us of his resurrection. ²³ And they appointed two, Joseph called Barsabas, who was surnamed Justus, and Matthias. ²⁴ And they prayed, and said, Thou, Lord, which knowest the hearts of all men, shew whether of these two thou hast chosen, ²⁵ That he may take part of this ministry and apostleship, from which Judas by transgression fell, that he might go to his own place. ²⁶ And they gave forth their lots; and the lot fell upon Matthias; and he was numbered with the eleven apostles.

Explanation

Here, the Lord Jesus Christ is speaking to his disciples, informing them that He will go away to prepare a place for them and all believers. However, He will send a Comforter, which is the Holy Ghost, also defined as the anointing of God, resting upon the believer, for such a time as this. The fire depicts that it is a spiritual baptism. **Acts 1: 4-8**
Text
St Matthew 3:11-12

Matthew 3

¹ In those days came John the Baptist, preaching in the wilderness of Judaea, ² And saying, Repent ye: for the kingdom of heaven is at hand. ³ For this is he that was spoken of by the prophet Esaias, saying, The voice of one crying in the wilderness, Prepare ye the way of the Lord, make his paths straight. ⁴ And the same John had his raiment of camel's hair, and a leathern girdle about his loins; and his meat was locusts and wild honey. ⁵ Then went out to him Jerusalem, and all Judaea, and all the region round about Jordan, ⁶ And were baptized of him in Jordan, confessing their sins. ⁷ But when he saw many of the Pharisees and Sadducees come to his baptism, he said unto them, O generation of vipers, who hath warned you to flee from the wrath to come? ⁸ Bring forth therefore fruits meet for repentance: ⁹ And think not to say within yourselves, We have Abraham to our father: for I say unto you, that God is able of these stones to raise up children unto Abraham. ¹⁰ And now also the axe is laid unto the root of the trees: therefore every tree which bringeth not forth good fruit is hewn down, and cast into the fire. ¹¹ **I indeed baptize you with water unto repentance. but he that cometh after me is mightier than I, whose shoes I am not worthy to bear: he shall baptize you with the Holy Ghost, and with fire:** ¹² **Whose fan is in his hand, and he will throughly purge his floor, and gather his wheat into the garner; but he will burn up the chaff with unquenchable fire.** *¹³ Then cometh Jesus from Galilee to Jordan unto John, to be baptized of him. ¹⁴ But John forbad him, saying, I have need to be baptized of thee, and comest thou to me? ¹⁵ And Jesus answering said unto him, Suffer it to be so now: for thus it becometh us to fulfil all righteousness. Then he suffered him. ¹⁶ And Jesus, when he was baptized, went up straightway out of the water: and, lo, the heavens were opened unto him, and he saw the Spirit of God descending like a dove, and lighting upon him: ¹⁷ And lo a voice from heaven, saying, This is my beloved Son, in whom I am well pleased.*

Explanation

Here, John the Baptist, (known for his ministry of baptism), is the forerunner of Christ, and speaks of Christ's mission here on earth. John the Baptist speaks to the converts in the book of St. Matthews, expounding upon the mystery of a higher, spiritual baptism. This baptism is sealed with fire, until the final day of redemption. Its job is to burn up all of

the undesirable, within the chosen vessel, appointed by God, through the process of sanctification, or daily spiritual cleansing. **St Matthew 3:11-12**

The Third Baptism with the evidence of Speaking in Tongues

Text
Acts 2: 1-4; also 15-21 (See full text above on 2nd baptism)

Acts 2

¹ And when the day of Pentecost was fully come, they were all with one accord in one place. ² And suddenly there came a sound from heaven as of a rushing mighty wind, and it filled all the house where they were sitting. ³ And there appeared unto them cloven tongues like as of fire, and it sat upon each of them. ⁴ And they were all filled with the Holy Ghost, and began to speak with other tongues, as the Spirit gave them utterance. ¹⁵ For these are not drunken, as ye suppose, seeing it is but the third hour of the day. ¹⁶ But this is that which was spoken by the prophet Joel; ¹⁷ And it shall come to pass in the last days, saith God, I will pour out of my Spirit upon all flesh: and your sons and your daughters shall prophesy, and your young men shall see visions, and your old men shall dream dreams: ¹⁸ And on my servants and on my handmaidens I will pour out in those days of my Spirit; and they shall prophesy: ¹⁹ And I will shew wonders in heaven above, and signs in the earth beneath; blood, and fire, and vapour of smoke: ²⁰ The sun shall be turned into darkness, and the moon into blood, before the great and notable day of the Lord come: ²¹ And it shall come to pass, that whosoever shall call on the name of the Lord shall be saved.

Explanation

Just before the Lord's ascension, he gave instructions for them to go to Jerusalem and tarry there in the upper room after his ascension, until they be endowed with power from on high. This empowerment will embody the believer, with strength, holy boldness, and confidence, and the power, needed to get the job done, in spite of impossible odds.

So what is the third baptism? It is the baptism of the Holy Ghost, with the evidence of speaking in tongues, defined in Acts chapter 2.

Remember the third baptism is an anointing of God, through the baptism of the Holy Ghost, that rest upon the believer's life. The fire quinces all impurities in the vessel of the believer's daily life. **I Corinthians 15:31 How does a believer obtain the gift, which can be classified as the third baptism?**

- Live in accordance to the instructions in the Word of God.
- *Love the Lord thy God with all of thy strength and with all of thy mind.* In other words, put God first.
- Remember daily the second greatest commandment, is love thy neighbor as thyself. Therefore, if we treat others the way that we would desire others to treat us; we are living in accordance to the principles of instruction in the Word of God, during the New Testament Church Age or the times of the Gentiles.
- However, we also want to remember to use the Comforter, as our Guide Teacher, and our Reprover of Sin. The Comforter, in the person of God the Holy Spirit will convict the believer, when we are about to trespass against the instruction of God. Consequently, we are to walk in obedience.
- Be thankful for all things, knowing that all will work out for our good, at the end of the test. Romans 8:28.
- Lastly, as we pray, pray in thanksgiving, praising and thanking God for his excellence, his majesty, and for just being Who He is, God.
- Then, with all of this in mind, as we outwardly pray, we will, in God's time, receive the gift of the Holy Spirit with unquenchable fire, witnessed with the evidence of speaking in tongues, when we least expect it. **Acts 2: 1-4; also 15-21**

Conclusion

The anointing of God:

1. Equips
2. Empowers
3. Enables
4. Executes
5. Exterminates

The anointing of God's power source is through God the Holy Spirit in the life of the believers.

Questions

What is the anointing of God?

_____ It is the workings of the Comforter in the life of the believer

_____It is the third baptism, for the believer

_____ It empowers the believer to serve in a divine appointment, a call by God for a special service of evangelizing in the kingdom of God

_____All of the above

The third baptism iscalled,

_____The baptism of the Holy Ghost with Fire

_____Which possesses the evidence of speaking in Tongues, of an unknown language, not learned, for a sign to the unbeliever

_____The Gift of the Holy Ghost, with the evidence of speaking in tongues

_____All of the above

What does the baptism of the Holy Ghost with the evidence of speaking in tongues do?

_____It provides a sign to the unbelievers, through the evidence of speaking in an unknown tongue

_____It empowers the believer to live a life for Christ, under impossible odds, through the evidence of the unquenchable fire, which is designed to burn out daily all that is not of God

_____All of the above

Name (5) E's performed by the anointing of God.

In reading the explanation comments, how does one obtain the gift of the Holy Ghost with the evidence of speaking in tongues?

Thought Question

The gift of the Holy Ghost with the evidence of speaking in tongues is also known as another act of Grace by God. It is for all believers. However, all do not possess the gift. In order to possess the gift the believer must spend daily time with God. One must live a set apart life, being in the world, but not of the world. The believer must pray and read God's Word daily, and practice praying out loud, in thanksgiving to God for His goodness. Some only witness the cloven tongues once in their lives. However, if you have been truly called by God, for a unique service for the up building of God's kingdom, you will have the Gift of Tongues in operation in your life. With that in mind, do you have the gift? Do you want the gift, if you do not possess it?

God the Holy Spirit
The Fullness of God
Chapter 9

Text
St. John 15:26
St. John 14:16
St. John 16:7
St John 16:14
St. John 16:12
St. John 16:13
St. John 16:8
St. John 14:26

Introduction

In this segment, we shall talk about some aspects of the Holy Spirit, already reviewed; however they will be expounded upon in a difference light. God the Holy Spirit, is not only the third person in the Holy Entity, He has specific tasks that are clearly defined.

The Lesson
The Third Entity in the Godhead is God the Holy Spirit

He is a gift from God
St. John 15:26 (See chapter 4, full text)
But when the **Comforter** is come, whom I will send unto you from the Father, even the Spirit of truth, which proceedeth, from the Father, he will testify of me.

And

St. John 14:16(See chapter 7, full text)

And I will pray the Father, and He shall give you another Comforter, that he may abide with you forever.

Explanation(s)
God the Holy Spirit

- **Forbids: St. John 16:7** (See chapter 7, full text)
- Nevertheless, I tell you the truth; It is expedient for you that I go away, for if I go not away, the Comforter will not come unto you; but if I depart, I will send him unto you.
- **Glorifies God the Son: St John 16:14 (See** chapter 7, full text) *He shall glorify me; for he shall receive of mine, and shall show it unto you.*
- **Guides, Appoints, Decides: St. John 16:12** (See chapter 7, full text) *I have yet many things to say unto you, but you cannot bear them now.*
- **Foretells: St. John 16:13** (See chapter 7, full text) *Howbeit when he, the Spirit of truth, is come, he will guide you into all truth: for He shall not speak of himself; but whatsoever he shall hear, that shall he speak: and he will show you things to come.*
- **Convicts: St. John 16:8** (See chapter 7, full text) *And when he is come, he will reprove the world of sin, and of righteousness, and of judgement:* 9. *of sin, because they believe not on me*; 10 *of righteousness, because I go to my Father, and ye see me no more*; 11. (refers to judgement), *because the prince of this world is judged*
- **Witness: St. John 15:26** (See chapter 4, full text), *But when the Comforter is come, whom I shall send unto you from the Father, even the Spirit of Truth, which proceedeth from the Father, he will testify of me.*
- **Teach & bring to your Remembrance: St. John 14:26** (See chapter 4 for full text) *But the Comforter, which is the Holy Ghost, whom the Father will send in my name, he shall teach you all things, and bring all things to your remembrance, whatsoever, I have said unto you.*

Conclusion

God the Holy Spirit we have relearned in this segment is a multifunctional Holy Ghost and Holy Spirit. We have learned the following in this segment:

- We learned that He is a witness of things to come, through the Word of God.
- God uses the Holy Spirit to convict others while in the believer's presence.
- We ourselves, as believers, carry in our body the Holy Ghost that not only aids us, but also assists others, when in the servant of God's presence.
- The Holy Ghost, will also convict others as well as ourselves, when as we strive to walk according to the will of God.

These are all thoughts, not mentioned in the previous segments, as the functions of the Holy Ghost or the Holy Spirit.

Questions

How can the Holy Ghost be a witness of things to come?

How does the Holy Ghost convict others?

What do we as believers carry within our vessel or body, which is to be a representation of our reasonable service of a **faithful walk** with God?

Thought Question

When do you think that God will quicken our mortal bodies?

Chapter 10

Week One: Review
Week Two: Open Book Test
Week Three: Review and Open Discussion of the Unit

UNIT 8 THE FULLNESS OF GOD

Practice for Review
And later
Unit Test

Chapter 1 God the Father Part 1

Who are the three that bare record in heaven and agree as one? Provide the scripture.

What is this text explaining?

Who are the three that bare record on earth, making up the key components of the composition of mankind? Provide the scripture.

Who is the begotten of the Father? What does begotten mean. Provide scripture.

Name seven titles of God which also defines His identity, and role within the Holy Scriptures. Supply the following:

Title Role Scripture

Chapter 2 God the Father Part 2

Name seven (a) titles, with (b) definitions and (c) scriptures for Almighty God, Jehovah.

Title	Definition	Scripture
_____	_____	_____
_____	_____	_____
_____	_____	_____
_____	_____	_____
_____	_____	_____

As a new convert, joining a church one of the first things that the instructor or minister should provide the believer with is the doctrinal principles of what the church and the congregational beliefs are associated with for that denomination defined as the_____ of

It is just as important to have a generalized knowledge of key components of the W_____ of_____ in the areas of salvation. It is also important to know what is needed to walk daily by faith, and what will take believers to the last phase of their salvation which is everlasting_____or immortality with .

Chapter 3 God the Father Part 3

Provide (3) scriptures stating that God is our Creator.

Provide (3) Names for the Maker of all things.

Who is God?

_____Jehovah

_____God the Son

_____God the Holy Spirit

_____ All of the above

When will the Great White Throne Judgment take place?

_____After the Second Coming of Christ

_____When the Messiah returns to judge the earth?

_____ After the King of Kings and the Lord of Lords return to receive all of the believers

_____All of the above

Chapter 4 God the Son, Part 1

Why the oneness of God is considered a mystery?

_____A mystery is something that we will not fully understand in our carnal state

_____A mystery is something that we can only begin to comprehend in the spirit man

_____A mystery may not be clearly understood, until the Day of Trumpets, in a twinkling of an eye, when we change from mortal/carnal to immortal/celestial

_____ All of the above

The Oneness of God is explained by some as:

_____God the Father, God the Son, God the Holy Spirit

_____The Tribune God

_____The Godhead or an Entity to others

_____Yahweh, (Almighty God) Yashua Hanutzrel, (Jesus Christ) and the Holy Ghost

_____All of the above

Notice that there are (7) I AM's of Christ, the term, I AM refers to God's ever present existence, as Jehovah Shammah, therefore, through these I AM's of Christ, what does that imply?

_____I AM has no beginning nor ending

_____I AM is a state of existence

_____I AM is also associated with God the Father, when Moses asked God whom shall I say sent me? Therefore, here, as spoken of in (7) realms, places God the Father and God the Son, as the fullness of God, with the Holy Spirit

_____All of the above

Chapter 5 God the Son Part 2

Name (3) roles defined also as titles for the Lord Jesus Christ. Provide scripture.

Why is there no longer a need for a confession booth? State the reason and provide the scripture.

In Romans 10:9 & 10
What does confessing with your mouth refer to?

_____Confession that we are sinners, lost without Christ, in need of a Savior

_____Therefore, if we confess, then we believe. So we believe that Jesus became the
Sacrifice for our sins

_____Also, we believe, refers to believing, that God raised Jesus from the dead

_____We are saved by faith, in believing in the Promises of God

_____All of the above
Who is our Chief High Priest and why? Provide scripture.

Who is the Intercessor, or Mediator, and the Advocate, who stands before God continually, asking for forgiveness of our sins, daily? Provide scripture.

Not only is there a throne of God, in the heavenlies, but we as believers should come to the throne of God daily to_____ our_____ in the presence of God.

During the last words of instruction with this lesson, which is entitled the Great Commission to all believers, God is with us always in the person of God_____ Holy_____

Chapter 6 God the Son Part 3

Mary was informed that she would bring forth a Son. What does the name Jesus mean? What scripture location supports this?

What does the name Immanuel mean? Who does it refer to? Provide the scripture.

Provide (3) statements that we know that refer to the Times of the Gentiles or the Church Age.

The Lost House of Israel, refers to the Jewish Nation, composed of all descendents from the (12) tribes of Judah or Israel. What facts do we know help to support that they are yet looking for the Messiah? Select.

_____The Jews crucified the Lord

_____The Jews called Christ the King of the Jews while He hung on the Cross for our sins

_____The Jews said, while He was on the cross, that if thou be the Son of God, (as a Prince) save yourself

_____However, Christ did not come to save Himself

_____None of the above

_____All of the above

According to St. John 1:12 who can be saved?

Not only can anyone be saved, but according to Acts 16:31 God gives all the promise, if we hold fast to our profession of faith, without wavering all of our _____ shall also be saved.

What did we learn happened to the Bright and Morning Star, in Acts 1:9 & 10?

Who were the eye witnesses that witnessed Christ's ascension?

Chapter 7 God the Holy Spirit Part 1

Name twelve tasks that God the Holy Spirit performs for and in the believer's life. Provide scripture.

Tasks Scripture

What are (4) titles for God the Holy Spirit?

C_____

S_____O_____T_____

T_____

G_____

The Holy Spirit convicts and reproves the world of sin. What does that mean? Provide scripture.

Chapter 8 God the Holy Spirit Part 2

What is the anointing of God?

_____It is the workings of the Comforter in the life of the believer

_____It is the third baptism, for the believer

_____It empowers the believer to serve in a divine appointment, a call by God for a special service of evangelizing in the kingdom of God

_____ All of the above

What is the third baptism called?

_____ Baptism of the Holy Ghost with Fire

_____Possession of the evidence of speaking in Tongues, of an unknown language, not learned, for a sign to the unbeliever

_____The Gift of the Holy Ghost, with the evidence of speaking in tongues

_____All of the above

What does the baptism of the Holy Ghost with the evidence of speaking in tongues do?

_____It provides a sign to the unbelievers, through the evidence of speaking in an unknown tongue

_____It empowers the believer to live a life for Christ, under impossible odds, through the evidence of the unquenchable fire, which is designed to burn out daily all that is not of God

_____ All of the above

Name (5) E's performed by the anointing of God.

In reading the explanation comments, how does one obtain the gift of the Holy Ghost with the evidence of speaking in tongues?

Chapter 9 God the Holy Spirit Part 3

How can the Holy Ghost be a witness of things to come?

How does the Holy Ghost convict others?

What do we, as believers carry within our vessel or body, which is to be a representation of our reasonable service of a faithful walk with God?

UNIT 9: THE CHURCH, AND THE FALLEN

Contents

Unit Introduction

We have learned about salvation. We have expounded upon the mysteries of God, through the Fullness of God, so what else is there to know. You might say, that you attend church. You know what is going on in church. You know the make up of the service, and the purpose of attendance is to fellowship with other believers to gain from each other an increased measure of strength, faith, wisdom through teaching and instruction by way of a pastor and or a Sunday school and a bible class instructor. So why do we talk now about Church? And who is this who has fallen? These and other questions will be answered in this unit, as we talk about *The Church and the Fallen* . . .

The Church
The Body of Believers
Chapter 1

Text
I Corinthians 12:12-14
2 Corinthians 11:12
Ephesians 1:22-23

Introduction

In our Statement of Faith, we believe that the church is composed of all believers, whether they are Jew or Gentile. We believe that once we have accepted salvation through our Redeemer, that each day we look for that Blessed Hope, of the Messiah's return to receive His church, as His Bride.

The Lesson

Text
I Corinthians 12:12-14 (See previous Unit, chapter 7)

I Corinthians 12

12 For as the body is one, and hath many members, and all the members of that one body, being many, are one body: so also is Christ. 13 For by one Spirit are we all baptized into one body, whether we be Jews or Gentiles, whether we be bond or free; and have been all made to drink into one Spirit. 14 For the body is not one member, but many.

Explanation

The church is made up of a **body of believers**, defined as members of the body of Christ. They all individually have tasks, which brings them together for one common goal, which is the edifying of the church, through spiritual growth and evangelism.**I Corinthians 12:12-14**
Text
2 Corinthians 11:2

2 Corinthians 11

*¹ Would to God ye could bear with me a little in my folly: and indeed bear with me. ² **For I am jealous over you with godly jealousy: for I have espoused you to one husband, that I may present you as a chaste virgin to Christ**. ³ But I fear, lest by any means, as the serpent beguiled Eve through his subtilty, so your minds should be corrupted from the simplicity that is in Christ. ⁴ For if he that cometh preacheth another Jesus, whom we have not preached, or if ye receive another spirit, which ye have not received, or another gospel, which ye have not accepted, ye might well bear with him. ⁵ For I suppose I was not a whit behind the very chiefest apostles. ⁶ But though I be rude in speech, yet not in knowledge; but we have been throughly made manifest among you in all things. ⁷ Have I committed an offence in abasing myself that ye might be exalted, because I have preached to you the gospel of God freely? ⁸ I robbed other churches, taking wages of them, to do you service. ⁹ And when I was present with you, and wanted, I was chargeable to no man: for that which was lacking to me the brethren which came from Macedonia supplied: and in all things I have kept myself from being burdensome unto you, and so will I keep myself. ¹⁰ As the truth of Christ is in me, no man shall stop me of this boasting in the regions of Achaia. ¹¹ Wherefore? because I love you not? God knoweth. ¹² But what I do, that I will do, that I may cut off occasion from them which desire occasion; that wherein they glory, they may be found even as we. ¹³ For such are false apostles, deceitful workers, transforming themselves into the apostles of Christ. ¹⁴ And no marvel; for Satan himself is transformed into an angel of light. ¹⁵ Therefore it is no great thing if his ministers also be transformed as the ministers of righteousness; whose end shall be according to their works. ¹⁶ I say again, let no man think me a fool; if otherwise, yet as a fool receive me, that I may boast myself a little. ¹⁷ That which I speak, I speak it not after the Lord, but as it were foolishly, in this confidence of boasting. ¹⁸*

Seeing that many glory after the flesh, I will glory also. ¹⁹ For ye suffer fools gladly, seeing ye yourselves are wise. ²⁰ For ye suffer, if a man bring you into bondage, if a man devour you, if a man take of you, if a man exalt himself, if a man smite you on the face. ²¹ I speak as concerning reproach, as though we had been weak. Howbeit wheresoever any is bold, (I speak foolishly,) I am bold also. ²² Are they Hebrews? so am I. Are they Israelites? so am I. Are they the seed of Abraham? so am I. ²³ Are they ministers of Christ? (I speak as a fool) I am more; in labours more abundant, in stripes above measure, in prisons more frequent, in deaths oft. ²⁴ Of the Jews five times received I forty stripes save one. ²⁵ Thrice was I beaten with rods, once was I stoned, thrice I suffered shipwreck, a night and a day I have been in the deep; ²⁶ In journeyings often, in perils of waters, in perils of robbers, in perils by mine own countrymen, in perils by the heathen, in perils in the city, in perils in the wilderness, in perils in the sea, in perils among false brethren; ²⁷ In weariness and painfulness, in watchings often, in hunger and thirst, in fastings often, in cold and nakedness. ²⁸ Beside those things that are without, that which cometh upon me daily, the care of all the churches. ²⁹ Who is weak, and I am not weak? who is offended, and I burn not? ³⁰ If I must needs glory, I will glory of the things which concern mine infirmities. ³¹ The God and Father of our Lord Jesus Christ, which is blessed for evermore, knoweth that I lie not. ³² In Damascus the governor under Aretas the king kept the city of the damascenes with a garrison, desirous to apprehend me: ³³ And through a window in a basket was I let down by the wall, and escaped his hands.

For I am jealous over you with godly jealousy: for I have espoused you to one husband that I might present you as a chaste virgin to Christ.

Explanation

In this scripture, one husband refers to the Messiah. The virgin refers to the body of believers, who are the bride of Christ, adorned in righteousness.
2 Corinthians 11:2
Text
Ephesians 1:22-23

Ephesians 1

¹ Paul, an apostle of Jesus Christ by the will of God, to the saints which are at Ephesus, and to the faithful in Christ Jesus: ² Grace be to you, and peace,

*from God our Father, and from the Lord Jesus Christ. ³ Blessed be the God and Father of our Lord Jesus Christ, who hath blessed us with all spiritual blessings in heavenly places in Christ: ⁴ According as he hath chosen us in him before the foundation of the world, that we should be holy and without blame before him in love: ⁵ Having predestinated us unto the adoption of children by Jesus Christ to himself, according to the good pleasure of his will, ⁶ To the praise of the glory of his grace, wherein he hath made us accepted in the beloved. ⁷ In whom we have redemption through his blood, the forgiveness of sins, according to the riches of his grace; ⁸ Wherein he hath abounded toward us in all wisdom and prudence; ⁹ Having made known unto us the mystery of his will, according to his good pleasure which he hath purposed in himself: ¹⁰ That in the dispensation of the fulness of times he might gather together in one all things in Christ, both which are in heaven, and which are on earth; even in him: ¹¹ In whom also we have obtained an inheritance, being predestinated according to the purpose of him who worketh all things after the counsel of his own will: ¹² That we should be to the praise of his glory, who first trusted in Christ. ¹³ In whom ye also trusted, after that ye heard the word of truth, the gospel of your salvation: in whom also after that ye believed, ye were sealed with that holy Spirit of promise, ¹⁴ Which is the earnest of our inheritance until the redemption of the purchased possession, unto the praise of his glory. ¹⁵ Wherefore I also, after I heard of your faith in the Lord Jesus, and love unto all the saints, ¹⁶ Cease not to give thanks for you, making mention of you in my prayers; ¹⁷ That the God of our Lord Jesus Christ, the Father of glory, may give unto you the spirit of wisdom and revelation in the knowledge of him: ¹⁸ The eyes of your understanding being enlightened; that ye may know what is the hope of his calling, and what the riches of the glory of his inheritance in the saints, ¹⁹ And what is the exceeding greatness of his power to us-ward who believe, according to the working of his mighty power, ²⁰ Which he wrought in Christ, when he raised him from the dead, and set him at his own right hand in the heavenly places, ²¹ **Far above all principality, and power, and might, and dominion, and every name that is named, not only in this world, but also in that which is to come: ²² And hath put all things under his feet, and gave him to be the head over all things to the church, ²³ Which is his body, the fulness of him that filleth all in all.***

Explanation

Christ is the Head of the Body of Christ, called the Church. **Ephesians 1:22-23**
Text
Ephesians 5:25-27

Ephesians 5

¹ Be ye therefore followers of God, as dear children; ² And walk in love, as Christ also hath loved us, and hath given himself for us an offering and a sacrifice to God for a sweetsmelling savour. ³ But fornication, and all uncleanness, or covetousness, let it not be once named among you, as becometh saints; ⁴ Neither filthiness, nor foolish talking, nor jesting, which are not convenient: but rather giving of thanks. ⁵ For this ye know, that no whoremonger, nor unclean person, nor covetous man, who is an idolater, hath any inheritance in the kingdom of Christ and of God. ⁶ Let no man deceive you with vain words: for because of these things cometh the wrath of God upon the children of disobedience. ⁷ Be not ye therefore partakers with them. ⁸ For ye were sometimes darkness, but now are ye light in the Lord: walk as children of light: ⁹ (For the fruit of the Spirit is in all goodness and righteousness and truth;) ¹⁰ Proving what is acceptable unto the Lord. ¹¹ And have no fellowship with the unfruitful works of darkness, but rather reprove them. ¹² For it is a shame even to speak of those things which are done of them in secret. ¹³ But all things that are reproved are made manifest by the light: for whatsoever doth make manifest is light. ¹⁴ Wherefore he saith, Awake thou that sleepest, and arise from the dead, and Christ shall give thee light. ¹⁵ See then that ye walk circumspectly, not as fools, but as wise, ¹⁶ Redeeming the time, because the days are evil. ¹⁷ Wherefore be ye not unwise, but understanding what the will of the Lord is. ¹⁸ And be not drunk with wine, wherein is excess; but be filled with the Spirit; ¹⁹ Speaking to yourselves in psalms and hymns and spiritual songs, singing and making melody in your heart to the Lord; ²⁰ Giving thanks always for all things unto God and the Father in the name of our Lord Jesus Christ; ²¹ Submitting yourselves one to another in the fear of God. ²² Wives, submit yourselves unto your own husbands, as unto the Lord. ²³ For the husband is the head of the wife, even as Christ is the head of the church: and he is the saviour of the body. ²⁴ Therefore as the church is subject unto Christ, so let the wives be to their own husbands in every thing. ²⁵ ***Husbands, love your wives, even as Christ***

also loved the church, and gave himself for it; [26] *That he might sanctify and cleanse it with the washing of water by the word,* [27] *That he might present it to himself a glorious church, not having spot, or wrinkle, or any such thing; but that it should be holy and without blemish.* [28] *So ought men to love their wives as their own bodies. He that loveth his wife loveth himself.* [29] *For no man ever yet hated his own flesh; but nourisheth and cherisheth it, even as the Lord the church:* [30] *For we are members of his body, of his flesh, and of his bones.* [31] *For this cause shall a man leave his father and mother, and shall be joined unto his wife, and they two shall be one flesh.* [32] *This is a great mystery: but I speak concerning Christ and the church.* [33] *Nevertheless let every one of you in particular so love his wife even as himself; and the wife see that she reverence her husband.*

Explanation

The Church, Composed of Believers

We believe that the Church, as the Body of Christ, is a spiritual organism made up of all believers of this present age. In addition, as Christ is the head of the body of believers, the Word of God shows that by example the husband is the head of his household. In that respect as the Church, or the Bride of Christ, respects, loves and honors her husband, the Lord Jesus Christ, the bride or the wife of the man or the husband, should also love, honor and respect her head, as well. The teachings and practices of the Word of God begin first at home. **Ephesians 5:25-27**

Text

Acts 2: 41-42(See Unit 8, chapter 7, full text)

[41] *Then they that gladly received his word were baptized: and the same day there were added unto them about three thousand souls.* [42] *And they continued stedfastly in the apostles' doctrine and fellowship, and in breaking of bread, and in prayers.*

Explanation

This is the beginning of the makings of the first church, recorded in the Book of the Acts of the Apostles. It also states that the Church continued to grow. **Acts 2: 41-42**

Text

I Corinthians 11:23-26

1 Corinthians 11

¹ Be ye followers of me, even as I also am of Christ. ² Now I praise you, brethren, that ye remember me in all things, and keep the ordinances, as I delivered them to you. ³ But I would have you know, that the head of every man is Christ; and the head of the woman is the man; and the head of Christ is God. ⁴ Every man praying or prophesying, having his head covered, dishonoureth his head. ⁵ But every woman that prayeth or prophesieth with her head uncovered dishonoureth her head: for that is even all one as if she were shaven. ⁶ For if the woman be not covered, let her also be shorn: but if it be a shame for a woman to be shorn or shaven, let her be covered. ⁷ For a man indeed ought not to cover his head, forasmuch as he is the image and glory of God: but the woman is the glory of the man. ⁸ For the man is not of the woman: but the woman of the man. ⁹ Neither was the man created for the woman; but the woman for the man. ¹⁰ For this cause ought the woman to have power on her head because of the angels. ¹¹ Nevertheless neither is the man without the woman, neither the woman without the man, in the Lord. ¹² For as the woman is of the man, even so is the man also by the woman; but all things of God. ¹³ Judge in yourselves: is it comely that a woman pray unto God uncovered? ¹⁴ Doth not even nature itself teach you, that, if a man have long hair, it is a shame unto him? ¹⁵ But if a woman have long hair, it is a glory to her: for her hair is given her for a covering. ¹⁶ But if any man seem to be contentious, we have no such custom, neither the churches of God. ¹⁷ Now in this that I declare unto you I praise you not, that ye come together not for the better, but for the worse. ¹⁸ For first of all, when ye come together in the church, I hear that there be divisions among you; and I partly believe it. ¹⁹ For there must be also heresies among you, that they which are approved may be made manifest among you. ²⁰ When ye come together therefore into one place, this is not to eat the Lord's supper. ²¹ For in eating every one taketh before other his own supper: and one is hungry, and another is drunken. ²² What? have ye not houses to eat and to drink in? or despise ye the church of God, and shame them that have not? what shall I say to you? shall I praise you in this? I praise you not. **²³ For I have received of the Lord that which also I delivered unto you, that the Lord Jesus the same night in which he was betrayed took bread: ²⁴ And when he had given thanks, he brake it, and said, Take, eat: this is my body, which is broken for you: this do in remembrance of me. ²⁵ After the same manner also he took the cup, when he had supped, saying, this cup is the new testament in my blood: this do ye, as oft as ye drink it, in**

remembrance of me. [26] For as often as ye eat this bread, and drink this cup, ye do shew the Lord's death till he come. [27] Wherefore whosoever shall eat this bread, and drink this cup of the Lord, unworthily, shall be guilty of the body and blood of the Lord. [28] *But let a man examine himself, and so let him eat of that bread, and drink of that cup.* [29] *For he that eateth and drinketh unworthily, eateth and drinketh damnation to himself, not discerning the Lord's body.* [30] *For this cause many are weak and sickly among you, and many sleep.* [31] *For if we would judge ourselves, we should not be judged.* [32] *But when we are judged, we are chastened of the Lord, that we should not be condemned with the world.* [33] *Wherefore, my brethren, when ye come together to eat, tarry one for another.* [34] *And if any man hunger, let him eat at home; that ye come not together unto condemnation. And the rest will I set in order when I come.*

Explanation

Lord's Supper should be as a remembrance of Christ's death and shed blood for our sins. Through the church, believers are to be taught to obey the Lord and to testify concerning our faith in Christ as Savior and to honor Him by holy living, through the Word of God.
I Corinthians 11:23-26

Conclusion

* In this lesson, we have learned that there are many terms that can be used as the Church. The church can be called a solemn assembly, and to the Hebrew faith it is called a holy convocation.
* We have also learned that the beginning of the first church was recorded in the book of Acts, through the Apostles, upon receiving the Great Commission, to go forth and to evangelize the world, one city at a time, beginning with our neighborhood.
* Here are some of the titles, based upon doctrinal verses to further, define the Church:
 1. The Bride of Christ (Revelation Ch 19)
 2. The Bride (St. Matthew 25: 1-13)
 3. The Believers (I Peter 2:9; I Timothy 4:12; Acts 5:14.
 4. The Church (Acts 2: 41-42 & V47)
 5. The Body of Christ (Ephesians 4: 11-16)

Questions

The first church is recorded in what book of the New Testament?

Name five titles, that define the body of believers, who are the church. Also provide scripture.

Why do we take communion, collectively at a solemn assembly, or individually as at home? (2)What is its meaning in regard to the bread and the wine? (3) What do they also represent?

Thought Question

Do you feel the need to belong to a solemn assembly? If so why?

Angels & Demons
Chapter 2

Text
Psalm 148:2
Hebrews 1: 13-14
Isaiah 14: 12-17
Ezekiel 28:12-15
St. Matthew 25:41
Revelation 20:10

Introduction

Angels are ministering spirits that are sent forth upon the earth to minister to individuals, through divine appointments from Almighty God. One third of the angels were cast out of heaven with Lucifer, Son of the Morning. The bible states, that his divine appointment was his first estate. Now those fallen angels are called demons, designed to serve, what Lucifer is now called, the devil. He was renamed by God.

The Lesson
Angels

Text
Psalm 148:2

Psalms 148

*¹ Praise ye the LORD. Praise ye the LORD from the heavens: praise him in the heights. ² **Praise ye him, all his angels: praise ye him, all his hosts.** ³ Praise ye him, sun and moon: praise him, all ye stars of light. ⁴ Praise him, ye heavens of heavens, and ye waters that be above the heavens. ⁵ Let them praise the name of the LORD: for he commanded, and they were created. ⁶ He hath also stablished them for ever and ever: he hath made a decree which shall not*

pass. ⁷ Praise the LORD from the earth, ye dragons, and all deeps: ⁸ Fire, and hail; snow, and vapours; stormy wind fulfilling his word: ⁹ Mountains, and all hills; fruitful trees, and all cedars: ¹⁰ Beasts, and all cattle; creeping things, and flying fowl: ¹¹ Kings of the earth, and all people; princes, and all judges of the earth: ¹² Both young men, and maidens; old men, and children: ¹³ Let them praise the name of the LORD: for his name alone is excellent; his glory is above the earth and heaven. ¹⁴ He also exalteth the horn of his people, the praise of all his saints; even of the children of Israel, a people near unto him. Praise ye the LORD.

Explanation

This is a Psalm written by King David that states that all creation, which includes the heavenly host, give **continual praises** unto the Lord Jehovah God.
Psalm 148:2

Angels and Demons
The spirits which are allowed to walk among us for a little while

- Angels assist in making up the heavenly host.
- They are also created to worship God.
- They do not fully understand humans, who have been allowed to be redeemed by the blood of the saving grace of the Lord Jesus Christ.
- They do not understand why we serve God, and are counted righteous before God, within our sinful vessel made of carnality.
- They do not understand that in the midst of trouble, we can glorify God.
- The Word of God states they are sent forth to minister to us, whom they do not understand.
- They were not created in the likeness of God, through the freedom of choice, as we.
- Revelation 7:13-14 *And one of the Elders answered saying unto me, what are these that are arrayed in white robes? And whence came they? 14 And I said unto him, Sir thou knowest. And he said unto me, these are they which came out of great tribulation, and have washed their clothes and made them white, through the blood of the Lamb.*

Text
Hebrews 1: 13-14

Hebrews 1

¹ God, who at sundry times and in divers manners spake in time past unto the fathers by the prophets, ² Hath in these last days spoken unto us by his Son, whom he hath appointed heir of all things, by whom also he made the worlds; ³ Who being the brightness of his glory, and the express image of his person, and upholding all things by the word of his power, when he had by himself purged our sins, sat down on the right hand of the Majesty on high: ⁴ Being made so much better than the angels, as he hath by inheritance obtained a more excellent name than they. ⁵ For unto which of the angels said he at any time, Thou art my Son, this day have I begotten thee? And again, I will be to him a Father, and he shall be to me a Son? ⁶ And again, when he bringeth in the firstbegotten into the world, he saith, And let all the angels of God worship him. ⁷ And of the angels he saith, Who maketh his angels spirits, and his ministers a flame of fire. ⁸ But unto the Son he saith, Thy throne, O God, is for ever and ever: a sceptre of righteousness is the sceptre of thy kingdom. ⁹ Thou hast loved righteousness, and hated iniquity; therefore God, even thy God, hath anointed thee with the oil of gladness above thy fellows. ¹⁰ And, Thou, Lord, in the beginning hast laid the foundation of the earth; and the heavens are the works of thine hands: ¹¹ They shall perish; but thou remainest; and they all shall wax old as doth a garment; ¹² And as a vesture shalt thou fold them up, and they shall be changed: but thou art the same, and thy years shall not fail. **¹³ But to which of the angels said he at any time, Sit on my right hand, until I make thine enemies thy footstool? ¹⁴ Are they not all ministering spirits, sent forth to minister for them who shall be heirs of salvation?**

Explanation

We believe in the reality and personality of **angels.** We believe that God created the angels to be His servants and messengers. **Hebrews 1: 13-14**

Lucifier

These upcoming passages in the books of Isaiah and Ezekiel provide the background information on the history of the fall of Lucifer, Sun of the Morning. It also expounds upon why we now have demons that walk the earth.

Text
Isaiah 14: 12-17

Isaiah 14

¹ For the LORD will have mercy on Jacob, and will yet choose Israel, and set them in their own land: and the strangers shall be joined with them, and they shall cleave to the house of Jacob. ² And the people shall take them, and bring them to their place: and the house of Israel shall possess them in the land of the LORD for servants and handmaids: and they shall take them captives, whose captives they were; and they shall rule over their oppressors. ³ And it shall come to pass in the day that the LORD shall give thee rest from thy sorrow, and from thy fear, and from the hard bondage wherein thou wast made to serve, ⁴ That thou shalt take up this proverb against the king of Babylon, and say, How hath the oppressor ceased! the golden city ceased! ⁵ The LORD hath broken the staff of the wicked, and the sceptre of the rulers. ⁶ He who smote the people in wrath with a continual stroke, he that ruled the nations in anger, is persecuted, and none hindereth. ⁷ The whole earth is at rest, and is quiet: they break forth into singing. ⁸ Yea, the fir trees rejoice at thee, and the cedars of Lebanon, saying, Since thou art laid down, no feller is come up against us. ⁹ Hell from beneath is moved for thee to meet thee at thy coming: it stirreth up the dead for thee, even all the chief ones of the earth; it hath raised up from their thrones all the kings of the nations. ¹⁰ All they shall speak and say unto thee, Art thou also become weak as we? art thou become like unto us? ¹¹ Thy pomp is brought down to the grave, and the noise of thy viols: the worm is spread under thee, and the worms cover thee. **¹² How art thou fallen from heaven, O Lucifer, son of the morning! how art thou cut down to the ground, which didst weaken the nations! ¹³ For thou hast said in thine heart, I will ascend into heaven, I will exalt my throne above the stars of God: I will sit also upon the mount of the congregation, in the sides of the north: ¹⁴ I will ascend above the heights of the clouds; I will be like the most High. ¹⁵ Yet thou shalt be brought down to hell, to the sides of the pit.**

¹⁶ **They that see thee shall narrowly look upon thee, and consider thee, saying, Is this the man that made the earth to tremble, that did shake kingdoms; *¹⁷* That made the world as a wilderness, and destroyed the cities thereof; that opened not the house of his prisoners?** *¹⁸* *All the kings of the nations, even all of them, lie in glory, every one in his own house. ¹⁹ But thou art cast out of thy grave like an abominable branch, and as the raiment of those that are slain, thrust through with a sword, that go down to the stones of the pit; as a carcase trodden under feet. ²⁰ Thou shalt not be joined with them in burial, because thou hast destroyed thy land, and slain thy people: the seed of evildoers shall never be renowned. ²¹ Prepare slaughter for his children for the iniquity of their fathers; that they do not rise, nor possess the land, nor fill the face of the world with cities. ²² For I will rise up against them, saith the LORD of hosts, and cut off from Babylon the name, and remnant, and son, and nephew, saith the LORD. ²³ I will also make it a possession for the bittern, and pools of water: and I will sweep it with the besom of destruction, saith the LORD of hosts. ²⁴ The LORD of hosts hath sworn, saying, Surely as I have thought, so shall it come to pass; and as I have purposed, so shall it stand: ²⁵ That I will break the Assyrian in my land, and upon my mountains tread him under foot: then shall his yoke depart from off them, and his burden depart from off their shoulders. ²⁶ This is the purpose that is purposed upon the whole earth: and this is the hand that is stretched out upon all the nations. ²⁷ For the LORD of hosts hath purposed, and who shall disannul it? and his hand is stretched out, and who shall turn it back? ²⁸ In the year that king Ahaz died was this burden. ²⁹ Rejoice not thou, whole Palestina, because the rod of him that smote thee is broken: for out of the serpent's root shall come forth a cockatrice, and his fruit shall be a fiery flying serpent. ³⁰ And the firstborn of the poor shall feed, and the needy shall lie down in safety: and I will kill thy root with famine, and he shall slay thy remnant. ³¹ Howl, O gate; cry, O city; thou, whole Palestina, art dissolved: for there shall come from the north a smoke, and none shall be alone in his appointed times. ³² What shall one then answer the messengers of the nation? That the LORD hath founded Zion, and the poor of his people shall trust in it.*

Explanation

The devil held the highest angelic position in the heavenly host. He was not only the most powerful, but he was also the most beautiful of all creations. However, he made a mistake.

- He decided that he would not give God the glory, acknowledging him as his Creator.
- He decided that he would be equal to God.
- The Word of God states that there is only one God and one Creator, his name is Elohim, Adoni, our Lord, El Shaddai, our Almighty God. **Isaiah 14: 12-17**

Text
Ezekiel 28:12-15

Ezekiel 28

¹ The word of the LORD came again unto me, saying, ² Son of man, say unto the prince of Tyrus, Thus saith the Lord GOD; Because thine heart is lifted up, and thou hast said, I am a God, I sit in the seat of God, in the midst of the seas; yet thou art a man, and not God, though thou set thine heart as the heart of God: ³ Behold, thou art wiser than Daniel; there is no secret that they can hide from thee: ⁴ With thy wisdom and with thine understanding thou hast gotten thee riches, and hast gotten gold and silver into thy treasures: ⁵ By thy great wisdom and by thy traffick hast thou increased thy riches, and thine heart is lifted up because of thy riches: ⁶ Therefore thus saith the Lord GOD; Because thou hast set thine heart as the heart of God; ⁷ Behold, therefore I will bring strangers upon thee, the terrible of the nations: and they shall draw their swords against the beauty of thy wisdom, and they shall defile thy brightness. ⁸ They shall bring thee down to the pit, and thou shalt die the deaths of them that are slain in the midst of the seas. ⁹ Wilt thou yet say before him that slayeth thee, I am God? but thou shalt be a man, and no God, in the hand of him that slayeth thee. ¹⁰ Thou shalt die the deaths of the uncircumcised by the hand of strangers: for I have spoken it, saith the Lord GOD. ¹¹ Moreover the word of the LORD came unto me, saying, **¹² Son of man, take up a lamentation upon the king of Tyrus, and say unto him, Thus saith the Lord GOD; Thou sealest up the sum, full of wisdom, and perfect in beauty. ¹³ Thou hast been in Eden the garden of God; every precious stone was thy covering, the sardius, topaz, and the diamond, the beryl, the onyx, and the jasper, the sapphire, the emerald, and the carbuncle, and gold: the workmanship of thy tabrets and of thy pipes was prepared in thee in the day that thou wast created. ¹⁴ Thou art the anointed cherub that covereth; and I have set thee so: thou wast upon the holy mountain of**

God; thou hast walked up and down in the midst of the stones of fire. *¹⁵* **Thou wast perfect in thy ways from the day that thou wast created, till iniquity was found in thee.** *¹⁶ By the multitude of thy merchandise they have filled the midst of thee with violence, and thou hast sinned: therefore I will cast thee as profane out of the mountain of God: and I will destroy thee, O covering cherub, from the midst of the stones of fire. ¹⁷ Thine heart was lifted up because of thy beauty, thou hast corrupted thy wisdom by reason of thy brightness: I will cast thee to the ground, I will lay thee before kings, that they may behold thee. ¹⁸ Thou hast defiled thy sanctuaries by the multitude of thine iniquities, by the iniquity of thy traffick; therefore will I bring forth a fire from the midst of thee, it shall devour thee, and I will bring thee to ashes upon the earth in the sight of all them that behold thee. ¹⁹ All they that know thee among the people shall be astonished at thee: thou shalt be a terror, and never shalt thou be any more. ²⁰ Again the word of the LORD came unto me, saying, ²¹ Son of man, set thy face against Zidon, and prophesy against it, ²² And say, Thus saith the Lord GOD; Behold, I am against thee, O Zidon; and I will be glorified in the midst of thee: and they shall know that I am the LORD, when I shall have executed judgments in her, and shall be sanctified in her. ²³ For I will send into her pestilence, and blood into her streets; and the wounded shall be judged in the midst of her by the sword upon her on every side; and they shall know that I am the LORD. ²⁴ And there shall be no more a pricking brier unto the house of Israel, nor any grieving thorn of all that are round about them, that despised them; and they shall know that I am the Lord GOD. ²⁵ Thus saith the Lord GOD; When I shall have gathered the house of Israel from the people among whom they are scattered, and shall be sanctified in them in the sight of the heathen, then shall they dwell in their land that I have given to my servant Jacob. ²⁶ And they shall dwell safely therein, and shall build houses, and plant vineyards; yea, they shall dwell with confidence, when I have executed judgments upon all those that despise them round about them; and they shall know that I am the LORD their God.*

Explanation

We believe in the existence and personality of Satan and demons. Satan is a fallen angel, who led a group of angels in rebellion against God. As fore stated, Lucifer and one third of the heavenly host were cast out and down from heaven into the atmosphere.**Ezekiel 28:12-15**
Text

St. Matthew 25:41

Matthew 25

¹ Then shall the kingdom of heaven be likened unto ten virgins, which took their lamps, and went forth to meet the bridegroom. ² And five of them were wise, and five were foolish. ³ They that were foolish took their lamps, and took no oil with them: ⁴ But the wise took oil in their vessels with their lamps. ⁵ While the bridegroom tarried, they all slumbered and slept. ⁶ And at midnight there was a cry made, Behold, the bridegroom cometh; go ye out to meet him. ⁷ Then all those virgins arose, and trimmed their lamps. ⁸ And the foolish said unto the wise, Give us of your oil; for our lamps are gone out. ⁹ But the wise answered, saying, Not so; lest there be not enough for us and you: but go ye rather to them that sell, and buy for yourselves. ¹⁰ And while they went to buy, the bridegroom came; and they that were ready went in with him to the marriage: and the door was shut. ¹¹ Afterward came also the other virgins, saying, Lord, Lord, open to us. ¹² But he answered and said, Verily I say unto you, I know you not. ¹³ Watch therefore, for ye know neither the day nor the hour wherein the Son of man cometh. ¹⁴ For the kingdom of heaven is as a man travelling into a far country, who called his own servants, and delivered unto them his goods. ¹⁵ And unto one he gave five talents, to another two, and to another one; to every man according to his several ability; and straightway took his journey. ¹⁶ Then he that had received the five talents went and traded with the same, and made them other five talents. ¹⁷ And likewise he that had received two, he also gained other two. ¹⁸ But he that had received one went and digged in the earth, and hid his lord's money. ¹⁹ After a long time the lord of those servants cometh, and reckoneth with them. ²⁰ And so he that had received five talents came and brought other five talents, saying, Lord, thou deliveredst unto me five talents: behold, I have gained beside them five talents more. ²¹ His lord said unto him, Well done, thou good and faithful servant: thou hast been faithful over a few things, I will make thee ruler over many things: enter thou into the joy of thy lord. ²² He also that had received two talents came and said, Lord, thou deliveredst unto me two talents: behold, I have gained two other talents beside them. ²³ His lord said unto him, Well done, good and faithful servant; thou hast been faithful over a few things, I will make thee ruler over many things: enter thou into the joy of thy lord. ²⁴ Then he which had received the one talent came and said, Lord, I knew thee that thou art an hard man, reaping where thou hast not sown, and gathering

where thou hast not strawed: ²⁵ *And I was afraid, and went and hid thy talent in the earth: lo, there thou hast that is thine.* ²⁶ *His lord answered and said unto him, Thou wicked and slothful servant, thou knewest that I reap where I sowed not, and gather where I have not strawed:* ²⁷ *Thou oughtest therefore to have put my money to the exchangers, and then at my coming I should have received mine own with usury.* ²⁸ *Take therefore the talent from him, and give it unto him which hath ten talents.* ²⁹ *For unto every one that hath shall be given, and he shall have abundance: but from him that hath not shall be taken away even that which he hath.* ³⁰ *And cast ye the unprofitable servant into outer darkness: there shall be weeping and gnashing of teeth.* ³¹ *When the Son of man shall come in his glory, and all the holy angels with him, then shall he sit upon the throne of his glory:* ³² *And before him shall be gathered all nations: and he shall separate them one from another, as a shepherd divideth his sheep from the goats:* ³³ *And he shall set the sheep on his right hand, but the goats on the left.* ³⁴ *Then shall the King say unto them on his right hand, Come, ye blessed of my Father, inherit the kingdom prepared for you from the foundation of the world:* ³⁵ *For I was an hungred, and ye gave me meat: I was thirsty, and ye gave me drink: I was a stranger, and ye took me in:* ³⁶ *Naked, and ye clothed me: I was sick, and ye visited me: I was in prison, and ye came unto me.* ³⁷ *Then shall the righteous answer him, saying, Lord, when saw we thee an hungred, and fed thee? or thirsty, and gave thee drink?* ³⁸ *When saw we thee a stranger, and took thee in? or naked, and clothed thee?* ³⁹ *Or when saw we thee sick, or in prison, and came unto thee?* ⁴⁰ *And the King shall answer and say unto them, Verily I say unto you, Inasmuch as ye have done it unto one of the least of these my brethren, ye have done it unto me.* ⁴¹ ***Then shall he say also unto them on the left hand, Depart from me, ye cursed, into everlasting fire, prepared for the devil and his angels****:* ⁴² *For I was an hungred, and ye gave me no meat: I was thirsty, and ye gave me no drink:* ⁴³ *I was a stranger, and ye took me not in: naked, and ye clothed me not: sick, and in prison, and ye visited me not.* ⁴⁴ *Then shall they also answer him, saying, Lord, when saw we thee an hungred, or athirst, or a stranger, or naked, or sick, or in prison, and did not minister unto thee?* ⁴⁵ *Then shall he answer them, saying, Verily I say unto you, Inasmuch as ye did it not to one of the least of these, ye did it not to me.* ⁴⁶ *And these shall go away into everlasting punishment: but the righteous into life eternal*

Explanation

This is the everlasting punishment prepared for the devil and his angels. All unbelievers will also have their place in the Lake of Fire. **St. Matthew 25:41**
Text
Revelation 20:10

Revelation 20

*¹ And I saw an angel come down from heaven, having the key of the bottomless pit and a great chain in his hand. ² And he laid hold on the dragon, that old serpent, which is the Devil, and Satan, and bound him a thousand years, ³ And cast him into the bottomless pit, and shut him up, and set a seal upon him, that he should deceive the nations no more, till the thousand years should be fulfilled: and after that he must be loosed a little season. ⁴ And I saw thrones, and they sat upon them, and judgment was given unto them: and I saw the souls of them that were beheaded for the witness of Jesus, and for the word of God, and which had not worshipped the beast, neither his image, neither had received his mark upon their foreheads, or in their hands; and they lived and reigned with Christ a thousand years. ⁵ But the rest of the dead lived not again until the thousand years were finished. This is the first resurrection. ⁶ Blessed and holy is he that hath part in the first resurrection: on such the second death hath no power, but they shall be priests of God and of Christ, and shall reign with him a thousand years. ⁷ And when the thousand years are expired, Satan shall be loosed out of his prison, ⁸ And shall go out to deceive the nations which are in the four quarters of the earth, Gog, and Magog, to gather them together to battle: the number of whom is as the sand of the sea. ⁹ And they went up on the breadth of the earth, and compassed the camp of the saints about, and the beloved city: and fire came down from God out of heaven, and devoured them. ¹⁰ **And the devil that deceived them was cast into the lake of fire and brimstone, where the beast and the false prophet are, and shall be tormented day and night for ever and ever.** ¹¹ And I saw a great white throne, and him that sat on it, from whose face the earth and the heaven fled away; and there was found no place for them. ¹² And I saw the dead, small and great, stand before God; and the books were opened: and another book was opened, which is the book of life: and the dead were judged out of those things which were written in the books, according to their works. ¹³ And the*

sea gave up the dead which were in it; and death and hell delivered up the dead which were in them: and they were judged every man according to their works. [14] And death and hell were cast into the lake of fire. This is the second death. [15] And whosoever was not found written in the book of life was cast into the lake of fire.

Explanation

He is the great enemy of God and man, and the demons are his servants in evil. He and his demons will be eternally punished in the lake of fire. **Revelation 20:10**

Conclusion

Angels are ministering spirits, sent forth to aid others.
Angels are also designed to glorify God.
Demons on the other hand, assist their head, which is the devil, and perform whatever, he so desires, that is contrary to the will of God.
However, there are some demons, who not only have gone the way of Cain, (the first murderer, who killed his brother Abel, the sons of Adam, through the seeds of unrighteousness, evil and jealousy) but believe that they can do anything that they desire.

Questions

What three things have you learned about the devil in this lesson, which resulted in his fall? All begin with the statement "I." Also provide the scripture.

How was the Adversary described in both texts?
Ezekiel 28:12-15

Isaiah 14:12-17

Name three names for the devil, denoted in the two texts?

Thought Question

What lesson does this provide for the believer, when we become too proud and forget our Creator?

Chapter 3

Week One: Review
Week Two: Open Book Test
Week Three: Review and Open Discussion of the Unit

Unit 9: The Church, and the Fallen
Practice for Review
And later
Unit Test
The Church

Who and where is the forming of the first church recorded?

Name seven names that define the body of believers, who are the church.
Also provide scripture.

The Body of Believers Defined Scripture

(1)Why do we take communion? (2)What is its meaning in regard to the
bread and the wine? (3) What do theyrepresent?

Angels and Demons

What three things have you learned about the devil in this lesson, which resulted in his fall? All begin with the statement "I." Also provide the scripture.

How was the Adversary described in both texts?
Ezekiel 28:12-15

Isaiah 14:12-17

Name three names for the devil, denoted in the two texts?

UNIT TEN: INNER CONFLICT AND RESOLUTION

Contents

Unit Introduction

You have probably learned by now, in your spiritual walk, which is a growing process, that you have a war going on within your spirit, your will and your heart. Although, you have learned now that by being reborn, passing from carnality to spiritually, through the acceptance of the finished work of Christ, our Redeemer, and our daily Advocate, that you have a problem sometimes, doing what you need to do. In this unit, we shall disclose the mystery of salvation present, which is our daily walk by faith. It is a mystery, because even though we do not always do what we should, and even though we are in this body of flesh, as long as we know or realize that it is not a quick fix, we have the right and the inheritance to the gift of eternal life in heaven. We do not completely understand. The word of God states that we shall understand all things, when that which is perfect shall come. Until them, remember that you are in warfare, with sin, flesh, and the devil. Remember that you are in a arfare with the will of God, as opposed to the will and the desires of the flesh. Also remember that it is the will of the Adversary to take what you have, validated in St. John 10:10, by killing, stealing or destroying the fruits of righteousness. So therefore, take heed to the ***Conflict and the Resolution . . .***

The Inner Conflict
The Battle From Within Ourselves
Chapter 1

Text
Roman Chapter 7: 14-25

Introduction

Within the hear**t of man, there is a battle against what we should do and what we should not do.** When, we as believers in Christ Jesus, do those things that we should we **are spiritual.** When we do those things which we should not do, we are carnal.

The Lesson

Text
Romans 7: 14-25

Romans 7

¹ Know ye not, brethren, (for I speak to them that know the law,) how that the law hath dominion over a man as long as he liveth? ² For the woman which hath an husband is bound by the law to her husband so long as he liveth; but if the husband be dead, she is loosed from the law of her husband. ³ So then if, while her husband liveth, she be married to another man, she shall be called an adulteress: but if her husband be dead, she is free from that law; so that she is no adulteress, though she be married to another man. ⁴ Wherefore, my brethren, ye also are become dead to the law by the body of Christ; that ye should be married to another, even to him who is raised from the dead, that we should bring forth fruit unto God. ⁵ For when we were in the flesh, the motions of sins, which were by the law, did work in our members to bring forth fruit unto death. ⁶ But now we are delivered from the law, that being

dead wherein we were held; that we should serve in newness of spirit, and not in the oldness of the letter. ⁷ What shall we say then? Is the law sin? God forbid. Nay, I had not known sin, but by the law: for I had not known lust, except the law had said, Thou shalt not covet. ⁸ But sin, taking occasion by the commandment, wrought in me all manner of concupiscence. For without the law sin was dead. ⁹ For I was alive without the law once: but when the commandment came, sin revived, and I died. ¹⁰ And the commandment, which was ordained to life, I found to be unto death. ¹¹ For sin, taking occasion by the commandment, deceived me, and by it slew me. ¹² Wherefore the law is holy, and the commandment holy, and just, and good. ¹³ Was then that which is good made death unto me? God forbid. But sin, that it might appear sin, working death in me by that which is good; that sin by the commandment might become exceeding sinful. ¹⁴ For we know that the law is spiritual: but I am carnal, sold under sin. ¹⁵ For that which I do I allow not: for what I would, that do I not; but what I hate, that do I. ¹⁶ If then I do that which I would not, I consent unto the law that it is good. ¹⁷ Now then it is no more I that do it, but sin that dwelleth in me. ¹⁸ For I know that in me (that is, in my flesh,) dwelleth no good thing: for to will is present with me; but how to perform that which is good I find not. ¹⁹ For the good that I would I do not: but the evil which I would not, that I do. ²⁰ Now if I do that I would not, it is no more I that do it, but sin that dwelleth in me. ²¹ I find then a law, that, when I would do good, evil is present with me. ²² For I delight in the law of God after the inward man: ²³ But I see another law in my members, warring against the law of my mind, and bringing me into captivity to the law of sin which is in my members. ²⁴ O wretched man that I am! Wo shall deliver me from the body of this death? ²⁵ I thank God through Jesus Christ our Lord. So then with the mind I myself serve the law of God; but with the flesh the law of sin.

The Explanation

Paul states in Romans Chapter 7

14 We have a natural man, which is this body of flesh, which is also called carnal. We also, through the spiritual rebirth, into salivation through the shed blood of the Lord and Savior, Jesus Christ, are once again in the right standing with God.15 ut because we are in this corruptible body, there is a constant struggle of what we do, what we should do, and what we are not

suppose to do.16 If we, as believers, do what we are not supposed to do, then we are telling others, representing the world, that it is alright to do so. Therefore, it must be righteous; not so.17 his verse states that it is not good, it is sinful, but the carnal mind, which represents our sinful nature, states that this is really what we want do.

18 e have a will to do good, but because of our sinful nature, coming from the nature of Adam we all find it easier to do evil.19 e know that what we do is wrong, even though we do it. 0 Now because we have a Christ-like nature, in the spirit, through salvation or the rebirth, we know when we are doing something that is not of God, and should repent to God, and to others where it applies, daily. I John 1:9;21. Therefore begins a struggle against the old nature, which is of sin, and the new nature, which is of the spirit of God. 2 ven though there is a struggle, we, as believers find peace or delight in doing that which is of God, as we stay in, and abide by the Word of God, with prayer, and through fellowship with God and other believers. 3 As long as we are in this body of flesh, there will be a war against doing what is right **and** doing what is wrong. We must bring the carnal or sinful nature into subjection to the spiritual things of God.24 nly God can deliver us from this spiritual battle, against good and evil, from within our bodies of flesh. St. John 3:16-17. **25** Consequently, in our minds we are to have the mind of Christ do those things which are pleasing in His sight. When we do otherwise, we are operating in sin. **Roman Chapter 7: 14-25**

Conclusion:

- Once the believer in Christ takes on salvation, through our Lord and Savior, Jesus Christ, there begins a spiritual battle between good and evil.
- This battle is defined as a battle of wanting to do the right thing, but doing what is contrary to the will and to the Word of God.
- The battle between the carnal and the spiritual continues until, the vessel or body of flesh has been transcended to immortality, and a celestial body, in a twinkling of an eye, during the final Feast of Trumpets, upon the Lord's return.
- The Spiritual Battle: The Battle between Good and Evil from within is also defined as a mystery.

- We, as believers will not completely understand the struggle, until we pass from this life to life eternal in heaven.
- Until then, we must repent daily and correct our wrong doings to others and then to God.

Questions

What does it mean to have a struggle within the inward or the carnal man that wars against the spiritual man?

_____Another law in my members, warring against the law of sin

_____A law, that, when I would do good, evil is present with me

_____The law is spiritual; but I am carnal

_____ All of the above

What is the old nature? What is the new nature? What do they constantly do?

What defines the battle between good and evil?

_____Free will

_____ Conscience

_____ Being in the image and likeness of God

_____Spirit man

_____Carnal man

_____ All of the above

Salvation, for the believer is also stated as:

_____Being Born Again

_____New Birth

_____Accepting the Lord Jesus Christ as your Personal Savior

_____All of the above

Describe three examples of the struggle between the carnal man and the spiritual man.

What is another term for free will? C

Thought Question

Name a constant battle in your life?

The Resolution to the Inner Conflict
Chapter 2

Text
I Timothy 4:13
2 Timothy 2:15
Hebrews 10:25:

Introduction

In the previous lesson, we learned that we have two natures, which battle constantly within us whenever a moral decision needs to be determined in our lives. Within this lesson we shall learn how to use basic principles to stay on a solid foundation, without wavering. These principles are defined as the resolutions to the inner conflict from within.

The Lesson
The Word of God
Reading, Studying, Practicing, Teaching

Text
I Timothy 4:13

1Timothy 4

¹ Now the Spirit speaketh expressly, that in the latter times some shall depart from the faith, giving heed to seducing spirits, and doctrines of devils; ² Speaking lies in hypocrisy; having their conscience seared with a hot iron; ³ Forbidding to marry, and commanding to abstain from meats, which God hath created to be received with thanksgiving of them which believe and know the truth. ⁴ For every creature of God is good, and nothing to be refused, if it be received with thanksgiving: ⁵ For it is sanctified by the word of God and prayer. ⁶ If thou put the brethren in remembrance of these things, thou shalt be a good minister of Jesus Christ, nourished up in the words of faith and of good

doctrine, whereunto thou hast attained. *7 But refuse profane and old wives' fables, and exercise thyself rather unto godliness. 8 For bodily exercise profiteth little: but godliness is profitable unto all things, having promise of the life that now is, and of that which is to come. 9 This is a faithful saying and worthy of all acceptation. 10 For therefore we both labour and suffer reproach, because we trust in the living God, who is the Saviour of all men, specially of those that believe. 11 These things command and teach. 12 Let no man despise thy youth; but be thou an example of the believers, in word, in conversation, in charity, in spirit, in faith, in purity. 13 **Till I come, give attendance to reading, to exhortation, to doctrine.** 14 Neglect not the gift that is in thee, which was given thee by prophecy, with the laying on of the hands of the presbytery. 15 Meditate upon these things; give thyself wholly to them; that thy profiting may appear to all. 16 Take heed unto thyself, and unto the doctrine; continue in them: for in doing this thou shalt both save thyself, and them that hear thee.*

Explanation

We have a responsibility of reading daily. Reading the Word of God helps us, as believers in Christ Jesus to stay in tone to the will and the Voice of God.

Exhortation is an elevation offering exercised by believers to help build someone up in the most holy faith. In simplified terms, it can mean to encourage another.**I Timothy 4:13**

Text

2 Timothy 2:15

2 Timothy 2

1 Thou therefore, my son, be strong in the grace that is in Christ Jesus. 2 And the things that thou hast heard of me among many witnesses, the same commit thou to faithful men, who shall be able to teach others also. 3 Thou therefore endure hardness, as a good soldier of Jesus Christ. 4 No man that warreth entangleth himself with the affairs of this life; that he may please him who hath chosen him to be a soldier. 5 And if a man also strive for masteries, yet is he not crowned, except he strive lawfully. 6 The husbandman that laboureth must be first partaker of the fruits. 7 Consider what I say; and the Lord give thee understanding in all things. 8 Remember that Jesus Christ of the seed of David was raised from the dead according to my gospel: 9 Wherein I suffer

trouble, as an evil doer, even unto bonds; but the word of God is not bound. [10] Therefore I endure all things for the elect's sakes, that they may also obtain the salvation which is in Christ Jesus with eternal glory. [11] It is a faithful saying: For if we be dead with him, we shall also live with him: [12] If we suffer, we shall also reign with him: if we deny him, he also will deny us: [13] If we believe not, yet he abideth faithful: he cannot deny himself. [14] Of these things put them in remembrance, charging them before the Lord that they strive not about words to no profit, but to the subverting of the hearers. [15] **Study to shew thyself approved unto God, a workman that needeth not to be ashamed, rightly dividing the word of truth.** [16] But shun profane and vain babblings: for they will increase unto more ungodliness. [17] And their word will eat as doth a canker: of whom is Hymenaeus and Philetus; [18] Who concerning the truth have erred, saying that the resurrection is past already; and overthrow the faith of some. [19] Nevertheless the foundation of God standeth sure, having this seal, The Lord knoweth them that are his. And, let every one that nameth the name of Christ depart from iniquity. [20] But in a great house there are not only vessels of gold and of silver, but also of wood and of earth; and some to honour, and some to dishonour. [21] If a man therefore purge himself from these, he shall be a vessel unto honour, sanctified, and meet for the master's use, and prepared unto every good work. [22] Flee also youthful lusts: but follow righteousness, faith, charity, peace, with them that call on the Lord out of a pure heart. [23] But foolish and unlearned questions avoid, knowing that they do gender strifes. [24] And the servant of the Lord must not strive; but be gentle unto all men, apt to teach, patient, [25] In meekness instructing those that oppose themselves; if God peradventure will give them repentance to the acknowledging of the truth; [26] And that they may recover themselves out of the snare of the devil, who are taken captive by him at his will.

Explanation

Abide by the Principles of the Word of God by reading, studying and applying them to our hearts and minds. **2 Timothy 2:15**

Fellowship

Text
Hebrews 10:25

Hebrews 10

¹ For the law having a shadow of good things to come, and not the very image of the things, can never with those sacrifices which they offered year by year continually make the comers thereunto perfect. ² For then would they not have ceased to be offered? because that the worshippers once purged should have had no more conscience of sins. ³ But in those sacrifices there is a remembrance again made of sins every year. ⁴ For it is not possible that the blood of bulls and of goats should take away sins. ⁵ Wherefore when he cometh into the world, he saith, Sacrifice and offering thou wouldest not, but a body hast thou prepared me: ⁶ In burnt offerings and sacrifices for sin thou hast had no pleasure. ⁷ Then said I, Lo, I come (in the volume of the book it is written of me,) to do thy will, O God. ⁸ Above when he said, Sacrifice and offering and burnt offerings and offering for sin thou wouldest not, neither hadst pleasure therein; which are offered by the law; ⁹ Then said he, Lo, I come to do thy will, O God. He taketh away the first, that he may establish the second. ¹⁰ By the which will we are sanctified through the offering of the body of Jesus Christ once for all. ¹¹ And every priest standeth daily ministering and offering oftentimes the same sacrifices, which can never take away sins: ¹² But this man, after he had offered one sacrifice for sins for ever, sat down on the right hand of God; ¹³ From henceforth expecting till his enemies be made his footstool. ¹⁴ For by one offering he hath perfected for ever them that are sanctified. ¹⁵ Whereof the Holy Ghost also is a witness to us: for after that he had said before, ¹⁶ This is the covenant that I will make with them after those days, saith the Lord, I will put my laws into their hearts, and in their minds will I write them; ¹⁷ And their sins and iniquities will I remember no more. ¹⁸ Now where remission of these is, there is no more offering for sin. ¹⁹ Having therefore, brethren, boldness to enter into the holiest by the blood of Jesus, ²⁰ By a new and living way, which he hath consecrated for us, through the veil, that is to say, his flesh; ²¹ And having an high priest over the house of God; ²² Let us draw near with a true heart in full assurance of faith, having our hearts sprinkled from an evil conscience, and our bodies washed with pure water. ²³ Let us hold fast the profession of our faith without wavering; (for he is faithful that promised;) ²⁴ And let us consider one another to provoke unto love and to good works: **²⁵ Not forsaking the assembling of ourselves together, as the manner of some is; but exhorting one another: and so much the more, as ye see the day approaching.** *²⁶ For if we sin wilfully after that we have received the knowledge of the truth, there remaineth no more sacrifice for sins, ²⁷ But*

a certain fearful looking for of judgment and fiery indignation, which shall devour the adversaries. ²⁸ *He that despised Moses' law died without mercy under two or three witnesses:* ²⁹ *Of how much sorer punishment, suppose ye, shall he be thought worthy, who hath trodden under foot the Son of God, and hath counted the blood of the covenant, wherewith he was sanctified, an unholy thing, and hath done despite unto the Spirit of grace?* ³⁰ *For we know him that hath said, Vengeance belongeth unto me, I will recompense, saith the Lord. And again, The Lord shall judge his people.* ³¹ *It is a fearful thing to fall into the hands of the living God.* ³² *But call to remembrance the former days, in which, after ye were illuminated, ye endured a great fight of afflictions;* ³³ *Partly, whilst ye were made a gazingstock both by reproaches and afflictions; and partly, whilst ye became companions of them that were so used.* ³⁴ *For ye had compassion of me in my bonds, and took joyfully the spoiling of your goods, knowing in yourselves that ye have in heaven a better and an enduring substance.* ³⁵ *Cast not away therefore your confidence, which hath great recompence of reward.* ³⁶ *For ye have need of patience, that, after ye have done the will of God, ye might receive the promise.* ³⁷ *For yet a little while, and he that shall come will come, and will not tarry.* ³⁸ *Now the just shall live by faith: but if any man draw back, my soul shall have no pleasure in him.* ³⁹ *But we are not of them who draw back unto perdition; but of them that believe to the saving of the soul.*

Explanation

We have a responsibility as believers, to come together in a solemn assembly, which some call, a worship service, others in the Hebrew faith call it a holy convocation.

The Word of God is God's principles and instructions

Its purpose, as the Word of God is to equip the believer to:
- Be informed of current events
- Be informed of the time in which we live in
- Know just how close we are to the Messiah's return for the Church, made up of all believers worldwide
- Be ready for the Messiah's return

- Know what is needed and have the ability to live a God fearing life, before God and man, through obedience to the Word of God. **Hebrews 10:25**

Conclusion

- Keep in mind that the resolution to the conflict of keeping your carnal inner man, under subjection, with the aid of the spiritual man is to focus upon the teachings and instructions in the Word of God.
- Not only do we apply the principles to our lives, but we also practice being around godly influences.
- Throughout this entire course, we note the doctrinal principles needed to maintain a godly life in Christ Jesus, our Redeemer and Day Star, which should be noted, for our example for Christian living.

Questions

What do we do when we give an elevation offering?

_____Focus our attention on someone else

_____Encourage one another

_____Exhort one another, through the word of God, individually or collectively within a gathering or holy assembly, for example

_____All of the above

According to I Timothy 4:13, *Till I come, give attendance to reading* refers to

_____Goal to read the word of God daily

_____ Believers should attend to the task of daily Bible reading

_____ Read daily, realizing that the Word of God is God speaking to us

_____All of the above

According to I Timothy 4:13, along with other scriptures, exhortation refers to

_____Encouragement

_____To bring the faults of the individual to his/her attention

_____To tell the believer that he/she may not be able to fulfill his/her service to God, through his/her appointment or call to service, such as a deacon, Sunday school teacher, or merely standing in front of the congregation to make the announcements, etc

_____ All of the above

According to I Timothy 4:13, doctrine refers to:

_____Teachings and instructions of the Word of God

_____The Biblical teachings and promises built upon obedience to the basic commandments and principles of God

_____The doctrine of God, expounded upon, through the Word of God

_____ All of the above

2 Timothy 2:15 Explains to the believer the importance of S _____ g the word of God so that we may be able to _____ divide the_____ of _____.

Name (4) reasons why it is important to study the Word of God

Name three interpretations of a church service? Name one identified in the Hebrew faith?

Thought Question

The Word of God is God speaking to you. With that in mind, why should we read and study the Word of God?

Put God First
Chapter 3

Introduction

In order to obtain what we want from God, we must first know how to pray, and what is prayer, accompanied with having a code of ethics, even though, we are no longer under the law. God gives us Grace, when we sin, based upon knowing the condition of our heart. Lastly, we must know how to put God first.

The Lesson
Sin

Text
Ephesians 2:5
Even when we were dead in sins, hath quickened us together with Christ, (by grace ye are saved).

Explanation

As believers in Christ Jesus, we are reborn, going from the natural to spiritual rebirth. We are born again. We are quickened, through the Holy Spirit to a newness of life, in Christ Jesus. **Ephesians 2:5**

Text

I John 1:9 (See Unit 3 chapter 2 full text)

If we confess our sins, he is faithful and just to forgive us our sins, and to cleanse us from all unrighteousness.

Explanation

We are to exercise daily confession of our sins, through Christ Jesus, our Lord. **I John 1:9**

Text

Hebrews 10:26

Hebrews 10

¹ For the law having a shadow of good things to come, and not the very image of the things, can never with those sacrifices which they offered year by year continually make the comers thereunto perfect. ² For then would they not have ceased to be offered? because that the worshippers once purged should have had no more conscience of sins. ³ But in those sacrifices there is a remembrance again made of sins every year. ⁴ For it is not possible that the blood of bulls and of goats should take away sins. ⁵ Wherefore when he cometh into the world, he saith, Sacrifice and offering thou wouldest not, but a body hast thou prepared me: ⁶ In burnt offerings and sacrifices for sin thou hast had no pleasure. ⁷ Then said I, Lo, I come (in the volume of the book it is written of me,) to do thy will, O God. ⁸ Above when he said, Sacrifice and offering and burnt offerings and offering for sin thou wouldest not, neither hadst pleasure therein; which are offered by the law; ⁹ Then said he, Lo, I come to do thy will, O God. He taketh away the first, that he may establish the second. ¹⁰ By the which will we are sanctified through the offering of the body of Jesus Christ once for all. ¹¹ And every priest standeth daily ministering and offering oftentimes the same sacrifices, which can never take away sins: ¹² But this man, after he had offered one sacrifice for sins for ever, sat down on the right hand of God; ¹³ From henceforth expecting till his enemies be made his footstool. ¹⁴ For by one offering he hath perfected for ever them that are sanctified. ¹⁵ Whereof the Holy Ghost also is a witness to us: for after that he had said before, ¹⁶ This is the

covenant that I will make with them after those days, saith the Lord, I will put my laws into their hearts, and in their minds will I write them; ¹⁷ *And their sins and iniquities will I remember no more.* ¹⁸ *Now where remission of these is, there is no more offering for sin.* ¹⁹ *Having therefore, brethren, boldness to enter into the holiest by the blood of Jesus,* ²⁰ *By a new and living way, which he hath consecrated for us, through the veil, that is to say, his flesh;* ²¹ *And having an high priest over the house of God;* ²² *Let us draw near with a true heart in full assurance of faith, having our hearts sprinkled from an evil conscience, and our bodies washed with pure water.* ²³ *Let us hold fast the profession of our faith without wavering; (for he is faithful that promised;)* ²⁴ *And let us consider one another to provoke unto love and to good works:* ²⁵ *Not forsaking the assembling of ourselves together, as the manner of some is; but exhorting one another: and so much the more, as ye see the day approaching.* ²⁶ **For if we sin wilfully after that we have received the knowledge of the truth, there remaineth no more sacrifice for sins,** ²⁷ *But a certain fearful looking for of judgment and fiery indignation, which shall devour the adversaries.* ²⁸ *He that despised Moses' law died without mercy under two or three witnesses:* ²⁹ *Of how much sorer punishment, suppose ye, shall he be thought worthy, who hath trodden under foot the Son of God, and hath counted the blood of the covenant, wherewith he was sanctified, an unholy thing, and hath done despite unto the Spirit of grace?* ³⁰ *For we know him that hath said, Vengeance belongeth unto me, I will recompense, saith the Lord. And again, The Lord shall judge his people.* ³¹ *It is a fearful thing to fall into the hands of the living God.* ³² *But call to remembrance the former days, in which, after ye were illuminated, ye endured a great fight of afflictions;* ³³ *Partly, whilst ye were made a gazingstock both by reproaches and afflictions; and partly, whilst ye became companions of them that were so used.* ³⁴ *For ye had compassion of me in my bonds, and took joyfully the spoiling of your goods, knowing in yourselves that ye have in heaven a better and an enduring substance.* ³⁵ *Cast not away therefore your confidence, which hath great recompence of reward.* ³⁶ *For ye have need of patience, that, after ye have done the will of God, ye might receive the promise.* ³⁷ *For yet a little while, and he that shall come will come, and will not tarry.* ³⁸ *Now the just shall live by faith: but if any man draw back, my soul shall have no pleasure in him.* ³⁹ *But we are not of them who draw back unto perdition; but of them that believe to the saving of the soul.*

Explanation

Once we have taken on the new birth, and **commit sins,** the bible states that if we willfully sin, then God will not forgive us. Once we realize our transgressions, we are to ask God to help us to forsake that sin.
As we:

Scripture	Tasks	Purpose
St. Luke 18:1	Pray.	To communicate with God
Psalm 35:13	Fast.	To die out to self will/desires
11 Tim. 2:15:	Read/study God Word.	To know what is required
Hebrews 10:25	Fellowship w/ believers.	To gain strength with others

The Lord, in the form of the **Comforter**, will supply the believer with the ability to defeat the desire to continue to commit that sin, against God, one's self, and even against others. **Hebrews 10:26**

Love Covers All

Text
I Peter 4:8

1 Peter 4

*¹ Forasmuch then as Christ hath suffered for us in the flesh, arm yourselves likewise with the same mind: for he that hath suffered in the flesh hath ceased from sin; ² That he no longer should live the rest of his time in the flesh to the lusts of men, but to the will of God. ³ For the time past of our life may suffice us to have wrought the will of the Gentiles, when we walked in lasciviousness, lusts, excess of wine, revellings, banquetings, and abominable idolatries: ⁴ Wherein they think it strange that ye run not with them to the same excess of riot, speaking evil of you: ⁵ Who shall give account to him that is ready to judge the quick and the dead. ⁶ For for this cause was the gospel preached also to them that are dead, that they might be judged according to men in the flesh, but live according to God in the spirit. ⁷ But the end of all things is at hand: be ye therefore sober, and watch unto prayer. ⁸ **And above all things have fervent charity among yourselves: for charity shall cover the multitude of sins**. ⁹ Use hospitality one to another without grudging. ¹⁰ As every man hath received the gift, even so minister the same one to another, as good stewards of*

the manifold grace of God. 11 If any man speak, let him speak as the oracles of God; if any man minister, let him do it as of the ability which God giveth: that God in all things may be glorified through Jesus Christ, to whom be praise and dominion for ever and ever. Amen. 12 Beloved, think it not strange concerning the fiery trial which is to try you, as though some strange thing happened unto you: 13 But rejoice, inasmuch as ye are partakers of Christ's sufferings; that, when his glory shall be revealed, ye may be glad also with exceeding joy. 14 If ye be reproached for the name of Christ, happy are ye; for the spirit of glory and of God resteth upon you: on their part he is evil spoken of, but on your part he is glorified. 15 But let none of you suffer as a murderer, or as a thief, or as an evildoer, or as a busybody in other men's matters. 16 Yet if any man suffer as a Christian, let him not be ashamed; but let him glorify God on this behalf. 17 For the time is come that judgment must begin at the house of God: and if it first begin at us, what shall the end be of them that obey not the gospel of God? 18 And if the righteous scarcely be saved, where shall the ungodly and the sinner appear? 19 Wherefore let them that suffer according to the will of God commit the keeping of their souls to him in well doing, as unto a faithful Creator.

Explanation

Charity refers to love. The bible states that if we, as believers love the brethren, as ourselves, and put God first in our lives, that covers all of the law. **I Peter 4:8**

Love and Treat Others as Yourself

Text
St. John 13:34-35

John 13

1 Now before the feast of the passover, when Jesus knew that his hour was come that he should depart out of this world unto the Father, having loved his own which were in the world, he loved them unto the end. 2 And supper being ended, the devil having now put into the heart of Judas Iscariot, Simon's son, to betray him; 3 Jesus knowing that the Father had given all things into his hands, and that he was come from God, and went to God; 4 He riseth from supper, and laid aside his garments; and took a towel, and girded himself. 5

After that he poureth water into a bason, and began to wash the disciples' feet, and to wipe them with the towel wherewith he was girded. ⁶ Then cometh he to Simon Peter: and Peter saith unto him, Lord, dost thou wash my feet? ⁷ Jesus answered and said unto him, What I do thou knowest not now; but thou shalt know hereafter. ⁸ Peter saith unto him, Thou shalt never wash my feet. Jesus answered him, If I wash thee not, thou hast no part with me. ⁹ Simon Peter saith unto him, Lord, not my feet only, but also my hands and my head. ¹⁰ Jesus saith to him, He that is washed needeth not save to wash his feet, but is clean every whit: and ye are clean, but not all. ¹¹ For he knew who should betray him; therefore said he, Ye are not all clean. ¹² So after he had washed their feet, and had taken his garments, and was set down again, he said unto them, Know ye what I have done to you? ¹³ Ye call me Master and Lord: and ye say well; for so I am. ¹⁴ If I then, your Lord and Master, have washed your feet; ye also ought to wash one another's feet. ¹⁵ For I have given you an example, that ye should do as I have done to you. ¹⁶ Verily, verily, I say unto you, The servant is not greater than his lord; neither he that is sent greater than he that sent him. ¹⁷ If ye know these things, happy are ye if ye do them. ¹⁸ I speak not of you all: I know whom I have chosen: but that the scripture may be fulfilled, He that eateth bread with me hath lifted up his heel against me. ¹⁹ Now I tell you before it come, that, when it is come to pass, ye may believe that I am he. ²⁰ Verily, verily, I say unto you, He that receiveth whomsoever I send receiveth me; and he that receiveth me receiveth him that sent me. ²¹ When Jesus had thus said, he was troubled in spirit, and testified, and said, Verily, verily, I say unto you, that one of you shall betray me. ²² Then the disciples looked one on another, doubting of whom he spake. ²³ Now there was leaning on Jesus' bosom one of his disciples, whom Jesus loved. ²⁴ Simon Peter therefore beckoned to him, that he should ask who it should be of whom he spake. ²⁵ He then lying on Jesus' breast saith unto him, Lord, who is it? ²⁶ Jesus answered, He it is, to whom I shall give a sop, when I have dipped it. And when he had dipped the sop, he gave it to Judas Iscariot, the son of Simon. ²⁷ And after the sop Satan entered into him. Then said Jesus unto him, That thou doest, do quickly. ²⁸ Now no man at the table knew for what intent he spake this unto him. ²⁹ For some of them thought, because Judas had the bag, that Jesus had said unto him, Buy those things that we have need of against the feast; or, that he should give something to the poor. ³⁰ He then having received the sop went immediately out: and it was night. ³¹ Therefore, when he was gone out, Jesus said, Now is the Son of man glorified, and God is glorified in him. ³² If God be glorified in him, God shall also glorify him in himself, and shall straightway

glorify him. [33] *Little children, yet a little while I am with you. Ye shall seek me: and as I said unto the Jews, Whither I go, ye cannot come; so now I say to you.* **[34] *A new commandment I give unto you, That ye love one another; as I have loved you, that ye also love one another.* [35] *By this shall all men know that ye are my disciples, if ye have love one to another.*** [36] *Simon Peter said unto him, Lord, whither goest thou? Jesus answered him, Whither I go, thou canst not follow me now; but thou shalt follow me afterwards.* [37] *Peter said unto him, Lord, why cannot I follow thee now? I will lay down my life for thy sake.* [38] *Jesus answered him, Wilt thou lay down thy life for my sake? Verily, verily, I say unto thee, The cock shall not crow, till thou hast denied me thrice.*

Explanation

Love all, as you love yourself. **St. John 13:34-35**

Also

Text
St. John 15:12-14 (See Unit 8 chapter 4 full text)
[12] *This is my commandment, That ye love one another, as I have loved you.* [13] *Greater love hath no man than this, that a man lay down his life for his friends.* [14] *Ye are my friends, if ye do whatsoever I command you.*

Explanation

We should **treat** others the way that we would want them to treat us. **St. John 15:12-14**
Text
James 2:8

James 2

[1] *My brethren, have not the faith of our Lord Jesus Christ, the Lord of glory, with respect of persons.* [2] *For if there come unto your assembly a man with a gold ring, in goodly apparel, and there come in also a poor man in vile raiment;* [3] *And ye have respect to him that weareth the gay clothing, and say unto him, Sit thou here in a good place; and say to the poor, Stand thou there,*

or sit here under my footstool: ⁴ Are ye not then partial in yourselves, and are become judges of evil thoughts? ⁵ Hearken, my beloved brethren, Hath not God chosen the poor of this world rich in faith, and heirs of the kingdom which he hath promised to them that love him? ⁶ But ye have despised the poor. Do not rich men oppress you, and draw you before the judgment seats? ⁷ Do not they blaspheme that worthy name by the which ye are called? **⁸ If ye fulfil the royal law according to the scripture, Thou shalt love thy neighbour as thyself, ye do well***: ⁹ But if ye have respect to persons, ye commit sin, and are convinced of the law as transgressors. ¹⁰ For whosoever shall keep the whole law, and yet offend in one point, he is guilty of all. ¹¹ For he that said, Do not commit adultery, said also, Do not kill. Now if thou commit no adultery, yet if thou kill, thou art become a transgressor of the law. ¹² So speak ye, and so do, as they that shall be judged by the law of liberty. ¹³ For he shall have judgment without mercy, that hath shewed no mercy; and mercy rejoiceth against judgment. ¹⁴ What doth it profit, my brethren, though a man say he hath faith, and have not works? can faith save him? ¹⁵ If a brother or sister be naked, and destitute of daily food, ¹⁶ And one of you say unto them, Depart in peace, be ye warmed and filled; notwithstanding ye give them not those things which are needful to the body; what doth it profit? ¹⁷ Even so faith, if it hath not works, is dead, being alone. ¹⁸ Yea, a man may say, Thou hast faith, and I have works: shew me thy faith without thy works, and I will shew thee my faith by my works. ¹⁹ Thou believest that there is one God; thou doest well: the devils also believe, and tremble. ²⁰ But wilt thou know, O vain man, that faith without works is dead? ²¹ Was not Abraham our father justified by works, when he had offered Isaac his son upon the altar? ²² Seest thou how faith wrought with his works, and by works was faith made perfect? ²³ And the scripture was fulfilled which saith, Abraham believed God, and it was imputed unto him for righteousness: and he was called the Friend of God. ²⁴ Ye see then how that by works a man is justified, and not by faith only. ²⁵ Likewise also was not Rahab the harlot justified by works, when she had received the messengers, and had sent them out another way? ²⁶ For as the body without the spirit is dead, so faith without works is dead also.*

Explanation

We should not do anything to someone that we would not want someone returning the same actions to us. This fulfils the Law in a nutshell, upon receiving salvation, along with putting God first. James 2:8

Therefore

Text
I John 5: 14-15

1 John 5

¹ Whosoever believeth that Jesus is the Christ is born of God: and every one that loveth him that begat loveth him also that is begotten of him. ² By this we know that we love the children of God, when we love God, and keep his commandments. ³ For this is the love of God, that we keep his commandments: and his commandments are not grievous. ⁴ For whatsoever is born of God overcometh the world: and this is the victory that overcometh the world, even our faith. ⁵ Who is he that overcometh the world, but he that believeth that Jesus is the Son of God? ⁶ This is he that came by water and blood, even Jesus Christ; not by water only, but by water and blood. And it is the Spirit that beareth witness, because the Spirit is truth. ⁷ For there are three that bear record in heaven, the Father, the Word, and the Holy Ghost: and these three are one. ⁸ And there are three that bear witness in earth, the Spirit, and the water, and the blood: and these three agree in one. ⁹ If we receive the witness of men, the witness of God is greater: for this is the witness of God which he hath testified of his Son. ¹⁰ He that believeth on the Son of God hath the witness in himself: he that believeth not God hath made him a liar; because he believeth not the record that God gave of his Son. ¹¹ And this is the record, that God hath given to us eternal life, and this life is in his Son. ¹² He that hath the Son hath life; and he that hath not the Son of God hath not life. ¹³ These things have I written unto you that believe on the name of the Son of God; that ye may know that ye have eternal life, and that ye may believe on the name of the Son of God. ¹⁴ ***And this is the confidence that we have in him, that, if we ask any thing according to his will, he heareth us: ¹⁵ And if we know that he hear us, whatsoever we ask, we know that we have the petitions that we desired of him.*** *¹⁶ If any man see his brother sin a sin which is not unto death, he shall ask, and he shall give him life for them that sin not unto death. There is a sin unto death: I do not say that he shall pray for it. ¹⁷ All unrighteousness is sin: and there is a sin not unto death. ¹⁸ We know that whosoever is born of God sinneth not; but he that is begotten of God keepeth himself, and that wicked one toucheth him not. ¹⁹ And we know that we are of God, and the whole world lieth in wickedness. ²⁰ And we know that the Son of God is come,*

and hath given us an understanding, that we may know him that is true, and we are in him that is true, even in his Son Jesus Christ. This is the true God, and eternal life. ²¹ Little children, keep yourselves from idols. Amen.

Explanation

If, we as believers in Christ Jesus walk obedient to the word of God, He gives us the promise, that He will hear and answer our prayers. **I John 5: 14-15**
Text
St. Matthew 6:33, 34

Matthew 6

¹ Take heed that ye do not your alms before men, to be seen of them: otherwise ye have no reward of your Father which is in heaven. ² Therefore when thou doest thine alms, do not sound a trumpet before thee, as the hypocrites do in the synagogues and in the streets, that they may have glory of men. Verily I say unto you, They have their reward. ³ But when thou doest alms, let not thy left hand know what thy right hand doeth: ⁴ That thine alms may be in secret: and thy Father which seeth in secret himself shall reward thee openly. ⁵ And when thou prayest, thou shalt not be as the hypocrites are: for they love to pray standing in the synagogues and in the corners of the streets, that they may be seen of men. Verily I say unto you, They have their reward. ⁶ But thou, when thou prayest, enter into thy closet, and when thou hast shut thy door, pray to thy Father which is in secret; and thy Father which seeth in secret shall reward thee openly. ⁷ But when ye pray, use not vain repetitions, as the heathen do: for they think that they shall be heard for their much speaking. ⁸ Be not ye therefore like unto them: for your Father knoweth what things ye have need of, before ye ask him. ⁹ After this manner therefore pray ye: Our Father which art in heaven, Hallowed be thy name. ¹⁰ Thy kingdom come, Thy will be done in earth, as it is in heaven. ¹¹ Give us this day our daily bread. ¹² And forgive us our debts, as we forgive our debtors. ¹³ And lead us not into temptation, but deliver us from evil: For thine is the kingdom, and the power, and the glory, for ever. Amen. ¹⁴ For if ye forgive men their trespasses, your heavenly Father will also forgive you: ¹⁵ But if ye forgive not men their trespasses, neither will your Father forgive your trespasses. ¹⁶ Moreover when ye fast, be not, as the hypocrites, of a sad countenance: for they disfigure their faces, that they may appear unto men

*to fast. Verily I say unto you, They have their reward. [17] But thou, when thou fastest, anoint thine head, and wash thy face; [18] That thou appear not unto men to fast, but unto thy Father which is in secret: and thy Father, which seeth in secret, shall reward thee openly. [19] Lay not up for yourselves treasures upon earth, where moth and rust doth corrupt, and where thieves break through and steal: [20] But lay up for yourselves treasures in heaven, where neither moth nor rust doth corrupt, and where thieves do not break through nor steal: [21] For where your treasure is, there will your heart be also. [22] The light of the body is the eye: if therefore thine eye be single, thy whole body shall be full of light. [23] But if thine eye be evil, thy whole body shall be full of darkness. If therefore the light that is in thee be darkness, how great is that darkness! [24] No man can serve two masters: for either he will hate the one, and love the other; or else he will hold to the one, and despise the other. Ye cannot serve God and mammon. [25] Therefore I say unto you, Take no thought for your life, what ye shall eat, or what ye shall drink; nor yet for your body, what ye shall put on. Is not the life more than meat, and the body than raiment? [26] Behold the fowls of the air: for they sow not, neither do they reap, nor gather into barns; yet your heavenly Father feedeth them. Are ye not much better than they? [27] Which of you by taking thought can add one cubit unto his stature? [28] And why take ye thought for raiment? Consider the lilies of the field, how they grow; they toil not, neither do they spin: [29] And yet I say unto you, That even Solomon in all his glory was not arrayed like one of these. [30] Wherefore, if God so clothe the grass of the field, which to day is, and to morrow is cast into the oven, shall he not much more clothe you, O ye of little faith? [31] Therefore take no thought, saying, What shall we eat? or, What shall we drink? or, Wherewithal shall we be clothed? [32] (For after all these things do the Gentiles seek:) for your heavenly Father knoweth that ye have need of all these things. [33] **But seek ye first the kingdom of God, and his righteousness; and all these things shall be added unto you. [34] Take therefore no thought for the morrow: for the morrow shall take thought for the things of itself. Sufficient unto the day is the evil thereof.***

Explanation

We need to not only be obedient to the will of God, but as believers we are to put God first. **St. Matthew 6:33**

Also

Text
St Matthews 6:34 (See above, full text)
Take therefore no thought for the morrow: for the morrow shall take though for the things of itself. Sufficient unto the day is the evil thereof.

Explanation

As we put God first in our lives, God will supply all of our needs, according to His riches through Christ Jesus. **St Matthews 6:34**
Text
St. Matthew 22: 37-40

Matthew 22

[1] And Jesus answered and spake unto them again by parables, and said, [2] The kingdom of heaven is like unto a certain king, which made a marriage for his son, [3] And sent forth his servants to call them that were bidden to the wedding: and they would not come. [4] Again, he sent forth other servants, saying, Tell them which are bidden, Behold, I have prepared my dinner: my oxen and my fatlings are killed, and all things are ready: come unto the marriage. [5] But they made light of it, and went their ways, one to his farm, another to his merchandise: [6] And the remnant took his servants, and entreated them spitefully, and slew them. [7] But when the king heard thereof, he was wroth: and he sent forth his armies, and destroyed those murderers, and burned up their city. [8] Then saith he to his servants, The wedding is ready, but they which were bidden were not worthy. [9] Go ye therefore into the highways, and as many as ye shall find, bid to the marriage. [10] So those servants went out into the highways, and gathered together all as many as they found, both bad and good: and the wedding was furnished with guests. [11] And when the king came in to see the guests, he saw there a man which had not on a wedding garment: [12] And he saith unto him, Friend, how camest thou in hither not having a wedding garment? And he was speechless. [13] Then said the king to the servants, Bind him hand and foot, and take him away, and cast him into outer darkness, there shall be weeping and gnashing of teeth. [14] For many are called, but few are chosen. [15] Then went the Pharisees, and took counsel how they might entangle him in his talk. [16] And they sent out unto him their disciples with the Herodians, saying,

Master, we know that thou art true, and teachest the way of God in truth, neither carest thou for any man: for thou regardest not the person of men. 17 Tell us therefore, What thinkest thou? Is it lawful to give tribute unto Caesar, or not? 18 But Jesus perceived their wickedness, and said, Why tempt ye me, ye hypocrites? 19 Shew me the tribute money. And they brought unto him a penny. 20 And he saith unto them, Whose is this image and superscription? 21 They say unto him, Caesar's. Then saith he unto them, Render therefore unto Caesar the things which are Caesar's; and unto God the things that are God's. 22 When they had heard these words, they marvelled, and left him, and went their way. 23 The same day came to him the Sadducees, which say that there is no resurrection, and asked him, 24 Saying, Master, Moses said, If a man die, having no children, his brother shall marry his wife, and raise up seed unto his brother. 25 Now there were with us seven brethren: and the first, when he had married a wife, deceased, and, having no issue, left his wife unto his brother: 26 Likewise the second also, and the third, unto the seventh. 27 And last of all the woman died also. 28 Therefore in the resurrection whose wife shall she be of the seven? for they all had her. 29 Jesus answered and said unto them, Ye do err, not knowing the scriptures, nor the power of God. 30 For in the resurrection they neither marry, nor are given in marriage, but are as the angels of God in heaven. 31 But as touching the resurrection of the dead, have ye not read that which was spoken unto you by God, saying, 32 I am the God of Abraham, and the God of Isaac, and the God of Jacob? God is not the God of the dead, but of the living. 33 And when the multitude heard this, they were astonished at his doctrine. 34 But when the Pharisees had heard that he had put the Sadducees to silence, they were gathered together. 35 Then one of them, which was a lawyer, asked him a question, tempting him, and saying, 36 Master, which is the great commandment in the law? 37 **Jesus said unto him, Thou shalt love the Lord thy God with all thy heart, and with all thy soul, and with all thy mind. 38 This is the first and great commandment. 39 And the second is like unto it, Thou shalt love thy neighbour as thyself. 40 On these two commandments hang all the law and the prophets.** *41 While the Pharisees were gathered together, Jesus asked them, 42 Saying, What think ye of Christ? whose son is he? They say unto him, The son of David. 43 He saith unto them, How then doth David in spirit call him Lord, saying, 44 The LORD said unto my Lord, Sit thou on my right hand, till I make thine enemies thy footstool? 45 If David then call him Lord, how is he his son? 46 And no man was able to answer him a word, neither durst any man from that day forth ask him any more questions.*

Explanation

These are the laws in a nutshell, that God requires us, as believers to abide by. Love our neighbors or the brethren and love the Lord thy God, as Adoni. **St. Matthew 22: 37-40**

Conclusion

In order to obtain what we, as believers want from God, we must:

- First know how to pray.
- Know what is prayer?
- We must have a code of ethics, even though, we are no longer under the law.
- God gives us Grace, when we sin, based upon knowing the condition of our heart.
- Lastly, we must know how to put God first.

Questions

Name three things, along with their tasks, that we as believers must do, in order to get what we want from God. Provide scripture.

What is our Code of Ethics in a nutshell? Provide scripture.

When does God supply all of our needs? Provide scripture.

Thought Question

What is it that you, as a believer, need to improve upon, in your daily walk with God, which will enable you to get what you want from God?

Put God first and love your neighbor as thyself.

Chapter 4

Week One: Review
Week Two: Open Book Test
Week Three: Review and Open Discussion of the Unit

Unit 10: Inner Conflict and Resolution
Practice for Review
And later
Unit Test
The Inner Conflict

What does it mean to have a struggle within the inward or the carnal man, that wars against the spiritual man?

_____ Another law in my members, warring against the law of sin

_____Is a law, that, when I would do good, evil is present with me

_____The law is spiritual; but I am carnal

_____With the mind I myself serve the law of God; but with the flesh the law of sin

_____All of the above

What is the old nature? What is the new nature? What do they constantly do? What does it mean to be in right standing with God? Provide scriptures.

What defines the battle between good and evil?

_____ Free will

_____Conscience

_____ Being in the image and likeness of God

_____The spirit man

_____The carnal man

_____ All of the above

Salvation, for the believer is also stated as:

_____ Being Born Again

_____ New Birth

_____ Accepting the Lord Jesus Christ as our Personal Savior

_____ All of the above

O wretched man that I am! Who shall deliver me from the body of this death? Where is this scripture located? What does it mean? What is the answer?

Describe three examples of the struggle between the carnal man and the spiritual man.

What is another term for free will? C _____

Resolution to the Inner Conflict

What do we do when we give an elevation offering?

_____Focus our attention on someone else

_____Encourage one another

_____Exhort one another, through the Word of God, individually or collectively within a gathering or holy assembly, for example

_____All of the above

According to I Timothy 4:13,

Till I come, give attendance to reading refers to

_____A goal to read the Word of God daily

_____Believers should attend to the task of daily Bible reading

_____Read daily, realizing that the Word of God is God speaking to us

_____All of the above

According to I Timothy 4:13, along with other scriptures, exhortation refers to

_____Encouragement

_____To bring the faults of the individual to his/her attention.

_____To tell the believer that he/she may not be able to fulfill his/her service to God, through his/her appointment or call to service, such

as a deacon, Sunday school teacher, or merely standing in front of the congregation to make the announcements, etc

_____All of the above

According to I Timothy 4:13, doctrine refers to:

_____Teachings and instructions of the Word of God

_____The Biblical teachings and promises built upon obedience to the basic commandments and principles of God

_____The doctrine of God, expounded upon, through the Word of God

_____All of the above

2 Timothy 2:15 Explains to the believer the importance of S_____g the Word of God so that we may be able to_____ divide the_____of _____.

Name (4) reasons why it is important to study the Word of God

Name three interpretations of a church service? One is identified in the Hebrew faith?

Put God First

Name three things we as believers must do, in order to get what we want from God. Provide scripture.

What is our Code of Ethics in a nutshell? Provide scripture.

UNIT 11: THE WORD OF GOD

Contents

Unit Introduction

In order to be armed and ready in the service of the Lord for yourself, in building up yourself in the most holy faith, as well as for others, as you let your light so shine before men that they may see your good works and glorify the Father which is in heaven, you must, as we have learned in the previous unit, learn to use the Word of God as a weapon. However, we cannot use something for good, if we do not believe it its validity. Therefore with that in mind, we shall share light on the *infallible Word of God* . . .

The Infallible Word of God
Chapter 1

Text
St. Matthew 5:18
2 Timothy 3:16-17
2 Peter 1:21

Introduction

We believe in our Statement of Faith, that the Word of God is the Voice of God. In this lesson we shall expound upon the scriptures of evidence stating that the Word of God is revelation from God. It is without error and why.

The Lesson
The Holy Scriptures

Text
St. Matthew 5:18

Matthew 5

¹ And seeing the multitudes, he went up into a mountain: and when he was set, his disciples came unto him: ² And he opened his mouth, and taught them, saying, ³ Blessed are the poor in spirit: for theirs is the kingdom of heaven. ⁴ Blessed are they that mourn: for they shall be comforted. ⁵ Blessed are the meek: for they shall inherit the earth. ⁶ Blessed are they which do hunger and thirst after righteousness: for they shall be filled. ⁷ Blessed are the merciful: for they shall obtain mercy. ⁸ Blessed are the pure in heart: for they shall see God. ⁹ Blessed are the peacemakers: for they shall be called the children of God. ¹⁰ Blessed are they which are persecuted for righteousness' sake: for theirs is the kingdom of heaven. ¹¹ Blessed are ye, when men shall revile you, and persecute you, and shall say all manner of evil against you falsely, for my sake. ¹² Rejoice,

*and be exceeding glad: for great is your reward in heaven: for so persecuted they the prophets which were before you. ¹³ Ye are the salt of the earth: but if the salt have lost his savour, wherewith shall it be salted? it is thenceforth good for nothing, but to be cast out, and to be trodden under foot of men. ¹⁴ Ye are the light of the world. A city that is set on an hill cannot be hid. ¹⁵ Neither do men light a candle, and put it under a bushel, but on a candlestick; and it giveth light unto all that are in the house. ¹⁶ Let your light so shine before men, that they may see your good works, and glorify your Father which is in heaven. ¹⁷ Think not that I am come to destroy the law, or the prophets: I am not come to destroy, but to fulfil. ¹⁸ **For verily I say unto you, Till heaven and earth pass, one jot or one tittle shall in no wise pass from the law, till all be fulfilled.** ¹⁹ Whosoever therefore shall break one of these least commandments, and shall teach men so, he shall be called the least in the kingdom of heaven: but whosoever shall do and teach them, the same shall be called great in the kingdom of heaven. ²⁰ For I say unto you, That except your righteousness shall exceed the righteousness of the scribes and Pharisees, ye shall in no case enter into the kingdom of heaven. ²¹ Ye have heard that it was said of them of old time, Thou shalt not kill; and whosoever shall kill shall be in danger of the judgment: ²² But I say unto you, That whosoever is angry with his brother without a cause shall be in danger of the judgment: and whosoever shall say to his brother, Raca, shall be in danger of the council: but whosoever shall say, Thou fool, shall be in danger of hell fire. ²³ Therefore if thou bring thy gift to the altar, and there rememberest that thy brother hath ought against thee; ²⁴ Leave there thy gift before the altar, and go thy way; first be reconciled to thy brother, and then come and offer thy gift. ²⁵ Agree with thine adversary quickly, whiles thou art in the way with him; lest at any time the adversary deliver thee to the judge, and the judge deliver thee to the officer, and thou be cast into prison. ²⁶ Verily I say unto thee, Thou shalt by no means come out thence, till thou hast paid the uttermost farthing. ²⁷ Ye have heard that it was said by them of old time, Thou shalt not commit adultery: ²⁸ But I say unto you, That whosoever looketh on a woman to lust after her hath committed adultery with her already in his heart. ²⁹ And if thy right eye offend thee, pluck it out, and cast it from thee: for it is profitable for thee that one of thy members should perish, and not that thy whole body should be cast into hell. ³⁰ And if thy right hand offend thee, cut it off, and cast it from thee: for it is profitable for thee that one of thy members should perish, and not that thy whole body should be cast into hell. ³¹ It hath been said, Whosoever shall put away his wife, let him give her a writing of divorcement: ³² But I say unto you, That whosoever shall*

put away his wife, saving for the cause of fornication, causeth her to commit adultery: and whosoever shall marry her that is divorced committeth adultery. ³³ *Again, ye have heard that it hath been said by them of old time, Thou shalt not forswear thyself, but shalt perform unto the Lord thine oaths:* ³⁴ *But I say unto you, Swear not at all; neither by heaven; for it is God's throne:* ³⁵ *Nor by the earth; for it is his footstool: neither by Jerusalem; for it is the city of the great King.* ³⁶ *Neither shalt thou swear by thy head, because thou canst not make one hair white or black.* ³⁷ *But let your communication be, Yea, yea; Nay, nay: for whatsoever is more than these cometh of evil.* ³⁸ *Ye have heard that it hath been said, An eye for an eye, and a tooth for a tooth:* ³⁹ *But I say unto you, That ye resist not evil: but whosoever shall smite thee on thy right cheek, turn to him the other also.* ⁴⁰ *And if any man will sue thee at the law, and take away thy coat, let him have thy cloak also.* ⁴¹ *And whosoever shall compel thee to go a mile, go with him twain.* ⁴² *Give to him that asketh thee, and from him that would borrow of thee turn not thou away.* ⁴³ *Ye have heard that it hath been said, Thou shalt love thy neighbour, and hate thine enemy.* ⁴⁴ *But I say unto you, Love your enemies, bless them that curse you, do good to them that hate you, and pray for them which despitefully use you, and persecute you;* ⁴⁵ *That ye may be the children of your Father which is in heaven: for he maketh his sun to rise on the evil and on the good, and sendeth rain on the just and on the unjust.* ⁴⁶ *For if ye love them which love you, what reward have ye? do not even the publicans the same?* ⁴⁷ *And if ye salute your brethren only, what do ye more than others? do not even the publicans so?* ⁴⁸ *Be ye therefore perfect, even as your Father which is in heaven is perfect.*

Explanation

We believe that the **Word of God** is composed of the Old and New Testaments, to be the inspired, infallible, and authoritative Word of God.
St. Matthew 5:18
Text
2 Timothy 3:16-17

2 Timothy 3

¹ *This know also, that in the last days perilous times shall come.* ² *For men shall be lovers of their own selves, covetous, boasters, proud, blasphemers, disobedient to parents, unthankful, unholy,* ³ *Without natural affection, trucebreakers,*

*false accusers, incontinent, fierce, despisers of those that are good, ⁴ Traitors, heady, highminded, lovers of pleasures more than lovers of God; ⁵ Having a form of godliness, but denying the power thereof: from such turn away. ⁶ For of this sort are they which creep into houses, and lead captive silly women laden with sins, led away with divers lusts, ⁷ Ever learning, and never able to come to the knowledge of the truth. ⁸ Now as Jannes and Jambres withstood Moses, so do these also resist the truth: men of corrupt minds, reprobate concerning the faith. ⁹ But they shall proceed no further: for their folly shall be manifest unto all men, as their's also was. ¹⁰ But thou hast fully known my doctrine, manner of life, purpose, faith, longsuffering, charity, patience, ¹¹ Persecutions, afflictions, which came unto me at Antioch, at Iconium, at Lystra; what persecutions I endured: but out of them all the Lord delivered me. ¹² Yea, and all that will live godly in Christ Jesus shall suffer persecution. ¹³ But evil men and seducers shall wax worse and worse, deceiving, and being deceived. ¹⁴ But continue thou in the things which thou hast learned and hast been assured of, knowing of whom thou hast learned them; ¹⁵ And that from a child thou hast known the holy scriptures, which are able to make thee wise unto salvation through faith which is in Christ Jesus. ¹⁶ **All scripture is given by inspiration of God, and is profitable for doctrine, for reproof, for correction, for instruction in righteousness: ¹⁷ That the man of God may be perfect, thoroughly furnished unto all good works.***

Explanation

In faith we hold the Bible to be inerrant, or without error in the original writings. **2 Timothy 3:16-17**

Text
2 Peter 1:21 (See Unit 7 chapter 1, full text)
Holy men of god spoke as they were moved by the Holy Ghost.

Explanation

The holy men wrote as the oracles of God. **2 Peter 1:21**

Conclusion

- The word of God is infallible.
- It was written by 40 writers who were inspired by the Holy Ghost.

- It is our road map and guide to eternal life.

Questions

What three scriptures tell of the purpose of the writings of the Bible?

How were the writings of the bible written? Provide (2) points taken from the lesson, with scripture.

Name (3) reasons why we should use the Word of God, found in this lesson. Provide scripture.

Thought Question

Even thought you are saved from your sins, and have taken on the new birth, do you really believe that the Bible is the infallible Word of God, or are you just going along with it, to make sure that you are saved to the very end, in the event that it is Truth?

Faith with a Weapon as the Word of God
Chapter 2

Text
Hebrews 4:12
St. Matthew 6:33
I Corinthians 10:13
Romans 8:37
James 3:8
II Timothy 1:7
Isaiah 54:17
St. John 10:10
Philippians 4:8

Introduction

Take hold to faith and learn to use the Word of God, as a weapon. In doing so, we as believers will learn how to conquer all obstacles in our lives. Remember to repeat the scripture over and over, until you gain the victory. That is why it is important to memorize key scriptures. Begin with these main scriptures, and memorize, so that when the adversary, or your carnal state, or through the influence of others, you doubt, or fall short of the mark of walking in obedience, you can quickly return to the path of righteousness.

The Lesson
Conquering all obstacles

Text
Hebrews 4:12

Hebrews 4

*¹ Let us therefore fear, lest, a promise being left us of entering into his rest, any of you should seem to come short of it. ² For unto us was the gospel preached, as well as unto them: but the word preached did not profit them, not being mixed with faith in them that heard it. ³ For we which have believed do enter into rest, as he said, As I have sworn in my wrath, if they shall enter into my rest: although the works were finished from the foundation of the world. ⁴ For he spake in a certain place of the seventh day on this wise, And God did rest the seventh day from all his works. ⁵ And in this place again, If they shall enter into my rest. ⁶ Seeing therefore it remaineth that some must enter therein, and they to whom it was first preached entered not in because of unbelief: ⁷ Again, he limiteth a certain day, saying in David, To day, after so long a time; as it is said, To day if ye will hear his voice, harden not your hearts. ⁸ For if Jesus had given them rest, then would he not afterward have spoken of another day. ⁹ There remaineth therefore a rest to the people of God. ¹⁰ For he that is entered into his rest, he also hath ceased from his own works, as God did from his. ¹¹ Let us labour therefore to enter into that rest, lest any man fall after the same example of unbelief. ¹² **For the word of God is quick, and powerful, and sharper than any twoedged sword, piercing even to the dividing asunder of soul and spirit, and of the joints and marrow, and is a discerner of the thoughts and intents of the heart.** ¹³ Neither is there any creature that is not manifest in his sight: but all things are naked and opened unto the eyes of him with whom we have to do. ¹⁴ Seeing then that we have a great high priest, that is passed into the heavens, Jesus the Son of God, let us hold fast our profession. ¹⁵ For we have not an high priest which cannot be touched with the feeling of our infirmities; but was in all points tempted like as we are, yet without sin. ¹⁶ Let us therefore come boldly unto the throne of grace, that we may obtain mercy, and find grace to help in time of need.*

Explanation

First remember what the Word of God is used for, as defined in this passage. It is used to conquer any obstacle, through faith in God, through obedience to His Word. **Hebrews 4:12**

Text

St. Matthew 6:33

Matthew 6

¹ Take heed that ye do not your alms before men, to be seen of them: otherwise ye have no reward of your Father which is in heaven. ² Therefore when thou doest thine alms, do not sound a trumpet before thee, as the hypocrites do in the synagogues and in the streets, that they may have glory of men. Verily I say unto you, They have their reward. ³ But when thou doest alms, let not thy left hand know what thy right hand doeth: ⁴ That thine alms may be in secret: and thy Father which seeth in secret himself shall reward thee openly. ⁵ And when thou prayest, thou shalt not be as the hypocrites are: for they love to pray standing in the synagogues and in the corners of the streets, that they may be seen of men. Verily I say unto you, They have their reward. ⁶ But thou, when thou prayest, enter into thy closet, and when thou hast shut thy door, pray to thy Father which is in secret; and thy Father which seeth in secret shall reward thee openly. ⁷ But when ye pray, use not vain repetitions, as the heathen do: for they think that they shall be heard for their much speaking. ⁸ Be not ye therefore like unto them: for your Father knoweth what things ye have need of, before ye ask him. ⁹ After this manner therefore pray ye: Our Father which art in heaven, Hallowed be thy name. ¹⁰ Thy kingdom come, Thy will be done in earth, as it is in heaven. ¹¹ Give us this day our daily bread. ¹² And forgive us our debts, as we forgive our debtors. ¹³ And lead us not into temptation, but deliver us from evil: For thine is the kingdom, and the power, and the glory, for ever. Amen. ¹⁴ For if ye forgive men their trespasses, your heavenly Father will also forgive you: ¹⁵ But if ye forgive not men their trespasses, neither will your Father forgive your trespasses. ¹⁶ Moreover when ye fast, be not, as the hypocrites, of a sad countenance: for they disfigure their faces, that they may appear unto men to fast. Verily I say unto you, They have their reward. ¹⁷ But thou, when thou fastest, anoint thine head, and wash thy face; ¹⁸ That thou appear not unto men to fast, but unto thy Father which is in secret: and thy Father, which seeth in secret, shall reward thee openly. ¹⁹ Lay not up for yourselves treasures upon earth, where moth and rust doth corrupt, and where thieves break through and steal: ²⁰ But lay up for yourselves treasures in heaven, where neither moth nor rust doth corrupt, and where thieves do not break through nor steal: ²¹ For where your treasure is, there will your heart be also. ²² The light of the body is the eye: if therefore thine eye be single, thy whole body shall be full of light. ²³ But if thine eye be evil, thy whole body shall be full of darkness. If therefore the light that is in thee be darkness, how great is that darkness! ²⁴ No man can serve two masters: for either he will hate the one, and

love the other; or else he will hold to the one, and despise the other. Ye cannot serve God and mammon. 25 *Therefore I say unto you, Take no thought for your life, what ye shall eat, or what ye shall drink; nor yet for your body, what ye shall put on. Is not the life more than meat, and the body than raiment?* 26 *Behold the fowls of the air: for they sow not, neither do they reap, nor gather into barns; yet your heavenly Father feedeth them. Are ye not much better than they?* 27 *Which of you by taking thought can add one cubit unto his stature?* 28 *And why take ye thought for raiment? Consider the lilies of the field, how they grow; they toil not, neither do they spin:* 29 *And yet I say unto you, That even Solomon in all his glory was not arrayed like one of these.* 30 *Wherefore, if God so clothe the grass of the field, which to day is, and to morrow is cast into the oven, shall he not much more clothe you, O ye of little faith?* 31 *Therefore take no thought, saying, What shall we eat? or, What shall we drink? or, Wherewithal shall we be clothed?* 32 *(For after all these things do the Gentiles seek:) for your heavenly Father knoweth that ye have need of all these things.* 33 ***But seek ye first the kingdom of God, and his righteousness; and all these things shall be added unto you.*** 34 *Take therefore no thought for the morrow: for the morrow shall take thought for the things of itself. Sufficient unto the day is the evil thereof.*

Explanation

Wait patiently on the Lord, for any request that you, as a believer hath made, before the Lord, in prayer, knowing that only through divine intervention, can the request be fulfilled, answered or completed. **St. Matthew 6:33**

Temptation, Test or Trail

Text
I Corinthians 10:13

1 Corinthians 10

1 *Moreover, brethren, I would not that ye should be ignorant, how that all our fathers were under the cloud, and all passed through the sea;* 2 *And were all baptized unto Moses in the cloud and in the sea;* 3 *And did all eat the same spiritual meat;* 4 *And did all drink the same spiritual drink: for they drank*

of that spiritual Rock that followed them: and that Rock was Christ. ⁵ But with many of them God was not well pleased: for they were overthrown in the wilderness. ⁶ Now these things were our examples, to the intent we should not lust after evil things, as they also lusted. ⁷ Neither be ye idolaters, as were some of them; as it is written, The people sat down to eat and drink, and rose up to play. ⁸ Neither let us commit fornication, as some of them committed, and fell in one day three and twenty thousand. ⁹ Neither let us tempt Christ, as some of them also tempted, and were destroyed of serpents. ¹⁰ Neither murmur ye, as some of them also murmured, and were destroyed of the destroyer. ¹¹ Now all these things happened unto them for ensamples: and they are written for our admonition, upon whom the ends of the world are come. ¹² Wherefore let him that thinketh he standeth take heed lest he fall. **¹³ There hath no temptation taken you but such as is common to man: but God is faithful, who will not suffer you to be tempted above that ye are able; but will with the temptation also make a way to escape, that ye may be able to bear it.** *¹⁴ Wherefore, my dearly beloved, flee from idolatry. ¹⁵ I speak as to wise men; judge ye what I say. ¹⁶ The cup of blessing which we bless, is it not the communion of the blood of Christ? The bread which we break, is it not the communion of the body of Christ? ¹⁷ For we being many are one bread, and one body: for we are all partakers of that one bread. ¹⁸ Behold Israel after the flesh: are not they which eat of the sacrifices partakers of the altar? ¹⁹ What say I then? that the idol is any thing, or that which is offered in sacrifice to idols is any thing? ²⁰ But I say, that the things which the Gentiles sacrifice, they sacrifice to devils, and not to God: and I would not that ye should have fellowship with devils. ²¹ Ye cannot drink the cup of the Lord, and the cup of devils: ye cannot be partakers of the Lord's table, and of the table of devils. ²² Do we provoke the Lord to jealousy? are we stronger than he? ²³ All things are lawful for me, but all things are not expedient: all things are lawful for me, but all things edify not. ²⁴ Let no man seek his own, but every man another's wealth. ²⁵ Whatsoever is sold in the shambles, that eat, asking no question for conscience sake: ²⁶ For the earth is the Lord's, and the fulness thereof. ²⁷ If any of them that believe not bid you to a feast, and ye be disposed to go; whatsoever is set before you, eat, asking no question for conscience sake. ²⁸ But if any man say unto you, this is offered in sacrifice unto idols, eat not for his sake that shewed it, and for conscience sake: for the earth is the Lord's, and the fulness thereof: ²⁹ Conscience, I say, not thine own, but of the other: for why is my liberty judged of another man's conscience? ³⁰ For if I by grace be a partaker, why am I evil spoken of for that for which I give thanks? ³¹ Whether therefore*

ye eat, or drink, or whatsoever ye do, do all to the glory of God. 32 Give none offence, neither to the Jews, nor to the Gentiles, nor to the church of God: 33 Even as I please all men in all things, not seeking mine own profit, but the profit of many, that they may be saved.

Explanation

We, as believers can go through any test, trail, or conquer any temptation, through faith in God. However, our faith will not be enough. We must exercise our faith through tasks performance. We must find out what we need to do to be able to bear the test, trail or temptation, as our way of escape, as we go through. Therefore, the Word of God tells us to first examine ourselves to see where we are in the faith. First, we ask ourselves the question: Are we walking the walk, or just talking? Secondly, do we take daily time out of our busy schedule to have a private fellowship with God? Third, have we repented of wrong actions to others and made correction, with our fellow man. Lastly, have we redeemed our actions with God, placing us once more into the right standing in the fellowship of His calling, through faith? **I Corinthians 10:13**

Also
Going Through, More than Conquers

Text
Romans 8:37 (See Unit 1 chapter 1 full text)
Nay, in all these things, we are more than conquerors, through Him that loved us.

Explanation

We must go through believing that, through Christ, we can conquer anything.
Romans 8:37

Remember the Power of the Tongue

Text
James 3:8

James 3

[1] *My brethren, be not many masters, knowing that we shall receive the greater condemnation.* [2] *For in many things we offend all. If any man offend not in word, the same is a perfect man, and able also to bridle the whole body.* [3] *Behold, we put bits in the horses' mouths, that they may obey us; and we turn about their whole body.* [4] *Behold also the ships, which though they be so great, and are driven of fierce winds, yet are they turned about with a very small helm, whithersoever the governor listeth.* [5] *Even so the tongue is a little member, and boasteth great things. Behold, how great a matter a little fire kindleth!* [6] *And the tongue is a fire, a world of iniquity: so is the tongue among our members, that it defileth the whole body, and setteth on fire the course of nature; and it is set on fire of hell.* [7] *For every kind of beasts, and of birds, and of serpents, and of things in the sea, is tamed, and hath been tamed of mankind:* [8] ***But the tongue can no man tame; it is an unruly evil, full of deadly poison.*** [9] *Therewith bless we God, even the Father; and therewith curse we men, which are made after the similitude of God.* [10] *Out of the same mouth proceedeth blessing and cursing. My brethren, these things ought not so to be.* [11] *Doth a fountain send forth at the same place sweet water and bitter?* [12] *Can the fig tree, my brethren, bear olive berries? either a vine, figs? so can no fountain both yield salt water and fresh.* [13] *Who is a wise man and endued with knowledge among you? let him shew out of a good conversation his works with meekness of wisdom.* [14] *But if ye have bitter envying and strife in your hearts, glory not, and lie not against the truth.* [15] *This wisdom descendeth not from above, but is earthly, sensual, devilish.* [16] *For where envying and strife is, there is confusion and every evil work.* [17] *But the wisdom that is from above is first pure, then peaceable, gentle, and easy to be intreated, full of mercy and good fruits, without partiality, and without hypocrisy.* [18] *And the fruit of righteousness is sown in peace of them that make peace.*

Explanation

Remember as we use the word as a weapon, that the tongue is the most powerful carnal weapon that we possess. Therefore, we are to remember what we say. Also, we are to think before we speak. **James 3:8**

Fear

Text
II Timothy 1:7

2 Timothy 1

¹ Paul, an apostle of Jesus Christ by the will of God, according to the promise of life which is in Christ Jesus, ² To Timothy, my dearly beloved son: Grace, mercy, and peace, from God the Father and Christ Jesus our Lord. ³ I thank God, whom I serve from my forefathers with pure conscience, that without ceasing I have remembrance of thee in my prayers night and day; ⁴ Greatly desiring to see thee, being mindful of thy tears, that I may be filled with joy; ⁵ When I call to remembrance the unfeigned faith that is in thee, which dwelt first in thy grandmother Lois, and thy mother Eunice; and I am persuaded that in thee also. ⁶ Wherefore I put thee in remembrance that thou stir up the gift of God, which is in thee by the putting on of my hands. ⁷ **For God hath not given us the spirit of fear; but of power, and of love, and of a sound mind.** *⁸ Be not thou therefore ashamed of the testimony of our Lord, nor of me his prisoner: but be thou partaker of the afflictions of the gospel according to the power of God; ⁹ Who hath saved us, and called us with an holy calling, not according to our works, but according to his own purpose and grace, which was given us in Christ Jesus before the world began, ¹⁰ But is now made manifest by the appearing of our Saviour Jesus Christ, who hath abolished death, and hath brought life and immortality to light through the gospel: ¹¹ Whereunto I am appointed a preacher, and an apostle, and a teacher of the Gentiles. ¹² For the which cause I also suffer these things: nevertheless I am not ashamed: for I know whom I have believed, and am persuaded that he is able to keep that which I have committed unto him against that day. ¹³ Hold fast the form of sound words, which thou hast heard of me, in faith and love which is in Christ Jesus. ¹⁴ That good thing which was committed unto thee keep by the Holy Ghost which dwelleth in us. ¹⁵ This thou knowest, that all they which are in Asia be turned away from me; of whom are Phygellus and Hermogenes. ¹⁶ The Lord give mercy unto the house of Onesiphorus; for he oft refreshed me, and was not ashamed of my chain: ¹⁷ But, when he was in Rome, he sought me out very diligently, and found me. ¹⁸ The Lord grant unto him that he may find mercy of the Lord in that day: and in how many things he ministered unto me at Ephesus, thou knowest very well.*

Explanation

When confronted with the **spirit of fear,** we as believers must remember that with God **fear does not exist.** We are to repeat the verse over and over, until that spirit of fear, leaves us and we are standing upon a positive belief. **II Timothy 1:7**

Against Adversity

Text
Isaiah 54:17

Isaiah 54

¹ Sing, O barren, thou that didst not bear; break forth into singing, and cry aloud, thou that didst not travail with child: for more are the children of the desolate than the children of the married wife, saith the LORD. ² Enlarge the place of thy tent, and let them stretch forth the curtains of thine habitations: spare not, lengthen thy cords, and strengthen thy stakes; ³ For thou shalt break forth on the right hand and on the left; and thy seed shall inherit the Gentiles, and make the desolate cities to be inhabited. ⁴ Fear not; for thou shalt not be ashamed: neither be thou confounded; for thou shalt not be put to shame: for thou shalt forget the shame of thy youth, and shalt not remember the reproach of thy widowhood any more. ⁵ For thy Maker is thine husband; the LORD of hosts is his name; and thy Redeemer the Holy One of Israel; The God of the whole earth shall he be called. ⁶ For the LORD hath called thee as a woman forsaken and grieved in spirit, and a wife of youth, when thou wast refused, saith thy God. ⁷ For a small moment have I forsaken thee; but with great mercies will I gather thee. ⁸ In a little wrath I hid my face from thee for a moment; but with everlasting kindness will I have mercy on thee, saith the LORD thy Redeemer. ⁹ For this is as the waters of Noah unto me: for as I have sworn that the waters of Noah should no more go over the earth; so have I sworn that I would not be wroth with thee, nor rebuke thee. ¹⁰ For the mountains shall depart, and the hills be removed; but my kindness shall not depart from thee, neither shall the covenant of my peace be removed, saith the LORD that hath mercy on thee. ¹¹ O thou afflicted, tossed with tempest, and not comforted, behold, I will lay thy stones with fair colours, and lay thy foundations with sapphires. ¹² And I will make thy windows of agates,

and thy gates of carbuncles, and all thy borders of pleasant stones. *[13]* *And all thy children shall be taught of the LORD; and great shall be the peace of thy children.* *[14]* *In righteousness shalt thou be established: thou shalt be far from oppression; for thou shalt not fear: and from terror; for it shall not come near thee.* *[15]* *Behold, they shall surely gather together, but not by me: whosoever shall gather together against thee shall fall for thy sake.* *[16]* *Behold, I have created the smith that bloweth the coals in the fire, and that bringeth forth an instrument for his work; and I have created the waster to destroy.* *[17]* ***No weapon that is formed against thee shall prosper; and every tongue that shall rise against thee in judgment thou shalt condemn. This is the heritage of the servants of the LORD, and their righteousness is of me, saith the LORD.***

Explanation

As a believer in Christ Jesus, we have the privilege of being able to use the Word of God as a weapon. All we have to do is repeat this verse over and over whenever doubt arises, when found in the midst of adversity. **Isaiah 54:17**

Text

St. John 10:10 (See Unit 8 chapter 4 full text)
The thief comes to kill, to steal and to destroy.

Explanation

The believer in Christ Jesus, those who have accepted the Lord Jesus Christ as their **personal savior,** must remember that it is the job of the **adversary,** to either,

- Kill
- Steal or
- Destroy

Whatever is good, perfect and or profitable, for the up building of the kingdom of God. The Adversary uses other people and or creates situations that will enable us to be tempted, at our weakest moment. We must not give in. Repeat, St. John 10:10, until we know with confidence, that God

will see us through, every step of the way, through Jesus Christ, our Savior. **St. John 10:10**

An Attack: To From Emotional Breakdown

Text
Philippians 4:8
Finally brethren, whosoever things are true, whatsoever things are honest, whatsoever things are just, whatsoever things are pure, whatsoever things are lovely, whatsoever things are of good report; if there be any virtue, if there be any praise, think on these things.

Explanation

Even though, we are believers in Christ Jesus, we sometimes have an attack of the emotional, mental or nervous system. When unrest attempts to prevail, we must remember to counter attack negative with positive thoughts. Repeat this verse over and over, until there is complete mental confidence, that God is in complete control of the situation, also remembering one or two other verses from above, to go along with this one. **Philippians 4:8**

Conclusion

- We as believer need to learn how to use the Word of God as a weapon.
- In doing so, we can have victory over any situation or circumstance, as we hold fast to our profession of faith, without wavering.
- Therefore, memorize God's Word.

Home Assignment

Select
- One scripture from each category,
Memorize
- It and
Learn
- To use it as a weapon.
Take the sheet with you where ever you go.

Questions

As a recruit, in the Armed Service of and for the Lord Jesus Christ, what is your field of service for evangelizing, or winning souls to Christ?

_____One on one missionary work, within your everyday travels

_____Assisting in the Soup Kitchen, or helping the needy in some other capacity

_____Passing out salvation tracts you have obtained from your local church, or the Bible Book store of your choice, to assist with an understanding of why we do the things that we do

_____Being a witness for Christ, in your community, by the life that you live

_____ All of the above

Thought Question

Which one of the scripture do you think you will use the most? Why?

The Sheet

Select a scripture from each of these categories to memorize.
Using the Sword of the Shield as a Weapon

Conquering all obstacles

Temptation, Test or Trail

Going Through

Remembering the Power of the Tongue

Fear

Against Adversity

An Attack: To Form Emotional Breakdown

Study Components for Bible Chapter 3

Text
II Timothy 2:15-16
II Thessalonians 2:7-8

Introduction

In our modern day society, we have access to at our fingertips a wealth of knowledge. We can study and learn whatever we desire through the thought of a topic, arriving at a reference source. If we have access to a computer, we do not have to leave the comfort of indoors. If we cannot afford a computer, we live in a world of freedom of education, for most societies, wherein we can walk, catch the bus, or drive to the neighborhood library.

If we like to read, the librarian is there to assist us with take out material. Again, all we need is a topic and a library card. If we want to access knowledge from the internet, but do not know how to use the computer, the librarian is there to assist us and to pull up information and even print it out for us. All we need to do is to go early, prior to evening hours. Therefore, we live in a world that there is no excuse. It is called technology and assistance. The Word of God admonishes us to study to be quiet. It is with that quiet spirit that God, through the unction of the Holy Spirit can speak to our hearts, and minds to provide topics of discussion and concern for us to investigate on our own. We live in a time, within our Western society that we have assess and freedom to do all things. However, that opportunity for us will soon be closed as we fastly approach the season of the appearing or the manifestation of the Anti-Christ. The spirit of the Anti-Christ is even now at the door. Note the following scripture which begins the lesson.

The Lesson

Text
II Thessalonians 2:7-8

2 Thessalonians 2

¹ Now we beseech you, brethren, by the coming of our Lord Jesus Christ, and by our gathering together unto him, ² That ye be not soon shaken in mind, or be troubled, neither by spirit, nor by word, nor by letter as from us, as that the day of Christ is at hand. ³ Let no man deceive you by any means: for that day shall not come, except there come a falling away first, and that man of sin be revealed, the son of perdition; ⁴ Who opposeth and exalteth himself above all that is called God, or that is worshipped; so that he as God sitteth in the temple of God, shewing himself that he is God. ⁵ Remember ye not, that, when I was yet with you, I told you these things? ⁶ And now ye know what withholdeth that he might be revealed in his time. **⁷ For the mystery of iniquity doth already work: only he who now letteth will let, until he be taken out of the way. ⁸ And then shall that Wicked be revealed, whom the Lord shall consume with the spirit of his mouth, and shall destroy with the brightness of his coming:** *⁹ Even him, whose coming is after the working of Satan with all power and signs and lying wonders, ¹⁰ And with all deceivableness of unrighteousness in them that perish; because they received not the love of the truth, that they might be saved. ¹¹ And for this cause God shall send them strong delusion, that they should believe a lie: ¹² That they all might be damned who believed not the truth, but had pleasure in unrighteousness. ¹³ But we are bound to give thanks alway to God for you, brethren beloved of the Lord, because God hath from the beginning chosen you to salvation through sanctification of the Spirit and belief of the truth: ¹⁴ Whereunto he called you by our gospel, to the obtaining of the glory of our Lord Jesus Christ. ¹⁵ Therefore, brethren, stand fast, and hold the traditions which ye have been taught, whether by word, or our epistle. ¹⁶ Now our Lord Jesus Christ himself, and God, even our Father, which hath loved us, and hath given us everlasting consolation and good hope through grace, ¹⁷ Comfort your hearts, and stablish you in every good word and work.*

Explanation

Iniquity in any form, fashion or person, is, and will, evolve to completion, but only for a little season, as we wait for the Second Coming of Christ. Therefore, study. Learn how to study and what to use to study in order to be able to successfully perform your study. You should have a working knowledge of the *study components of the Bible,* upon completion of this segment. **II Thessalonians 2:7-8**

Therefore

Text
II Timothy 2:15-16

2 Timothy 2

¹ Thou therefore, my son, be strong in the grace that is in Christ Jesus. ² And the things that thou hast heard of me among many witnesses, the same commit thou to faithful men, who shall be able to teach others also. ³ Thou therefore endure hardness, as a good soldier of Jesus Christ. ⁴ No man that warreth entangleth himself with the affairs of this life; that he may please him who hath chosen him to be a soldier. ⁵ And if a man also strive for masteries, yet is he not crowned, except he strive lawfully. ⁶ The husbandman that laboureth must be first partaker of the fruits. ⁷ Consider what I say; and the Lord give thee understanding in all things. ⁸ Remember that Jesus Christ of the seed of David was raised from the dead according to my gospel: ⁹ Wherein I suffer trouble, as an evil doer, even unto bonds; but the word of God is not bound. ¹⁰ Therefore I endure all things for the elect's sakes, that they may also obtain the salvation which is in Christ Jesus with eternal glory. ¹¹ It is a faithful saying: For if we be dead with him, we shall also live with him: ¹² If we suffer, we shall also reign with him: if we deny him, he also will deny us: ¹³ If we believe not, yet he abideth faithful: he cannot deny himself. ¹⁴ Of these things put them in remembrance, charging them before the Lord that they strive not about words to no profit, but to the subverting of the hearers. *¹⁵ **Study to shew thyself approved unto God, a workman that needeth not to be ashamed, rightly dividing the word of truth. ¹⁶ But shun profane and vain babblings: for they will increase unto more ungodliness.** ¹⁷ And their word will eat as doth a canker: of whom is Hymenaeus and Philetus; ¹⁸ Who concerning the*

truth have erred, saying that the resurrection is past already; and overthrow the faith of some. [19] Nevertheless the foundation of God standeth sure, having this seal, The Lord knoweth them that are his. And, let every one that nameth the name of Christ depart from iniquity. [20] But in a great house there are not only vessels of gold and of silver, but also of wood and of earth; and some to honour, and some to dishonour. [21] If a man therefore purge himself from these, he shall be a vessel unto honour, sanctified, and meet for the master's use, and prepared unto every good work. [22] Flee also youthful lusts: but follow righteousness, faith, charity, peace, with them that call on the Lord out of a pure heart. [23] But foolish and unlearned questions avoid, knowing that they do gender strifes. [24] And the servant of the Lord must not strive; but be gentle unto all men, apt to teach, patient, [25] In meekness instructing those that oppose themselves; if God peradventure will give them repentance to the acknowledging of the truth; [26] And that they may recover themselves out of the snare of the devil, who are taken captive by him at his will.

Explanation

We as believers in Christ Jesus have a responsibility to study the Word of God. In doing so, we are called stewards or workmen. **II Timothy 2:15-16**

Cross Reference

Explanation

- This is wherever the phrase is mentioned in similar fashion, in other locations of the Bible.
- The lower case letter or number beside the phrase is matched with the lower case letter/number in the cross reference located in the middle of the reference Study Bible. **II Timothy 2:15-16**

Index

Explanation

- It provides the location of various words, throughout the Bible.
- It can also serve as an over view of the bible contents.

- An online index can also be used.
 (See illustration below through the net by a bible index search).

Bible Dictionary

Explanation

- This provides Biblical meaning to words.
- Usually found:
 1. In the back of your Study Bible.
 2. Can be purchased separately online or through a Bible Book Store.
 3. Or words can be defined through the net in a Bible Dictionary Resource.

(See illustration below obtained through the net by a bible dictionary search)

Glossary of Biblical Words

Explanation

- This is located in a Reference Study Bible, in place of a Bible Dictionary, located in the back of the Bible.
- The glossary is used in place of a Bible Dictionary in the back of your Study Bible
- The **Glossary** is also defined as a dictionary and a cross reference.

Footnotes

Explanation

- Provide additional information from other resources, which begin, where ever the letter or number begins.
- The footnotes are located at the bottom of each page, where ever necessary, in a reference study Bible, labeled with the same lower case letter or number.

Home Assignment

- Followed after the Illustration
- Note the following illustration

An Illustration of all Examples

The illustration on sin serves as an all purpose example for bible study guide usage
All of the following components are illustrated:
Bible Index Online Illustration: **Bible Dictionary** can be included in the **glossary**. The glossary can serve as an index for **location** as well as providing **meaning. Glossary** of biblical words can be included in the index. The **Cross References** on sin show the **other** bible locations or **scriptures** noted in the index location.**Footnotes** are illustrated at the end of the online illustration, which begin with, **Sin.** www.bibletopics.com also www.bibletopics.com/sin.htm/

Home Assignment

Learn how to cross reference a scripture to obtain more information, in another location of the bible on the same subject. Know that a foot notes provides the reader with outside information, regarding the subject, and its reference source data.

SIN

SIN: Is the transgression of the law.**1 John 3:4** Whosoever committeth sin transgresseth also the law: for sin is the transgression of the law.Is of the devil. **1 John 3:8** He that committeth sin is of the devil; for the devil sinneth from the beginning. For this purpose the Son of God was manifested, that he might destroy the works of the devil. **John 8:44** Ye are of *your* father the devil, and the lusts of your father ye will do. He was a murderer from the beginning, and abode not in the truth, because there is no truth in him. When he speaketh a lie, he speaketh of his own: for he is a liar, and the father of it.All unrighteousness is. **1 John 5:17** All unrighteousness is sin: and there is a sin not unto death. Omission of what we know to be good is. **James 4:17** Therefore to him that knoweth to do

good, and doeth *it* not, to him it is sin.Whatever is not of faith is. **Romans 14:23** And he that doubteth is damned if he eat, because *he eateth* not of faith: for whatsoever *is* not of faith is sin. The thought of foolishness is. **Proverbs 24:9** The thought of foolishness *is* sin: and the scorner *is* an abomination to men. All the imaginations of the unrenewed heart are. **Genesis 6:5** And GOD saw that the wickedness of man *was* great in the earth, and *that* every imagination of the thoughts of his heart *was* only evil continually. **Genesis 8:21** And the LORD smelled a sweet savour; and the LORD said in his heart, I will not again curse the ground any more for man's sake; for the imagination of man's heart *is* evil from his youth; neither will I again smite any more every thing living, as I have done. Described as, Coming from the heart. **Matthew 15:19** For out of the heart proceed evil thoughts, murders, adulteries, fornications, thefts, false witness, blasphemies:The fruit of lust. **James 1:15** Then when lust hath conceived, it bringeth forth sin: and sin, when it is finished, bringeth forth death.The sting of death. **1 Corinthians 15:56** The sting of death *is* sin; and the strength of sin *is* the law.Rebellion against God. **Deuteronomy 9:7** Remember, *and* forget not, how thou provokedst the LORD thy God to wrath in the wilderness: from the day that thou didst depart out of the land of Egypt, until ye came unto this place, ye have been rebellious against the LORD. **Joshua 1:18** Whosoever *he be* that doth rebel against thy commandment, and will not hearken unto thy words in all that thou commandest him, he shall be put to death: only be strong and of a good courage.Works of darkness. **Ephesians 5:11** And have no fellowship with the unfruitful works of darkness, but rather reprove *them*, as dead works. **Hebrews 6:1** Therefore leaving the principles of the doctrine of Christ, let us go on unto perfection; not laying again the foundation of repentance from dead works, and of faith toward God, **Hebrews 9:14** How much more shall the blood of Christ, who through the eternal Spirit offered himself without spot to God, purge your conscience from dead works to serve the living God? It is the abominable thing that God hates. **Proverbs 15:9** The way of the wicked *is* an abomination unto the LORD: but he loveth him that followeth after righteousness. **Jeremiah 44:4** Howbeit I sent unto you all my servants the prophets, rising early and sending *them*, saying, Oh, do not this abominable thing that I hate. **Jeremiah 44:11** Therefore thus saith the LORD of hosts, the God of Israel; Behold, I will set my face against you for evil, and to cut off all Judah.Reproaching the Lord. **Numbers 15:30** But the soul that doeth *ought* presumptuously,

whether he be born in the land, or a stranger, the same reproacheth the LORD; and that soul shall be cut off from among his people. **Psalms 74:18** Remember this, *that* the enemy hath reproached, O LORD, and *that* the foolish people have blasphemed thy name. Defiling as, **Proverbs 30:12** *There is* a generation *that are* pure in their own eyes, and *yet* is not washed from their filthiness. **Isaiah 59:3** For your hands are defiled with blood, and your fingers with iniquity; your lips have spoken lies, your tongue hath muttered perverseness. Deceitful as, **Hebrews 3:13** But exhort one another daily, while it is called To day; lest any of you be hardened through the deceitfulness of sin. Disgraceful as, **Proverbs 14:34** Righteousness exalteth a nation: but sin *is* a reproach to any people. Often very great as in, **Exodus 32:20** And he took the calf which they had made, and burnt *it* in the fire, and ground *it* to powder, and strawed *it* upon the water, and made the children of Israel drink *of it*. **1 Samuel 2:17** Wherefore the sin of the young men was very great before the LORD: for men abhorred the offering of the LORD. Often might as, **Amos 5:12** For I know your manifold transgressions and your mighty sins: they afflict the just, they take a bribe, and they turn aside the poor in the gate *from their right*. Often manifold as, **Amos 5:12** For I know your manifold transgressions and your mighty sins: they afflict the just, they take a bribe, and they turn aside the poor in the gate *from their right*. Often presumptuous as, **Psalms 19:13** Keep back thy servant also from presumptuous *sins*; let them not have dominion over me: then shall I be upright, and I shall be innocent from the great transgression. Sometimes open and manifest as, **1 Timothy 5:24** Some men's sins are open beforehand, going before to judgment; and some *men* they follow after. Sometimes secret as, **Psalms 90:8** Thou hast set our iniquities before thee, our secret *sins* in the light of thy countenance. **1 Timothy 5:24** Some men's sins are open beforehand, going before to judgment; and some *men* they follow after. Besetting as, **Hebrews 12:1** Wherefore seeing we also are compassed about with so great a cloud of witnesses, let us lay aside every weight, and the sin which doth so easily beset *us*, and let us run with patience the race that is set before us. Like scarlet and crimson as, **Isaiah 1:18** Come now, and let us reason together, saith the LORD: though your sins be as scarlet, they shall be as white as snow; though they be red like crimson, they shall be as wool. Reaching unto heaven as, **Revelation 18:5** For her sins have reached unto heaven, and God hath remembered her iniquities. Entered into the world by Adam as, **Genesis 3:6-7** And when the woman saw that the tree *was*

good for food, and that it *was* pleasant to the eyes, and a tree to be desired to make *one* wise, she took of the fruit thereof, and did eat, and gave also unto her husband with her; and he did eat. And the eyes of them both were opened, and they knew that they *were* naked; and they sewed fig leaves together, and made themselves aprons. All men are conceived and born as, **Genesis 5:3** And Adam lived an hundred and thirty years, and begat *a son* in his own likeness, after his image; and called his name Seth: **Job 15:14** What *is* man, that he should be clean? and *he which is* born of a woman, that he should be righteous? **Job 25:4** How then can man be justified with God? or how can he be clean *that is* born of a woman? **Psalms 51:5** Behold, I was shapen in iniquity; and in sin did my mother conceive me. All men are shapen in. **Psalms 51:5** Behold, I was shapen in iniquity; and in sin did my mother conceive me. Scripture concludes all under. **Galatians 3:22** But the scripture hath concluded all under sin, that the promise by faith of Jesus Christ might be given to them that believe. No man is without. **1 Kings 8:46** If they sin against thee, (for *there is* no man that sinneth not,) and thou be angry with them, and deliver them to the enemy, so that they carry them away captives unto the land of the enemy, far or near; **Ecclesiastes 7:20** For *there is* not a just man upon earth, that doeth good, and sinneth not. Christ alone was without as in, **2 Corinthians 5:21** For he hath made him *to be* sin for us, who knew no sin; that we might be made the righteousness of God in him. **Hebrews 4:15** For we have not an high priest which cannot be touched with the feeling of our infirmities; but was in all points tempted like as *we are, yet* without sin. **Hebrews 7:26** For such an high priest became us, *who is* holy, harmless, undefiled, separate from sinners, and made higher than the heavens; **1 John 3:5** And ye know that he was manifested to take away our sins; and in him is no sin. (This is a partial cross reference) www.bibletopics. com also www.bibletopics.com/sin.htm/

Explanation

This illustration is a cross reference, Bible topical index/definition, glossary, all in one illustrated from the Net, using the look up of *sin*. Once looked up, it was impossible to cut it short. This text covers all aspects of sin throughout the entire Bible. If you have access to a computer, you have access to a world of knowledge, more than you could possibly imagine, just by asking a question in the top margin of the internet.

Chapter 4

Week One: Review
Week Two: Open Book Test
Week Three: Review and Open Discussion of the Unit

Unit 11 the Word of God
The Infallible Word of God

What three scriptures tell of the writings of the Bible?

How were the writings of the bible written? Provide (3) points taken from the lesson, with scripture.

Name (3) reasons why we should use the Word of God, found in this lesson. Provide scripture.

With Faith, Use the Word of God as a Weapon
Home Assignment

Select
• One scripture from each category,
Memorize
• It and
Learn
• To use it as a weapon.
Take the sheet with you where ever you go.

The Sheet

Select a scripture from each of these categories to memorize.
Using the Sword of the Shield as a Weapon

Conquering all obstacles

Temptation, Test or Trail

Going Through

Remembering the Power of the Tongue

Fear

Against Adversity

An Attack: To Form Emotional Breakdown

Study Components of the Bible

Home Assignment

Learn how to cross reference a scripture to obtain more information, in another location of the bible on the same subject. Know that a foot notes provides the reader with outside information, regarding the subject, and its reference source data.

UNIT 12: FINAL PREPARATION

Contents

Unit Introduction

With this unit we shall conclude all things for the year. This text is used as a beginner's class for New Converts. This course is entitled: ***Salvation and Spiritual Growth.*** In this class, there is no failures, only winners. You will have to work, in order to achieve what God wants you to achieve, which is to have a working knowledge of: What Salvation is. What it means to began a journey with God, through His Son, by way of The Eternal Instructor, the Holy Spirit. Take time out to write down everything. It is through repetition that the Holy Spirit will bring whatever is need, back to your remembrance, when there is no Bible to refer to. Very soon, as we begin to approach the end of Liberty of spirituality, for those, who are in this Western World, our Bibles will be taken away from us. Someone will enter our homes and take all that is of God and will forbid us to teach, read, and associate with the doctrine of Salvation and those who have been reborn.

There are others in other parts of the world who are experiencing such. Our time, if the Lord does not return, in His Second Coming, and delay His arrival, is yet at the door. Will you be ready when He comes? It is stated that as He arrives He will come as a Thief in the Night. It is further stated that no one knows the day, nor the hour when the Son of Man cometh. The Word of God further states that even the Son of God does not know, nor the angels in heaven. There is only One who know and His Name is I AM. *Get ready and be ready . . .*

Chapter 1
Preparation for the Final Exam

If you are not in a classroom setting, it is suggested that you have a study partner, so that you can perform these tasks amongst yourselves. Students or Believers in Christ Jesus will: Review all end of the chapter questions from the unit. Be prepared for your open book exam the following week. If you are being self taught, it is suggested that you have a study partner, even if you have to share your book with that selected partner. Remember, there are no failures only winners. This course is designed for all who can read and understand English, to successfully past the course with excellence.Repetition is the key to learning. Then once you have learned, apply it to your life. This is a three year level course. Within the three year period, you should have acquired the following self taught text books:

Salvation and Spiritual Growth—*Beginners Level 1 or New Convert*
Salvation and the Spiritual Walk—*Intermediate Level 2*
Salvation with A Faith Walk—*The Matured Level 3*

In addition, I have a Poetic Message for fine reading entitled:

A Song in the Night Season

All Four of these books will be at Amazon.com and at Barnes and Nobles Bookstores, within the next six months. As a conclusion for your thought for study, I will leave you with this scripture: Matthews 5:39 Search the scriptures, for in them ye think ye have eternal life, and they are they which testify of me.

God Bless you all.

Apostle Dr. June H. Lawrence, Phil 4:7.

The Final Exam
Open Book
Take Home

Instructions

General

- Read the statement of Faith
- Answer the following Questions below

Materials Needed

- Your Bible
- Your Notebook
- Pen or Pencil
- The Exam
- Nothing else should be on your desk if in a classroom or within another setting.

Questions

The Infallible Word of God

What three scriptures tell of the purpose of the writings of the Bible?

How were the writings of the bible written? Provide (2) points taken from the lesson, with scripture.

Name (3) reasons why we should use the Word of God, found in these lessons. Provide scripture.

Angels and Demons

What three things have you learned about the devil in this lesson, which resulted in his fall? Take note that all should be interpreted through the passages that begin with the statement "I." Also provide the scripture. (It is defined as a statement, within itself)

How was the Adversary described in both texts?
Ezekiel 28:12-15

Isaiah 14:12-17

Name three names for the devil, denoted in the two texts?

The Church: The Body of Believers

The first church is recorded in what book of the New Testament?

Provide five titles for the body of believers who are the church. Also, provide scripture

Why do we take communion? (2)What is its meaning in regard to the bread and the wine? (3) What do they also represent?

God the Father

Who are the three that bare record in heaven and agree as one? Provide the scripture. What is this text explaining?

Who are the three that bare record on earth, making up the key components of the composition of mankind? Provide the scripture.

Who is the begotten of the Father? What does begotten mean. Provide scripture.

Name seven titles of God which also defines His identity, and role within the Holy Scriptures. Supply the following:
Title_____Role_____Scripture

Name (7), titles, with definitions and scriptures for Almighty God, Jehovah.
Title Definition Scripture

As a new convert, joining a church one of the first things that the instructor or minister should provide the believer with is the doctrinal principles of what the church and the congregational beliefs are associated with for that denomination defined as the _____of_____.

It is just as important to have a generalized knowledge of key components of the W_____ of_____ in the areas of salvation. It is also important to know what is needed to walk daily by faith, and what will take believers to the last phase of their salvation which is everlasting_____ or immortality with_____.

Provide (3) scriptures stating that God is our Creator.

Provide (3) Names for the Maker of all things.

Who is God?

_____Jehovah

_____God the Son

_____God the Holy Spirit

_____All of the above

When will the Great White Throne Judgment take place?

_____After the Second Coming of Christ

_____When the Messiah returns to judge the earth

_____After the King of Kings and the Lord of Lords return to receive all of the believers

_____All of the above

The Son of God

Why is the Oneness of God considered a mystery?

_____A mystery is something that we will not fully understand in our carnal state

_____A mystery is something that we can only begin to comprehend in the spirit man

_____A mystery may not be clearly understood, until the Day of Trumpets, in a twinkling of an eye, when we change from mortal/carnal to immortal/celestial

_____ All of the above

The Oneness of God is explained by some as:

_____God the Father, God the Son, God the Holy Spirit

_____The Tribune God

_____The Godhead

_____Yahweh, Yashua Hanutzrel, and the Holy Ghost

_____All of the above

Notice that there are (7) I AM's of Christ, the term, I AM refers to God's ever present existence, as Jehovah Shammah, therefore, through these I AM's of Christ, what does that imply?

_____I AM has no beginning nor ending

_____I AM is a state of existence

_____I AM is also associated with God the Father, when Moses asked God whom shall I say sent me? Therefore, here, as spoken of in (7) realms, it places God the Father and God the Son, as the fullness of God, with the Holy Spirit

_____All of the above

Name three roles defined also as titles for the Lord Jesus Christ. Provide scripture.

Why is there no longer a need for a confession booth? State the reason and provide the scripture.

In Romans 10:9 & 10

What does confessing with your mouth refer to?

_____ Confession that we are sinners, lost without Christ, in need of a Savior

_____Therefore, if we confess, then we believe. So we believe that Jesus became the sacrifice for our sins

_____Also, we believe, refers to when we confess our sins, that God raised Jesus from the dead

_____ In knowing all of this, we are saved by faith, in believing in the Promises of God,

_____All of the above

Who is our Chief High Priest and why? Provide scripture.

Who is the Intercessor, or Mediator, and the Advocate, who stands before God continually, asking for forgiveness of our sins, daily? Provide scripture.

Not only is there a throne of God, in the heavenlies, but we as believers should come to the throne of God daily to_____ our_____ in the presence of God. During the last words of instruction with this lesson, which is entitled the Great Commission to all believers, God is with us always in the person of God_____Holy_____.

Mary was informed that she would bring forth a Son. What does the name Jesus mean? What scripture location supports this?

What does the name Immanuel mean? Who does it refer to? Provide the scripture.

Provide (3) statements that we know that refer to the Times of the Gentiles or the Church Age.

The Lost House of Israel, refers to the Jewish Nation, composed of the all descendents from the (12) tribes of Judah or Israel. What facts do we know help support that they are yet looking for the Messiah?

The Jews crucified the Lord.

The Jews called Christ the King of the Jews while He hung on the Cross for our sins

The Jews said, while He was on the cross, that if thou be the Son of God,

(as a Prince) save yourself

However, Christ did not come to save Himself

None of the above

All of the above

According to St. John 1:12 who can be saved?

Not only can anyone be saved, but according to Acts 16:31 God gives all the promise, if we hold fast to our profession of faith, without wavering that our_____ shall also be saved.

What did we learn happened to the Bright and Morning Star, in Acts 1:9 & 10.

Were there some eye witnesses that witnessed that? If so, who were they implied to be?

God the Holy Spirit

Name (12) tasks that God the Holy Spirit performs for and in the believer's life, also provide scripture.

_____Tasks _____Scripture _____

What are (4) titles for God the Holy Spirit?

C_____

S_____O_____T_____

T_____

G_____

The Holy Spirit convicts and reproves the world of sin. What does that mean? Provide scripture.

What is the anointing of God?

_____ Is the workings of the Comforter in the life of the believer

_____ Is the third baptism, for the believer

_____ Empowers the believer to serve in a divine appointment, as a call by God for a service in the up building of God's kingdom, of winning souls for Christ

_____ Enables the believer to witness to others, promoting spiritual growth, by the lifethat they live, before others

_____ It provides memory, guidance, teaching, and foreknowledge of the things of God, allowing the believer to instruct others

_____ All of the above

What is the third baptism called?

_____ It is the baptism of the Holy Ghost with Fire

_____ It possesses the evidence of speaking in Tongues, of an unknown language, not learned, for a sign to the unbeliever

_____ It is the Gift of the Holy Ghost, with the evidence of speaking in tongues

_____ All of the above

What does the baptism of the Holy Ghost with the evidence of speaking in tongues do?

_____It provides a sign to the unbelievers, through the evidence of speaking in an unknown tongue

_____It empowers the believer to live a life for Christ, under impossible odds, through the evidence of the unquenchable fire, which is designed to burn out daily all that is not of God

_____It holds a seal in the believer's life, that we are called by God, through our anointing, which serves as a mark to the unbelievers, who can witness our seal, but does not understand

_____All of the above

Name (5) E's performed by the anointing of God.

In reading the explanation comments, how does one obtain the gift of the Holy Ghost with the evidence of speaking in tongues?

Who is our Divine Teacher? Provide scripture.

Who baptizes all believers into his body? Provide scripture.

Who is the Spirit of Truth? Provide scripture.

What are the three witnesses to the human body which were made to fellowship with God, our Creator, Elohim. Provide the scripture.

Who is the first Adam?

What type of sin did he perform? Why?

Who was the third player amongst Adam and Eve, which showed them another outlook on life? Is that one of the reasons why there is a need to listen, to the voice of God, through instruction?

Does the Devil still, perform the same tasks today, through deceit, in the hearts of believers who do not listen and follow the instructions and teachings found in the infallible Word of God?

If so, what are the Adversary's continual tasks? Take a moment out and look up St. John 10:10 and name three assignments he focuses upon, for all believers focused upon the things of God.

Salvation: Past, Present and Future

Salvation is a process, possessing (3) levels or tenses to salvation. Complete the three tenses or processes to salvation. Also, provide scripture and definition.

_____Tense _____Scripture
Salvation:

Salvation:

Salvation:

List five things that Adam did in disobedience to God in the Garden, which resulted in sin.

As a result of Adam disobeying God, there is now broken fellowship between God and man, in Genesis 2. Therefore, there is a need for mankind to be brought back into right standing with God, which defines redemption. List three ways that you have observed, through these passages that define the broken fellowship.

What does it mean to confess our sins?

_____ Ask God to forgive us from our sins

_____ Believe that Christ died was buried and rose again for our redemption, taking our place on the Cross.

_____ Confess that we are a sinner lost without Christ.

_____ All of the above

The First and Second Adam and the Mediator

Name the punishments that exist between Adam, Eve, and the Serpent, that exist to this day.
(1)Adam: three part punishment. Provide scripture.

(2) Eve: three part punishment. Provide scripture.

(3) The Serpent: three part punishment. Provide scripture.

Who was the originator of the generational curses?

What happened to bring on the generational curse for all humanity? (You already have knowledge of this from previous scripture found in other lessons).

If we daily confess our sins to Yahweh, or God, through His Son, the Lord Jesus Christ, what will He do for us according to I John 1:9?

Who is our daily intercessor or Mediator to God, as our Savior and Day Star and why? Provide scripture.

Who is our Advocate and state two other names for Him, having the same meaning.

M_____

I _____

The Need for Salvation

True or False

_____Man was made in the image and likeness of God

_____ Man was therefore made with a conscience, which is in the image and likeness of God, of which he realized after committing sin

_____Man was made with free will, therefore being in the image and likeness of God

_____While we were yet sinners, Christ died for us and became our Redeemer, Personal Savior, and the Mediator, between God and man

_____ Romans 6: 23 refers to death as being eternal separation from God, if studied and applied thoroughly

_____Salvation is a gift of God's Grace, through Faith

_____Ephesians 2:8 & 9 states that we can get saved, by doing good deeds

What is the one thing that we are appointed to do, if we do not accept Christ into our hearts, souls and minds, through repentance? Provide the scripture

What does it imply to believe on the Lord Jesus Christ, and we will be saved? Provide scripture.

What type of assurance do we have, when we take on the gift of eternal life?

What is the one thing that we are appointed to do, if we do not accept Christ into our hearts, souls and minds, through repentance? Provide the scripture.

What does it imply to believe on the Lord Jesus Christ, and we will be saved? Provide scripture.

What type of assurance do we have, when we take on the gift of eternal life?

The Gospel

What is the Gospel in a Net shell?

State which gospels identify Christ as a prophet, priest, king, servant and the branch?

Books Christ identified as

Matthew _____

Mark _____

Luke_____

John_____

What is Grace?

_____Unmerited favor with God

_____Underserved favor with God

_____ Being in the right standing with God, thereby counted righteous before God, through the shed blood of His Son, the Lord Jesus Christ

_____All of the above

Name the four gospels and provide (2) other focus points for each.

The Gospels (2) Other focused points

Matthew _____

Mark _____

Luke _____

John _____

The Blessed Hope

What is the Blessed Hope?

_____ Second Coming of the Messiah

_____Glorious appearing of our Lord Jesus Christ, when He appears the second time for the body of believers

_____When the bible speaks that every eye shall see Him

_____This will usher in the Great White Throne judgment for all unbelievers

_____Will also proceed with the 1000 Year Reign of Christ on the Earth, with the New Heaven and the New Earth, wherein the Devil and his demons are locked up for 1000 years

_____All of the above

What is the Book of Life?

_____It has the names of all believers, in Christ Jesus, our Redeemer written in it

_____It represents the Word of God, and those who walk according to the Word of God

_____ It is also called the Lambs book of Life, symbolizing our Personal Savior

_____All of the above

And what happens to the souls of those who are found written in the Book of Life?

_____Possess the final stages of the gift of eternal life with God in the heavenlies

_____Shall live and reign with Christ during the millennium period of 1000 years on Earth

_____Shall live and reign with The Lamb of God forever

_____All of the above

Does the Son of God, and or the Devil know when the Lord will return in the Second Coming, which is also called the second resurrection?

What happens to the souls of the unbelievers, who are not found written in the Book of Life?

_____Are pronounced judgment with the Devil and his messengers/assistants along with the demons

_____Cast into the Lake of Fire for eternal torment

_____Are judged in the Great White Throne Judgment, according to their works of unrighteousness, prior to being sentence with the Devil and the demons that ruled for a short season

_____All of the above

Name _____

Date _____

May God continue to Bless and Keep you in His care.

Apostle Dr. June H. Lawrence, Phil. 4:7

The Last Session for the Year
Chapter 3

If you are not in a classroom setting, it is suggested that you have a study partner, so that you can perform these tasks amongst yourselves.

Returned Finals:

- Be prepared to discuss and review.
- All answers are located in the outlined answer and review section from each unit.
- We shall review the unit and chapter answers as outlined for study in the Final
- Review Study Outline.
- Repetition is the source for memorization.

Questions and Comments
Certificates passed out.

Chapter 4

Answers to Unit 1 to 11
Unit One: Prayer

Chapter One
What is Prayer?

What is Prayer?
1. Prayer is communicating with God.
- Name (7) types of Prayer? Provide scripture.

Types of Prayer	Scripture
1. Intercessory	I Timothy 2:15
2. Repentance Daily	I John 1:9
3. Praise	Psalms 95:6-7
4. Thanksgiving	I Samuel 2: 1-2
5. Vow	I Samuel 1:8:15
6. Request	St. John 14:16
7. Meditation	St. Luke 10:27
8. Sinners Prayer for Salvation	St. Luke 18: 10-14

- What is one of the ways that we know that we can obtain what we want from God?
 1. We can obtain what we want from God in accordance to His Will, when we put God first.
 2. St. Matthew 6:33
- Do we have to speak out loud when we pray?
 1. Refer to I Samuel 1:13 & See explanation of I Samuel 2: 1 & 2.
 2. No, we do not have to speak out loud when we pray.
- Where is the sinner's prayer of repentance found?
 1. St Luke 18:13
 2. God be merciful to me a sinner.
- Why did God not hear the Pharisee's prayer?
 1. Select all of the above.

- Can doing good deeds get us into heaven? Or do we come through the door, which is the blood of the Lord Jesus Christ, the Redeemer of our sins through repentance?
 1. No.
 2. Select the latter for the answer, upon stating no.

Chapter Two
The Lord's Prayer
- Do you know the Lord's Prayer by heart? If so write it.
 1. The answer should be yes.
 2. St. Matthew 6:9-13
 Our Father which art in heaven, Hallowed be thy name. Thy kingdom come. Thy will be done in earth, as it is in heaven. Give us this day our daily bread. And forgive us our debts, as we forgive our debtors. And lead us not into temptation, but deliver us from evil: For thine is the kingdom, and the power, and the glory, for ever. Amen.
- Who was the prayer originally for? What is it used for? Locate both answers in the introduction.
 1. The prayer was originally formed for the disciples.
 2. It is used as a guide for the believers.
- What does it mean to lead us not into temptation? Refer to St. Matthew 6:13
 1. God does not led us into temptation.
 However, when we are tempted, we need Him, through the person of God the Holy Spirit to remind us that we need assistance. Our assistance comes through the Word of God, along with prayer, St. Luke 18:1 and fasting Psalm 35:13, to die out of self desire.

Unit Two: The Gospel

Chapter One
The Gospel in A Nut Shell
- What is the Gospel in a Net Shell? The Gospel in a nutshell is described in I Corinthians 15: 3, 4, 5 & 7, which is composed of three key words, or two or three word phases, associated with the Lord Jesus Christ.
 1. Christ died

 2. He rose

 3. He was seen

- State which gospels identify Christ as a Prophet, Priest, King, Servant and the Branch?

Books	Christ identified as
St. Matthew	King
St. Mark	Worker, Servant, the Branch
St. Luke	Prophet
St. John	Priest and Prophet

What is Grace?

 1. Select all of the above.

Name the four gospels and associate (2) other focus points for each.

The Gospels	(2) Focused points
St. Matthew	Focus is on events; He is also the King of the Church
St. Mark	Found in like fashion as a man; the lowly servant
St. Luke	God's mouthpiece and foreteller to individuals
St. John	People's representative with God, mediator and advocate

Chapter Two
The Blessed Hope

- What is the Blessed Hope?
 1. Select all of the above.
- What is the Book of Life?
 1. Select all of the above.
- And what happens to the souls of those who are found written in the Book of Life?
 1. Select all of the above.
- Does the Son of God, and or the Devil know when the Lord will return in the Second Coming?
 1. No one knows but God or Yahweh, Himself.
 2. St. Matthew 24:36
- What happens to the souls of the unbelievers, who are not found written in the Book of Life?
 1. Select all of the above.

Unit Three: The Need for Salvation

Chapter One
 The Need for Salvation
Salvation from the Creation to the Gentile
All answers are true or false.
T_Man was made in the image and likeness of God.
T_Man was therefore made with a conscience, which is in the image and likeness of God, of which he experience after committing sin.
T_Man was made with free will, therefore being in the image and likeness of
God.
T_While we were yet sinners, Christ died for us and became our Redeemer, Personal Savior, and the Mediator, between God and man.
T_Romans 6: 23, refers to death as being eternal separation from God, if studied and applied thoroughly.
T_Salvation is a gift of God's Grace, through Faith.
F_Ephesians 2:8 & 9 states that we can get saved, by doing good deeds
All answers are **true,** with the exception of the last

Chapter Two
 The Need for Salvation
What Is Salvation? It's Need
- What is the one thing that we are appointed to do, if we do not accept Christ into our hearts, souls and minds, through repentance? Provide scripture.
 1. Hebrews 9: 27
 2. And as it is appointed unto men once to die, but after this the judgment:
- What does it imply to believe on the Lord Jesus Christ, and we shall be saved? Provide scripture.
 1. Romans 10:9 & 10
 2. According to verse 9, if we believe, on the finished works of Christ for salvation to all mankind, we will ask God to come into your heart and save us from our sins. Romans 3:23 states that all have sinned and come short of the glory of God.

3. *V 9 That if thou shalt confess with thy mouth the Lord Jesus, and shalt believe in thine heart that God hath raised Him from the dead, thou shalt be saved.*

4. Upon our confession, according to verse 10, we will then be placed in right standing with God, as a born again believer in Christ Jesus. St. John Chapter 3. Christ now has become our Personal Savior. We now have a spiritual walk by faith, believing in the principles of the Word of God. *V10 For with the heart man believeth unto righteousness; and with the mouth confession is made unto salvation.*

- What type of assurance do we have, when we take on the gift of eternal life? Provide scripture.
 1. Saint Johns 3:16 & 17
 2. *V 16 For God so loved the world, that He gave His only begotten Son, that whosoever believeth in Him should not perish, but have everlasting life.*
 3. *V 17 For God sent not His Son into the world to condemn the world; but that the world through Him might be saved.*
 4. These two scriptures provide the believer with the assurance that if we believe on verse 17, and accept what is stated on verse 16, then we have the assurance of the gift of everlasting life.

Unit Four: Salvation, Past, Present and Future

Chapter One
Salvation Past

Salvation is a process, possessing (3) levels or tenses to salvation. Complete the three tenses or processes to salvation. Also, provide scripture and definition.

Tenses	Definition	Scripture
Salvation: Past	Saved from the penalty of sin.	Romans 6:23
Salvation: Present	Saved from the guilt of sin.	I John 1:9
Salvation: Future	Saved from the presence of sin.	I Corinthians 15:

51-58 I Thessalonians 4:13-18

List three things that Adam did in disobedience to God in the Garden, which resulted in sin.

1. He listened to the Serpent, and let him entice him.
2. He listened to the women, and let her convince him that it was OK.
3. Then he ate of the forbidden fruit. It was forbidden, because he was given instructions not to eat of that tree, the Tree of Knowledge of Good and Evil.

 As a result of Adam disobeying God, we read on to find there is now broken fellowship between God and man, in Genesis 2. Now, there is a need for mankind to be brought back into right standing with God, which defines redemption.

List three ways that you have observed, through this passage that defines the brokenfellowship between God and man

1. Adam hid himself from God.
2. He was ashamed of his nakedness.
3. God wanted Adam to believe that He could not recognize Adam, because he was now in a sinful state.
4. We may find some other components that are linked with this. (However, we should have listed at least one of the (3) above).

- What does it mean to confess our sins?
 1. Select all of the above

Chapter Two
Salvation Present
- If we daily confess our sins to Yahweh, or Almighty God, through His Son, the Lord Jesus Christ, what will He do for us according to **I John 1:9**?
 1. He will forgive us our daily sins.
- Who is our daily intercessor or Mediator to God, our Savior and Day Star and why? Provide scripture.
 1. **I John 2: 1, 2**
 2. States the Lord Jesus Christ is our Mediator between God and man.
- Who is our Advocate?
 1. The Lord Jesus Christ is our Advocate.

2. State two other names for Him, having the same meaning. He is also called:
3. The Mediator of the New Testament.
4. The Mediator.
5. The Intercessor
6. Our High Priest

Chapter Three
Salvation Future

- What two passages in the Word of God speak of the church or the body of believers being caught up, or raptured, through God the Holy Spirit, when, the Messiah or Christ returns in His Second Coming?
 1. I Thessalonians 4:13-18
 2. I Corinthians 15: 51-58.
- From which of the two texts, describe what will happen to those who are asleep in Christ, Jesus, when the Messiah, the Christ, returns in His Second Coming?
 1. I Thessalonians 4: 13-18,
 2. According to this scripture, the dead in Christ will raise first to be resurrected, and caught up to meet the Lord in the air.
 From which of the two texts, describes what will happen to those who are alive, in Christ Jesus, when He returns, in His Second Coming? Where is the scripture located?
 3. According to I Thessalonians 4: 13-18 those who are alive and remain shall be caught up to meet the Lord in the air.
- What is the secular term used in the Church to describe the Lord's return as a Thief in the Night which is not actually recorded in the Word of God?
 1. The second coming of Christ is known in it's secular term, as the Rapture.
- Who is written in the Lamb's Book of Life? Where is this scripture located?
 1. I Corinthians 15: 51-58,
 2. This scripture lets us know that all believers will be saved, therefore, they are written in the Lambs book of life.
- Read Revelation 20:12 & 15. In the text, what does the term, incorruptible refer to?
 1. Refers to a body that does not decay.

2. Refers to an immortal body, that lives on forever.

- What is the mystery? Is there more than one? Provide a scripture text.

 1. A mystery is something that cannot be fully explained in the natural. Only through the spirit of God, can we as believers begin to understand the components, or the full act of God.

 2. Therefore, a mystery is noted here as changing form mortality to immortality, at the moment in a twinkling of an eye, at the Feast of Trumpets, at the last trumpet, states the scripture in I Corinthians 15: 51-58.

 3. Yes there is more than one mystery.

 4. They are acts performed throughout the bible.

Unit 5: Justification through Salvation: The First and the Second Adam

Chapter One
The First Adam

The First Testator

It's Failure

- Who is the first Adam?

 1. The first Adam is the first man, the beginning of all creation, created on the 6th day of creation.

 2. He is the beginning of all mankind.

- What type of sin did he perform? Why?

 1. He performed the sin of disobedience. He was instructed to not eat of the forbidden Tree of Knowledge of Good and Evil. Therefore, his sin was a transgression. He knew, what he was not supposed to do. He was enticed or tempted, by his wife, who was tempted of the serpent.

- What are the three witnesses to the human body which was made to fellowship with God, our Creator, Elohim. Provide the scripture.

 1. The three witnesses to the human body are the spirit, the body and the soul.

 2. The spirit is the conscience, knowing right and wrong.

 3. The soul, possess the personality.

 4. The body is the vessel, wherein the spirit of God is to dwell in the body of the believer, in the Person of the Comforter.

5. The scripture is I John 5:8.

• Who was the third player amongst Adam and Eve, which showed them a different outlook on life? Is this one of the reasons why there is a need to listen, to the voice of God, through instruction?

1. The third player was the devil, or the serpent, who showed Adam and Eve, a different way of looking at the transgression.
2. Yes, this is one of the reasons why we need to listen to the voice of God, through the Word of God, our daily instruction.

• Does the Devil still, perform the same tasks today, through deceit, in the hearts of believers who do not listen and follow the instructions and teachings found in the infallible Word of God

1. Yes he does.
2. That is why the bible states the following text:
3. St Matthews 10:16 Be ye therefore wise as serpents, yet harmless as doves.
4. II Corinthians 2:11 *Lest Satan should get an advantage of us, for we are not ignorant of his devices.* The second verse is also to be noted.

• If so, what are the Adversary's continual tasks? Take a moment out and look up St. John 10:10 and name three tasks he focuses upon, directed to all believers who continuously focus upon the things of God.

The devil is described as the thief. He comes to:

1. Kill: Once the believer is tempted, and willfully transgressed against God, the bible states that there remains no more sacrifice for our sins. Therefore, we are presented with the consequences of that sin, as we remain in this life. So, our blessing, are killed, through disobedience of instructions, through the Word of God, and by the guidance of God the Holy Spirit, our teacher, guide and reprover of sin. Read Hebrews 10:26.
2. Steal: Whatever blessings that have been promised to us, as the believers, in accordance to the Word of God, the Adversary attempts to steal, through instilling disbelief.
3. Destroy: His aim is to destroy the Faith of the believer. Without faith, nothing can be accomplished, nor can we even serve God successfully and completely. Read Hebrews 11: 1 & verse 6.

Chapter Two
The Second Adam: The Second Testator

- Name the punishments that exist between Adam, Eve, and the Serpent, that exist to this day.
- Adam's: three part punishment. Provide scripture. Genesis 3:17-19, The bible states:
- *Cursed is the ground for thy sake; in sorrow shalt thou eat of it all the days of thy life;*
- *Thorns also and thistles shall it bring forth to thee; and thou shalt eat the herb of the field;*
- *In the sweat of thy face shalt thou eat bread, till thou return unto the ground*
- Adams punishment was that the earth would no longer bring forth food automatically. The ground would be cursed.
- He would from that point on, till the ground to produce a harvest of food.
- He would have to work hard all the rest of his life.
- He no longer had fellowship with God.

Eve's: three part punishment. Provide scripture.
Genesis 3:16

- *I will greatly multiply thy sorrow and thy conception; in sorrow thou shalt bring forth children;*
- *Thy desire shall be to thy husband,*
- *He shall rule over thee.*

The Serpent's: three part punishment. Provide scripture.
Genesis 3:14

- *Thou art cursed above all cattle, and above every beast of the field.*
- *Upon thy belly shalt thou go*
- *Dust shalt thou eat all the days of thy life:*
- Who was the originator of the generational curses?
 1. Adam is the originator of the general curses. The answer is found in the explanation which states:
 2. Genesis 3:14-19
 3. God pronounces punishment and tells in detail what will happen to all generations, beginning with them. The punishment or curse will follow mankind and the serpent, throughout the Ages, until the Lord's return.

- What happened to bring on the generational curse for all humanity? (You have already learned this in previous scriptures found in other lessons).
 1. Adam, transgressed or sinned against the instructions of God
 2. This resulted in the vessels of all mankind being defiled
 3. Consequently, the defilement broke fellowship with God, bringing about a need for redemption

Chapter Three
The Mediator of the New Testament
- What is a testator? How does it relate to the New Testament, provide scripture?
- Hebrews 9:15-20.
 1. He represents a time or era.
 2. The testator is the giver of and for that time and purpose. In other words, without the testator there would be no time and purpose.
- How does it relate to the New Testament, provide scripture?
 1. Adam provided Life. He was the father of all living. Everything was created for him, in the beginning, to assist him in glorifying God.
 2. The Lord Jesus Christ was the second Adam. He is the Savior and the Redeemer of all living. All mankind must come to him to be born again, in a newness of life, through repentance, acknowledgement of sin, acceptance of Christ, and the belief that life after death will be an eternity in the service of glorifying God.
 3. The first testator was Adam. The second testator is The Lord Jesus Christ, who is the Mediator of the New Testament.
- Who is the High Priest of good things to come, the Mediator of the New Testament? Provide scripture.
 1. Read Hebrews 9 verses 11 & 15
 2. The Lord Jesus Christ is the High Priest of good things to come, the Mediator of the New Testament.
- Who or What is the Holies of Holies, the Tabernacle, not made by hands?
Provide scripture.
 1. Hebrews 9: 11

2. This passage states that The Chief Shepherd, the Lord Jesus Christ is now our Holies of Holies, as our Intercessor to God.

- What was performed once a year to atone for man's sin, in the Old Testament and by whom? Provide scripture.
 1. Hebrews 9: 25-26
 2. The yearly sacrifices for the sins of mankind were performed once a year, when the high priest entered the holy of holies to make atonement for the sacrifices of the sins of the people, which referred to doing Old Testament times as the Hebrew Nation.
- What type of blood sacrifice was made? For what purpose was the blood sacrifice made? Provide scripture.
 1. Hebrews 9:12-14
 2. The type of the sacrifice made was the blood of bulls, goats and the ashes. of a heifer sprinkling
 Hebrews 9:13, *For if the blood of bulls and of goats, and the ashes of an heifer sprinkling, the unclean, sanctified to the purifying of the flesh.*

The purpose of the sacrifice was to sanctify and purify the flesh, as a Perfect spotless blood atoning sacrifice.

Hebrews 9:11, *But Christ being come an high priest of good things to come, by a greater and more perfect tabernacle, not made with hands, that is to say, not of this building;*

- What made the blood sacrifice incomplete, and unsuccessful? Provide scripture.
 1. Read, Hebrews 9:22-26.
 2. There was a need for a better and more perfect sacrifice.
 3. V 23 *It was therefore necessary that the patterns of things in the heavens should be purified with these: but the heavenly things themselves with better sacrifices than these.*

Unit Six: Initiating Spiritual Growth

Chapter One
- **The Fruit of the Spirit**
- Jesus is the Light of the World, and as followers of Christ, we, as believers in Christ Jesus are also called the light of the world. Why are we, also called the light of the world, according to St. Matthew?

- Read St. Matthew 5:16 *Let your light so shine before men, that they might see your good works and glorify the Father which is in heaven.* The light is God the Holy Spirit, illuminating through the body of the believer, as he/she walks by faith and not by sight, in accordance to the Word of God.In abiding by the Word of God, the Fruit of the Spirit will manifest itself, through the daily life of the believers and others will see what he/she possesses:
Goodness
Faith
Meekness
Longsuffering
Peace
Love
Joy
Temperance
- Name (8) components or attributes of the Fruit of the Spirit.Why are they needed in the life of the believer? What is the scripture text? Galatians 5: 22-23 states the Fruit of the Spirit of God. They are as follows:

Fruit	Why needed	Scripture
Goodness	Think and act on good thoughts.	V22
Faith	Needed to obtain salvation.	V22
Meekness	The proud will not enter into heaven.	V23
Longsuffering	Must be patient with God and with man	V22
Peace	God is not the author of confusion	V22
Love	Love your neighbor as yourself	V22
Joy	Be happy that things are as well as they are.	V22
Temperance	Knowing when to stop, anything, without being told	V23

- Why is our spiritual walk, a walk by faith, according to Hebrews 11: 1 and 6?
 1. Hebrews 11:1
 2. Now faith is the substance of things hoped for and the evidence of things not seen.
 3. Therefore, we walk by faith and not by sight. We were not eye witnesses to:
- The Lord living here on earth.
- The writings of the Word of God.

- Hebrews 11:6
 1. But without faith, it is impossible to please him, for he that cometh to God must believe that he is, and that he is a rewarder of them that diligently seek him.
 2. This also links into what was already stated as the explanations or answers to the first part of the question. The same answers apply to this scripture.

Chapter Two
The Whole Armor of God
- Name the seven parts of the whole armor of God and their purposes. Where is the text located in the bible?
 1. The scripture is located in Ephesians 6: 13-17
 2. Each part of the armor possesses one quality or one key attribute needed for salvation kept, as we go forward in our spiritual warfare between,
 - Self will, within our minds.
 - Our body of flesh, representing the old nature.
 - We are surrounded by the influence of others.
 - Lastly we, as believers are being tempted or enticed by the adversary.

Parts	Purpose	Scripture
Loins girt about with truth	Truth covering	V14
Breastplate of righteousness	Righteousness covering	V14
Gospel of peace	The Gospel covering feet	V15
The shield of faith	Faith covering inside of mind	V16
Helmet of salvation	Salvation covering the outer head	V17
Sword of the spirit	The Word of God, to be used by faith and action.	V17

What is it that we must do, when we do not know what to do, or seem to have gone our limit?
 1. We as believers in Christ Jesus should have the shield of faith to believe that things will work out, once we give it to the Lord in prayer and stand our ground, having unwavering faith.
- According to Hebrew 9:12, what are the tasks of the sword of the spirit? Name three tasks that identify its purpose.

1. Use it as a weapon to ward off unbelief, refers to more powerful than a two edged sword.
2. It is used to divide the spiritual from the natural. Piercing and dividing the soul and spirit. The soul refers to the personality. The spirit refers to the things of God, found written in the Word of God.
3. It reveals what is in the intentions found in the heart of man. Therefore, it expounds on the capability of man, along with a remedy for all actions, and intentions, based upon the Word of God.
4. It also reveals what is the capability of man, referred as discerner of the intents of the heart.

- Once we accept the Lord Jesus Christ as our Personal Savior, we embark against a spiritual journey, which can also be defined as warfare.
 1. As believers in Christ Jesus, we daily war against, sin, flesh and the devil.
- The daily job of the Adversary can be divided into a three categories, in which he goes about deceiving, and enticing the believer.
 1. Therefore, he <u>kills</u>, <u>steals</u> and <u>destroys</u>. Located in St John 10:10.
- There are two types of man in our body of flesh that war against each other constantly.
 1. Therefore, there is a need to put on the Whole Armor of God.
 2. These two forces that war inwardly are called the carnal man and the spiritual man. Read Romans 7:14-25.
- What is it that we must do, when we do not know what to do, or seem to have gone our limit?
 1. Have the shield of faith to believe that things will work out, once we give it to the Lord in prayer and
 2. Stand our ground, having unwavering faith.

Chapter Three
The Seven Categories of Sin

- Name and define the seven categories of sin. Where are they located in the scriptures?

Name	Define	Scripture Proverbs CH6:
1. A proud look	Pride	V17
2. Lying tongue	Deceitful Speaking	V17
3. Hands that shed innocent blood	Accusing the innocent	V17

4. A heart that deviseth wicked imaginations Evil thoughts V18
5. Feet that be swift in running to mischief Enjoying mischief V18
6. A false witness that speaketh lies Lying on another V19
7. He that soweth discord among the brethren. Initiator of confusion V19

- God hates and despises these categories of sin, because they are the root of all sin.
 Select all of the above.
- What does it mean to put a bridle on our tongue?
 Select **all** for the answer.

Unit Seven: Bible Comprehension and Usage

Chapter One
The Old and the New In Contrast

- Name two types of people that the Old Testament deals with?

The Old Testament deals with basically three types of people and they are as follows:

1. The Hebrew Nation or the Israelites or the Jews
2. The Gentile Nation which includes all of those who are not Jews.
3. The Gentiles in Old Testament times are also called the heathen. Believers and Non-Believers were not classified and introduced until The Messiah's mission here on earth was accomplished. Christ's mission, is defined as the suffering of Christ and the Glory which would follow, promises to all believers-the gift of everlasting life.

- The New Testament introduces what age, and what type of people?
 1. It introduces the Church Age or the Age of the Gentiles.
 2. It introduces the times of the Gentiles, or the Non Jewish Nations.
- The Bible is divided into how many parts? What are they?
 1. The Bible is divided into two parts.
 2. It is divided into: the Old Testament and the New Testament.
- Name the basic four components/categories of the Old Testament.
 1. Law
 2. History
 3. Prophecy

4. Poetry

Chapter Two
The Word of God as Outlined in the Old Testament Books
- How many books are there in the Old Testament?
 39
- How many books are there in the New Testament?
 27
- What two numbered amounts are the books usually grouped into, within each category?
 1. (5)
 2. (12).
- Name the five categories of books in the Old Testament.
 Books of Law or Pent etude:
 Books of History
 Books of Minor Prophets
 Books of Major Prophets
 Books of Poetry

Chapter Three
The Word of God as Outlined in the New Testament Books
- The Law was given by whom? Who is the Giver of Grace and Truth? Provide scripture.
 1. The answer is located in St. John 17
 2. The Law was given by Moses.
 3. The Giver of Grace and Truth came through our Lord Jesus Christ.
- The Four Gospels tell:
 1. The Good News of the Lord Jesus Christ
 2. They tell the plan of salvation, through our Lord and Savior, Jesus Christ.
 3. They tell that Jesus, was born, His ministry, His purpose, which was to become the sin blood atoning sacrifice for all mankind, through His death, burial, resurrection and ascension.
- What is Grace?
 1. All of the above.
- Name (4) things that the four Gospels focus upon.
They focus upon Christ being a

1. Teacher
2. Prophet
3. Priest
4. King
5. Messiah
6. Savior or Redeemer
7. Christ' ministry here on earth
8. Christ death, burial, resurrection
9. Christ's promise of the Blessed Hope to all believers

- Name three things that define the Book of Acts.
 1. This book is in a class of its own.
 2. Acts tells of the formation of the 1ˢᵗ Church
 3. It introduces signs and wonders from the Apostles, after Christ ascension.
 4. There is events taking place after Christ' ascension, as the testator of the New Testament.

- The major Epistles are written to what churches? What were the locations of each of the church? (Note, the name of each body of believer is the name of the book). Look in the book and find the name of the location of each group of people or believers. if you cannot figure it out. (For example, when writing to the Romans, the location of the church would be in Rome).
 1. They were written to the church of believers mention as the title of each book. Name the title of the believers mentioned in each book:
 - Romans
 - Corinthians
 - Galatians
 - Ephesians
 - Philippians
 - Colossians
 - Thessalonians
 2. The location of the church was from the root of the title, composed of the, named as the believers. Name each of the church locations to the best of your knowledge, or look it up in each of the books.
 - Rome
 - Corinth
 - Galatia

- Ephesus's
- Philippi
- Colossians
- Thessalonica
- Name three things that define the Book of Revelation.
 1. This last book, Revelation, foretells in the Old Testament the things to come, up to the Church Age.
 2. It also tells prophecies of things to come, consisting of the Second Coming of Christ, and what is to follow.
 3. It tells of the New Heaven and the New Earth. We are in the Church Age, and the Age of Grace, through the New Testament.

Unit Eight: The Fullness of God

Chapter One:
God the Father
The Fullness of God
- Who is the fullness of God in title?
 1. Elohim
- Who is the Most High God in title?
 1. EL Elyon:
- How is Yahweh or Almighty God defined in position, tasks and identity? Provide scripture.
 1. Exodus 6:3
 2. Jehovah's proper identity is Yahweh or Jahweh.
 3. He is defined as I AM OR I WILL
 4. He is known as God Almighty. I AM and I WILL refers to his everlasting existence.
- Who are the three witnesses that bare record in heaven? Provide scripture.
 1. I John 5:7
 2. God the Father
 3. God the Son
 4. God the Holy Spirit
- Who are the three witnesses that bare record in earth? Provide scripture.
 1. I John 5:8
 2. The Spirit

3. The Water
4. The Blood

Chapter Two:
God the Father Part 2

God: Yahweh

• Name seven titles, with definitions and scriptures for Almighty God, Jehovah.

Title_____Location_____Meaning

Title	Location	Meaning
Jehovah Sabaoth	Psalm 90:2	God is Eternal
El Olam	I Timothy 1:17	God is Infinite
Jehovah	Psalm 93:1	God is Sovereign
Jehovah Rohi.	Psalm139: 1-2	God is Omniscient
Jehovah Shammah	Psalm 139: 7-8	God is Omnipresent
El Shaddai.	Revelation 19:6	God is Omnipotent
Jehovah Nissi	Malachi 3:6	God is Unchanging
Jehovah Rohi	Deuteronomy 32:4	God is Just
Jehovah Tsidkenu	Exodus 9:27	God is Righteous
Jehovah Rophe	I John 4:8	God is Love
Jehovah Shammah	Ephesians 2:8	God is Gracious
Jehovah Jireh	I Peter 1:3	God is Merciful
Jehovah M'Kaddesh	Romans 8:28	God is Good

• As a new convert, joining a church one of the first things that the instructor or minister should provide the believer with is the doctrinal principles of what the church and the congregational beliefs are associated with for that denomination defined as the
 1. Statement of Faith.
• It is just as important to have a generalized knowledge of key components of the Word of God in the areas of salvation. It is also important to know what is needed to walk daily by faith, and what will take us as believers to the last phase of our salvation which is everlasting life or immortality with God.

Chapter Three:
God the Father Part 3
The Oneness of God Part 3
* Provide (3) scriptures stating that God is our Creator.
 1. Isaiah 45:9, *Woe unto him that striveth with his Maker.*
 2. Romans 9:20, *Nay but O man, who art thou that repliest against God? Shall the thing formed say to him that formed it; Why hast thou made me thus?*
 3. I Corinthians 8:6, *But to us there is but one God, the Father of whom are all things, and we in him; and one Lord Jesus Christ, by whom are all things and we by him.*
* Provide (3) Names for the Maker of all things
 1. Almighty God
 2. God
 3. God the Father
 4. Jehovah God
 5. Our Creator
* Who is God?
 1. Jehovah
* When will the Great White Throne Judgment take place?
 1. All of the above.

Chapter Four:
God the Son Part 1
The Fullness of God: God the Son
* Why is the Oneness of God considered a mystery?
 1. All of the above.
* The Oneness of God is explained by some as:
 1. All of the above
* Notice that there are (7) I AM's of Christ, the term, I AM refers to God's ever present existence, as Jehovah Shammah, therefore, through these I AM's of Christ, what does that imply?
 1. All of the above.

Chapter Five:
God the Son Part 2

The Role of the Son of God

- Name (3) roles defined also as titles for the Lord Jesus Christ. Provide Scripture.

Title and Role	Scripture
The Lamb of God: Our Redeemer	St. John 1:29
Mediator: Advocate and High Priest or Intercessor	I Timothy 2:5
The Last Adam is our Judge	St. Matthew 28: 18-20

- Why is there no longer a need for a confession booth? State the reason and provide the scripture. (Any of these answered scriptures).
 1. I Timothy 2:5, *For there is one God, and one mediator between God and men, the man Christ Jesus.*
 2. Hebrews 4: 14, *seeing then that we have a great high priest, that is passed into the heavens, Jesus the Son of God, let us hold fast our profession.*
 3. 3. Hebrews 9:11, *But Christ being come a high priest of good things to come, by a greater and more perfect tabernacle, not made with hands, that is to say, not of this building.*
 4. 4. I Timothy 2:5, *For there is one God, and one mediator between God and men, the man Christ Jesus;*
 5. 5. Through all of the above scriptures, we find proof that God the Son is now the mediator and the High Priest, between God and man.
- In Romans 10:9 & 10, what does confessing with your mouth refer to?
 1. All of the above.
- Who is our Chief High Priest and why? Provide scripture.
 1. Hebrews 4: 14, *Seeing then that we have a great high priest, that is passed into the heavens, Jesus the Son of God, let us hold fast our profession.*
 2. The Lord Jesus Christ is our High Priest.
- Who is the Intercessor, or Mediator, and the Advocate, who stands before God continually, asking for forgiveness of our sins, daily?
 1. The Lord Jesus Christ is our:
 Mediator: Advocate and High Priest or Intercessor
 2. I Timothy 2:5

- Not only is there a throne of God, in the heavenlies, but we as believers should come to the throne of God daily to confess our sins in the presence of God. Provide scripture. I John 1:9.
- During the last words of instruction with this lesson, which is entitled the Great Commission to all believers, God is with us always in the person of God the Holy_Spirit.

Chapter Six:
God the Son Part 3
The Oneness of God, through the Son of God
- Mary was instructed that she would bring forth a Son. What does the name Jesus mean? What scripture location supports this?
 1. The name Jesus means a Savior for our sins.
 2. St. Matthew 1: 21
 And she shall bring forth a son, and thou shalt call his name Jesus, for he shall save his people from their sins.
- What does the name Immanuel mean? Who does it refer to? Provide the scripture.
 1. Matthew 1:23
 2. Immanuel means God with us.
 3. It refers to the believers in Christ.
 Behold, a virgin shall be with child and shall bring forth a son, and thou shalt call his name Immanuel, which being interpreted is, God with us.
- Provide (3) statements that we know that refer to the Times of the Gentiles or the Church Age. The Times of the Gentiles refers to:
 1. The offering of redemption of all non Hebrews from all walks of life.
 2. The Gentiles who are yet looking for the Lord to return. Everything we have is His.
 3. The Times of the Gentiles is a walk by faith and not by sight.
- The Lost House of Israel, refers to the Jewish Nation, composed of all descendents from the (12) tribes of Judah or Israel. What facts do we know help support that they are yet looking for the Messiah?
 1. All of the above.
- According to St. John 1:12 who can be saved?
 1. All that receive His Word of Salvation, through the gospel, can be saved.

2. St. John 1:12

 But as many as received him, to him gave he power to become the sons of God, even to them that believe on his name.

- Not only can anyone be saved, but according to Acts 16:31 God gives all the promise, if they hold fast to their profession of faith, without wavering that their Family shall also be saved.
- What did we learn happened to the Bright and Morning Star, in Acts 1:9 & 10.

 1. According to Acts 1:9, Christ ascended up into heaven.
 2. According to Acts 1: 10, the eye witnesses were two men, standing by in white apparel, presumed to be angels.

Chapter Seven:
God the Holy Spirit Part 1

The Fullness of God through the Holy Spirit, Part 1

- Name (12) tasks that God the Holy Spirit performs for and in the believer's life. Also provide scripture.

Tasks of the Holy Spirit	Scripture
Abides	St. John 14:16
Keeper	St. John 14: 16
Forbids	St. John 16:7
Glorifies God the Son	St John 16:14
Guides	St. John 16:12
Appoints	St. John 16:12
Decides	St. John 16:12
Foretells	St. John 16:13
Convicts	St. John 16:8-11
Witness	St. John 15:26
Teach	St. John 14:26
Recall	St. John 14:26

- What are (4) titles for God the Holy Spirit? Provide scripture.

Titles	Scripture
Comforter	St. John 15:26
Spirit of Truth	St. John 14:26
Teacher	St. John 14:26
Guide	St. John 16:12

- The Holy Spirit convicts and reproves the world of sin. What does that mean? Provide scripture.

1. St. John 26: 8-11
2. The Holy Spirit convicts the unsaved and the saved daily, as the believer sins knowing, or not knowing, through:
 V 9 states through sin, because they believe not on me;
3. The Holy Spirit reproves the world of sin through:
 V10 of righteousness, because I go to my Father, and ye see me no more;
 V11 of judgment, because the prince of this world is judged
 Therefore, The Holy Spirit is the Comforter, sent in place of Christ, after His ascension.

Chapter Eight:
God the Holy Spirit Part 2
The Anointing of God: The Role of the Holy Spirit, Part 2
- What is the anointing of God?
 1. All of the above.
- What is the third baptism called?
 1. All of the above
- What does the baptism of the Holy Ghost with the evidence of speaking in tongues do?
 1. Both of the above.
- Name (5) E's performed by the anointing of God.
 1. Equips
 2. Empowers
 3. Enables
 4. Executes
 5. Exterminates
- In reading the explanation comments, how does one obtain the gift of the Holy Ghost with the evidence of speaking in tongues?
 1. Live in accordance to the instructions in the Word of God.
 2. Love the Lord thy God with all of thy strength and with all of thy mind.
 3. In other words, put God first.
 4. Remember daily the second greatest commandment, is love thy neighbor as thyself.
 5. However, we also want to remember to use the Comforter, as our Guide, Teacher, and our Reprover Sin. The comforter, in the person of God the Holy Spirit will convict the believer, when we

are about to trespass against the instruction of God. Consequently, in step (4) we are to walk in obedience.

6. .Be thankful for all things, knowing that all will work out for our good, as the test concludes. Romans 8:28.

7. Lastly, as we pray, pray in thanksgiving, praising and thanking God for His excellence, his majesty, and for being who He is, God

 Then, with all of this in mind, as we outwardly pray, we will, in God's time, receive the gift of the Holy Spirit with unquenchable fire, witnessed with the evidence of speaking in tongues, when we least expect it.

Chapter Nine:
God the Holy Spirit Part 3
The Oneness of God, through the Holy Spirit

- Who is our Divine Teacher? Provide scripture.
 1. I Corinthians 2:9-12, 10 *But God hath revealed them to us by his Spirit, for the Spirit searcheth all things, ye the deep things of God. 11 For what man knoweth the things of a man, save the spirit of man which is in him? 12 Even so the things of God, knoweth no man, but the Spirit of God.*
 2. God, the Holy Spirit is our Divine Teacher.
- Who baptizes all believers into his body? Provide scripture.
 1. Corinthians 12:13 *For by one Spirit were we all baptized into one body, whether we be Jews or Gentiles, whether we be bond or free: and hath all been made to drink into one Spirit.*
 2. God, the Holy Spirit baptizes all believers into one body. This is the first baptism, upon receiving salvation through our Lord and Savior, Jesus Christ.
- Who is the Spirit of Truth? Provide scripture.
 1. St. John 16:7, 13, 7 *Nevertheless, I tell you the truth; It is expedient for you that I go away, for if I go not away, the Comforter will not come unto you; but if I depart, I will send him unto you. 13 He will guide you into all truths.*

Unit 9: The Church, Hope and the Fallen

Chapter One:
The Church

- The first church is recorded in what book of the New Testament?
 1. The forming of the first church is located in the Book of Acts.
 2. Acts 2: 41-42.
- Name five names that define the body of believers, who are the church. Also provide scripture.
 1. The Bride of Christ, Revelation Ch 19;
 2. The Bride, St. Matthew 25: 1-13;
 3. The Believers, I Peter 2:9;
 4. I Timothy 4:12; Acts 5:14.
 5. The Church, Acts 2: 41-42 & V47;
 6. The Body of Christ, Ephesians 4: 11-16.
- Why do we take communion? (2) What is its meaning in regard to the bread and the wine? (3) What do they also represent?
 1. We take communion to commemorate the last supper that our Lord and Savior had with his disciples before He died on the cross.
 2. To have fellowship with Christ recognizing his death, burial, resurrection and ascension, until He returns, as the Blessed Hope to receive the Body of Believers to him.
 3. The bread represents the body of Christ.
 4. The wine represents the blood that was shed on the Cross at Calvary as the Sin Blood AtoninSacrifice, the Lord Jesus Christ

Chapter Two:
Angels and Demons

- What (5) things have you learned about the devil in this lesson, which resulted in his fall? All begin with the statement "I." *I*, refers to as a statement within itself. Also provide the scripture.

Isaiah 14: 12-17
 1. I will ascend into heaven,
 2. I will exalt my throne above the stars of God:
 3. I will sit also upon the mount of the congregation, in the sides of the north:
 4. I will ascend above the heights of the clouds:

5. I will be like the most High.

- How was the Adversary described in both texts?
 1. Ezekiel 28:12-15, *Son of man, take up a lamentation upon the king of Tyrus, and say unto him, Thus saith the Lord God; thou sealest up the <u>sum full of wisdom, and perfect in beauty</u>. Every precious stone was they covering the sardius, topaz, and the diamond, the beryl, the onyx, and the jasper, the sapphire, the emerald, and the carbuncle, and gold: the workmanship of thy tabrets and of thy pipes was prepared in thee in the day that thou wast created.<u>He is the sum full of wisdom and perfect in beauty.</u>*
 2. Isaiah 14:12-17, *Is this the man that made the earth to tremble, that did shake kingdoms; That made the world as a wilderness, and destroyed the cities thereof; that opened not the house of his prisoners? <u>He is the man that made the earth to tremble.</u>*
- Name three names for the devil, denoted in the two texts?
 1. Isaiah 14: O Lucifer, son of the morning
 2. Ezekiel 28: The Sum of all Beauty
 The Anointed Cherub

Unit 10: Inner Conflict and Resolution

Chapter One
The Inner Conflict From Within

- What is the old nature? What is the new nature? What do they constantly do?
 1. Roman Chapter 7: 14-25
 2. The old nature is the carnal man or the natural man identified as the desires of the flesh.
 3. The new nature is the spiritual man, which identifies the spiritual things pertaining to God.
 4. The natural and the spiritual man constantly war against each other.
- What are the components that define the battle between good and evil?
 1. All of the above
- Salvation, for the believer is also stated as:
 1. All of the above.

- Describe three examples of the struggle between the carnal man and the spiritual man.

 Most believers will probably have a struggle with the following:
 1. Reading the bible daily.
 2. Saying our prayers at night before going to bed.
 3. Apologizing to someone, even though that person provoked us, and then asking for God's forgiveness.
 4. Attending church during the Super Bowl celebration.
 5. Placing whatever God told us to set aside for church and charity offerings.
 6. Praying and asking God for direction in the decision making process of future goals. Therefore, asking him what does He want us to do, as opposed to doing what we desire to do. We were placed here to glorify God, not to glorify ourselves, once salvation is achieved. Examples:
 7. Purchasing a home, or a car, (Is it this home? Should I purchase this model car?).
 8. Not over indulging in anything. Too much of anything is a sin.
 9. Of course, putting God first in everything that we do.
 10. Do we thank God in the morning for waking us up? It was He that did that.
 11. To name a few that we struggle upon doing or not doing.
- What is another term for free will?
 1. Conscience provides us with the knowledge of what is good or evil, right or wrong, without looking for a definition. It is made up in our nature, defined as being partly formed in the image of God.

Chapter Two
The Resolution from the Inner Conflict
- What do we do when we give an elevation offering?
 1. All of the above.
- According to I Timothy 4:13,
 Till I come, give attendance to reading refers to:
 1. All of the above.
- According to I Timothy 4:13, along with other scriptures, exhortation refers to
 1. Encouragement

- According to I Timothy 4:13, doctrine refers to:
 1. All of the above.
- II Timothy 2:15 Explains to the believer the importance of studying the word of God so that we may be able to rightly divide the word of truth.
- Name (4) reasons why it is important to read and study the Word of God.
 1. Be informed of current events
 2. Be informed of the time defined in which we live in
 3. Know just how close we are to the Messiah's return for the Church, made up of all believers worldwide.
 4. Be ready for the Messiah's return.
 5. Know what is needed and have the ability to live a God fearing life, before God and man, through obedience to the Word of God.
 6. The Word of God reveals God's will for the believer, as he/she walks by faith.
- Name three interpretations of a church service? One is identified in the Hebrew faith?
 1. Worship service
 2. A solemn assembly
 3. Holy Convocation (Hebrew)

Chapter Three
Put God First

- Name three things that we as believers must do, in order to get what we want from God.

Scripture	Tasks	Purpose
St. Luke 18:1	Pray.	To communicate with God
Psalm 35:13	Fast.	To die out to self will/desires.
11 Tim. 2:15:	Read/study God Word.	To know what is required.
Hebrews 10:25	Fellowship w/ believers	To gain strength with others.

- What is our Code of Ethics in a nutshell? Provide scripture.
 1. St. Matthew 22: 37-40
 2. On these two commandments hang all the law and the prophets.
 3. This is the Code of Ethics in a Nutshell.
- When does God supply all of our needs? Provide (2) scriptures.

468

1. St. Matthew 6:33-34
2. He supplies all of our needs when we put him first.
3. Then we tell Him our request, and give it no more thought. God in His time will supply the need.

Unit 11: The Word of God

Chapter One
The Infallible Word of God

- What three scriptures tell of the purpose of the writings of the Bible?

Scripture	Description
II Tim. 2:15	Study to know what is right and wrong, along with promise
II Tim. 3:16-17	Doctrinal instruction and Correction in the spiritual walk
II Peter 1:21	Holy men of God wrote by the unction of the Holy Ghost

- How were the writings of the bible written? Provide (2) points taken from the lesson, with scripture.

Scripture	Description
II Timothy 3:16	They were written through the inspiration of God.
I Peter 1:21	Holy men of God wrote by the unction of the Holy Ghost

- Name (3) reasons why we should use the Word of God, found in this lesson. Provide scripture.
 1. 2 Timothy 3:16-17
 2. All scripture is given by inspiration of God, and is profitable for:
 - Doctrine or instruction
 - Reproof or correction
 - Correction or guidance
 - Instruction in righteousness or a way of life

Chapter Two:
With Faith, Use the Word as a Weapon

As a recruit, in the Armed Service of and for the Lord Jesus Christ, what is your field of service for evangelizing, or winning souls to Christ?

___One on one missionary work, within your everyday travels

____ Assisting in the Soup Kitchen, or helping the needy in some other capacity

____ Passing out salvation tracts you have obtained from your local church, or the Bible book store of your choice

____Being a witness for Christ, in your community, by the life that we live

____All of the above

Only you can answer this. However, these would be the authors' scriptures.

The Sheet

Make selections from the scripture for each of these categories to memorize.

Conquering all obstacles

St. Matthew 6:33 *But seek ye first the Kingdom of God and His righteousness, and all of these things shall be added unto you.* **Romans 8:37** *Nay, in all these things, we are more than conquerors, through Him that loved us.*

Temptation, Test or Trail

I Corinthians 10:13 *There hath no temptation taken you, but such is as common unto man, but God is faithful, who will not hath you to be tempted above that ye are able.*

Going Through

Romans 8:37 *Nay, in all these things, we are more than conquerors, through Him that loved us.*

Remembering the Power of the Tongue

James 3:8 *But the tongue can no man tame, it is an unruly evil, full of deadly poison.*

Fear

II Timothy 1:7 *God hath not given you the spirit of fear, but of power, of love and of a sound mind.*

Against Adversity

Isaiah 54:17 *No weapon that is formed against thee shall prosper: and every tongue that shall rise against thee in judgment, thou shall condemn.*

An Attack: To Form Emotional Breakdown

Philippians 4:8 *Finally brethren, whosoever things are true, whatsoever things are honest, whatsoever things are just, whatsoever things are pure, whatsoever things are lovely, whatsoever things are of good report; if there be any virtue, if there be any praise, think on these things.*

Epic Log

In this last section, as you review the answers you shall obtain the following:
- Have a working knowledge of another point of view.
- Have the location and scripture, if required for the answers.
- Be provided with other cross referenced scripture which supports the subject.

I as the writer of this text, written under the unction of the Holy Ghost, will not expect you to answer all, as the writer. However you should:
- Have at least one component of the writers answer, incorporated into your thoughts.
- Even thought your answers are worded differently, you are expected to read over and over, until you obtain a better understanding of what the writer is attempting to get across to you, as the student.
- When reviewing the writer's answers, you should be able to understand the answer based upon all that has been said, studied and reviewed, up to that explanation or answer.

As the student of this course, you will begin to realize, that you have a *book within a book,* at the end of the book, consisting a wealth of additional knowledge, through the answers:

- The answers are an extension of knowledge, which will transform you, as the believer into a world of thought that **you could not grasp upon yourself**, if you are a new convert.
- In addition, you will be assisted by God the Holy Spirit, as the Comforter, the Teacher, and Guide to further obtain a better understanding of God's Word.
- Upon the conclusion of this text, you will be ready for intermediate teachings entitled: ***Salvation and the Spiritual Walk*: The Intermediate Level as Volume II.** Therefore, look for my second text book @ Barnes & Noble and www.Amazon.com

May the Lord Bless you and keep you in His Perfect Care, until we meet againin text.
Your author and instructor:
Apostle Dr. June H. Lawrence, Phil 4:7

Day Break Ministries Incorporated

Bible School and Textbook Ministry Divisions

This Certifies that

Has successfully completed the studies

In

The First Year Level of Instruction

As

The New Converts and Beginners

Course

Salvation and Spiritual Growth

During the period of

Apostle, Dr. June H. Lawrence, Philippians 4:7

President, Author and Instructor
Day Break Ministries Bible School

Acknowledgement

I would like to acknowledge the following, in some form that were instrumental in assisting me in bringing topics to my remembrance for development in the Word of God,(King James Version).
God in the Entity of God the Holy Spirit, manifested through:
The Revelation Knowledge Gifts (**I Corinthians 12: 8-10**):

> The Gift of Knowledge
> The Word of Wisdom
> The Gift of Prophecy
> The Gift of Faith
> The Gift of Discernment of the Spirit

My various Church Homes down through forty years of my born again life experience, (through salvation by Grace, as the gift of God through which all things for me from past, to present and for eternal future, come into existence) as I sat weekly in their Bible Classes.
In addition Bible school attendance for eleven years part-time, possessing knowledge of all subjects offered upon graduation, obtaining:
Advanced Evangelical Teaching Certification
Lastly, I would like to acknowledge the resource for the uniform scripture copy on SIN: **www.bibleontheweb.com**, **King James Version**

Also

Unit 11 Topical Index summary on *SIN* was taken from: **www.bibletopics. com/sin.htm**

May the peace of God that passeth all understanding rest, rule and abide with you, until we meet . . .
Your author and instructor of the text
Apostle Dr. June H. Lawrence, Philippians 4:7